Digital SLR
Photography
ALL-IN-ONE
FOR
DUMMIES®
A Wiley Brand

2nd Edition

Digital SLR Photography

ALL-IN-ONE

FOR

DUMMIES®

A Wiley Brand

2nd Edition

by Robert Correll

FOR

DUMMIES®

A Wiley Brand

Digital SLR Photography All-in-One For Dummies®, 2nd Edition

Published by
John Wiley & Sons, Inc.
111 River Street
Hoboken, NJ 07030-5774

www.wiley.com

Copyright © 2013 by John Wiley & Sons, Inc., Hoboken, New Jersey

Published by John Wiley & Sons, Inc., Hoboken, New Jersey

Published simultaneously in Canada

For general information on our other products and services, please contact our Customer Care Department within the U.S. at 877-762-2974, outside the U.S. at 317-572-3993, or fax 317-572-4002.

For technical support, please visit www.wiley.com/techsupport.

Wiley publishes in a variety of print and electronic formats and by print-on-demand. Some material included with standard print versions of this book may not be included in e-books or in print-on-demand. If this book refers to media such as a CD or DVD that is not included in the version you purchased, you may download this material at http://booksupport.wiley.com. For more information about Wiley products, visit www.wiley.com.

Library of Congress Control Number: 2013934420

ISBN 978-1-118-59082-9 (pbk); ISBN 978-1-118-70091-4 (ebk); ISBN 978-1-118-70084-6 (ebk); ISBN 978-1-118-70070-9 (ebk)

Manufactured in the United States of America

10 9 8 7 6 5 4 3 2 1

About the Author

Robert Correll is the author of several books about digital photography and imaging, including both editions of *Digital SLR Photography All-in-One For Dummies*. His camera-specific digital SLR titles include *Canon EOS 5D Mark III For Dummies, Sony Alpha SLT-A65/A77 For Dummies,* and *Sony Alpha SLT-A35/A55 For Dummies*. He coauthored *Canon EOS Rebel T3/1110D* and *Canon EOS 60D For Dummies* with Julie Adair King. His other recent works include *Photo Retouching and Restoration Using Corel PaintShop Pro X5,* Fifth Edition; *HDR Photography Photo Workshop,* Second Edition (with Pete Carr); and *High Dynamic Range Digital Photography For Dummies*.

When not writing, Robert enjoys family life, photography, playing the guitar, grilling, and recording music. Robert graduated from the United States Air Force Academy and resides in Indiana.

Dedication

To my family.

Author's Acknowledgments

I'm grateful to have worked with so many talented people. Their time, skills, devotion, and attention to detail have helped me reach the high goals I set for this edition of the book.

In particular, I am deeply thankful to the wonderful publishing team at John Wiley & Sons. Tonya Cupp, Steve Hayes, and Annie Sullivan are part of the talented team of editors who helped create this book. I am also thankful to technical editor Michael Sullivan, whose insights and expertise helped keep the content of the book as accurate as possible.

It was my goal to introduce many more dSLR add-ons and accessories in this edition of the book. I have many thanks to give to the individuals and companies who were so generous with their equipment and time. They are: Bill Bailey of Nodal Ninja, Robert Gantt of Gary Fong Inc., Keri Friedman of LensBaby, Stephanie Murano of Lomography USA, and Joost Nieuwenhuijse of New House Internet Services B.V. (sellers of PTGui and PTGui). I would also like to thank the many other retailers and delivery staff who helped me find what I needed and deliver it.

Many thanks to my agent, David Fugate of Launchbooks.com.

A big "Thank you!" to our Pine Hills Church family. From shooting movies to photographing practices and services, your encouragement and assistance have been invaluable.

As always, thanks to my wife and children for encouraging, supporting, loving, and sustaining me.

Thank you for reading this. You're the reason we all worked so hard putting it together!

Publisher's Acknowledgments

We're proud of this book; please send us your comments at `http://dummies.custhelp.com`. For other comments, please contact our Customer Care Department within the U.S. at 877-762-2974, outside the U.S. at 317-572-3993, or fax 317-572-4002.

Some of the people who helped bring this book to market include the following:

Acquisitions and Editorial

Project Editor: Tonya Maddox Cupp

 (Previous Edition: Nicole Sholly)

Executive Editor: Steve Hayes

Technical Editor: Michael Sullivan

Editorial Manager: Jodi Jensen

Editorial Assistant: Anne Sullivan

Sr. Editorial Assistant: Cherie Case

Cover Photo: © Olivia Bell Photography / Getty Images

Composition Services

Sr. Project Coordinator: Kristie Rees

Layout and Graphics: Jennifer Creasey, Joyce Haughey

Proofreaders: Debbye Butler, John Greenough

Indexer: BIM Indexing & Proofreading Services

Publishing and Editorial for Technology Dummies

 Richard Swadley, Vice President and Executive Group Publisher

 Andy Cummings, Vice President and Publisher

 Mary Bednarek, Executive Acquisitions Director

 Mary C. Corder, Editorial Director

Publishing for Consumer Dummies

 Kathleen Nebenhaus, Vice President and Executive Publisher

Composition Services

 Debbie Stailey, Director of Composition Services

Contents at a Glance

Table of Contents

Book IV: Lighting and Composition 309

Introduction

Digital SLRs (dSLRs) are fantastic cameras. If you want the opportunity to take great photos and high-def movies, you can't beat the combination of power, flexibility, growth potential, and "accessorize-ability" of a dSLR.

I find its versatility breathtaking. With a dSLR, you can take photos (and movies!) of people, plants, animals, planes; action shots, still lifes, close-ups, far-aways, and everything in between. Much of this is due to the fact that the lenses are interchangeable. If you want to shoot distant objects on safari in Africa, get yourself a telephoto lens. If you'd rather photograph weddings and receptions, find a good prime lens. If you want to take great landscapes while on vacation, invest in a wide-angle zoom lens.

The sky is the limit. Deciding what to do and how to spend your time and money is up to you. I hope to help you along your journey into dSLR photography by showing what it's all about.

About This Book

Digital SLR Photography All-in-One For Dummies, 2nd Edition, is for anyone who's interested in enjoying photography using a dSLR camera. My goal is to demystify and un-convolute the technical aspects and illustrate the artistic elements of dSLR photography.

You don't need to have a dSLR to enjoy this book; maybe it's on your wish list. If you do have a dSLR, you can immediately apply the knowledge you glean from these pages. In classic *For Dummies* tradition, I've tried to write a book that's both friendly and accessible to beginners yet not beneath more advanced photographers.

How This Book Is Organized

Digital SLR Photography All-in-One For Dummies, 2nd Edition, is split into seven minibooks. Each minibook has its own broad focus, ranging from what you need to get started, to giving practical advice designed to help you photograph certain subjects. Within each minibook, you find the chapters that flesh things out. Some have more than others. That's okay. It just depends on the subject.

Although you can read this book from start to finish, you don't have to. Are you interested in design first? Turn to Book IV first. You don't even need to read the chapters within a minibook in order. If you want to immediately jump to the chapter on shutter speed, by all means do.

If you're new to photography, though, I *do suggest* starting at the beginning and reading the first minibook in order. When you've finished that, you should be able to turn to any place in the book and not get totally lost.

Here's a quick summary of each minibook.

Book I: Getting Started with Digital SLRs

I start out with a book that has everything you need to get started. I talk about dSLRs and how they work, what makes them tick, what all the buttons are, how to work the menu, and how to set up the camera. You should be able to properly hold your camera, clean it, attach lenses, insert and remove batteries and memory cards, and start taking photos.

Book II: Going Through the Looking Glass

This book goes into great detail about the different types of lenses you can use with a dSLR. You read about standard zoom lenses, explore how to photograph wide-angle scenes, and get creative with macro and telephoto lenses. Along the way, I pass along tips and tricks for using each lens type and suggest what they're best for. All fully illustrated!

Book III: Hey, Your Exposure's Showing

If you want to exercise more creative control over the photos your camera takes, then this book is for you. You see how to control the aperture (which affects depth of field), shutter speed (which controls motion blur), and ISO (which increases your camera's sensitivity to light). You also read about filters and how to think and plan in units of exposure.

Book IV: Lighting and Composition

If you take photos indoors or in poor light, knowing even a little about flash photography will help you take much better photos. In this minibook, you see how to use your camera's built-in flash, see whether getting an external flash is right for you, and explore a ton of cool flash and lighting accessories in this book.

To take good photos, you need to know what elements should go in the frame and how to organize them. This book covers both aspects. First, I explain how to *design* a photo — consciously choosing the elements you want to photograph. It doesn't have to be random! Then, I explain the best way to arrange the elements you choose so the photo looks compelling. Great stuff.

Book V: "Spiffifying" Your Photos

This book is mostly about software. I explain how to manage your photos using different software packages, as well as process raw exposures and edit JPEGs. You also see how to shoot and process *HDR (high dynamic range)* photos and panoramas. Finally, I explain ways to convert photos into black and white or creatively colorize them.

Book VI: Shooting Movies

A few years ago, compact cameras dominated the moving picture market. It's now possible to take *HD (high-definition)* movies with just about every dSLR sold. Moviemaking is here and isn't going away soon. I reveal what all the fuss is about, and how to shoot your own HD movies, in this book. Share your creations with your family, church, school, business, or the world at large. You can even shoot commercials and movies with dSLRS.

Book VII: Getting Specific About Your Subject

The last book has five gallery chapters. Each one is devoted to a different type of subject: people and animals, landscape and nature, sports and action, building and cities, and close-ups. I've chosen some of my favorite photos to share and give you insight into how I took them.

Icons Used in This Book

Helpful icons are scattered throughout the book. They appear beside information I want you to pay particular attention to (or to avoid if you see fit). Each icon has a unique meaning:

 The Warning icon highlights lurking danger. Pay attention and proceed with caution. Your equipment or photos or safety might be at stake. You know, as if you were about to drive off a cliff or stumble onto a cache of hidden dynamite. I've tried to include as many warnings as possible to make thing exciting for you. Just kidding. I might warn you this way: "Keep hold of your camera when taking it off a tripod. You don't want to drop it!"

 The Remember icon marks an interesting fact that you should tuck away in your brain to remember and use later. They're often facts. (With some wiggle room thrown in for good measure.) Here's what I mean: "The best time to go outside and photograph landscapes is during the morning or evening golden hour, which is around sunset."

 The Tip icon points out helpful information that might save you time. It's something you might want to try or do. Here's an example: "Use a wide aperture to create small depths of field. This will blur the background and make portraits look even better." I love tips. If I could, I would make every paragraph a tip.

When you see this icon, you know that technical information lurks nearby. If that's not your cuppa tea, skip it. Here's one to see whether you might like tech stuff: "Normal lenses have focal lengths approximately the same as your camera's sensor, measured diagonally."

Where to Go from Here

First, have a look at the table of contents. Next, jump to somewhere in the book that looks interesting or has information you want to know right now. Then go out and take some pictures. Rinse and repeat.

Seriously, no matter how much you fill your brain with information, photography is about *doing something* with that information. Use your camera to capture something of your world.

If you're feeling a little intimidated, put your camera in Auto shooting mode, don't change any other setting (with the possible exception of the photo quality), set the focus to Auto, and use your dSLR as an awesomely capable point-and-shoot camera. Become comfortable holding and using it, then read about something new and try it. Rinse and repeat.

Accumulate hands-on experience. It'll sink in.

If you're already pretty savvy, push yourself in new directions. I have. If you don't normally take photos of buildings, try it. If you don't normally shoot wide-angle shots, do it. If you don't typically venture more than five miles from home to take photos, go farther. If you've never processed a raw photo, shot HDR, attempted a panorama, taken shots at a basketball game, shot macros, gotten your feet wet in a river bed, then now is the time to get started. It's all here, waiting for you!

Book I

Getting Started with Digital SLRs

getting started
with
digital
SLRs

Contents at a Glance

Chapter 1: What's So Special about Digital SLRs?

In This Chapter

✔ Getting excited about digital SLRs

✔ Grouping dSLRs into categories

✔ Seeing what's new in dSLR world

✔ Understanding the specifications

✔ Buying a dSLR

✔ Accessorizing

What's so special about dSLRs? The short answer is: Lots!

Digital SLRs are tremendous cameras. They take great photos, are versatile enough to capture different scenes in a wide variety of situations, perform well in different light, and can be customized and enhanced.

But (yes, there had to be one) people often think digital SLRs are complex, expensive, professional cameras that are hard to master. But (this is the good kind) learning to use a dSLR isn't tough. Don't be intimidated. You don't have to start out with the model that has the most buttons and esoteric features. You can find a camera with the right features and price for you, no matter what your skill or interest level. Once you do, you can learn and grow at your own pace. The sky is the limit.

You'll be amazed at the photos you can take. It'll be worth it.

Introducing the Digital SLR

Digital single lens reflex cameras (also known as *digital SLR, dSLR,* or *DSLR cameras*) are SLR (single lens reflex) cameras that capture scenes with the help of an image sensor rather than using 35mm film. The sensor collects light, converts the data to 1s and 0s, and then processes and stores the result as a digital image file on your camera's memory card. The most common file type is JPEG, followed by a proprietary raw data format called Raw.

Flexing the mirror

A *single lens reflex (SLR)* cameras use a reflex — moving — mirror to reflect incoming light towards different paths inside the camera. Light passes through the camera's lens and either hits the mirror or passes directly to the sensor. Figure 1-1 illustrates these paths.

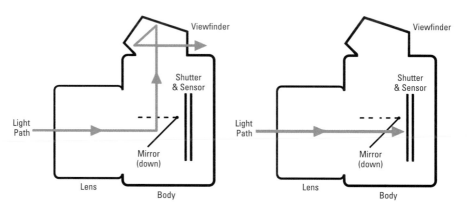

Figure 1-1: Light path through a digital SLR.

At the time it was invented, this was a revolutionary design that gave you the same view as the film in the camera. This meant that you could line up a scene through the viewfinder (also called *framing*) with the confidence that your efforts would be rewarded by a photo taken from the same perspective. You weren't using another lens or viewfinder positioned close by. You actually *saw* what the film would see when exposed to the light. This setup also meant that you could *meter* the scene (tell how strong the light was) using the same light.

Compared to older film cameras, framing and metering through the lens that would be used to take the photo was a great improvement. Prior to this, everyone looked through a second lens (twin-lens reflex), through what amounted to a hole in the camera body (cereal box top reflex), or through a flimsy framing rectangle that popped up on top of the camera (let's pretend it's reflex). You either focused by walking off the distance to your subject, or

not at all. Metering was just a wild guess! Rangefinder cameras tried to make finding the range easier, but without modern ranging techniques, focusing was still a chore.

Using interchangeable lenses

Another hallmark of SLR cameras is their lens flexibility. Although having an interchangeable lens system isn't a unique property of digital SLRs (using a single lens is), it's often thought of as a defining characteristic. To make a long point short, the lenses are interchangeable, which means you can customize your camera. Find the lens that works best for the subjects you want to photograph and attach it to the camera body. If you need more than one lens (many photographers do), buy them and keep them with you.

Figure 1-2 shows just how flexible this property is. You can change one camera body (a Nikon D300S, in this case) with as many lenses as you can afford to buy or rent — each with a different purpose and characteristics. Book I, Chapter 4, tells you how to attach a different lens.

Figure 1-2: A healthy lens stable.

Swap It Out

Being able to remove and attach different lenses to the same camera body is such a powerful concept that a new camera type has emerged over the last few years to great fanfare: the interchangeable lens compact camera. Examples include the Olympus PEN system of cameras, the Canon G1, and the Nikon 1. These cameras put a dSLR-sized sensor into a body the size of a compact digital camera that has a smaller lens mount that its larger cousins.

Buttons and dials

Another factor that sets dSLRs apart from other digital cameras is their devotion to control. Figure 1-3 shows the controls on the back of a Canon EOS Rebel T3/1100D. Despite being an entry-level camera, the Canon has plenty of controls to modify the camera's behavior. Compact digital cameras have many fewer . Don't let the controls intimidate you. They give you the control you need at your immediate fingertips. The less time you have to spend mucking about in menus, the more time you're shooting.

Figure 1-3: dSLRs focus on control.

Why to buy

Ultimately, only you can decide if a dSLR is the right camera for you. Every system, every camera, and every technology has tradeoffs. Digital SLRs aren't as small as compact cameras, as handy as your phone, or as simple to use as a door stop.

However, they have a lot going for them.

✔ **You're going to like what you see.** Ultimately, it's about the pictures. That doesn't mean dSLRs are better than other camera types in every situation and scenario, but they take potentially amazing pictures. When my family upgraded from a compact digital camera to an entry-level dSLR, we were immediately amazed at how much better the photos were, even using Auto mode.

As a matter of fact, your photos will get worse when you venture away from your dSLR's Auto mode and start taking photos where you set up the camera, evaluate the exposure, and focus. It takes time to learn how to use your dSLR fully and develop as a photographer. Don't give up. Your photos will get better with practice!

Figure 1-4 is an example of this excellent picture quality (if I do say so myself). It's a photo of several mercury votives arranged in depth and lit in a dark room. I used a lens with a wide aperture to produce the shallow depth of field. (Book III, Chapter 1 talks more about depth of field.) It didn't take long to set up or take, and the camera made it possible. Shots like these are what make the effort worth it.

Figure 1-4: Digital SLRs take great photos.

✏ **You're impatient.** I don't like waiting to take photos. I don't like waiting for the camera to get ready. I don't like pressing the shutter button and having to wait (without moving) to hear the shutter click. If you're like me, that makes dSLRs a perfect fit for you. dSLRs start up faster and have less shutter lag (the time between pressing the shutter release button and when the photo gets taken) than compact digitals.

✏ **You can practically do the splits.** Digital SLRs are incredibly flexible. You can shoot close-up macros or sweeping landscapes, ultra-wide angle or telephoto, intimate portraits, family gatherings, fast-action sports, slow waterfalls, and everything in between — large, small, fast,

slow. What more could you want from a camera? Books II and VII talk you through shooting these different kinds of photos. Figure 1-5 is a dynamic action shot taken with a telephoto lens. You can see the sand on the drivers' faces and their determination. Compare it to Figure 1-4, which is a designed, static shot. They were both taken with dSLRs.

✔ **Sensor size:** Even cropped-body dSLRs (whose sensors are smaller than a frame of 35mm film; see a full explanation later in this chapter) have larger sensors than compact digitals and super zooms. Interchangeable lens compacts (compact cameras with dSLR sensors that also let you change lenses) now compete with dSLRs in this regard, but you still get tremendous advantages to using a traditional dSLR.

✔ **Large viewfinder:** The worst dSLR viewfinder is still larger and better than the one most compacts have. Well, that's if a compact even has a viewfinder. Most don't, which makes you rely exclusively on the LCD monitor on the back of the camera. Figure 1-6 shows a Canon compact camera sitting next to a larger Nikon dSLR. The compact camera doesn't have a viewfinder at all. You're expected to frame and shoot everything using the monitor, which can be tough in some lighting conditions.

Figure 1-5: Determined to win.

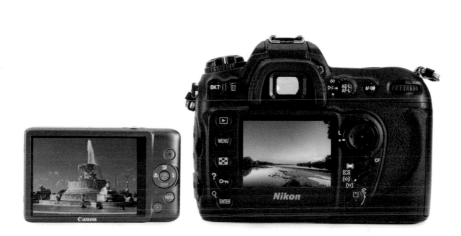

Figure 1-6: Most compact cameras don't even have a viewfinder.

✔ **Interchangeable lenses:** Changing lenses isn't a cure-all, but you can tailor your camera to take the photos you need. To me, that's an enormous benefit. Being able to take off a lens when you need to and take a portrait instead is tremendously valuable.

✔ **Manual control:** I can't tell you how many times I've been frustrated with compact digital cameras. They never seem to have *just the right* automatic scene I need at the time. That, and it takes me ten minutes to find it. Automatic shooting modes can make photography easier, but being able to exercise manual (even partly manual) control over your camera when you need it can be a real help. *You* make the creative decisions. *You* set the priorities. *You* manage your shots. Figure 1-7 shows the shooting display of a Nikon D3200 in Manual mode. I can change all the settings. I can change aperture (see Book III, Chapter 1) shutter speed (see Book III, Chapter 2), ISO (see Book III, Chapter 3), and flash settings (see Book IV, Chapter 1).

✔ **Automatic controls:** You don't need to be a rocket scientist to use a dSLR. In fact, entry-level dSLRs have enough automatic shooting modes to satisfy the casual photographer in all of us. The truth is that most digital SLRs, even those that cost thousands of dollars, can act like a point-and-shoot camera. Digital SLRs have manual controls and complexity *if you want them.*

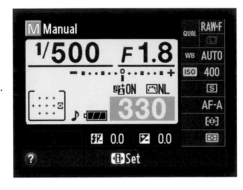

Figure 1-7: Using a camera in Manual mode.

✔ **Hot shoe:** Digital SLRs have a *hot shoe* on top of their viewfinder. It's the silver bracket in Figure 1-8. A hot shoe is mainly to mount external flashes and other accessories.

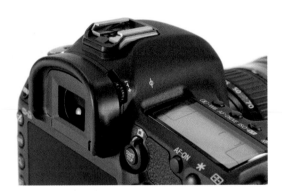

Figure 1-8: Hot shoes mount external flashes and other accessories.

✔ **Accessible to all:** dSLRs come in enough designs and models to make everyone happy. If you're new to photography, you can pick up an entry-level model and start taking photos *right away*. If you're a professional, you have access to cameras with much more power and flexibility. You can shop for the dSLR that meets your demanding needs and find it. That you can use a dSLR both professionally and in your backyard is a testament to excellent design.

✔ **Tough:** dSLRs, which are much more rugged than compact digital cameras, are built to stand up to more punishment without breaking. That doesn't mean go out and hammer nails with them.

High-end dSLRs emphasize the fact that their bodies are made from magnesium alloy, but even low-end dSLRs with plastic (also known as *polycarbonate*) bodies are rugged. People with magnesium bodies tend to claim that theirs are better, and people with polycarbonate bodies tend to say that theirs are better.

✔ **Accessories:** Have I mentioned that you get to buy and use everything from a bubble level that mounts on your camera's hot shoe (you can see whether your camera is level or not) to sophisticated external flash units, amazing flash unit accessories and other lighting modifiers, Global Positioning System receivers, and more? If you're the type who likes installing spoilers and underbody lighting, dSLRs deliver.

✔ **Cool factor:** Nothing says cool (or maybe nerd; but nerd is the new cool) like walking into a cocktail party with your significant other on your arm and a huge dSLR around your neck. That's me taking a photo in Figure 1-9 with the Canon 5D Mark III.

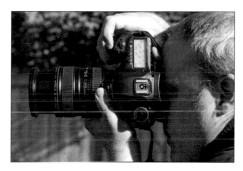

Figure 1-9: A dSLR signals that you're really interested in photography.

Categorizing Digital SLRs

You can decide digital SLRs into several categories based on their price, form, and features/capabilities. These categories give manufacturers the flexibility to create and market cameras to vastly different audiences. Not everyone wants or needs a $5,000 camera. By the same token, a professional may be willing to pay that much. In the end, this gives you, the consumer, choices.

I break down the market in the following sections.

You gotta start somewhere: Entry-level

These cameras are for beginners or those with a limited budget. Prices are under $750, give or take. The least expensive dSLRs are between $400 and $600. More advanced entry-level dSLRs range from around $600 to $750. At $750, you have to decide whether to get the "best" entry-level model or move up to a basic mid-range camera.

The least expensive entry-level cameras may not have an articulated monitor, but more expensive entry-level cameras might.

Entry-level dSLRs have these features:

- ✔ Low maximum ISO speeds
- ✔ A lower maximum shutter speed than other dSLRs
- ✔ A slower frame rate
- ✔ Slower flash sync speed
- ✔ Fewer movie options
- ✔ Different internals (sensor, processor, and other technologies)

Entry-level cameras don't generally have features more advanced photographers need, such as the capability to trigger an external flash wirelessly, attach a PC sync cord (to connect flash units), or connect external microphones. Most entry-level cameras have a lower pixel count than their more expensive brethren, but not all. The Nikon D3200 (see Figure 1-10) is an example of a camera that has really jumped ahead of the trend.

Entry-level cameras are all cropped-frame (which is explained fully in this chapter).

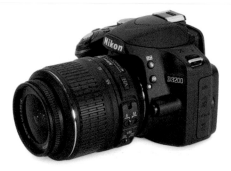

Figure 1-10: The Nikon D3200 is a good example of an entry-level dSLR.

Upgrading to mid-range models

Mid-range cameras are for amateur photographers who want a bit more out of their dSLR and are willing to spend the extra money. Prices range from between $750 to $1,000. These are very good cameras, and $750 isn't cheap.

Mid-range cameras tend to have a bit more of everything entry-level cameras have:

- Higher ISO speeds
- Larger monitors with more pixels
- Faster frame rates

This depends on when the cameras you're comparing were released. A 2013 entry-level dSLR might have better in many areas than a 2011 mid-range dSLR. Compare apples to apples. You basically get a modest-to-moderate performance upgrade from entry-level capabilities for a few hundred dollars when choosing a dSLR in this category. These dSLRs are also cropped-frame and made from polycarbonate plastic. Figure 1-11 shows the Sony Alpha A55.

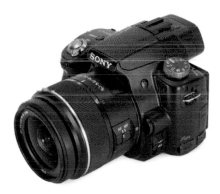

Figure 1-11: The Sony Alpha A55 is an upgrade from an entry-level camera.

Entering the high-end amateur category

When you get to between $1,000 and $1,500, you're talking about amateur photographers who mean business. $1,500 is serious money for a camera. High-end cameras are squarely in the middle of a manufacturer's lineup (at least with Nikon and Canon, who have multiple cameras at every level). They include pro-level features, which means professionals who don't need a $5,000 camera often find something in this range they can use. At the same time, amateurs who want a serious upgrade from entry-level cameras can be happy with the same camera.

High-end cameras often have a

- ✓ Faster maximum shutter speed
- ✓ Faster flash sync speeds
- ✓ Faster frame rates
- ✓ A better viewfinder
- ✓ More options and functions for setup
- ✓ Better autofocus system with more AF points
- ✓ More precise metering

They're also larger and heavier than entry-level and mid-range dSLRs but considered a lightweight professional camera. Magnesium alloy may strengthen the camera body. These dSLRs are all cropped-frame. Figure 1-12 shows the Canon EOS 60D.

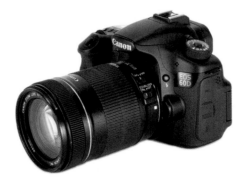

Figure 1-12: High-end amateur cameras add even more power and features.

Going semi-pro

These dSLRs, ranging between $1,500 and $2,500 or thereabouts, are considered semi-pro. Semi-pro? Semi-pro?!? (Sing it to the tune of "Playoffs? Playoffs?!? Are you kidding me?") Yes. It's a weird world in which professional photographers use cameras up and down the spectrum, but a $2,000 camera is considered semi-pro. The reason for this seeming oddity is that these cameras are designed to operate professionally, but may have performance limitations and form factor compromises (for example, they may not have a built-in grip) that keep them affordable, all things considered. Semi-pro cameras provide professional results but are accessible to professionals and amateurs.

Semi-pro cameras are larger than those that came before them. They also weigh more, use some or all magnesium alloy, and have many more features. Frame rates should be faster and autofocus systems better than high-end amateur models. The metering system should also be better. This category features the first full-frame dSLRs, such as the Nikon D600 and Canon EOS 6D. Figure 1-13 shows the cropped-frame, yet still very powerful, Sony Alpha A77, with vertical grip attached.

Figure 1-13: Semi-pro dSLRs have most of the features of pro cameras, but are slightly different.

All-in with professional dSLRs

Professional-level dSLRs cost over $2,500. That sounds pretty expensive until you realize that there are two tiers. *Standard* professional dSLRs run between $2,500 and $3,500. *Premier* dSLRs represent the pinnacle of a company's dSLR lineup. At this level, the Canon EOS-1D X lists for $6,999 and

the Nikon D3X lists for $7,999. The Nikon D4, arguably better than the D3X (certainly newer, with higher ISOs and full HD movie capability), is less expensive, coming in at $5,999.

All these cameras are full-frame with magnesium alloy bodies, and most have built-in vertical grips. AF and metering systems are as good as it gets, as are the viewfinders, customization options, and many other features. Figure 1-14 shows the full-frame Canon EOS 5D Mark III. It's a standard pro camera that lacks the built-in vertical grip.

Figure 1-14: The 5D Mark III represents the Standard professional camera.

Getting Shiny New Features: Recent Developments

Digital SLRs continue to evolve. That is truly fantastic news, because photographers benefit from the new capabilities and technology. Here are some of the main recent dSLR developments and trends:

- **The dSLT:** Digital SLTs *(single lens translucent)* are a close relative of the dSLR. So close that I don't distinguish in this book between the two. For most practical purposes, they look like, act like, sound like, and take photos like dSLRs. The main difference is that dSLTs don't have a reflex mirror. Instead, they have a semi-transparent or *translucent* mirror that doesn't need to move out of the way. It allows some light to pass through, and bounces the rest up into the camera's viewfinder (or into a sensor that drives the electronic viewfinder).

Although Sony didn't invent the idea, they appear to have fully committed to this technology. Between the first and second editions of this book, Sony stopped all dSLR production. Its entire lineup is now dSLTs!

✔ **Electronic viewfinder:** The electronic viewfinder is related to the dSLT, but not by necessity. Sony again has led the charge and has electronic viewfinders on all its dSLTs.

Normal viewfinders are *optical.* You look through a prism that directs light from the reflex mirror to your eye. They work whether the camera is on or off. Sony's electronic viewfinders are small, high-resolution *organic light-emitting diode (OLED)* monitors that are used in place of an optical viewfinder. They basically combine the functionality of a standard viewfinder with the LCD monitor on the back of the camera. You can compose and frame the scene normally, view photos during playback, see the camera's shooting display, and use the menu — all without taking your eye away from the viewfinder. Truly awesome.

✔ **Articulated monitors:** Articulated monitors swing out from the camera back in various ways, so you can creatively position the camera during Live view shooting. See Figure 1-15. The monitors are becoming more prevalent. You won't often find them on the cheapest entry-level models, but they abound on mid- and higher-end amateur dSLRs.

✔ **Full HD movies:** A few years ago, not many dSLRs even shot movies. Today, to be competitive, a dSLR has to. Not only that, but it can't get away with shooting only standard-definition movies (640 x 480 pixels). Full HD (1920 x 1080 pixels) is the new standard. Cameras set themselves apart by offering different file formats, file sizes, frame rates, and other specialized movie settings. Book VI, Chapter 1 explains more about movies.

✔ **Expanded shooting modes:** Some dSLRs offer creative shooting modes. In other words, you're not limited to the four advanced shooting modes: Program auto, Aperture priority, Shutter priority, and Manual mode. See Book I, Chapter 5 for a full explanation of each shooting mode. These include Automatic modes, Creative Auto, a plethora of scenes (portraits, action, landscape, night portrait, and so forth), automatic HDR modes, panoramas, 3D panoramas, easy-to-use double-exposure modes, and more.

Figure 1-15: Pull the monitor out from the back of the camera and position it.

✔ **Help!** Current entry-level dSLRs have a tremendous number of helpful tools to get you started. This includes features like giving you context-sensitive help when you're looking at the menu system to a guided shooting mode. Figure 1-16 shows Guide mode from a Nikon D3200.

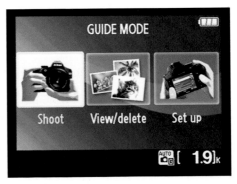

Figure 1-16: In Guide mode, choose your adventure!

✔ **In-camera raw processing:** Some digital SLRs let you perform post-capture raw processing in the camera. You can tweak white balance, fine-tune the exposure, resize photos, and save your own JPEGs on the fly and without having to use a computer. Book VI, Chapter 2 talks more about raw.

✔ **In-camera JPEG processing:** You may also be able to work with JPEGs in much the same way. Brighten, improve contrast, resize, and so forth. See Book V, Chapter 3 for more about JPEGs.

✔ **Higher ISOs:** Maximum ISOs continue to rise. Entry-level cameras routinely have maximum ISOs of 6400 (*not* 1600 or 3200), while professional-level cameras can top out at 204800! See Book III, Chapter 3 for more about ISO.

✔ **Higher pixel counts:** Pixel counts also continue to rise. Newer entry-level dSLRs have more pixels than professional models from years past. This means that you can take photos and make poster-sized prints without losing quality. You can also crop them and still have a pretty large photo.

✔ **Multiple memory cards and/or slots:** Some dSLRs support more than one type of memory card. Some even support having more than one card in the camera at once. You can configure these setups in different ways. You may want to use them as a single, large card or have a primary and backup. Figure 1-17 shows two cards in the Canon 5D Mark III.

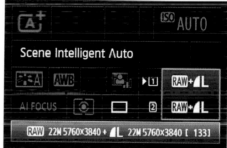

Figure 1-17: In this case, both cards are set to record the same image quality.

✔ **Live view:** Live view (see Figure 1-18) has become a staple on all dSLRs. Careful, though: Not all Live view shooting modes are good in all situations. Live view lets you use the LCD monitor on the back of the camera to compose and take shots with rather than the viewfinder. Book I, Chapter 5 has more information on how to use Live view.

In my opinion, Sony still leads the pack in terms of offering a practical Live-view-on-the-go capability. You point and you shoot. It's that simple. Nikon and Canon Live view modes take some time to set up, get focused, and shoot with. They work great in the studio. Not so great for birthday parties. They're getting better, though.

Figure 1-18: In Live view, you look at the back of the camera to compose and set up the shot.

Getting Picky about Specifications

Specifications are the camera's detailed characteristics. *Specs* tend to be technical, and they're important. Companies put this information on their websites, and each camera's manual devotes several pages toward the rear exclusively to the specifications.

These details

- Define a camera.
- Provide the information you need to understand what a camera can do.
- Are how you compare one model to another.

The data itself is pretty standardized; companies tend to use the same terminology and language (except for their naming methods). I'm not going to get into every possible technical specification in this section; I do want to list a few important ones and explain what they are.

Sometimes every camera has the same capability. This makes that specification useless as a discriminator. File format is a good example. All dSLRs today save RAW and JPEG photos. It wouldn't make any sense for you to go up to a salesperson and ask her to show you all the dSLRs that shoot RAW. They all do! That's why I don't include every specification in this chapter.

Make and model

Each camera manufacturer has a method to its naming madness.

- **Nikon** starts each camera name with the letter *D* (presumably for digital), followed by a number. The numbers sort of make sense. The D3200 is an entry-level camera that evolved from the D3000 and D3100. The D800 is a full-frame professional camera that sprang from the D700. The D200 evolved into the D300, and now the D600.

- **Canon** uses the term *EOS* (electro-optical system) and then the specific model number to identify its digital SLR line. For example, a semi-pro model is the Canon EOS 6D, which takes over from the 7D. Canon uses the term *Rebel* to identify its consumer dSLRs. The Canon EOS Rebel T4i is an example. The Rebels also sport a number, depending on the market. The EOS Rebel T4i is also known as the 650D.

✔ **Sony** has lately changed to two-digit identifiers, such as the A99. The *A* is actually the Greek letter alpha (α). The numbers progress from low to high. The current entry-level camera is the A37, and the A77 is a semi-pro model.

✔ **Pentax** uses the letter *K* followed by an identifying number, such as the K-5 II.

✔ **Olympus** uses the letter *E* followed by a number. The E-5 is its current semi-professional dSLR.

Year introduced

When was your camera announced and, give or take, when did it first go on sale? Technology comes and goes pretty fast. You won't find anything new for sale older than a few years. Don't fall so in love with a camera body that you won't give it up in five or eight years.

Your lenses are your best long-term investment. A mate to this rule is to avoid wasting money on a camera body that has features or performance you don't need. It'll be out of date in a few years anyway.

Sensor size

One way that digital SLRs are categorized is by their sensor size. Digital SLRs sensors vary in size.

✔ dSLRs whose sensors are the same size as a 35mm frame of film are called *full-frame* dSLRs.

✔ dSLRs whose sensors are smaller are called *cropped-frame* dSLRs.

This list explains a more technical designation:

✔ **35mm:** Also known as *full-frame cameras.* Their sensor is the same size as a 35mm frame of film, which measures 36 x 24mm. This is the gold standard of SLR film/sensor sizes. Nikon calls its full-frame cameras *FX.*

✔ **APS-H:** This category is unique to Canon. It's in between full-frame and the smaller APS-C.

✔ **APS-C:** This is the standard sensor size for most digital SLRs. It's actually much smaller than a 35mm frame of film, but far larger than a compact digital camera sensor. Canon's APS-C sizes are a bit smaller than others. Nikon calls its APS-C cameras *DX.*

✔ **Four Thirds:** These sensors have a 4:3 aspect ratio (of length to height) instead of the more traditional 3:2. Although the aspect ratio isn't a factor in sensor size, Four Thirds sensors are all much smaller than full-frame dSLRs, and even smaller than APS-C sensors. This makes the cameras cheaper and lighter, so they can compare in size (not considering the lens) of smaller compact digital cameras.

Figure 1-19 shows a full-frame camera, the Canon EOS 5D Mark III, with the mirror raised. You're seeing the sensor inside. It virtually fills the body cavity. Notice the two frames to the side of the camera. These are enlarged, but in the correct proportion. The APS-C sized sensor is relatively small compared to the 35mm sized full-frame.

Full-frame

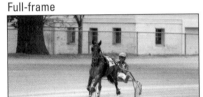

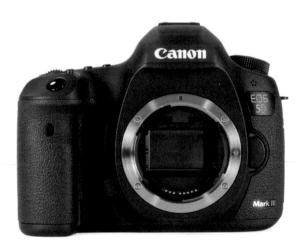

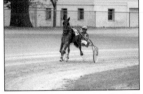

APS-C

Figure 1-19: Comparing full-frame to APS-C.

Of note, sensors fit into a certain category but may be off by a millimeter or two one way or another. You can sometimes find sensor size differences in cameras with the same sensor class from the same manufacturer.

Crop factor

Crop factor doesn't have to be confusing, but it sometimes seems like it when a person tries to explain it. In other words, it's simpler than it sounds.

A dSLR's *crop factor* relates to the size of its sensor compared to a 35mm frame of film. Right. That reference again.

Rather than go into a long-winded explanation, I jump to the numbers:

- Full-frame dSLRs have a crop factor of 1.0. This means their sensors are the same size as a 35mm frame of film.

- Most APS-C sensors have crop factors of 1.5 or 1.6. These sensors are about one and a half times smaller than the frame of film.

- Four Thirds sensors have a crop factor of 2.0. To turn it around, that means a 35mm frame of film is about twice the size of a Four Thirds sensor (give or take; remember, their aspect ratios aren't the same).

The final connection is that a camera's crop factor, which is based on its sensor size, affects the *apparent focal length* (also called *effective focal length* or *35mm equivalent*) of every lens attached to the camera.

Because of smaller sensors (the crop factor), a lens with the same *focal length* (distance between the optical center of the lens and the camera sensor) has a more restricted field of view on a cropped-frame camera than it will when it's mounted on a full-frame camera. Book II covers using lenses with different focal lengths in detail. *Field of view* is how wide an angle you can see through the lens. A 50mm lens feels close to normal (what you see with your eyes) on a full-frame dSLR, but is into telephoto range on a cropped-frame camera. See Figure 1-20 for a comparison.

To get the effective focal length of the lens, multiply the focal length by the camera's crop factor. Like this:

- A 50mm lens mounted on a full-frame dSLR with a crop factor of 1.0 has an effective focal length of 50mm.

- A 50mm lens mounted on an APS-C sensor with a crop factor of 1.5 has an effective focal length of 75mm.

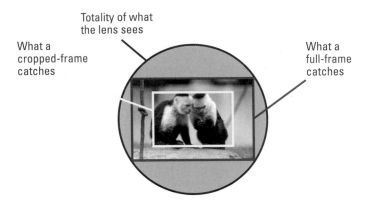

What a
cropped-frame
catches

Totality of what
the lens sees

What a
full-frame
catches

Figure 1-20: The effect of a larger crop factor is to "zoom into" the scene.

You can't get free optical zoom with a cropped-frame sensor. The photo is *cropped,* not zoomed. It looks zoomed, but the lens is doing nothing different and providing no more detail. You're just seeing it from a different perspective.

Aside from generally being interesting, a practical point about the crop factor is that it gives you a way to predict how dSLR lenses will perform on different cameras with different sensor sizes. That helps you choose the lens that will produce the right field of view for you. A 50mm lens is a 50mm lens, regardless of what you put it on. However, it won't always act like one!

- When you mount it on a full-frame camera, it will look like a 50mm lens.

- When you mount it on an APS-C camera, it will feel more like a 75mm lens.

- When you mount it on a camera with a Four Thirds sensor, it will act effectively like a 100mm lens on a standard 35mm SLR.

And now for a technical note. If you want to do the calculations yourself, crop factor is based on the diagonal measurement of the sensor compared to the diagonal size of 35mm film. Field of view is also diagonal. On a full-frame camera, a 50mm lens takes photos that have a 46-degree field of view. On a cropped-frame dSLR with a crop factor of 1.5, the same lens takes photos of approximately 31.5 degrees.

Pixel count

Look for how many *effective megapixels* a dLSR has. *Effective megapixels* is different than the total number of pixels on the camera sensor. Pixels are only really, truly effective in the area that actually produces the photo. This measurement affects your photos' pixel dimensions and file size, as shown in Figure 1-21. The photo's type, size, and dimension are just below the Image Quality line in this figure.

Type, size, and dimension

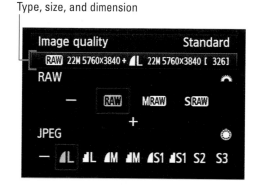

Figure 1-21: These large photos are 22 megapixels in size.

It's hard to say what the "right" number is. Ten megapixels was a good size a few years ago, but has been shown up by better cameras shooting more and more pixels. I recommend using pixel count as a tiebreaker. All other aspects being equal, the camera with more pixels will probably serve you better in the long run. Realize, though, that the greater the effective pixel count, the larger your photos will be. Larger photos take up more space on memory cards and on your hard drive. They will also stress your computer if you need to edit or process them.

ISO

ISO, also called *ISO speed* or *ISO sensitivity,* is a measure of the camera sensor's sensitivity to light. You can turn it up or down. The specification will list the camera's ISO range. Sometimes a dSLR allows you to *expand* this range either up (mostly) or down (from 100 to 50, for example). These aren't listed as native ISO speeds by the manufacturer (*native* comes with your camera), but instead as ISO expansion. See Book III, Chapter 3 for more information on ISO.

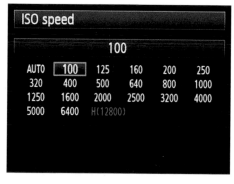

Figure 1-22: Setting the ISO.

Figure 1-22 shows me setting the ISO on my dSLR. Note the grayed-out H(12800) setting. This is an expansion value that hasn't been enabled.

ISO speeds should be high on your list of criteria when choosing a new dSLR. In general, look for the largest maximum ISO speed you can afford. Higher ISOs improve your ability to shoot in low light and let you turn up the shutter speed when capturing action. The effect of using higher ISOs will be noise to varying degrees. Book III, Chapter 3 explains further. Entry-level cameras don't perform as well as more advanced dSLRs.

Maximum shutter speed

Practically speaking, dSLRs use only two maximum shutter speeds. Entry-level models top out at 1/4000 second (see Figure 1-23), while more advanced models can shoot at 1/8000 second. I don't think you're going to run out and buy a camera based on this. However, as with pixel count, maximum shutter speed can be a tiebreaker.

Make sure the camera you're interested in is comparable to its peers. If it isn't, you may want to reconsider. I don't think you'd regret choosing a camera with a 1/4000 second maximum shutter speed, but always ask yourself what tradeoffs were made to create any particular camera.

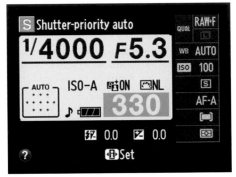

Figure 1-23: On this camera, 1/4000 seconds is as fast as it gets.

Metering and exposure

While the specifics are technical, cameras provide you with ways to evaluate their *metering* (how they sense the amount of light in the scene) and autofocus capabilities.

When looking at metering specs, look for how many pixels or zones the camera uses to evaluate the exposure. However, heads up: The Nikon D3200 has a 420-pixel RGB sensor for this. The Canon EOS Rebel T4i uses a 63-zone metering system. They're both fine, but use different techniques. So, realize that Canon and Nikon meter differently. Comparing the details of their systems is like comparing apples and oranges.

What you can do is look at different cameras of the same brand. The Nikon D600 uses a 2016-pixel RGB sensor. Compared to the D3200, the advantage goes to the D600.

Autofocus points

The autofocus system is another area where you can compare cameras. Each camera has a number of *autofocus (AF)* points. More is better. The Nikon D3200 has 11 AF points. They can be used in single-point AF, dynamic areas A, auto-area AF, and 3D-tracking AF. Sounds pretty good. Professional cameras have more points and more ways to choose them. The Canon T4i has 9 AF points, with automatic or manual point selection. In Figure 1-24, I'm choosing a single AF point manually.

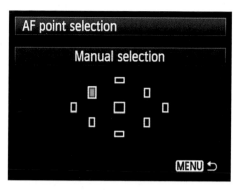

Figure 1-24: The camera focuses at the AF point you've chosen in Manual mode.

Flash sync speed

This is another specification that may not seem that big of a deal, but can be. *Flash sync speed* is the maximum shutter speed a camera can use along with the built-in flash. They're slower than you might think, and entry-level dSLRs don't work as well as fancier cameras. You may wish to use this as a tiebreaker.

Regardless, you can't take great high-speed shots with a built-in flash. If you're going to try to catch a lot of action, get an additional flash. I talk more about that in Book IV, Chapter 1.

Movies

Virtually all dSLRs shoot movies. Not only that, but Full HD movies (1080p) are the new standard. When you look at your camera's specs, examine the movie section closely. Look for these things:

- ✔ How many different sizes and frame rates it offers.

- ✔ Focusing and metering options.

- ✔ Whether you have any control over exposure.

Entry-level cameras offer less than more expensive models.

- ✔ Full HD movies are 1920 x 1080 pixels.

- ✔ HD movies are 1280 x 720.

- ✔ Standard definition (SD) movies are 640 x 480 pixels.

Shooting modes

You can put a dSLR in different shooting modes (also called *exposure modes*) based on the situation. The degree of control you have over the camera varies from mode to mode, from controlling the whole shebang in Manual mode to giving up all the control in Auto mode.

Traditionally, dSLRs have at least these five shooting modes: Manual, Aperture priority, Shutter priority, Programmed autoexposure, and Bulb. Entry-level cameras have even more modes. They're meant to help you. You'll find one or more Auto mode, a Flash off mode, and several scene modes (landscape and macro, for instance).

One way to tell between cameras is to carefully check out the automated modes scenes they offer. Some cameras have HDR, panorama, 3D panorama, super-fast continuous action, and double-exposure modes. Book I, Chapter 5 talks more about these modes.

Media

Digital cameras store photos and movies on memory cards. The cards come in different types, and several models and speeds of each type. If you're upgrading cameras, it's always nice to be able to reuse equipment. Different cameras require different memory cards.

- **SD cards** appear to be the most prevalent type of memory card. They're reasonably small and work fine. The best way to make sure you get the right card is to look at the camera's specifications. I have several cameras that require SD cards, and have never had a problem.

- **CF (Compact Flash) cards** are larger than SD cards. I've used many cameras that require CF cards, and they're good. My thing to be aware of: If the pins inside the reader (that go into the card) get bent, it won't work.

Viewfinder specs

Take a look at two specifications relating to viewfinders:

- **Frame coverage:** How much you see of what the sensor will actually record. Oddly enough, most dSLRs don't show you the entire scene when you look through the viewfinder. Much of the time, a small bit here and there won't hurt, especially when you can recompose or crop later. However, sometimes you want to be as precise as possible and need a camera with as much viewfinder coverage as you can afford.

✏ **Magnification:** Most digital SLRs reduce magnification of the scene. In other words, they make it smaller. If you take your eye away from the viewfinder, things get larger. Magnification is mostly personal preference. The Sony Alpha A77 magnifies the scene by 107 percent. On the other hand, the capable Canon 5D Mark III has a magnification factor of 71 percent.

The key, again, is to check cameras against others in the same class. If you're looking at a mid-range camera and it has more viewfinder coverage or magnification, you can use that information to break a tie.

Lens mount

This specification tells you what lens mount the camera has. You have to buy lenses that work with your camera's mount.

Steadying your hand: Image stabilization

Image stabilization is especially important when shutter speeds are slow. Any camera movement or lens shakiness will rob you of a sharp photo. And if you're still getting shaky photos, consider a tripod. Cameras tackle shaky hands by two different approaches:

✏ **Lens:** The image is stabilized in the lens, not the camera body. Current lens-based stabilization systems are named differently, depending on the brand of camera you are referring to. Canon calls it Image Stabilization (IS). Nikon calls its system Vibration Reduction (VR). In both cases, the lens has a floating optical element that, when active, is gyroscopically stabilized. When the lens moves a bit (there are practical limitations, of course), the IS/VR unit moves in opposition. This keeps the image focused on the sensor rather than jumping around.

The advantage to using lens-based stability systems is that the entire camera benefits when the image is stabilized by the lens. The autofocus sensor, the image sensor, the metering sensor, and the viewfinder (that's you) all see a stable picture.

✏ **Body:** Body-based image stabilization (called SteadyShot by Sony) adjusts the position of the image sensor in opposition to movement, thereby enabling you to capture a clear photo. These systems move the image sensor only. Nothing else benefits.

The advantages to body-based stability systems is that you have it no matter what lens is attached to your camera. The most expensive long-range super-telephoto lens in the world and the cheapest plastic lens will both benefit from in-camera stabilization.

Here is a quick summary of the top three manufacturers:

- ✔ **Nikon** uses the F mount. The mount will not be any different between cropped and full-frame cameras. However, cropped-frame cameras are compatible with FX and DX lenses. Full-frame Nikon cameras are only compatible with FX lenses.
- ✔ **Canon** uses the EF lens mount. Similar to Nikon, this mount is used on cropped and full-frame cameras. Canon uses the EF-S designation to identify lenses that are only compatible with cropped-frame Canon cameras with the EF lens mount.
- ✔ **Sony** uses the Alpha mount or A-mount. Of note, DT lenses are only compatible with cropped-frame bodies.

Shopping for a dSLR

Shopping for a dSLR doesn't have to be stressful. Be ready with facts, however, about how the dSLR market works and how to evaluate cameras.

Understanding the dSLR system

Bottom line: You can't mix and match lenses (there are limited exceptions to this), camera bodies, flash units, and other accessories between different camera systems.

When you buy a digital SLR, you're buying into a system from a specific manufacturer, such as Canon, Nikon, or Sony. Although this may not affect your immediate purchase, it will if you want to buy more lenses, flashes, and other accessories. Compatibility becomes more of an issue if you already have several lenses and accessories from one manufacturer and want to upgrade camera bodies. You have to stay in your lane if you want things to work on your new camera.

Even if you buy lenses from a third-party manufacturer such as Sigma, Tamron, or Tokina, you're still locked into the mount that you bought the lens to fit on. For example, Sigma makes its 10-20mm f/4-5.6 ultra wide-angle lens for the Canon EF mount, the Nikon F mount, and the Sony Alpha mount. While the lens may be the same, the built-in mount locks it to a particular camera system.

Switching brands is harder the longer you use a single brand. It's not impossible to make the change, but it takes effort. Consider putting things up for auction online to defray some of the expense.

Going shopping

I offer you this general method as someone who has gone through it himself, made mistakes, and learned from them. In the last few years I have bought, rented, and handled a fair number of dSLRs from entry-level cameras like the Nikon D3200 to the professional models such as the Canon 5D Mark III. I've also visited every manufacturer's website, looked at every available dSLR specification, downloaded every manual, and pored over every specification to try to boil this down to a handful of indicators you should be looking for.

To shop for a digital SLR, follow these general steps:

1. **Set a budget.**

 There's no sense in looking at a $3,400 camera if you can't afford it. Seriously, people will tell you (or you will read) how much better a $3,400 camera is than one that sells for $800 until you're sick of it. Though they may be right, that information is entirely irrelevant to you and your decision! Your budget depends on you and is probably based largely on factors unrelated to photography.

 Set a budget. It'll save you time and frustration. Don't forget to factor in lenses, bags, tripods, filters, flashes, extra batteries, and remote shutter releases. Those things all add up.

2. **Check out cameras that are in your price range.**

 This step is about collecting information, not weeding out cameras or making a decision now.

 Look at camera models from one or more manufacturers. You should find yourself looking at cameras in the same general category, unless your price range straddles a boundary. For example, if your price range is from $500 to $700 and you want the latest models, you're squarely in the entry-level category. If you have $1,000 to $12,00 to spend, you might be looking at high-end amateur or mid-range cameras.

 Pay attention to these qualities:

 - **Sensor size:** This isn't a question as much as a realization. If you can't spend over $2,000, you're in the cropped-frame category.

 - **Age:** Was the camera released three year ago? If so, it might soon be replaced by a better model. If you want the latest technology and performance, wait or choose another model. On the other hand, you may be able to get a good deal on a camera close to the end of its shelf life (which is far shorter than its practical service life).

 - **Pixel count:** By itself, this isn't a determining factor. It may be a tiebreaker, however.

- **ISO:** This may be the most practical specification to look at. High ISO performance is quite important when shooting in low light, especially if you don't have an ultra-fast (large aperture) lens.

- **Movie capabilities:** Take a look at frame rate and other movie options. Most new cameras shoot Full HD movies, so differences are harder to spot.

- **Articulated monitor:** To taste. If you like the idea or have used one in the past, make sure the cameras you look at have an articulated monitor.

- **Shooting options:** If you want more than the basic shooting modes (commonly abbreviated as PASM, for Program, Aperture priority, Shutter priority, and Manual), make sure the camera has the scenes and other modes (panorama, HDR, and others) that you want.

3. **Weed out some cameras.**

 Prioritize your wants and needs and start removing those cameras from your list that don't meet them. You may want a camera with the highest maximum ISO. If so, note that. You may want the best movie options or the most automatic shooting modes. It might come down to physical factors, like whether a particular dSLR has an articulated monitor.

 - Compare each camera's specifications against your needs and against each other.

 - Look for reviews and see if you can find a store so you can hold the camera.

 You want to find the sweet spot where your needs meet the price you can afford and the performance you desire.

 Specifications are relative. Technologies and performance characteristics change. In five years, a five frame-per-second (fps) shooting speed will be irrelevant. The proper way to analyze and compare camera specifications won't be.

 For example, Sony might have a full-frame dSLR that shoots 12 fps by then. Fine. How does it compare with the others in its class? Is it better, worse, or the same? Does the camera cost more, less, or the same? Do other factors that make it stand out from the crowd, even if it suffers when comparing frame rates?

4. **Make a decision.**

 Trust yourself. Realize that this doesn't lock you in for life. Relax and know that whatever experience you gain from using this camera will help you with the next one.

Accessorizing to Your Heart's Content

You can accessorize the heck out of a dSLR. I encourage you *not* to start here. After you get some experience under your belt, you'll discover areas of your photography that you want to add, change, improve, or fix. For example, you may be frustrated with your camera's built-in flash and want to improve your ability to take pro-style flash photos. You can find accessories for that. If the strap that came with your camera scratches your neck, you might want to look for one that doesn't. Don't forget to coordinate with your mushroom-pattern belt!

Go to your local camera shop and look around. What dominates the store? All the add-ons, doo-dads, accessories, thingys, and whatzits. Many represent good ideas that someone dreamed up and created to help you capture that special photo. (You can also go online and search for accessories, but the effect is less in your face than if you are looking at the stuff in person.)

You can expect some of these general categories:

- **Lenses:** Of course lenses are the number-one dSLR accessory.

- **Filters and filter accessories:** What's a lens without filters? Read about them in Book III, Chapter 4.

- **Focus-alignment tools:** You can buy cards that you photograph to check the focus on your lenses.

- **Built-in flash accessories:** These accessories modify the built-in flash. Some block the light, which is useful if you want to use your built-in flash as a wireless trigger but don't want its light contributing to the scene. See Book IV, Chapter 1 about flash, and Book IV, Chapter 2 about flash accessories.

- **External flashes:** They cost more, but add quite a bit of flexibility to your photography.

- **External flash accessories:** Mount external flashes on light stands with an umbrella. Smaller flash brackets move the flash away from your camera. The list of lighting modifiers for external flashes is quite tremendous.

- **Lighting gear:** There's enough lighting gear to fill several chapters in this book. Examples include extra lighting, light stands, umbrellas, soft boxes, reflectors, and more. See Book IV, Chapter 2.

- **Backgrounds:** Backgrounds are important if you want to shoot portraits.

- **Straps:** Secure your camera around your neck or to your wrist with a cool strap.

- **Pods of all sorts:** Tripods (see Book I, Chapter 5), monopods (see Book II, Chapter 3), and small gear like the Gorrilapod (by Joby) all stabilize your camera.

- **GPS gear:** If your camera doesn't have built-in *GPS* (Global Positioning System), think about adding it with an external unit. It can imprint your photos with the latitude and longitude where you took the photos. The information is stored the same way the camera model and exposure settings are stored.

- **Wireless transfer gear:** If you want to transfer files wirelessly, look into external transfer devices. This works great when you're shooting in a studio. You don't have to stop and take your memory card out of the camera. Just have your assistant (he says with tongue in cheek) download photos to a laptop or other computer.

 Seriously, wireless transfer can streamline your work process by making it easier to get files off the camera and to your computer. Anyone (assistantless or not) can benefit from that.

- **Smart device connectivity:** Some new dSLRs (the D3200, for example) can connect to your mobile phone with a small wireless mobile adapter that plugs into the camera.

- **White balance cards:** If the camera has a hard time getting the correct *white balance* (see Book I, Chapter 5), pick up a white balance card. Mostly gray, they serve as a reference for you to be able to calculate the correct color temperature of the scene. WhiBal is a good one.

- **Cases:** You can go crazy with cases: large ones, small ones, tiny ones, and everything in between. Standard cases have a handle and a shoulder strap. Sling bags go over your shoulder and are easy to walk around; you can get into them quickly. Backpack cases are best for hiking with your camera.

- **Cleaning supplies:** You have to keep your lenses, camera body, LCD monitor, and other accessories clean and smudge free. Cloths, swabs, and cleaning agents of various kinds help you. Please see Book I, Chapter 4 for more information on cleaning your camera.

- **Protective covers:** You can buy silicon armor to keep your camera a bit safer than normal. See Book I, Chapter 4.

- **Rain gear:** Rain gear protects your camera from rain. Covers don't solve humidity problems, however. If you're in an environment with high humidity, seek a dry place to air out your camera.

✔ **Underwater gear:** When you're shooting underwater, the correct gear is an absolute necessity.

✔ **Vests and clothing:** Buying specialized photography clothing gives you additional pockets to stuff lenses and accessories instead of constantly having to open your camera bag.

✔ **LCD hoods:** Keep light from shining on the LCD monitor on the back of your camera, which makes it easier to see what's on the screen. *LCD hoods* are a must if you shoot movies in bright light.

✔ **LCD loupes:** *LCD loupes,* on the other hand, turn your monitor into a viewfinder. These are awesome.

✔ **Eyecups:** You can buy larger eyecups for your standard viewfinder. They make looking through the viewfinder more comfortable, especially if you wear glasses, and block extra light.

✔ **Viewfinder diopters:** If you can't adjust the viewfinder enough to correct for your vision, you may need to buy a *viewfinder diopter* that has a larger adjustment built in. See Book I, Chapter 2 for more information.

✔ **Focusing screens:** Some cameras let you change out the focusing screen, which fits underneath the camera's viewfinder.

✔ **Power adapters:** If you don't want to run your camera off batteries, buy the compatible power adapter and never change another battery.

✔ **HDR and time-lapse controllers:** These controllers give you more options for shooting HDR brackets (see Book VI, Chapter 4) and time-lapse exposures than are common on standard dSLRs.

✔ **Remotes:** Remotes are wonderful accessories if you shoot landscapes, or in a studio, or portraits. Remotes reduce camera shake by taking your finger off the camera. You should be set up using a tripod for this to make any sense.

✔ **Et cetera and so on and so forth:** As much as I'd like, I can't list every type of dSLR accessory. Use this as a start and keep looking!

Chapter 2: Anatomy of a Digital SLR

In This Chapter

- ✏ **Touring the front**
- ✏ **Checking out the backside**
- ✏ **Peering down at the top**
- ✏ **Looking up at the bottom**
- ✏ **Uncovering the sides**
- ✏ **Falling in love with lenses**

I think one of the most effective ways to learn photography is to become more knowledgeable about your camera. Knowing what and where the controls are means you can use them without thinking about it. When you can do that, you'll find that you're focused on *photography,* not merely operating a sophisticated piece of modern machinery. That's the good news. The even better news is that it's not hard to get a handle on.

I spread the wealth in this chapter and don't focus on any one particular dSLR or dSLT. You see cameras in this chapter from the three big names in dSLRs today: Canon, Nikon, and Sony. I include brand new, mostly new, entry-level, professional, and in-between models to illustrate what you run across. You see some of the common themes in dSLT design, some of the differences between brands, and some differences in cameras certain tiers.

Your camera might be different from those I show you here — no matter. They all have similar pieces and parts. In fact, they all share a remarkably close basic design.

Dissecting Digital SLRs

The best way to start off is to show you a photo of a camera. Figure 2-1 shows the Nikon D3200. It's an entry-level model that, while modest, shoots fantastic photos. The camera is small, which is typical for entry-level dSLRs. The lens came as part of the *kit* (you get a camera body *and* lens in a kit; bodies are also sold separately). It has vibration reduction, which is unusual at this price point.

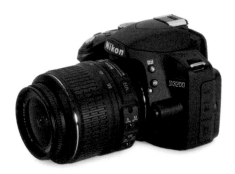

Figure 2-1: An entry-level dSLR with its 18-55mm kit lens.

All dSLRs can take fantastic photos. Don't let the *entry-level* distinction make you think it's a toy. It's not! Entry-level cameras just aren't designed to excel in *all* situations or to be super customizable like the more expensive cameras. However, with a camera like the one in Figure 2-1, you can take pictures like that shown in Figure 2-2.

Figure 2-3 shows a much larger setup. This is the Sony Alpha A77 semi-professional cropped-frame dSLR, complete with the add-on vertical grip. The grip, built into the largest dSLR models, gives you an idea of how big these cameras can get. It hold two batteries and lets you turn the camera sideways and shoot normally. Of course, it's not all about size. This stupendously satisfying camera can succeed at just about everything you put it to.

Figure 2-2: A fountain shot with an entry-level dSLR.

The Sony DT 16–50mm f/2.8 kit lens is shown attached. This lens is large and much heavier than the lens on the D3200 in Figure 2-1. The lens is made for pros and is an example of differences you see between a semi-pro versus entry-level kit.

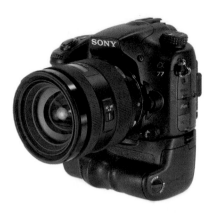

Figure 2-3: The much larger Sony Alpha A77 with vertical grip.

The A77 class's strengths are flexibility, durability, longevity, customization, and an expanded *sweet spot* (where good photos are possible). In addition, cameras like this perform much better than entry-level cameras in areas that you can't tell from these photos, such as its autofocus and metering features.

The following sections cover each of the six sides of a digital camera:

- **Front:** The business end. This is where you mount the lens. There will also be various focus and flash controls, a depth-of-field preview button, remote sensors, self-timer lamps, AF illuminators, and possibly a microphone or two.

- **Back:** The command center. This is where you control most features, use the menu, look at the LCD monitor, and play back photos.

- **Top:** At minimum, the top will have a power switch, a dial or button to set the shooting mode, and the shutter button. You may also see one or more shooting function buttons that let you set the ISO speed and enter exposure correction. More expensive cameras have a top LCD panel. The pop-up flash (if applicable) and hot shoe are located here.

- **Bottom:** You'll find the tripod socket here, and either a battery compartment cover or combo battery/memory card compartment cover. The combo occurs in dSLRs that put their memory cards in the same compartment as the battery.

- **Sides:** Where you grip the camera. The right side (looking at the camera from behind) is where your right hand goes and is often completely devoid of controls. You may see a memory card door here. The left side hosts the camera's input and output terminals, which are illustrated and explained more in a bit.

Different cameras may have different controls, but dSLR design is pretty similar between species. I think you'll get a good sense of that by looking at the figures in this chapter.

Taking the Full Frontal View

While the front of the camera is pretty important, you'll rarely see it when you're shooting. Get familiar with it before going out.

Figure 2-4 shows the front end of a Nikon D3200 *without* the lens attached. Although it's an entry-level camera, notice the following features:

- ✔ **Lens mount:** The most obvious thing from this view is the large silver lens mount, which secures the lens to the camera body. Every dSLR/dSLT has one. Notice the mirror inside the body cavity. It's down, hiding the sensor. This is a cropped-frame body, so the mirror and sensor look a bit small in relation to the overall size of the lens mount. The mirror and sensor look much larger on full-frame cameras.

- ✔ **Lens release button:** To the side of the lens sits the lens release button. Push this button to release the lens from the mount.

 Don't press the lens release button unless you have a hand on the lens and intend to change it. See Book I, Chapter 4, for more information on changing lenses.

- ✔ **Lamp:** The round lamp performs several chores. It's an autofocus assist illuminator, self-timer lamp, and red-eye reduction lamp. Make sure not to cover lamps like this with your finger or get them dirty. Some cameras use the built-in flash for AF-assist.

- ✔ **Infrared receiver:** The small dark circle on the grip is this camera's infrared receiver. This allows you to use a wireless remote to operate the camera. Not all cameras have this feature, but many of those that do put it here. The theory is that your hand won't be on the camera covering it up.

- ✔ **Microphone:** Your camera's internal microphone will often look like three to five small holes in the camera body. Always be aware of where the microphone is so that when shooting movies you don't put your finger on it.

- ✔ **Grip:** The grip is a prominent protrusion (in this case, beneath the red triangle — a Nikon design element) that fits in your hand sort of like a joystick. It has room for three to four fingers to hold on to the camera from the front. Your index finger can work the shutter button, a front dial (if present), and topside controls. Use your pinky to press the depth-of-field preview and function buttons if your camera has them.

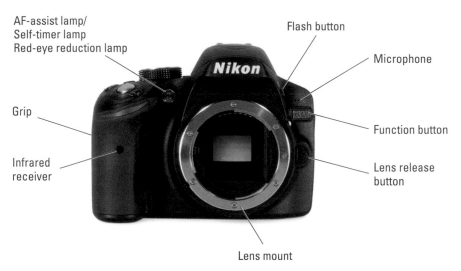

AF-assist lamp/
Self-timer lamp
Red-eye reduction lamp

Flash button

Microphone

Grip

Function button

Infrared
receiver

Lens release
button

Lens mount

Figure 2-4: The front of the camera has a few controls and one large lens mount.

The D3200 has a few other controls on its front, but you can't see them easily in this shot:

- **Flash button:** This button pops up the flash. On the D3200, it also doubles as a flash exposure compensation button. Remove any hot shoe accessories or external flash before pressing this button. See Book IV, Chapter 1, for more flash information.

 Speaking of flash, Figure 2-5 shows the Canon EOS 60D with its internal flash raised (or *popped*). You can see the flash button on the side of the camera next to the name badge, right above the lens release button.

- **Function button:** In this case, the Function button is programmable. You can make it change image quality, white balance, ISO sensitivity, or other shooting functions.

The front of the A77 (a more complicated camera) is shown in Figure 2-6. It has a few more controls:

- **Front dial:** Some cameras have a front control dial, also called a *command dial.* Depending on the mode your camera's in, the front dial has different purposes. For example, when you're in Aperture priority, it changes aperture.

Pay special attention to generic dials and buttons that change operation. Camera designers try to consolidate functions to make operating the camera possible.

Nikon cameras have a rear dial, adding a front dial only in their more expensive cameras. Canon, on the other hand, puts one dial on top of the camera; that's it. Sony cameras currently have a front dial on all cameras and a rear dial on the more sophisticated ones.

✔ **DOF preview button:** This button is the *depth-of-field (DOF)* preview button. (For more information on DOF, the area in focus, turn to Book III, Chapter 1.) When you have all settings except the aperture dialed in, press the button to get an instant DOF preview.

Open flash

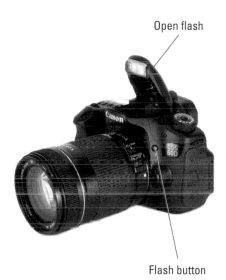

Flash button

Figure 2-5: Pushing the flash button opens the flash when you aren't in an automatic shooting mode.

✔ **Focus mode dial:** More advanced dSLRs have additional focus controls on the front of the camera. This selector enables you to change between autofocus modes (*continuous,* meaning the lens keeps focusing to follow subjects versus a single focus when you press the shutter halfway) and manual focus. Nikon cameras with this control use a switch instead of a dial.

Front dial

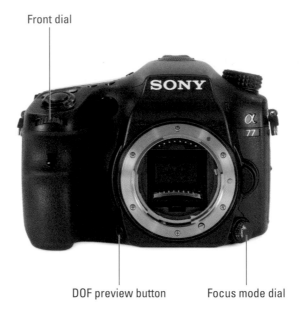

DOF preview button Focus mode dial

Figure 2-6: More sophisticated cameras often have more in the front.

- ✏ **Covers and terminals:** You may see a few terminals on the front of older cameras. Nikon put its flash sync and remote terminals here before moving them to the side of the camera.

dSLR Got Back

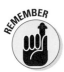

The back of a digital SLR is your office. It's where you do most of your work: frame, compose, adjust, review, and set options. That means you need to be quite familiar with all the buttons, knobs, levers, and screens, and be able to work them without hesitation.

Figure 2-7 shows the back of the Canon EOS Rebel T3. This is another entry-level dSLR. You wouldn't think so, given the number of buttons and other features present! That's good, because I get to show them to you:

- ✏ **LCD monitor:** The dominant feature of all modern dSLRs is the LCD monitor on the back of the camera. Some are more centered under the viewfinder. Others, as shown here, are located to the left side of the camera. This setup makes room for the plethora of controls on the right.

 You use the monitor to display camera settings, shooting functions, and the menu; to play back photos and movies; and to frame and focus when shooting in Live view mode. Your camera's LCD monitor is so important

that you can't operate a modern dSLR/dSLT without it. Protect it and keep it clean.

✔ **Optical viewfinder:** The second most prominent feature you can see when looking at the rear of the camera is the optical viewfinder. Look through it to see the scene. Lots of helpful information is available in the viewfinder. The most important information relates to the shooting mode, exposure details, and the focus and metering modes you're in. The exact type and location depend on the camera and the mode that's active at the time.

Optical viewfinders "blink" when you take a photo because the mirror that lets you see through the lens swings up and out of the way. When taking quick shots, you might not even notice. For longer exposures, it becomes quite noticeable. It'll come back when the exposure is over.

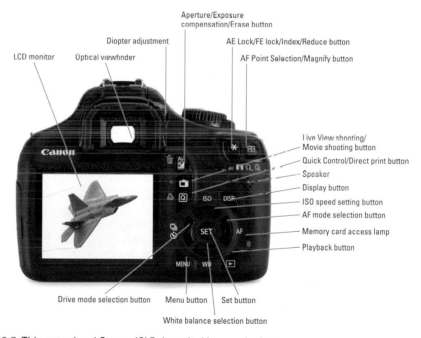

Aperture/Exposure
compensation/Erase button

Diopter adjustment

AE Lock/FE lock/Index/Reduce button

LCD monitor Optical viewfinder

AF Point Selection/Magnify button

Live View shooting/
Movie shooting button

Quick Control/Direct print button

Speaker

Display button

ISO speed setting button

AF mode selection button

Memory card access lamp

Playback button

Drive mode selection button Menu button Set button

White balance selection button

Figure 2-7: This entry-level Canon dSLR doesn't skimp on the buttons.

The other features on the back of the camera are normally organized into functional areas. If you need to use them when shooting, they'll be somewhere more accessible than those you can use at your leisure (reviewing and menu controls). Many times, buttons can have more than one purpose, depending on the mode your camera is in. The rest of the features on the back of the T3 (working from the top down, excluding the circular control buttons) follow:

- **AE Lock/FE lock/Index/Reduce button:** When shooting, this button locks the autoexposure (AE) or flash exposure (FE). In playback, it displays a photo index or zooms out.

- **AF Point Selection/Magnify button:** Pressing this button when shooting calls up the autofocus (AF) point selection screen, which enables you to choose different AF selection points. When you're playing back photos, zoom in by pressing this button.

Do yourself a favor: Enlarge photos and inspect them carefully for focus when you're playing them back. It's not enough to see them full-frame — even bad photos look good at this magnification. Press the Magnify button to zoom in to a detailed feature to be able to tell.

- **Aperture/Exposure compensation/Erase button:** When you're in Manual mode, pressing and holding down this button lets you set the aperture with the camera's dial. Otherwise, you press and hold it to dial in exposure compensation. When playing back, pressing this button will erase photos.

- **Live view shooting/Movie shooting button:** This button has two functions. When you aren't in Movie mode, pressing the button turns on Live view, which displays the live scene on your LCD monitor with shooting information (like you typically see through the viewfinder). Compose and focus shots using the LCD monitor, not the viewfinder. The viewfinder is blocked and you can't use it when you enter Live view mode. When you're in Movie mode, this button starts and stops recording.

You typically must use Live view when in your camera's Movie mode.

- **Quick Control/Direct print button:** Pressing this button when shooting enters Canon's Quick Control mode, which allows you to directly set the camera's shooting functions that are displayed onscreen. It's a very handy way to control the camera. When Easy printing, this button prints another photo using the most recent settings.

- **Display button:** This button displays different informational screens when you're shooting, or changes the amount of information displayed when you're playing back photos and movies.

- **Menu button:** Opens the menu system — handy.

- **Playback button:** The playback button kicks the camera into playback mode, where you review your photos or movies. If the camera is already in playback, it returns you to shooting.

Canon calls the four directional buttons on this camera *cross keys.* You'll find them, or something close, on many cameras. In their center is another important button — the Set key. Press it to make choices. Collectively, you use these buttons to navigate menus (go left, right, up, and down) and to change shooting functions. They're very important buttons.

When you aren't using them to navigate menus, here are their functions:

- **ISO speed setting button:** Calls up a screen to set the camera's ISO speed. This determines the camera sensor's sensitivity to light.

- **White balance selection button:** Shows the white balance options. Choose a light source that matches the conditions, such as Sunlight, Shade, Flash, Incandescent, or Fluorescent.

- **Drive mode selection button:** Enables you to select a drive mode, which controls whether you take one shot or enter a continuous shooting mode when you press the shutter button.

- **AF mode selection button:** This button lets you change between autofocus modes. In this case, the options are

 - **One Shot:** The camera focuses once; best for still subjects.

 - **AI Focus:** The camera switches automatically.

 - **AI Servo:** Continuous focus; best for moving subjects.

You can see three other features on the back of the T3:

- **Speaker:** You know what a speaker is, right? This one is on the right side of the camera. All you can see are the holes, not the speaker itself.

- **Diopter adjustment:** Used to correct the viewfinder to accommodate your vision.

- **Memory card access lamp:** This lamp turns on when the camera is writing to the memory cards. Make sure that this lamp is off before removing the card. Some lamps are larger than others.

The T3 is a good example, but there are lots of ways to organize the controls on the back of a dSLR. Figure 2-8 shows the Nikon D3200, which has a Multi selector (a single circular button) rather than four separate cross keys. In addition, Nikon puts a row of buttons on the left side of the LCD monitor, almost without fail (the D5100 and newer D5200 are, of course, exceptions). Their functions are most often playback and menu related.

It's worth pointing out these additional controls:

- **Zoom out/Thumbnails/Help button:** When you're playing back photos, zoom out or display a thumbnail page. The latter function displays help that pertains to what you're doing. Pretty helpful!

- **Information Edit:** Nikon's equivalent to Canon's Quick Control button displays shooting settings and enables you to change them.

- **Rear control dial:** Set the shutter speed, aperture, and quickly move between photos or menu options. Nikon calls it a *Command dial*.

✔ **Lock button:** During shooting, push this button to lock the auto or flash exposure. When playing back photos, protect them from deletion by pushing this button.

✔ **Rear infrared receiver:** Similar to those found on the front of most cameras. This one is on the rear.

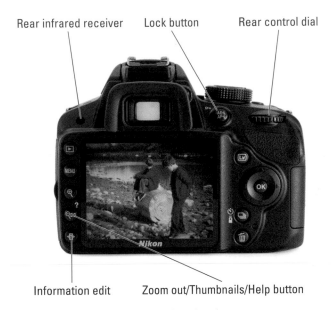

Rear infrared receiver Lock button Rear control dial

Information edit Zoom out/Thumbnails/Help button

Figure 2-8: This Nikon is equally functional.

Figure 2-9 shows the back of the Sony Alpha A35. It's a clean-looking camera back. Notice that the memory card access lamp is lit. Sony dSLTs have several features that make them unique.

These two key features are noticeable from the rear of the camera:

✔ **Electronic viewfinder:** The electronic viewfinder is a versatile piece of equipment. Although you look through it the same way you do a traditional optical viewfinder (it may even look better than an optical viewfinder, especially in low light), it has many more uses. With it, you can

- Compose and focus.
- See more shooting functions.
- View photo playback.
- Access menus.

✏ **Eyepiece sensors:** The eyepiece sensors are just below the viewfinder. The sensors detect whether you're looking through the viewfinder. You can set up the camera to automatically toggle between the viewfinder and the LCD monitor (see Book I, Chapter 3), depending on what you're looking at.

WARNING!

In Figure 2-9, you can see how far the electronic viewfinder of the A35 juts out. Be careful when setting down this kind of camera.

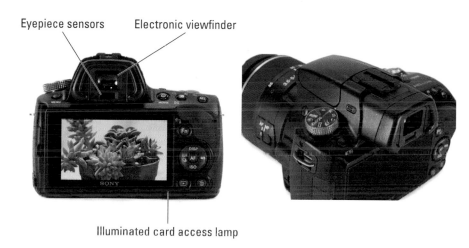

Eyepiece sensors Electronic viewfinder

Illuminated card access lamp

Figure 2-9: The Sony has fewer buttons and a gorgeous electronic viewfinder.

Figure 2-10 shows a much larger back: the Sony Alpha A77 with grip returns. I want you to see this so you get an idea of how complicated it can seem. In reality, the extra buttons on the grip are all duplicates. They let you hold the camera vertically and still use the controls as if you were holding it horizontally. In the end, this isn't any more complicated than an entry-level model.

One feature, however, on the back of the A77 *isn't* on the other cameras in this chapter: a built-in light sensor (on the lower-left side of the monitor frame). It senses light and adjusts the monitor's brightness automatically, if you wish.

While many cameras put controls and displays in the same general place, the exact placement may vary. Figure 2-10 also shows a close-up of the diopter adjustment knob of the Canon EOS 5D Mark III. It's on the top corner of the viewfinder, behind the rubber eyepiece. Sony cameras have theirs near the bottom right.

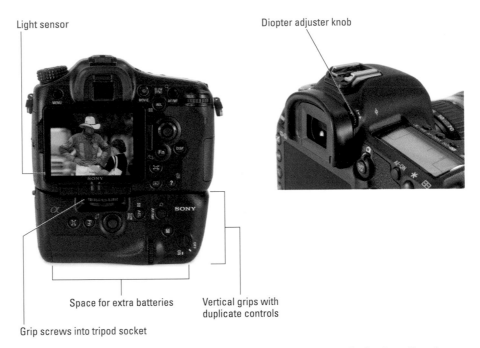

Light sensor

Diopter adjuster knob

Space for extra batteries

Vertical grips with duplicate controls

Grip screws into tripod socket

Figure 2-10: This camera is an impressive sight to behold; use its small wheel to adjust the viewfinder to your eyesight.

Read your camera's manual if you need help finding a control or button. You might have to spend some extra time, like I did, to get past the confusing parts. You don't have to "get it" all at once.

Many dSLRs and dSLTs come with articulated monitors, one of which is shown in Figure 2-11. Although the style may vary, they all swing or move up and out from the back of the camera so you can position them. Some work a lot like a camcorder monitor, and many have a secure position for storage. I put the 60D monitor facing inward to secure and protect the monitor when travelling.

Figure 2-11: Articulated monitors can be positioned very flexibly. You can close them up tight.

Figure 2-12 shows another style of articulated monitor. The Sony A77's monitor flips up with a small shelf *plus* it rotates (but does not slice, dice, or chop).

Figure 2-12: This articulated monitor can sit up on a shelf in addition to rotating.

Looking at the Top

Depending on the camera, you might have a few or a lot of controls on the top. The Canon EOS Rebel T3, shown in Figure 2-13, has very few: the mode dial, power switch, flash button, the Main dial, and the shutter button. Other cameras have a lot more.

If your camera has a simple top, you don't need to practice using it much. You can pretty much work it by touch. For cameras that have more sophisticated controls on top (not to mention an LCD monitor), practice how you want to work the buttons and wheels until your fingers know where things are.

The Canon EOS 60D is a more complicated camera; see Figure 2-14. It has these features:

- ✔ **Strap mounts:** The top of the camera has two camera strap mounts. Thread the end of your strap through the hole and secure it back on itself. Some cameras have their mounts farther down the sides. Others have eyelets that move around. (The A77 is a good example of eyelets and is shown in this chapter in Figure 2-3.)

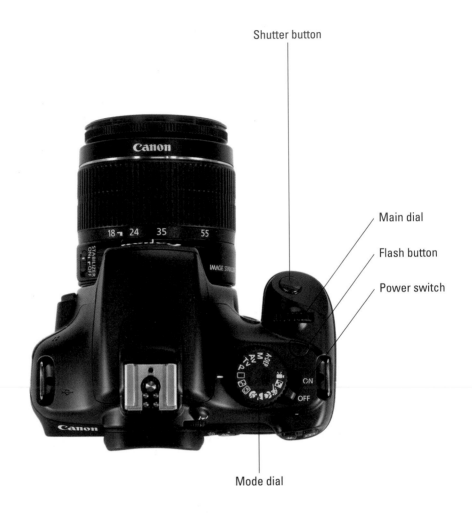

Shutter button

Main dial

Flash button

Power switch

Mode dial

Figure 2-13: This Canon has a minimal top with few controls.

✔ **Mode dial:** Sets the camera's shooting mode. In this case, you've quite a handful!

The mode dial is an important feature. It changes form and position from camera to camera. Some cameras have chunky dials. Some are slimmer. They may be on the right or left side. Spin the dial to change modes. Some may even be a button.

✓ **Mode dial lock-release button:** The mode dial is normally locked. You must press this to turn it. This feature isn't on many cameras.

✓ **Power switch:** On this camera, the power switch is under the mode dial.

✓ **Shutter button:** This is *the* button. Hopefully, it's the button you use most — on your camera, at least. Press halfway to autofocus and all the way down to take the picture. The shutter button (also known as the *shutter release button*) is always on top of the camera to the right. Depending on the design, it may be angled toward the front.

✓ **Main dial:** In this case, the "front" dial is on top of the camera, behind the shutter button. Notice that on some cameras, is the main dial is on the front beneath the shutter button.

✓ **Pop-up flash:** The pop-up flash is under that cover in front of the hot shoe. It stows nicely out of the way when you aren't using it. Higher-end dSLRs may not have a pop-up flash.

Commit to mastering one feature or button on your camera at a time. Look your dSLR over periodically and ask yourself whether you're neglecting anything. You might be, and it might make your photos better if you used it more.

Five buttons run across the top of the LCD panel:

✓ **AF mode selection button:** Press this button to select a different AF selection mode. You normally have several options, ranging from a single point to a region or automatic selection. See Book I, Chapter 5, for more information on autofocus modes.

✓ **Drive mode selection button:** This button lets you change drives. Examples are single shot and continuous.

✓ **ISO speed setting button:** Press to access and change ISO speed. This sets the camera sensor's sensitivity.

✓ **Metering mode selection button:** Use this button to select a different *metering mode* (how the camera evaluates a scene's brightness). You'll often be able to choose from between spot, center-weighted, and some form of pattern metering. See Book I, Chapter 5, for more information on autofocus modes.

✓ **LCD panel illumination button:** This is the odd man out. It turns on the LCD panel's back light. Nikon cameras use the on-off switch for LCD illumination. See Figure 2-14.

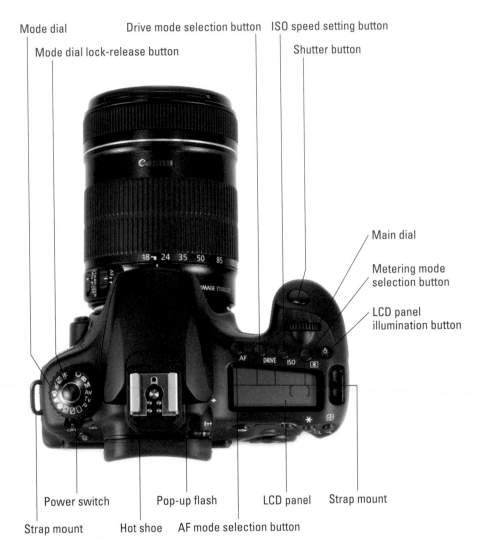

Mode dial

Mode dial lock-release button

Drive mode selection button

ISO speed setting button

Shutter button

Main dial

Metering mode selection button

LCD panel illumination button

Power switch

Pop-up flash

LCD panel

Strap mount

Strap mount

Hot shoe

AF mode selection button

Figure 2-14: The Canon 60D has a more complicated top.

The other features on top of the 60D are:

✔ **Hot shoe:** This is the standard Canon hot shoe. You might see it called an *accessory shoe.* Attach external flashes and other accessories such as levels or remote flash triggers. It, along with those by Nikon, is metal. Sony models, which are direct descendants of Minolta cameras, are plastic, and not compatible with accessories that fit in the metal hot shoe type without an adapter.

✔ **LCD panel:** This feature isn't on entry-level cameras. This is a convenient place to summarize how the camera is set up. The 60D displays the drive mode, autofocus mode, ISO speed, shots remaining, metering mode, exposure level indicator, exposure compensation, auto exposure bracketing information, and more.

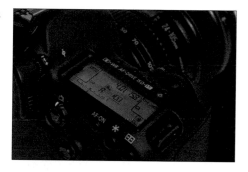

Figure 2-15 shows a lit LCD panel on top of the Canon EOS 5D Mark III. It's gorgeous. In this view, you get a nice look at how this panel is organized. Top LCD panels are very useful and contain a lot of information. This information may be available in other places on your camera, but having it here will help in many situations — especially when you're looking down on the camera!

Figure 2-15: A lit LCD panel of the 5D Mark III.

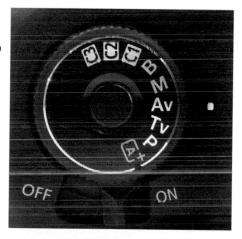

Some mode dials can be very simple. The Canon EOS 5D Mark III dial, shown in Figure 2-16, is nice and clean. If you use this professional-level camera, it has expectations of you: You should know how to set up shots and not rely on Scene mode. On the other hand, some mode dials include everything but the kitchen sink. The Nikon D3200 dial is in the bottom of Figure 2-16. It has an Auto mode, a Guide mode, PASM, No Flash, and several scenes.

Table 2-1 shows the exposure modes you'll find on most mode dials. At a minimum, you should be able to select from Programmed Auto, Aperture priority, Shutter priority, and Manual modes.

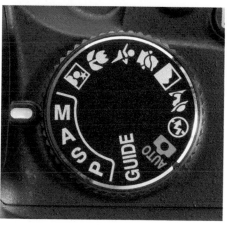

Figure 2-16: Top: The Canon EOS 5D Mark III sports a minimal mode dial. Bottom: The Nikon D3200 has many more shooting modes.

Table 2-1		Common Mode Dial Settings
Mode	*Abbreviation*	*Description*
Auto	Auto	Automatic operation. The camera figures out the exposure and sets up the controls to take the best photo.
No Flash	Graphical icon	Automatic shooting but doesn't use the flash.
Program AE	P	Also called Programmed Auto, which is very close to Auto mode, but lets you change many more camera settings. See Book I, Chapter 5.
Aperture priority	A or Av	You set the aperture and the camera handles the other exposure elements.
Shutter priority	S or Tv	You set the shutter speed and the camera handles the other exposure elements.
Manual	M	You set the camera's controls.
Bulb	B	A special shutter mode opens the shutter when you press the shutter button and closes it when you release it.
Scene	It depends	Automatic exposure modes where you tell the camera what you're shooting so it knows how best to take the photo. Landscape, portrait, night, and fireworks are examples of scenes.
Custom	C	Some cameras let you register shooting modes in one or more Custom mode positions.
Movie	A movie-related icon	Enter movie mode, if applicable, to shoot movies with your dSLR.

Reviewing from the Bottom Up

You hardly ever see pictures of dSLR bottoms. I'm committed to rectifying that problem in this section. See Figure 2-17, for example. Despite the fact that there's not much to say about the camera bottom, the features are important:

✔ **Battery/memory card compartment door:** Unlatch the door and pop it up to get into the battery chamber, and if applicable, memory card slot. That part is fairly standard. Some cameras have a small catch that keeps the battery from falling out. Press the catch to allow the battery to slide in and out.

✔ **Tripod socket:** Screw the tripod or monopod into this socket. This socket is also where you screw in vertical grips (if your camera has one).

Battery compartment door

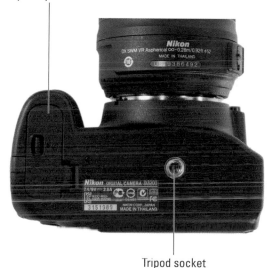

Tripod socket

Figure 2-17: The bottom of a typical dSLR.

Quick-release plates, which screw into the camera bottom and then mount on the tripod head, are great time-savers. These plates are easier and safer to use than having to literally screw your camera down onto a tripod every time you mount it. When I do that, I feel like I'm going to drop it or strangle myself with the strap.

Simply Sides

Every camera has two sides: right and left (naturally). The sides of your camera should have one or more covers and few, if any, controls.

The grip is on the right side and where your right hand will rest most of the time. Curl your fingers around the grip and use them with your palm to hold on to the camera. While some cameras put nothing on this side at all, others put the memory card slot, as shown in Figure 2-18. In this case, the memory card door belongs to a Nikon D3200.

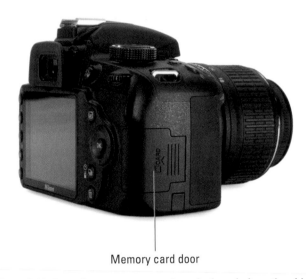

Memory card door

Figure 2-18: Sometimes, memory cards go in the grip from the side.

The current trend in dSLR design is to put all the input/output *terminals* (holes) on the left side of the camera. Entry-level models only have a few, as shown in Figure 2-19. The rubber door swings out of the way but stays attached to the camera. I've digitally removed it in the second image to make the terminals more visible.

In this case, there are only three terminals:

- **Remote terminal:** Open the rubber cover and use this terminal to plug in the remote commander or other compatible remote shutter release. Using a remote keeps your fingers off the camera and prevents shutter-button shake.

- **USB terminal:** Use the USB terminal to connect your camera to a computer. USB cables are most often included with a camera.

- **HDMI terminal:** Connect the mini end of an HDMI cable into this terminal to play back your photos and movies on an HDTV with HDMI input. HDMI cables aren't always included when you buy a camera.

Remote terminal

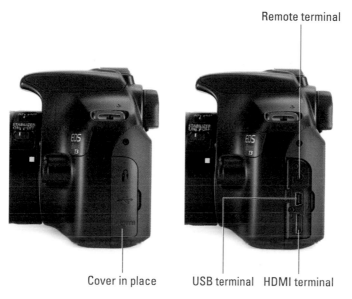

Cover in place USB terminal HDMI terminal

Figure 2-19: This entry-level Canon sports very few input/output terminals.

More advanced cameras have more terminals. Figure 2-20 shows the additional terminals underneath the Sony Alpha A77 covers (aside from the remote, HDMI, and USB terminals already covered):

- **Flash sync terminal:** Flash sync terminals have become a rarity on all but decidedly professional camera models. While sync cords (a.k.a. *PC cords*) are sometimes cumbersome, with them you can reliably control remote flashes from your camera. Alternatives include the various types of wireless triggers (which are becoming very popular), including the one built into your camera. Flash, sync cords, and wireless are covered in Book IV, Chapters 2 and 3.

- **DC in terminal:** Connect an adapter to provide uninterrupted power when shooting, playing back, downloading, or brewing coffee. Some cameras snake their adapter into the battery compartment instead of attaching here.

- **Microphone jack:** It's karaoke time! You can connect an external stereo microphone to your camera with this jack. Doing so disables the on-board microphone. See Book VII, Chapter 1.

Holding the camera, having the cover open, and plugging in items is cumbersome. Try using a tripod if you can.

Remote terminal Flash sync terminal Microphone jack

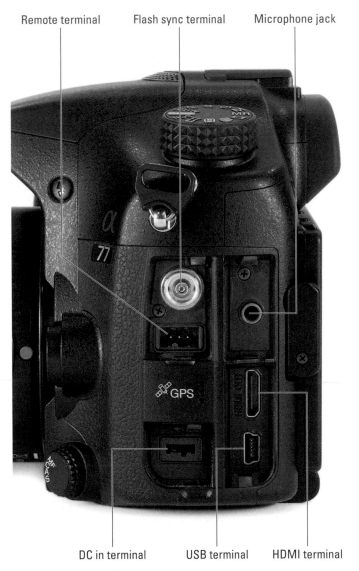

DC in terminal USB terminal HDMI terminal

Figure 2-20: This semi-pro Sony dSLT has more.

Looking at Lenses

Your lens is separate from your camera, but try to be as familiar with it as you are with your camera body. If you want to see more about different types of lenses, and the types of photos you can take with them, turn to Book II after reviewing this section.

Lens parts

Depending on the lens you have, it might have these parts (see Figures 2-21 through 2-23 for reference):

- **Hood mount:** Many lenses come with a detachable lens hood, which usually rotates on with a quarter- or half-turn. Lens hoods block stray light from entering the lens, but may cause *vignetting* (when the corners of the photo looks darker than the center).

- **Filter threads:** Most lenses mount screw-in filters at the front. Filter size is measured in millimeters. On some lenses (those with very large front diameters, for instance), filters go toward the rear and are dropped in with special trays.

- **Focus mode switch:** Switch between manual and auto focus here. Some telephoto lenses let you choose a distance region.

- **Zoom ring:** On zoom lenses, the zoom ring changes the focal length, which lets you zoom in and out. Depending on the lens, the zoom ring may be larger than the focus ring.

- **Focusing ring.** Use this ring to focus manually. In the old days of manual focus, these rings were often larger than zoom rings. With fewer people manually focusing, they've gotten much smaller.

- **Focus mode switch:** Changes the lens from auto to manual focus. Not all lenses have this switch.

- **Vibration reduction (VR) or image stabilization (IS) switch:** Turns on the lens's internal vibration reduction or image stabilization feature. When your camera is mounted on a tripod, you don't need this feature.

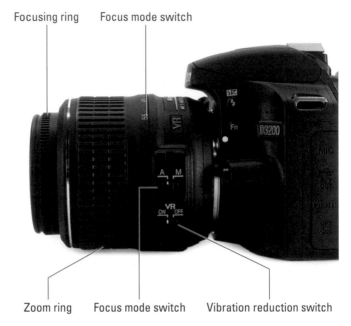

Focusing ring Focus mode switch

Zoom ring Focus mode switch Vibration reduction switch

Figure 2-21: This small kit lens even has vibration reduction.

- ✔ **Focal length scale:** Zoom lenses show you what your lens's focal length is. Line up the number with the focal length index line.

- ✔ **Distance or depth-of-field scale:** The scale shows you the *focal plane distance* (the distance that the lens is focused at, measured from the camera sensor) and sometimes the depth of field. Though this feature is handy at times, it's becoming less so with digital SLRs.

- ✔ **Lock switch:** Some lenses let you lock in the current focal length. This prevents *focal length creep* when you're pointing the camera down. Some cameras let you lock in the focus, as opposed to the focal length.

- ✔ **Mount:** The rear of the lens is the mount, which locks into the camera. Keep the rear cover on lenses when not in use.

- ✔ **Lens mount index:** There's usually a dot on the side or rear of the lens. Match it up to the corresponding mark on the camera mount before inserting it into the camera.

- ✔ **CPU contacts:** These little gizmos send computerized data to the camera from the lens. See Figure 2-23.

Distance scale Focal length scale

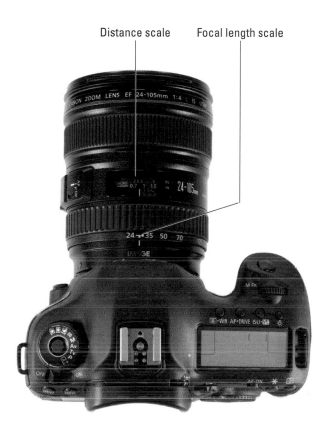

Figure 2-22: This professional lens give you more information.

CPU contacts are critical to modern lenses. Don't bend them, break them, or otherwise mess with them. Keep them covered.

✔ **Aperture ring:** Older lenses (and some new or specialized lenses) have an aperture ring on the lens. Newer, computerized lenses forego it — you have to set the aperture in-camera.

CPU contacts Lens mount index

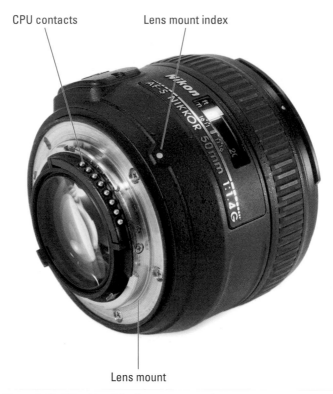

Lens mount

Figure 2-23: This side of the lens mounts to the camera.

Getting funky

Before I finish the section on lenses, I encourage you to seek out alternative designs. Even though a lens must fit your camera body, not every lens has to fit the same mold. In fact, you can have a lot of fun with creative lenses and accessories like these:

✔ **LensBaby products:** LensBaby (visit www.lensbaby.com and have a look 'round) has created several unique and creative lenses and accessories for digital SLRs. All have creative tilt-shift/bellowslike functionality that enable creative focusing methods. They aren't traditional, but they aren't toys. They act and feel solid. I shot Figure 2-24 using the Composer Pro with the Double-Glass Optic installed. Tilting the lens down and to the left a bit let me move the circle of sharp focus where I wanted it. The letters and parts of the board that aren't in this sweet spot are blurred, which is the main effect this lens offers.

Figure 2-24: LensBaby has carved out a creative niche in lenses.

✔ **Diana F+:** Plastic Diana cameras were introduced in the 1960s and are making a real comeback. While the actual cameras use film, you can mount the lenses on a dSLR with the right adapter. The Diana F+ is Lomography's (`www.lomography.com`) take on the classic camera. I took the photo shown in Figure 2-25 with the fisheye lens attached to a Nikon D3200 with the help of the Nikon F mount adapter. I used an external flash held to the side with the help of an off-camera hot shoe cord (see Book IV, Chapter 3).

One note of advice regarding the Diana lens focal lengths: Use the widest angles possible for normal fields of view. The Diana lenses are designed to be used on film cameras whose film is much larger than a dSLR sensor. You're only going to see a small portion of what the lens can truly capture. I recommend the fisheye lens as a most practical focal length for dSLRs.

✔ **Holga:** Holga lenses (available from different stores) are also for the toy camera crowd. Unlike the Diana F+ lenses, however, you don't need an adapter. You simply buy the lens that fits your camera. I have to say that, although these lenses are cheap plastic and you have to guess at the exposure, I love playing around with them. I've taken many photos with my Holga lenses and feature several of them in this book.

To see other examples of what's possible with each of these funky lens designs, visit the listed websites, browse through photos on Flickr, or do a Google search.

Figure 2-25: You can coax beautiful photos out of Diana F+ lenses.

Chapter 3: Menus and Settings Extravaganzapalooza

In This Chapter

✔ Digging into the menu system

✔ Reviewing a long list of basic menu settings

✔ Setting advanced menu options

You may not realize it, but you have a friend with you every single time you go out to take photos. It's your digital SLR! That's right, your camera is your friend. It remembers things for you — like what kind of photos you want to save, how large they should be, what time it is, and what sort of displays you want.

Your camera takes care of you. All you need to do is make sure it knows what you want. That's what this chapter is about. Read how to access your camera's menu system and perform routine setup and maintenance, and about some of the more esoteric options available.

Don't let your camera's menu system intimidate you. The plethora of menus and options and settings may be many, but you'll get comfortable. Just vow to master each element one at a time. There's really nothing to it.

Ordering from the Menu

Getting into your camera's menu system is as easy as pie. Even if you've never used a dSLR before, you will be able to quickly master opening the menu and making changes and choices. This section explains some of the basics of accessing and navigating your camera's menu.

Opening the menu

To open your dSLR's menu, look for a button named Menu on the back of the camera. It will (probably) be in one of three places:

✔ It may be on the far left, beside the LCD monitor.

✔ On the other hand, it might be on the left side, above the LCD monitor and beside the viewfinder.

✔ Another common spot is on the right side of the monitor. When the Menu button is on the right, it's usually low enough that you can press it with your thumb. Regardless, it will be clearly labeled and have one purpose.

Press the Menu button to turn on the menu system. It will appear on the camera's LCD monitor, and you will be able to see it until the camera turns it off (to save power). If you're using a Sony dSLR, you can also see the menu through the electronic viewfinder.

Getting around menus

Working your way around your camera menus is pretty easy. You'll soon find that you can access any menu item you need with a minimum of fuss. If you fumble at first, keep practicing.

Major options

When you're working with the menu, keep a few key principles in mind:

✔ **Navigate:** Look at the four arrow buttons or a circular controller. (The latter is shown in Figure 3-1.) Use the buttons to go up, down, left, and right in menus and settings.

Not all navigation controllers look identical. Some cameras have separate arrow keys (the Canon EOS Rebel T4i). Most cameras now use a round dial that you can press in any of the four directions. Other cameras, such as the Canon EOS 5D Mark III and Sony Alpha A77, have a controller that acts like a little joystick. You may also be able to navigate your menu system by spinning a control dial (aka *command dial*). Navigation controllers are also called by

Figure 3-1: The Nikon multiselector is a good example of a navigation controller.

different names: *arrow keys, multiselector, four-way controller, quick control dial, arrow pad,* and *cross keys* are other examples.

✔ **Select:** After you get to where you want to be, you have to be able to make choices. Think of it as clicking your mouse. To make a choice, either press a button in the center of the arrow keys or press the round multiselector-type button in the center. Some cameras have you press the right button. Depending on your camera, this button may be labeled differently. You may see OK, Set, AF, or nothing at all.

✔ **Cancel:** Most times, pressing the Menu button lets you cancel what you're doing. You may also be able to press the shutter release button halfway to kick yourself out of the menu system.

✔ **Additional controls:** You may need to turn other dials or press other buttons to get around and make selections. Check your camera's manual to see if this is the case. For example, some Canon models use the main dial to move between tabs in the menu system.

Opening the menu and choosing options

Typically, here's how you get to the menu and make changes:

1. **Press the Menu button.**

 I'm using a Canon camera to illustrate these steps. Compare it to the Nikon and Sony menus sprinkled throughout the chapter.

2. **Go to the menu or tab that contains the setting you want.**

 In Figure 3-2, I'm at Shooting 1 menu.

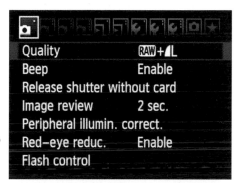

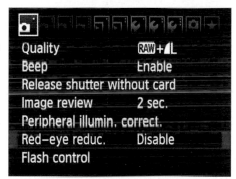

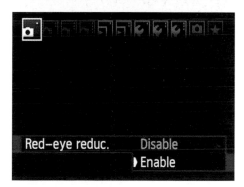

Figure 3-2: I've chosen a menu, then selected a choice to highlight it, and then seen my options.

3. **Highlight a specific setting.**

 In the second screen in Figure 3-2, I *scrolled down* (pressed down repeatedly to get past the initial screen) and highlighted the
 Red-Eye Reduction option.

4. **Press the Set or OK button.**

 Now you can choose the setting you want. In this case, only two options are available: Disable or Enable.

5. **Highlight a setting.**

 The *current setting* (Disable) is shown in blue. The *setting that I've chosen* (Enable) has an arrow beside it.

6. **Press Set or OK to change the setting.**

7. **Press the Menu button to exit.**

Setting Up Common Features

The features I describe in this section are common to most digital SLRs. I've grouped each major settings category into a separate heading. Although your camera's menus will undoubtedly be different, you can usually find the same divisions in your camera's menu.

At the beginning of each section that follows, I show you the comparable menu of the Nikon D3200. It's an entry-level camera with plenty of options. At times, I show examples of menus from other cameras when discussion specific menu options.

Looking for Answers

I would be remiss not to point out a few places where you can get more information about your camera and its menu options. First, numerous *For Dummies* books have been written for specific camera models. I've written and coauthored several, as a matter of fact. If you feel like you need a little more help, pick one up. And befriend your camera's manual. This is where you will get the most definitive information about your camera. The manual isn't colorful, and it doesn't show a lot of examples or share any personal insights, but it does have a lot of useful information.

Choosing the basics

Your camera's main setup options are in the Setup menu. Figure 3-3 shows the first page of the Nikon D3200's Setup menu. Each tab (here they're vertical) has its own unique icon. In this case, it's a small wrench (or *spanner,* if you prefer).

You need to set some options, like the date and time, only once. You use others, such as formatting the memory card, more frequently. Here are some typical setup options:

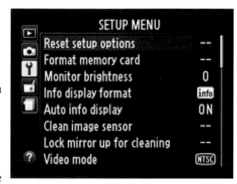

Figure 3-3: The D3200 Setup menu.

✓ **Date and time:** Set the date and time so that all your photos have the correct date and time imprinted in their *metadata* (data stored in a header that can be accessed and read apart from the image itself; examples of data include the camera make and date and time of the exposure). Some cameras show the date and time when turned on.

Check to see whether you can set the time zone, too — but remember to change it if you travel. If so, you often see a snazzy map, like Sony's in Figure 3-4. Sometimes you simply choose your zone from a list.

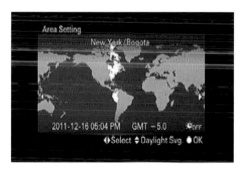

Figure 3-4: Setting the time zone.

✓ **Language:** Your camera can't speak to you (not yet, anyway — although if Apple made a dSLR, it probably would). Specifying the language makes it possible to read all the menus. All the options might look interesting, but you should choose the one you can read.

✓ **Format memory card:** This option (often listed simply as Format) erases all data on the memory card. Keep these memory card tips in mind:

- *Some* cameras toss only the file structure and don't reinitialize the card. If so, you may be able to rescue lost files before you overwrite them.

- To protect your privacy, be sure to reformat your card as aggressively as possible if you ever sell it or give it away.

- I always format my cards in the camera I'm going to use them in. This trick produces a clean slate, created by the system that will store my photos. I also reformat the card immediately after transferring photos and putting it back in the camera. This prevents the "Have I saved these or not?" dilemma.

✔ **File naming and numbering:** This setting determines how the camera names your files. The camera counts every photo you take, from 0001 to 9999, and puts the number to a preset base filename. You can sometimes change to a different base name and change the camera's behavior when it starts over on the renumbering. Figure 3-5 shows the file numbering options from a Sony dSLT: Series and Reset. You can't change the name, but you can force the camera to start over by choosing Reset.

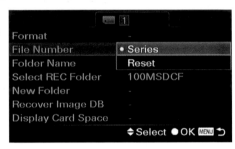

Figure 3-5: Exploring file numbering options.

✔ **File structure (folders):** Some cameras let you change the way folders are named on the memory card from a standard form (sequential numbering) to a date form (based on the date you take the first photo in the folder).

✔ **LCD brightness and color:** You may be able to dim or brighten your LCD monitor. Dim the beast if you're taking photos at night or somewhere in low light, where a super-bright LCD monitor might be distracting. Lowering the brightness of the LCD also decreases battery drain. Figure 3-6 shows the Brightness option on the Canon entry-level camera.

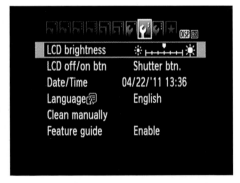

Figure 3-6: Brighten the LCD when you're in strong light.

✔ **Movie options:** You can typically set up the size and frame rate for movies. Read Book VI, Chapter 1 for more information about making movies.

✔ **Cleaning:** In some cases, you can activate the camera's self-cleaning mode — which may include shaking and automatically cleaning the sensor (or the filters on top of the sensor). In other cases, the mirror also locks up and out of

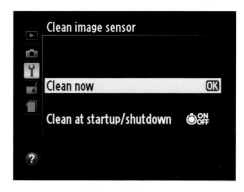

Figure 3-7: Setting up a cleaning routine.

the way so you can blow dust out or clean the sensor yourself. You may have the option to choose either method from the menu. Figure 3-7 shows the Clean Image Sensor option from a Nikon entry-level dSLR. You can clean the sensor now or set it to clean every time you start up or shut down.

Whatever you decide, be careful if you clean your camera yourself! You can ruin your camera if you scratch the low-pass filter that covers the sensor or the mirror.

Don't confuse Manual cleaning mode with mirror lockup (Nikon names it Mirror Up mode), which delays the photo more than normal after the mirror flips up to reduce camera shake from the mirror movement.

✔ **Auto rotate (camera orientation):** This setting records the camera's orientation when you take the picture and stores the information in the EXIF information. When you review the photo or open it in *smart software* (photo management or editing software that looks at the orientation information in the file to correctly display it), the picture is automatically rotated to its correct orientation. The auto rotate option prevents you from having to turn the camera every time you review a portrait-oriented photo. It makes the photo smaller-looking, though.

✔ **Video mode:** Let the camera know what type of television, VCR, or other video device you might connect it to so that you can review photos.

✔ **Grid:** The grid in the viewfinder or on the LCD monitor is turned on or off. In some cases, you may be able to customize the grid by having more or fewer lines. Some cameras (such as the D300S) have a virtual horizon that acts like a level. If you turn it on, the horizon appears on the LCD monitor.

Keep your camera's grid turned on to help keep elements level within the viewfinder and to better frame the shot.

✔ **Auto power off:** Have you ever accidentally left your camera on? You can automatically turn it off and save batteries with this option. Figure 3-8 shows this option set to 30 seconds in a Canon camera.

✔ **Battery information:** On some cameras, you have to identify a battery type. On others, this settings displays only how much battery life remains.

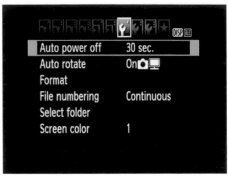

Figure 3-8: Shorten to save battery life; lengthen to keep the camera awake.

✔ **Revert to default settings:** Being able to automatically change all options (or a good percentage of them — see your manual for details) to their factory default settings is helpful. It helps you restore the standard camera setup if you change a setting and can't later recall its original values. This option frees you to be wildly creative and experiment with your camera.

Setting recording options

Your camera's basic still and movie recording settings control how your digital SLR shoots and saves photos and movies, as well as other photo- and exposure-related options. Figure 3-9 shows the first page of the Shooting menu from the D3200. The highlighted icon in the left column represents a dSLR. The scrollbar on the right side of the menu system tells you where you are — up or down — as you review the individual options within a tab. You often have to scroll past an initial page to see more options.

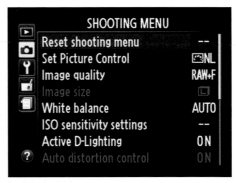

Figure 3-9: Looking at shooting options.

The following important settings affect photo size, quality, and type:

✔ **Image size and quality:** You've got a modern-day marvel in your hands. Your dSLT/dSLT can take magnificently clear, compelling photos. And let me tell you something more: You can get such photos in several sizes, aspect ratios, and qualities. Figure 3-10 shows the Quality option of a high-end amateur camera from Canon. You can see file size and the pixel dimensions.

Your dSLR/dSLT has no bad settings. Your camera has good settings and better ones. In general, if you plan on printing large copies of your photos, select the highest quality photo possible. If you're going to use the photos on a computer or make small prints, even the smaller, lower quality settings are fantastic.

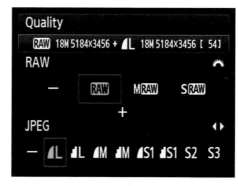

Figure 3-10: Image Quality combines several options together.

- **Choose JPEG** if you want to use a final product right out of the camera. You don't want to mess with processing the file yourself. You don't need the ultimate in quality and are happy with what the camera produces. You're using JPEGs on your computer or putting them online. (You can't upload Raw files to Flickr, Facebook, your blog, or your web page. Don't even think of tweeting them.)

- **Choose Raw or Raw + JPEG** if you want creative control over your photos and don't mind processing them yourself. You want the flexibility of making multiple edits throughout the process. For you, saving storage space and transferring photos faster aren't as important as having the flexibility, quality, and creative control that you get with Raw files.

Don't get too cocky about the superiority of Raw files over JPEGs. Unless you're good at processing Raw files, the JPEGs may look better.

✔ **Review time:** Specify the number of seconds a photo appears on the LCD monitor immediately after you shoot.

- **Yes indeedy doodly:** If you find yourself pressing the Playback button every time you take a photo to look at it — whether it's to check focus, brightness, or cuteness — turn on auto review.

- **No thanks:** If Auto Review is on, and find yourself continuously pressing the Shutter button halfway to get back to taking photos, either reduce the playback time or turn off auto review. You can always press the playback button to review specific photos. In Figure 3-11, I am configuring Auto Review on a high-end amateur Sony camera.

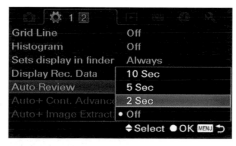

Figure 3-11: Customizing Auto Review.

✔ **Red-eye control:** Enabling red-eye reduction is sometimes part of the flash menu.

✔ **Color space:** Specify the color profile assigned to JPEGs file. Raw images *don't have* a color profile; it's assigned by the raw processor when you convert it to TIFF or JPEG format.

Choose from two color space options:

- **sRGB** defines a smaller color space but is more widely accepted. In fact, sRGB is the de facto standard and so ubiquitous that devices with no color management capabilities at all assume that all colors are defined in sRGB and reproduce sRGB photos perfectly. I recommend assigning this color space to your photos.

- **Adobe RGB** defines a larger color space than sRGB but is less widely used. The danger is that you may be viewing or editing colors on your system that other people can't display or print. If you work in an environment that's tightly color managed, you may be able to take advantage of Adobe RGB's greater color range.

✔ **Picture control or creative style:** This option specifies how the camera processes JPEGs from the image data. You normally have Standard, Portrait, Landscape, Vivid, Neutral, and Monochrome choices. Depending on the camera, you may have more or fewer choices. This setting doesn't affect Raw photos. It's like you're providing guidance to the camera about how to convert the raw data to a JPEG.

Picture Style				
A Auto	3	0	0	0
S Standard	3	0	0	0
P Portrait	2	0	0	0
L Landscape	4	0	0	0
N Neutral	0	0	0	0
F Faithful	0	0	0	0
INFO. Detail set.			**SET** OK	

Figure 3-12: Faithful is a standard Canon picture style.

Figure 3-12 shows some of the options available from a Canon camera. In this case, each style has four characteristics: sharpness, contrast, saturation, and color tone. You can accept the default values or modify them.

If you aren't saving raw exposures, *be careful:* When you apply a picture style after the JPEG is saved, you can't undo the change. Test the settings you like with copies of photos — not the ones you want to keep.

✔ **Dustoff:** Depending on the camera, this option may be named Image Dust Off Reference Photo or Delete Dust Data or something similar. See Figure 3-13 for an example from Canon. Your sensor's dust information (where the little dust bunnies are stuck to the sensor) is recorded by taking a photo of a light, featureless object to enable camera raw software to automatically remove it during processing.

Figure 3-13: Creating a dust reference photo for software to use later.

If you use a dust reference photo with your camera's raw software, your mileage may vary. Some photographers say that automatic sensor cleaning invalidates the reference photo (which is especially irritating to them when they have the camera set to clean the sensor every time it's turned on). It's good practice to take another reference shot every time you clean the sensor. After all, some (or all) of the original dust is surely gone.

✔ **No card:** This option, which might be named Release Shutter without Card, determines the camera's behavior if there's no memory card in it. I wonder why any camera will let you take a photo when you're not locked and loaded, but they do (probably so retailers can demonstrate camera settings without loading a card).

Always leave the No Card setting turned on so that you don't mistakenly believe that you've taken 100 outstanding photos and then find nothing there.

✔ **Dynamic range:** The dynamic range tries to protect you from blowing out highlights and losing details in shadow — not a bad deal, but not a free lunch, either. You may lose detail in certain tonal ranges, depending on what the camera has to do to enhance or protect shadows or highlights. You can do the same thing yourself, and enjoy total control over the process, when you process raw exposures and, to a limited degree, edit JPEGs.

✔ **Noise reduction:** You can toggle two types of noise reduction: high ISO and long shutter speed. The camera automatically processes the photo when you take it according to the type of noise reduction it has and the settings you've chosen. The downside to this is that you may lose some detail in your JPEGs (noise reduction is not applied to raw files).

✔ **Auto ISO:** You can give the camera permission to raise the ISO, if necessary, to set the proper exposure.

✔ **Aspect ratio (normal/wide):** Some cameras crop photos to a high-def aspect ratio of 16:9 for you. Be wary of this option. You aren't getting more photo — you're getting *less*. I suggest cropping in software unless you're seriously strapped for time and need an immediate final product. That way you can decide yourself what to keep and what to cut.

✔ **Live view:** The Live view settings, if applicable, control whether and how long to display the grid, autofocus modes, and exposure information. You may need to turn Live View on and off from the menu. Other cameras have a handy button somewhere on their bodies. See Book I, Chapter 5 for more information on Live View shooting.

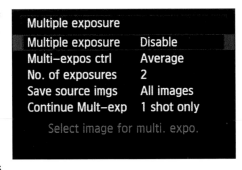

✔ **Multiple exposure:** When you use multiple exposure mode, you can take two or more photos and have the camera expose the same frame with each new shot. It's a neat special effect. Figure 3-14 shows the Multiple Exposure menu on a Canon camera.

Figure 3-14: Dig deep to find interesting options like multiple exposure.

✔ **Timer settings:** Set the self-timer, if you have one.

Delving into playback

Your camera should have an entire menu devoted to playing back photos and movies. It's an important aspect of using your dSLR. Figure 3-15 shows the D3200 Playback menu.

You should see these types of
options when looking at your
Playback menu:

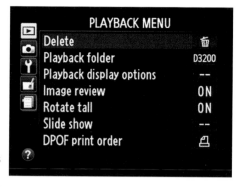

Figure 3-15: Examining Playback options.

✔ **Protect images:** Use this option
if you review your photos and
want to keep yourself from
accidentally deleting them.
Beware: They aren't protected
from reformatting. If you're like
me, and you *never* delete photos
from your card while it's in the
camera, this option is somewhat
superfluous.

✔ **Rotate:** Automatically rotate photos during playback that were taken
vertically (in portrait orientation).

✔ **Erase/Delete:** Delete a photo. (Be careful!)

✔ **Print order:** Identify exposures to print on a compatible PictBridge
printer and many photo finishing kiosks (and in which order) by setting
the *digital print order format (DPOF)* options. The more you look into the
print order, the more interesting it is. If you need to print the contents of
an entire memory card, it can be a true timesaver. Depending on your
camera, you can imprint on each photo (print on top or bottom of the
photo) the shutter speed, aperture, file number, and date the photo was
taken.

✔ **Slide show:** Set up and display
an automatic slide show of your
photos or movies. Figure 3-16
shows the slide show settings
on a high-end amateur camera
from Canon.

Figure 3-16: Setting up a slide show.

✔ **Histogram:** Turn on the *histo-
gram* (this graph indicates how
brightness is distributed
between dark and light in the
photo) when reviewing a photo
on the LCD monitor. This option
helps you tell whether you have
the correct exposure.

Making Miscellaneous Choices: Flash, Retouch, and Their Ilk

There are several important settings that don't fit easily into other categories, but that you should be aware of sooner rather than later. They may be on their own tab or integrated into another menu:

✔ **Retouch:** Some cameras let you retouch photos on the memory card. You'll enjoy being able to quickly produce finished photos in-camera, whether you don't like using your computer or you're on location and need to mock something up right away. You can find those settings on the Retouch menu. Figure 3-17 shows the Retouch menu on a Nikon camera.

Figure 3-17: You can retouch photos in-camera!

✔ **Shooting profiles:** More advanced cameras let you create, save, and load different shooting profiles with different settings. For example, you may have one ready for portraits and another for casual photography with your general-purpose zoom lens.

✔ **Custom functions:** Canon places many of their most esoteric options into a group called Custom Functions, which are then further divided into groups and numbered. Figure 3-18 shows the Custom Function entry screen on a Canon camera. More advanced Nikon cameras may have a Custom Settings menu that works similarly to Canon's Custom Functions.

Figure 3-18: Custom functions are unique to Canon cameras.

✔ **Autofocus:** The Canon EOS 5D Mark III in particular has a plethora of autofocus menu choices. This is one thing that separates professional cameras from amateur models. See Book I, Chapter 5 for more information on autofocus.

Protecting Yourself

If you plan on posting your photos online that you don't own, first read the fine print in the site's Terms of Service. If you don't like what you see, resist the urge to post there. For example, some sites may claim the right to redistribute or use everything you post for whatever purpose they may have. This recently happened at Pinterest. When people realized what was going on, they grew angry very quickly.

Some sites, such as Flickr, let you license the photos you post using Creative Commons licenses. *This doesn't necessarily protect your photos from misuse.* It simply tells people what they're legally entitled to do. You may restrict all rights, allow people to use your work non-commercially with attribution, not allow modifications, and so forth.

If you want maximum protection, consider making your photo smaller and include a visible copyright line somewhere in the photo. You can also put a watermark in the center. These actions make it possible for people to view your photos but deter other activities.

✔ **Copyright:** Enter your name or organization in your camera's Copyright information, if possible. This information gets embedded into your photos and helps to secure your rights. In Figure 3-19, I'm entering my name in a Canon camera.

✔ **Focus tuning:** You can fine-tune focus on more advanced cameras. You might need this option if a lens repeatedly focuses in front of *(front focus)* or behind *(back focus)* where it should. That indicates it needs

Figure 3-19: My precious! Adding copyright information.

to be sent to a service center and recalibrated. In the meantime, you can correct its vision.

✔ **Exposure/bracketing settings:** You often have the ability to fine-tune the way your camera sets exposure and controls auto exposure bracketing. Take advantage of these advanced settings to customize the way you like to work.

✔ **Display:** You may be able to select different screens that you want available when you press your camera's Display button. Toggle the options to make them part of the display rotation.

✓ **Custom controls:** You may be able to customize some of your camera's buttons and dials, which is handy at times. Do you want to change ISO when you press the Function button? You can (probably) do that! See Figure 3-20.

Be kind to other people's cameras. If you customize someone else's controls, put them back when you're done shooting. Use the camera's reset feature if it has one.

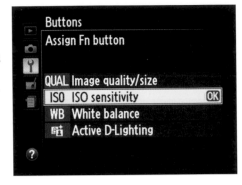

Figure 3-20: Customizing buttons and controls really lets you make the camera work for you.

✓ **Custom menu:** Canon in particular has a My Menu option that lets you customize to hold all your favorite menu options. You can even set up the camera to display My Menu (or rather, your My Menu) first.

✓ **Recent menu:** Nikon helps you find options easier by offering up those that you used most recently.

✓ **Firmware:** *Firmware* is what runs your camera. The cool thing about dSLRs is that you can change and update the firmware to smooth out bugs or introduce new features. Visit the manufacturer's website to see what the latest version for your camera is (look in the support area, download center, or on a page devoted to your camera), then check that against what your camera shows. Update if necessary.

Figure 3-21: Make sure firmware is up to date.

Updating involves either putting the firmware file(s) on your camera's memory card or connecting your camera to your computer. You can see in Figure 3-21 that C (for camera) firmware is 1.00 and L (which has lens distortion control data) firmware is 1.006.

Please read all applicable instructions before starting. Be careful when updating your camera's firmware. Do so with a full battery. If something goes wrong, you may have to take your camera to be serviced in order to revive it.

✓ **Flash options:** Some cameras have very few flash options. In this case, you can choose between automatic and manual. If you choose the latter, you can set the flash strength (something unheard of in an entry-level dSLR; features like this set this little D3200 apart from the competition). Other cameras enable you to set up wireless flash, use high-speed sync, and many other advanced flash options.

Chapter 4: Handling and Cleaning Your Camera and Gear

In This Chapter

- ✔ Confidently handling your dSLR
- ✔ Changing batteries
- ✔ Working with memory cards
- ✔ Handling lenses
- ✔ Cleaning without breaking
- ✔ Protecting your camera
- ✔ Working in weather

Good woodworkers know how to handle saws, hammers, screwdrivers, and lathes. Good electricians know how to handle wire, multimeters, lineman's pliers, wire strippers, breakers, and wire nuts. Good photographers know their tools and how to handle them, too. This practical chapter emphasizes working with your digital SLR, lenses, batteries, memory cards, and more. Consider knowing how to handle these elements of dSLR photography as part of your art and craft.

Handling and cleaning your camera and its gear is fun. Practice what you read in this chapter to create your own muscle memory. When that happens, your gray matter will be free for other tasks while your hands take over.

Gripping and Shooting

You'll become a much better shooter if you work on your grip — how you hold the camera — in different situations.

Always use one hand to hold the camera and work controls with the other. I call this my One Hand Is Always On the Camera At All Times rule. And don't forget to strap on. More on that later.

Getting a grip on handheld photography

Mastering your grip pays dividends in handheld photography. All these factors translate into sharper, cleaner photos right out of the box:

- You have a more stable platform to shoot from.
- You rely less on vibration reduction.
- You can use slower shutter speeds and not shake the camera.

In general, you mainly support the camera with your right hand. That's what the grip is for.

The following sections talk about photo-shooting positions you can work on.

Standard grip

The standard grip is shown in Figure 4-1.

- Use your right hand to grip and support the camera horizontally. Grip the grip with your right ring and middle fingers. Slide your pinky finger underneath the camera and use it as a supporting shelf.

- Work the controls on the right side of the camera with your thumb and index finger. Conveniently, you can work the back of the camera with your thumb and the top/front with your index (or, in a pinch, middle) finger. When you're ready to take the photo, your thumb should support the camera.

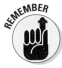

Don't forget about operating the flash. I temporarily hold the camera in my left hand and use my right hand to operate external flash controls.

Figure 4-1: Me, holding the camera normally.

✔ Use your left hand free to work the lens (and, if necessary, the controls on the left side of the camera). When you're ready to take the photos, support the weight of the lens with your left palm. At times, you may be more comfortable supporting the entire weight of the camera with your left hand so that you can remove your right hand from the grip and work various dials, buttons, and controls. When you're ready to take the picture, move your right hand back into position on the grip to press the shutter button.

✔ To promote good posture and add some stability, lock down your left elbow against your stomach.

✔ Look through the viewfinder or watch the LCD screen to frame and focus.

Vertical grip

Your hands and fingers stay in the same place, but you twist them to hold the camera vertically. If I'm using auto focus and not zooming in and out, I use my left hand to support most of the camera's weight (see Figure 4-2), and my right hand stabilizes the camera vertically and takes the picture.

Over-the-shoulder grip

A well-known photographer promotes a grip style where you turn your body and point your shoulder to the subject. Turn your head and rest the camera against your shoulder. Your left hand wraps underneath and across the camera (not in front of the lens) to rest on the right, stabilizing and securing it. I've tried this technique and can't quite seem to get comfortable with it.

Figure 4-2: Vertical grip.

Live view grip

Gripping the camera when using Live view is a different feeling. You don't hold the camera close to your face and body like you do when you're looking through the viewfinder. You can see me checking the composition in Figure 4-3.

Figure 4-3: Working in Live view.

- ✔ Hold the camera away from your face so you can see the LCD monitor.

- ✔ When zooming or focusing, move your left hand back to the lens to operate these controls. Your right hand doesn't change at all.

Shooting in Live view from the LCD monitor is a much more casual setup, with benefits. Aside from comfort, you're able to keep track of what's going on around you better, whether that's kids playing football in your yard or cars going by. You're also able to talk and interact with your subjects better because your face isn't attached to the camera. However, the style has drawbacks. This position is much harder to stabilize.

Handling an articulated monitor

Using an articulated monitor isn't difficult. Your main concerns should be as follows:

- ✔ Don't whack the monitor against anything.

- ✔ Don't overstress the joints.

The articulated monitor on the back of the Sony Alpha A55 is a good example of how they work. It flips out from the back of the camera and then tilts and swivels. An LCD monitor with Live view gives you the flexibility of shooting when you can't look through the viewfinder, but having an *adjustable* (also called *articulated*) LCD monitor lets you shoot from a number of otherwise impossible positions, such as down low, up high, or even around a corner. You can use the monitor when it's flipped out from the camera, turned toward you, or turned to the side.

It tilts out 180 degrees and rotates 270 degrees. The monitor comes stowed, as shown in Figure 4-4. Carefully use your thumb or other finger to pull the

monitor out from the back of the camera. If you like, you can rotate the monitor. In this case, it's turned halfway around.

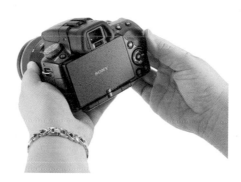

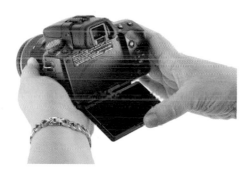

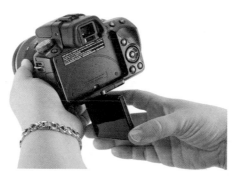

Figure 4-4: An LCD monitor can go from being put away to being pulled from its protective cocoon and flipped around.

You can also flip the monitor back up and fit it back into the camera with the screen out. In this setup, it acts like a normal LCD monitor on the back of the camera.

✔ **Kneeling:** Being able to kneel and shoot a picture is important when working without a tripod. Keeling stabilizes the camera and helps you avoid camera shake or blur Hold the camera normally — just kneel at the same time. Rather than bring your left elbow close to your body to stabilize it, as with standing, you may find that resting the camera on your knee is comfortable when you're kneeling.

✔ **Your eyes:** You can use either eye to look through the viewfinder. Set the diopter, if necessary, so that you're seeing clearly. If using your left eye, you may find that your nose wants to push buttons on the right side of the camera. Try not to let it.

✔ **Your body:** Maintain good posture. Don't hunch or bend over or else you'll tire easily and possibly hurt your back. Don't hold the camera at arm's length, even when shooting in Live view. This position strains your back too. Hold the camera close so that it becomes part of your central mass.

Using a support

If you're seeking stability (and, to some degree, safety), invest in a good tripod. One-legged monopods offer less support but are much more mobile.

You can use a fence, a rock, a vehicle, the ground, or another item if you need to stabilize your camera and don't have a 'pod.

Tripod

I use a tripod all the time (see Figure 4-5). It's good for ya. When taking more formal portraits or landscape shots, nothing works better. It moves the weight of the camera from your hands and neck (from the strap) to the tripod.

Aside from giving the camera a stable, jiggle-free zone to shoot from, you don't grow as tired on location. Using a tripod frees you and allows you to concentrate more on camera setup and framing than on taking a steady shot.

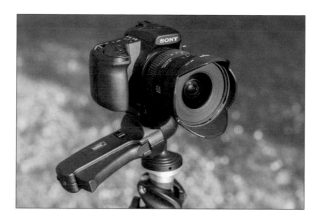

Figure 4-5: Ready and steady.

Monopod

It has a single leg that telescopes in and out to the height you want to work at, as shown in Figure 4-6. Most often, you see professional photographers at sporting events using monopods. They stand, sit, or kneel on the sidelines and use the monopod to support the weight of their camera. If they're using bulky, heavy telephoto lenses, you need all the support you can get. (In that case, the monopod mounts to the lens.)

Figure 4-6: Using a monopod to support a large camera and telephoto lens.

The trade-off with monopods is versatility for stability. Walking around with a monopod is much easier than lugging around a tripod. They're faster to set up and tear down. Setting the exact height you need on one leg versus fiddling around with three is a snap. But monopods aren't as stable as tripods, and if you forget they don't have three legs and let go, well, you're in for a nasty surprise.

Knowing the doohickeys

Digital SLRs certainly have a lot of parts. Besides operating the main shooting controls, lens, and whatnot, you need to know how to accomplish other tasks.

Familiarize yourself with your camera and practice the following actions:

- **Buttons:** Push them with a free finger. The most important button is the shutter release (aka shutter button). Press it (I'm tempted to say *squeeze* it) firmly and steadily. Don't jab at it, or you'll shake the camera. Get used to what it feels like to press it halfway; you have to do that to autofocus or pull yourself out of a menu option.

- **Knobs:** You'll more than likely have to remove a hand from the camera to turn knobs. The largest and most important is probably going to be the Mode dial, which you can see in Book I, Chapter 5.

- **Wheels:** Spin control wheels with your thumb or other free finger.

- **Sliders and other doohickeys:** Your camera has levers and selectors and other controls that take practice reaching and activating.

- **Lens controls:** If you're comfortable using your left hand, use it for lens buttons and switches (which are normally on the left side of the lens as it faces away from you). You have little choice other than to use your left hand to zoom and focus. Your right hand will hold on to the camera, ready to press the shutter release button. Manual focusing takes practice!

- **Open covers:** When you remove memory cards, change batteries, or make other connections, you'll open a cover on your dSLR. Sometimes a cover has a lever or slider (common with battery compartments). Or, you might slide the cover toward the back of the camera to unlatch it and then swing it open (common with memory card slots). Others (the camera's main terminals) are basically rubberized covers that pop in and out of the camera body, as shown in Figure 4-7.

Regardless of the type of cover, *don't force open a cover* and possibly break it. If it's stuck and you just can't open it, check the manual to make sure you're operating the specific cover correctly. If so, try again carefully. If it seems impossible, search for help on the Internet, e-mail the camera manufacturer for advice, get help from a local camera shop, or consider taking the camera in for servicing.

✔ **Connect cables:** Open the compartment that the connector is in or remove the cover carefully. Align the cable with the connector so that they join together correctly. USB and other data cables (not to mention remotes and power supplies) can be put in only one way.

Don't force a cable where it doesn't want to go! If it doesn't go in, pull back and look things over. Make sure that you have the correct cable and the correct connector. See whether all the parts are aligned correctly. If not, twist or turn it so that you do. It's tougher in dim light. Ideally, you know your camera by touch. If necessary, take a small flashlight with you so that you can see what you're doing.

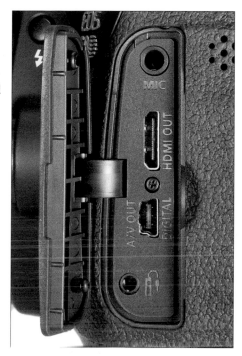

Figure 4-7: Use care when opening covers.

✔ **Change batteries and memory cards:** Although these actions are simple, they deserve their own sections. I cover them later.

✔ **Attach grips:** Vertical grips are very functional. They look cool and give your camera extra battery power. Attaching one is easy.

1. **Depending on your model, you may have to remove the camera's battery first.**

2. **Load two batteries into the vertical grip.**

3. **If the grip has an extension that slides into the camera's battery compartment, align it carefully.**

4. **Screw the grip into the tripod socket.**

Changing Batteries

Changing your camera's battery is a mundane task, but it's important. Batteries supply your dSLR with life. Never take that for granted. Always store your batteries (plural; buy more than one) properly (a cool, dry place) and charge them when needed.

Checking battery power

Your camera should have battery status indicators all over it. You should see one in the viewfinder, the top LCD panel (if your camera has one), and the back LCD monitor, as shown in Figure 4-8.

You may also be able to look in your camera's menu for a more detailed estimate. Look for a menu option related to the battery. When you select it, the battery information is shown, as shown in Figure 4-9. In this case, you learn how much charge is left, how many shots you've taken on this battery, and how well the battery is expected to recharge.

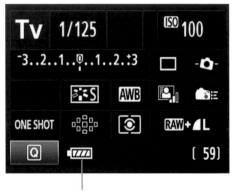

Remaining battery power

Figure 4-8: Look for battery power indicators in all displays.

Inserting a battery

If your camera has a lock lever in the battery compartment, make sure nothing catches on it when you're inserting the battery. Push it aside so the battery can slide past.

Here's how to insert a battery into your dSLR:

1. **Turn off the camera.**

2. **Release the catch on the battery compartment cover. See Figure 4-10.**

 The catch is on the bottom of the camera. The cover should either pop open (if it's spring loaded) or gently ease open on its own.

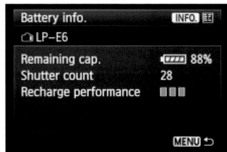

Figure 4-9: This camera gives you what borders on battery TMI.

Some cameras put their memory cards in the same overall compartment. They go in different slots and can't be mixed up, really. The only danger is probably dropping the memory card into an empty battery compartment. If that happens, just turn the camera over to get the card to drop into your hand.

3. **Orient the battery and insert it into the battery compartment.**

 Batteries go in contacts first. Most batteries are round on one end, so it's easy to tell which way they go in. If there's a locking lever (see Figure 4-11), you should gently press it out of the way. I use the corner of the battery for this.

4. **Press the battery in all the way or until it locks in place.**

 If there's a lock lever, make sure it locks the battery in place, as shown in Figure 4-11. If not, press the battery in and use your finger to keep it from falling out.

5. **Close the battery compartment cover.**

Removing a battery

Here's how to remove a battery:

1. **Turn the camera off.**

2. **Release the catch on the battery compartment cover.**

 The cover should pop or fall open.

3. **If necessary, press the battery lock lever in until it releases the battery.**

Figure 4-10: Slide the catch to release the door.

Figure 4-11: Be sure to move the locking lever out of the way as you insert the battery.

The battery will spring up a bit, as shown in Figure 4-12. Some batteries just fall out.

4. **Take the battery out of the camera.**

You can pull it with your fingers or hold the camera so that it falls out.

5. **If applicable, put another battery in the camera.**

Make sure to remove the protective battery cover from

Figure 4-12: A spring pushes up the battery a bit.

the new battery, should it have one. New batteries ship with a plastic cover that protects the contacts and keeps the batter from shorting out.

6. **Close the battery compartment door.**

Most manufacturers don't recommend leaving your battery to sit in the camera or charger for an extended period of time. If you aren't going to be using your camera, take the battery out and store it safely in a cool, dry place. Charge it shortly before you plan on using it (either the day or so before of the day of shooting).

Inserting and Removing Memory Cards

Treat your memory cards as though they hold the most precious cargo. They do!

Here are some general tips for handling a memory card:

✔ **Don't expose memory cards to the weather.** Don't let them get wet. Don't let them fry in the heat. Try to limit their exposure to dust and humidity.

✔ **Normal magnetism is fine.** Contrary to what you may believe, flash drives (which a memory card is a subset of) aren't affected by normal magnetic fields. Notice that I said *normal* magnetic field: If you run the card through an X-ray or MRI machine (the one in your basement?), you may be in for trouble.

✔ **Take a load off.** Memory cards aren't made from titanium. They can be crushed. Don't sit on them, step on them, drive over them, or rest heavy objects on them.

Inserting a memory card

To insert a memory card into your dSLR (after first making sure that the card and camera are compatible with each other), follow these steps:

1. **Turn off the camera.**

 Most cameras suggest strongly that the camera be powered down before swapping out memory cards.

2. **Open the card cover.**

 Depending on your model, you may have to operate a card cover release latch. Other models pull out and swing open, as shown in Figure 4-13.

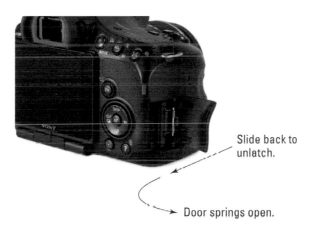

Slide back to unlatch.

Door springs open.

Figure 4-13: This cover slides back and then swings open.

3. **Orient and align the card properly.**

 SD cards have a notched corner. You can use this to orient the card the correct way every time. For other cards, try to remember which way the label faces.

4. **Insert the card into the slot and press until it's securely in place.**

 An eject button may pop up, indicating that the card is in position.

5. **Close the card cover.**

6. **Turn on the camera.**

7. **Check to see whether exposures register and the card seems to work.**

Removing a memory card

To remove the card, follow these steps:

1. **Turn off the camera.**

2. **Open the card cover.**

3. **Eject the card.**

 Depending on your camera model, press an eject button once to make the card pop up and press another time to make the card pop out. (This is how Compact Flash cards work.) Or, press in the card gently so that it releases and pops up, as shown in Figure 4-14. SD and Memory Stick cards work this way.

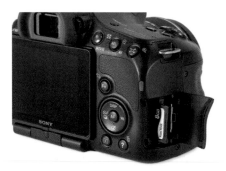

Figure 4-14: This card is ready to pull out.

4. **Fully remove the card.**

 Cameras that take larger Compact Flash cards (shown in the figure) use a device that lifts the card far enough so you can grab it. Smaller SD cards pop up when you push down on them.

5. **Insert another card or close the cover.**

Working with Lenses

The skills you use when handling lenses are just as important as those you use when handling the camera body. When you treat your lenses well, they will give you a lifetime of service.

Lenses are round and like to roll. If you set one down on its side, it can roll off a table or whatever it is on. Crash! Some lenses are tall. If you stand them on their end, they may be knocked over easily, then roll off the table and hit the floor. Don't put lenses in anything but protective cases, bags, or other storage containers.

Your grip doesn't have to be as steady when changing lenses on smaller cameras. You can just sort of wing it. However, heavy cameras offer more of a challenge.

In Grips 1 and 2, described in the following sections, try angling the front of the camera down a bit. Although it may feel awkward at first, this position helps prevent dust and other debris from getting into the camera. Practice so that you can attach and remove lenses without angling the camera up to see what you're doing. In fact, after some experience, you should be able to attach and remove lenses while blindfolded.

I've written this from the perspective of removing a lens, which is the more perilous task. To use these grips when attaching lenses, put your hands in the same positions. The difference is that when you grab the lens with your right hand, it's not attached to the camera. Your right hand will move it into position while your left hand (and possibly body) steady the camera.

By the way, if the camera is mounted on a tripod, most of the hand-holding and camera-supporting descriptions in this section are moot. The camera should be well supported by the tripod. Hold tightly to the lens, however. If you're using a lens-mounted support (monopod or other), you'll end up turning the camera instead of the lens.

Grip 1

Refer to Figure 4-15.

1. **Hold the camera's left side with your left hand.**

 Press its right side in to your body for additional support.

2. **Put your left thumb on top of the cameras (in this case, on the Mode dial) and stretch your left pinky underneath the camera for additional grip.**

 The camera will be facing to your right. Your left index finger will press the Lens release button when necessary.

3. **Use an overhand grip on the lens the way you would put your hand on a railing.**

 The C formed by your right index finger and thumb grips the lens from the top and faces the camera body.

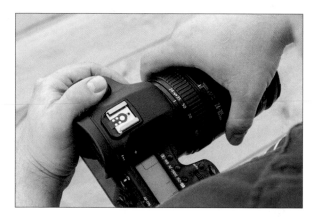

Figure 4-15: Grip 1 uses your body to help support the camera.

Grip 2

Refer to Figure 4-16. This grip is similar to Grip 1 in that the camera faces to the right. However, rather than use your body for support, your repositioned left hand does all the heavy lifting.

1. **Place your left palm on top of the camera (in this case, on the LCD panel).**

2. **Wrap your left thumb to the front of the camera and put it on the body to the side of the lens.**

 Really grip with your thumb.

3. **Reach down with the fingers on your left hand to the back of the camera and grab the bottom.**

 Your left index finger rests on the LCD monitor. Use it to stabilize things. You should be able to hold the entire weight of the camera with this hand. (It feels sort of like you're shaking hands with the camera, using your left hand.)

4. **Put your right hand on top of the lens.**

 Grip the lens near the lens collar (the part of the lens that's nearest the camera body). Your right thumb should be on the side of the lens nearest you.

5. **Use the knuckle on your right index finger to press the Lens release button in when you're removing a lens.**

 The last part sounds dodgy until you do it. Then it feels totally natural.

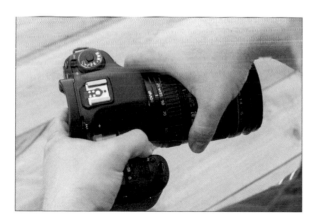

Figure 4-16: Grip 2 requires your left hand to manhandle the camera.

Mounting a lens

Mounting lenses isn't difficult, but it can be a little frightening until you get used to it. I remember being a bit nervous about the camera's insides being open to the world while I made a lens swap. Don't be. Unless you're in a dust storm or outside in the rain with no cover when changing lenses, the camera will survive. Just don't drop the lens (no pressure).

When you're mounting a lens, the key is to be quick without rushing and to be firm without being harsh. Got it?

Here's how to attach a lens to a digital SLR camera:

1. **Turn off the camera.**

 If you forget (I have), it isn't the end of the world. Ideally, you want the power to be off, though.

2. **Remove the rear lens cap from the lens.**

 Place the cap on a table, in your camera bag, or in your pocket for safekeeping. You need three hands if you're standing up (or two hands and a tripod or two hands and your camera strap).

3. **Remove the camera body cap or lens.**

 Most body caps twist off. Some have a locking function. Put away the cap or lens, if necessary. See the next section for how-to steps on removing lenses.

 Be more careful with your lens than with a small plastic cover. At these times, you can easily drop and break lenses.

4. **Get your grip on.**

 In other words, grip the camera and lens using one of the previously described hand grips.

5. **Line up the mounting index on the lens with the one on the camera body, if it exists.**

 Sometimes, it's orange, as shown in Figure 4-17. It can be any color.

Line up indices

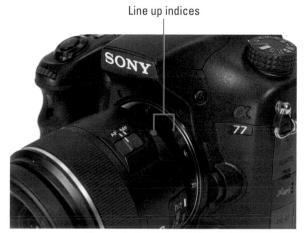

Turn to lock, once attached

Figure 4-17: Carefully line up the index marks.

6. **Insert the lens onto the mount.**

 You feel the lens and the camera fit together if they're properly lined up.

7. **Rotate the lens in the proper direction until it locks and clicks in place.**

 You should hear a click or feel it lock. Don't mess with the lens release button as you mount a lens

 Nikon users rotate the lens counterclockwise, as you're looking at the camera from the front. Others rotate the lens clockwise, which feels more natural to me.

8. **When you're ready, turn on the camera and remove the lens cap from the lens.**

 Check and set switches on the lens, such as autofocus or vibration reduction. You're ready to shoot.

Removing a lens

Taking a lens off is pretty easy. It feels a bit scarier until you get the hang of it. But that's why you're going to practice, right? Follow these steps to remove a lens:

1. **Turn off the camera.**

2. **Get your grip on.**

 In other words, grip the camera and lens using one of the previously suggested methods.

3. **Press and hold the lens release button.**

 Make sure to continue holding the lens as you press the release button so it doesn't accidentally fall out.

4. **Turn the lens until it releases from the mount.**

 Press the lens release button as you start turning the lens. Once the lens turns a bit, you don't need to hold the button in. Nikon users turn counterclockwise (from the perspective of looking at the camera back, like a photographer would). Other users turn clockwise. Reverse the rotation if you're holding the camera facing you.

 When you've turned the lens far enough, you feel the tension ease up and the lens float free within the mount. You might hear the lens come up against the mount stops. The mounting index will line up between the lens and the camera body.

5. **Pull the lens straight away from the camera body.**

 If you angle the lens as you take it out, you might damage the sensitive contacts on the rear of the lens, the collar, or the mount.

6. **Secure the lens.**

 Put the rear lens cap on quickly and set the lens in a safe place. If that spot is in your camera bag, you're done with it. Otherwise, make sure to pack it away safely when you take care of the camera body.

7. **Replace the body cap or attach another lens.**

 Don't leave the camera open to the elements. Always replace the body cap or mount another lens on the body right away.

Zooming in and out

Unless you have a *prime lens* (a lens that doesn't change focal lengths), you'll use the zoom ring to zoom in or out. Most new lenses have their zoom ring closer to the base of the lens, which is shown in Figure 4-18. Turn the zoom ring clockwise (from your perspective behind the camera) to zoom out; turn it counterclockwise to zoom in.

Zoom ring Focus ring Focal length Zoom position
index

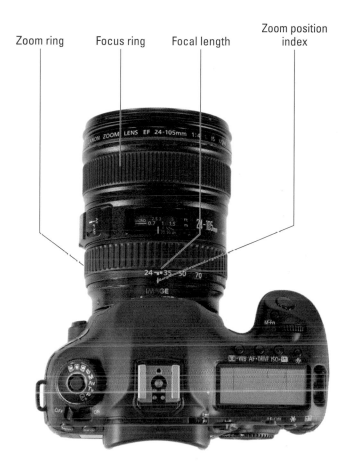

Figure 4-18: Focal lengths help indicate the effective zoom.

Focal lengths are printed on the lens's Zoom ring. Read your current focal length by noting the number (extrapolate if you're between printed numbers) lined up with the Zoom position index.

I'm holding the camera in Figure 4-19 with my left hand on the zoom ring, ready to zoom in or out. This position works well for looking through the viewfinder and using autofocus.

If you're manually focusing, zoom in or out first with this grip and then move your hand to the focus ring to manually focus the lens, as shown in the manually focusing section later in this chapter.

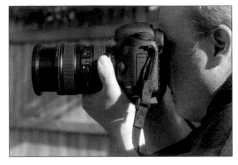

Autofocusing

To autofocus (AF) using the viewfinder, compose the scene, then press and hold the shutter button halfway down. It's pretty simple. If

Figure 4-19: Zooming in horizontal hold.

you like, you can customize the autofocus system to meet your needs or to deal with more difficult situations.

AF points

While *AF points* are the specific spot in the camera's viewfinder that's used to focus. The AF points that come up in your viewfinder aren't just there for show. The camera uses them to identify the subject and focus. You may need to take control and select the AF point yourself. Your two AF point selection options follow:

- ✔ **Automatic AF point selection:** You let the camera decide which points to use. Most of the time, it does a pretty good job. However, it does have a tendency to focus on the closest object, whether that's what you intend or not.

Automatic AF point selection may not be precise enough when you're working with extremely shallow depths of field (the area that appears in focus) or when needing to focus on one of several objects at different distances.

- ✔ **Manual AF point selection:** You select the AF point yourself. You generally have to press an AF Point Selection button or make a menu choice to make your selection. Depending on your camera, you may be able to choose a point, a zone, a group of points, a dynamic group of points, or other AF point selection methods.

AF modes

Your camera also has *AF modes,* which determine whether the camera focuses once and then beeps or continues to focus (which is helpful for moving subjects). See Figure 4-20. You may be able to choose from these different AF modes:

✔ **Single focus:** The camera focuses once and beeps at you. The AF point used might light up in the viewfinder. This works well for portraits and other non-moving subjects. Also called *one shot* or *single-servo AF*.

✔ **Continuous focus:** The camera focuses continually for as long as you hold the shutter halfway down. Use this mode to track moving subjects, or if you're moving. Continuous focus is also called *AI servo* or *continuous-servo AF*.

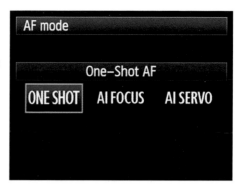

Figure 4-20: Selecting an AF mode.

✔ **Automatic switching**: In this mode, the camera automatically switches between single focus and continuous focus as the need arises. Also called *AI focus* or *auto servo AF*.

Autofocus can work differently when you're in Live view mode. With some cameras, and in some modes, you basically point and shoot. At times, however, you have to use focusing tools specifically designed for Live view.

Canon cameras, for instance, offer three Live view AF modes: Live mode, Face Detection Live mode, and Quick mode. They all have their pros, cons, and quirks. New Nikon cameras like the D3200, on the other hand, offer four AF area modes when in Live view: Face-priority AF, Wide-area AF, Normal-area AF, and Subject-tracking AF.

Keep these tips in mind when using autofocus:

✔ **Check focus:** One really cool thing about focusing in Live view is that you can often zoom in and check your focus very precisely, as shown in Figure 4-21.

✔ **Buttons and functions:** You may be able to press another button (instead of the Shutter button) to autofocus. This reduces the chances of accidentally taking photos when focusing. You may also be able to change button assignments.

Figure 4-21: Zooming in to check focus in Live view.

↙ **Low light:** In low light, you may have an AF-Assist beam shine out from the camera or flash to help the camera lock onto the target. If this bothers you, you may be able to disable it. Other cameras use a pulse from the built-in flash to help autofocus.

Switching from auto to manual focus

To change to manual focus, simply switch the focus mode switch on your lens to MF. The switch is on Autofocus (AF) in Figure 4-22.

Manually focusing

Despite how powerful modern AF system are, your own eyeballs, combined with the camera's viewfinder or LCD monitor, also work really well. I encourage you to try to work on manually focusing in the following conditions:

↙ **Close-ups:** When shooting close-ups, especially with wide apertures, nothing can beat your own ability to focus, especially if you're using a tripod. However, with steady hands and a reasonably fast shutter speed, even wiggly things like baby rabbits make a great case study for when manual focus is best. In this case (see Figure 4-23), I needed the precision of manual focus because the depth of field was too small and the camera didn't always focus exactly where I wanted it to. You sometimes can fix that by selecting a different AF point selection mode (and possibly choosing a specific AF point), but in this case, it was easier to switch to MF and handle it myself.

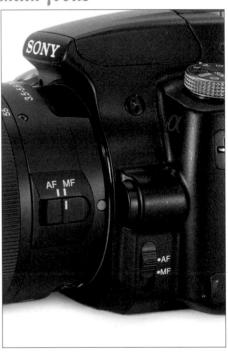

Figure 4-22: Switch to MF to take total focusing control.

↙ **Really distant subjects:** When photographing landscapes and other far-off subjects, set the focus to the *hyperfocal distance* (the focal distance at which you have the greatest depth of field; see Book III, Chapter 1 for more information on focal distances) and don't worry about it. Perfect. This focus works for fireworks and astrophotography as well. There is a sweet spot where things are far enough away for you not to be able to tell whether something is in good focus or not. In those cases, switch to AF.

Figure 4-23: Manual focus is very precise for well-lit close-ups.

✏ **Dark conditions:** Don't bother trying to manual focus in low light or dark conditions. You simply can't see well enough to discern the proper focal point. The best two options are to pre-focus or focus at a specific distance. Otherwise, switch to AF.

Manually focusing will change how you hold and support the camera. Figures 4-24 illustrates this point (compare to Figure 4-19, where I'm using the zoom ring). In one shot, I'm holding the camera horizontally, and my fingers are on the zoom ring. I've finished composing the shot and am ready to focus. Don't be afraid to grab the focus ring and use your left hand to steady the camera as you focus, but let your right hand support most of the camera's weight. The other shot in Figure 4-24 shows the same principle when holding the camera vertically. In that case, stiffen the fingers on your right hand as you hook them around the front of the grip. The camera can almost hang off them, which helps keep your hand from tiring out too quickly.

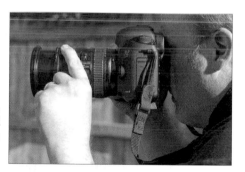

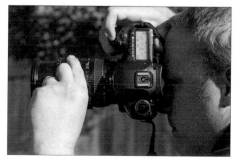

Figure 4-24: Manual focus in horizontal and vertical holds.

Activating the VR/IS

Nikon calls their lens-based stabilization system *vibration reduction (VR)*.
Canon calls their version *image stabilization (IS)*. Turning on VR/IS is easy.
Set the appropriate switch on your lens to On. See Figure 4-25.

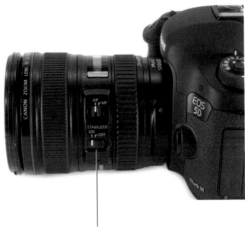

Image stabilizer switch

Figure 4-25: Engage the stabilizer!

For a whole lot of reasons (cost, necessity, and the like), not all lenses have
VR/IS. If you use a lens-based image stabilization camera, be on the lookout
for VR or IS in the lens name when you're shopping.

Cleaning Up Your Act

Cleaning your camera and lenses is an important part of the quality-control
process. Your equipment will thank you, and you'll take better photos. The
camera has lots of different elements to clean, so hang on!

Check your manual and follow its specific instructions for your camera.
They're generalized here by necessity.

Wiping off the camera body

Most manuals tell you not to use any sort of organic solvent to clean your camera body — no thinner, alcohol, or benzene.

For a normal level of cleaning, wipe the body with a soft cloth. Moisten the cloth, if needed. I've recently been using microfiber cloths for all my cleaning needs. I use the Quickie brand microfiber cloths from Lowe's because they're large; and I use them around the house too. Photo shops such as Adorama and Amazon also sell a number of microfiber products. Check them out. They're easy to use and require no chemicals or cleaners. If something is truly stuck on, wet the cloth with a *little* water.

Turn off the camera before you clean its body. That way, you can push buttons and turn knobs without throwing off your settings.

If your camera is in *bad* shape (wet, muddy, or stuff you can't clean), be safe and take it to an authorized service center to see whether someone can help.

Cleaning LCDs

Treat the LCD screen as you would treat your lenses. Don't use chemicals or abrasive cleaners to clean. You may mar or scratch the surface. In addition, pay special attention to the cloth you use. If it's especially rough (such as an industrial strength paper towel), you might scratch the LCD monitor. As more cameras move to touch-sensitive LCD monitors, get into the habit of turning the camera off before cleaning the monitor.

As with my camera bodies, I use microfiber cloths to clean the LCD monitor on the back and any LCD screens elsewhere on the camera.

Dusting and swabbing

Every dSLR user must know how to deal with dust. Even weatherized cameras are vulnerable to this problem. Unless you're working in a NASA clean room, you allow dust to enter your camera every time you change lenses.

Dust that shows up in your photos should be obvious: big, fuzzy, dark spots. You won't see much by looking into the camera when you change lenses unless you have a *loupe,* a special type of magnifying glass. If you're in doubt,

photograph a clear blue sky and check for spots in the photo. Book VI, Chapters 2 and 3 show an example apiece of removing dust from photos.

Address the problem — don't ignore it. Over time, dust bunnies will start showing up in your photos.

Self-cleaning

Self-cleaning (sensor shaking) is your first line of defense against dust. The camera shakes the dust off the sensor to try to clean it. You don't have to open the camera, blow anything in, or swab anything out. In that respect, it's relatively foolproof. It might say that cleaning is in progress, as shown in Figure 4-26. Most manuals suggest that you place the camera on a flat surface, bottom down.

Figure 4-26: Cleaning in progress.

Many cameras have a self-cleaning mode. Some use self-cleaning with manual blowing. After you make the menu choice, the sensor shakes and then the mirror locks up so that you can blow out dust. Some cameras can be set to perform the sensor shake every time you turn the camera on or off, or perform it on demand.

You may be able to turn off cleaning entirely. This will save your battery and speed start-up and shutdown times.

Blowing dust out

To blow dust out of your camera, follow these steps:

1. **Charge your camera's batteries.**

 Camera manufacturers recommend locking the mirror for manual cleaning with fresh batteries. If you have an AC power adapter, you can use it.

2. **Turn on the camera.**

3. **Go to your camera's sensor cleaning menu.**

4. **Turn on the manual cleaning mode.**

 It may have any name: Mirror Lock Up, Mirror Up, or Self Cleaning.

 Don't choose self-clean. You want the mirror raised and out of the way, but you're going to do the blowing yourself. The camera may shake the sensor during this step to throw off dust, and that's fine.

5. **Take off the lens or remove the body cap and make sure the mirror is raised.**

 If the mirror is still down, replace the lens or cap and turn the camera off. Return to Step 2 and start over. If you can't get the mirror to raise, and you know you're using the right menu, you may need to contact a service center.

6. **Move the camera so that the opening faces or is tilted downward.**

 This makes it easier for the dust to fall out of the camera when you blow it.

7. **Take a blower and squeeze-blow air into the sensor cavity three or four times.**

 - *Don't* push the tip of the blower into the open cavity. It isn't a vacuum cleaner. You get plenty of air movement by hovering the tip even with the lens mount or just outside the camera.

 - *Don't* use a canned-air spray blower. Don't use a blower brush, either. Use a blower that you squeeze with your hand.

 - *Don't* dally. The more you have the camera open, the more dust can get back in.

8. **Put down the blower and put the camera back together.**

9. **Turn off the camera.**

10. **Turn on and check the camera to make sure it's working.**

 Take a few test shots. Stop down to a small aperture and take a photo of the sky or your ceiling, to see whether it shows any dust spots. If it does, you can try cleaning the sensor yourself or send in the camera for maintenance.

Manually swabbing or brushing the sensor

Dust can be so infuriating that people are often tempted to resort to extraordinary measures to clean their cameras. The most extreme solution is to manually swab or brush the image sensor yourself. With the right equipment and a steady hand, it's not impossible.

However, I don't think a single camera manufacturer out there recommends you clean your camera lens via brushing it yourself. They suggest sending the camera to an authorized service center to be cleaned. If you insist on cleaning the sensor yourself, look in your manual for the proper procedures, if possible. *Don't open your camera and touch anything inside it unless you're sure of yourself and willing to take the risk.*

My take, which has evolved over time, is that if the problem is so bad that I can't take it anymore, I've gone past the DIY threshold and am squarely in Hire Someone Else to Do the Dirty Work land.

Actually, I'm talking about cleaning the low-pass filter that covers the sensor, not the sensor itself. Most people simply call it *the sensor.*

Look in your camera's manual for websites or phone numbers you can visit or call to find the nearest service center. Have your dSLR cleaned by someone trained and practiced in it. It's not the end of the world to pay for a bit of routine maintenance. Make sure to get it done before important trips, holidays, occasions, or other events where you'll be taking a lot of photos. That way you'll feel like it was worth it.

Cleaning lenses

Cleaning lenses is a lot less intimidating than cleaning your camera's sensor. Cleaning lenses is a lot like cleaning windows.

You should become comfortable cleaning lenses whether they are attached to the camera or not. You never know when you'll need to clean one. Also, you will rarely need to clean the rear lens element (it's normally covered by a cap or the camera). If you must, use the same steps as you would to clean the front of the lens. In either case, if you spray a cleaner, spray it on a cloth, not the lens itself. This keeps fluid from seeping into spots where you can't clean it.

1. **Brush off the lens before you go rubbing anything on it.**

 Or, use canned air to dust the surface. This will hopefully remove anything that might scratch the lens as you try to clean it.

2. **Use a damp (not sopping) microfiber cloth or unused coffee filter to clean; gently rub the lens from the center out.**

 That's if you're using a NIKKOR lens; Canon recommends wiping from the outside in, using a circular motion. (Think, "wax off.")

 Occasionally, I need to use a lens cleaning solution to remove oil. Nikon has a Lens Pen Cleaning System that I also use. It's a combination brush and scrubber.

3. **Make sure you've wiped off all cleaning fluid (water or otherwise).**

The important points are to use a soft, clean cloth or lens cleaning tissue and only approved lens cleaning solutions — or none. Most lens manufacturers recommend against thinners or benzene because of the plastics involved in the lens body. Be careful using any sort of chemicals on lenses with coatings.

Gearing up for Protection

Do yourself a favor: Invest in the right protective gear for your camera, lenses, and accessories.

Strapping it up

Using a camera strap is an important step toward safeguarding your investment. Assuming your camera strap is around your neck and you drop your camera, it might tug your neck a bit — but it won't crash to the ground. Get a comfortable strap that you like and will use. The more comfortable it is, the more likely you'll be to keep it on for long periods of time. It's not only good for your photos, it's also safer.

As an additional safety precaution, put the strap over your neck whenever you mount your camera on a tripod or remove it. I learned this trick the day I triggered the tripod release lever without thinking. The camera took a nosedive off the tripod due to the heavy lens I had on it. I barely caught it. Since then, I rely on a strap even when using a tripod.

In addition to securing your camera, snazzy straps make the camera easier to hold and carry. You can find as many types of straps as you can find cameras. Three broad categories of straps are listed here:

- **Standard strap:** The common neck strap that comes with all cameras. Most often, the default strap is a bit cheap and uncomfortable. Its main selling point is advertising for the camera manufacturer. (If they would only pay the wearers for the marketing!)

- **Better strap:** A wide, cushioned strap that has a quick-release mechanism. I have a couple of this kind. Some have straps that keep the camera from slipping off your shoulder when carrying them this way. UPstrap is one example of this type.

- **Hand strap:** Acts like a strap you see on a video camera. It loops around your hand and secures it to the camera — unlike a neck strap.

Putting it in the bag

Bite the bullet and get a good camera bag.

Ask yourself how you're going to use the bag, and then get the right one for you. You carry a conventional bag over your shoulder or by its handle. You tend to put it down when you shoot. I found myself not picking it back up again and walking over somewhere else, only to have to go back and get it. A sling bag was the solution for me. I don't take it off. I sling it over my shoulder and, when I need something out of it, I rotate it around front and open it.

I have a few ideas for tailoring your bags to match your excursions:

- **Base Camp.** I have one very large bag that fits two dSLRs, several lenses, filters, cleaning gear, extra batteries, memory cards, and so forth. It's the bag I carry when I want to work out of a base camp. I put the bag in one place — often in my vehicle — and take what I need with me. That makes walking about taking photos very light and easy. When I want to change things up, I return to the camp and reconfigure the camera and the gear I'm carrying.

- **On the Go.** I have smaller bags that fit one camera, a few lenses, and other small gear. I use these bags when I know I'll need to carry everything with me. They're small enough not to weigh me down.

 - Sling bags are for when you know you won't want to sit a bag down on the ground. I don't take these off.

 - Small traditional bags are for when you don't think sitting down bags will be a problem. They're light enough to carry but not comfortable enough to keep on all the time.

 - Backpack bags are great for hiking with your gear on your back. They come in different sizes to match how much gear you need to pack with you.

Look for these other characteristics when you're shopping for a bag:

- **Size:** Most bags let you carry a dSLR body with lens and at least two more. If you need more space, get a bigger bag. If you need less, look for a smaller bag. You don't have to be a rocket surgeon.

- **Padding:** Bags with padding protect your gear better. Baby it!

- **Strap support:** Test out your back and see whether the strap was made to cut wood. Sling bags (my favorite when I'm walking around, want my gear handy, and don't want to set it down) have good support in their straps.

Be sensible when packing your bag. Most often, you don't need to take everything with you. As long as you have these with you, you're set:

✔ Your camera

✔ Lens

✔ Charged battery

✔ Empty memory card

Having extra batteries and memory cards is preferable and doesn't take up too much space or weight. Try to narrow the number of lenses you want to use and take only those — not everything in your arsenal.

 I've found, quite by surprise, that my bag became easier to use and more practical as I winnowed it down. I don't have to wade through a full bag to find the one item I need. I have my glasses, remote shutter release, WhiBal (a white balance card) card, lens cloth, extra battery, extra memory card, camera with lens, and one or two other lenses. If I think I'll need a level, I may take it and an external flash (see Book IV, Chapter 2).

Buying extra lenses and camera caps

It goes without saying that you shouldn't leave your camera or lenses open to the elements. Always secure them with the proper caps.

What isn't so obvious? Having more than you need is really helpful.

I have a number of extra rear lens and camera body caps (see Figure 4-27). As long as the lens mount is the same, rear lens caps are interchangeable. Likewise, given the same lens mount, camera body caps fit the same, whether the camera's entry level or professional.

Figure 4-27: Extra body and lens caps make life easier on you and protect your gear.

Having extra means I can grab a cap and get my gear covered, whether it's the cap I took off or the one closest to me. Sometimes caps have a way of wandering off. If you keep your extras in the same place, you'll always be ready.

Buying multiple front lens caps isn't as practical. Lenses with different front ends (it's the filter size, actually) require differently sized front lens caps. If you use large filters and step-up rings to match lenses with the filters, then you should buy several front lens caps the same size as your standardized filters. In my case, that's 77mm. When the step-up ring is screwed into the lens, it requires the larger lens cap, not the original.

Armoring your camera

For extra protection, squeeze your camera into some silicon armor. The Delkin Snug It Pro Skin Camera Armor is shown in Figure 4-28. It's inexpensive and shields your camera from the occasional ding or scrape.

Figure 4-28: The body armor itself.

The cool thing about this type of setup is that everything that needs to be exposed — the lens mount, built-in flash, shutter button, main dial, and so forth — is, yet most of the camera is covered, including the buttons on the back. There's even a plastic cover to protect the LCD screen, as shown in Figure 4-29.

Figure 4-29: Protecting a camera.

Picking up some inexpensive rain covers

On your way to Niagara Falls? If you're going to shoot in the rain, mist, or spray, you can either fashion a homemade cover out of a trash bag or buy a specially designed rain cover.

Figure 4-30 shows the OP/TECH USA RAINSLEEVE, which promises to work not only in wet weather but to protect your camera against dust. If it looks suspiciously like a plastic bag thrown on the camera, well, it is. However, there are real advantages to using a product like this over a clear garbage bag. This cover has an opening for your lens and a hole in the back for the viewfinder. Slip the eyepiece from your camera, stretch the hole over the viewfinder, then secure the cover to the viewfinder with the eyepiece. Works like a charm!

The one odd thing about this shot is that I screwed a step-up ring onto the end of the lens to keep the bag from slipping off the front of the lens. If you have a lens hood (this lens doesn't), it should serve the same purpose.

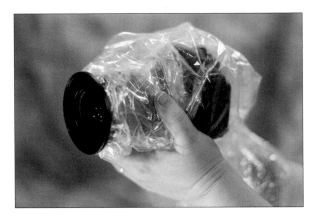

Figure 4-30: Keeping the rain out.

I Can't Work Under These Conditions! Adverse Weather

It's not always partly sunny and 72 degrees outside with no chance of rain. Sometimes, perfect weather is good. Sometimes, it's bad. If you want to shoot in bad weather (or anything less than ideal conditions), you must know how to protect yourself and your camera under different conditions.

You might find yourself working in these conditions:

- ✔ **Dust:** You can't do much about dust. Don't remove your lens in a dust storm.

- ✔ **Heat:** Don't leave your camera lying around in the sun. The sun is hot and can melt or fry your gear. Not only that, LCD monitors don't like heat (they don't like cold, either) and can discolor.

- ✔ **Humidity:** Bad. Your camera has circuits running all around inside it. If the conditions are very humid, your camera is at risk even if it doesn't get wet. Try not to leave your camera exposed to high humidity for long periods of time. Get it to a dry place and remove the lens, battery, and memory card so the camera can dry out.

- ✔ **Snow:** Snow is easy to work in as long as you're not wallowing around in it. You're not likely to drown the camera if a little snow gets on it. The main thing you have to deal with when you're in snow is the cold temperature.

✔ **Underwater:** Buy a special underwater housing that's certified for use with your camera. They vary greatly in capability and price, so shop around. Some are little more than sturdy plastic bags with room for lenses and access for your fingers. Others look like they were invented by Jacques Cousteau.

Cold and rain are extreme circumstances and deserve their own sections here.

Cold

Working in the cold makes everything more difficult. It can be a literal pain. Plastic and metal get extremely cold and uncomfortable to touch. You can't wear mittens the size of boxing gloves and work your camera. You can wear thinner gloves, which can be slippery or ineffective against the cold.

✔ If you do a lot of cold-weather shooting, check out special gloves designed with silicon grippies that make holding the camera easier. Some have finger caps that come off, exposing one or more fingertips to operate the camera with. Some are fingerless.

✔ Always give your lenses and camera time to adapt to the cold. If you don't, your lenses will fog up and you'll be forced to wait anyway. Sit the bag outside for a while if you want to stay warm. (Lenses can also fog up when you go from a cold environment to a warmer one, which means you are fogged coming and going.)

✔ When you're working in the cold, plastics become more brittle. Be careful not to drop your camera or lens. In addition, your batteries don't last as long as in warm weather.

Rain

Rain equals water. Water is bad. Avoid.

If it's a slow sprinkle, water won't automatically get into your camera. Keep lens changes to a minimum, and if you must change one, seek cover or point the camera downward to protect its insides. If it's raining even harder, don't go out without a weatherized camera and lens. Even then, try to protect it from the elements as much as possible.

Weather sealing is a debatable proposition. Some photographers think that it's more of a marketing gimmick than a practical advantage. Others swear by it. My sense is that additional protection from dust, humidity, and water is better than nothing, but I wouldn't trust it so far as to drop it in a bathtub.

Opteka (`www.opteka.com`) makes an interesting-looking rain cover, as shown in Figure 4-30. Try it out if you need to be in the rain. You can also make your own cover, from trash bags and duct tape, to impress everyone!

Chapter 5: Say Cheese: Taking Pictures with Your dSLR

In This Chapter

↙ **Reviewing your before-you-leave-home checklist**

↙ **Starting out on a good foot**

↙ **Preparing your camera**

↙ **Taking pictures**

↙ **Modifying the checklist**

This chapter is action-packed. I walk you through taking photos with your digital SLR from start to finish. I share tips and tricks for preparing photo shoots, packing things up, setting up when you're ready, choosing a shooting mode, and taking the photos.

Don't hesitate to flip back and forth between chapters and minibooks to find more details about certain subjects, such as lenses, composition, and HDR. That's the beauty of books in the *For Dummies* series: They're nonsequential reference books.

Checklists are great argument-starters — everyone has an opinion. Feel free to argue and quibble over this chapter. It stimulates your thinking. My purpose isn't to "straitjacket" you into a set of rules you don't want to follow. I want to give you a sense of what you need to take care of when you're shooting photos. It can be complicated, and there are a lot of things to forget.

I've organized this chapter into five main checklists. Each of these sections is a subset of a larger picture:

1. **Plan ahead:** Think about what you might need, so that you have it when you're out on location (even if it's just in your backyard).

2. **Set up:** Unpack and prepare to take pictures.

It's about what you want

If you put your digital SLR on autopilot, you'll get no argument from me. In that case you're free to concentrate on content and framing. Much can be said for point-and-shoot photography, even if you fancy yourself an advanced photographer. If you want to go 100-percent manual, focus with your fingers, and work your camera old-school style, that's fantastic. You're in charge, so make it happen. If you want to split the difference, there's no problem with that method, either.

Unless you're taking a photography class and your instructor has certain skills that you're expected to master, you don't have to do anything you don't want. These scenarios point out the brilliance of digital SLRs. They have something for just about everyone. As you read through this chapter, customize the lists to suit how you want to work with your camera.

3. **Choose a shooting mode.** You'll make a fundamental choice in this section: what shooting mode to use. The result determines whether, and to what degree, you can customize the camera in the next step.

4. **Fine-tune the camera:** Make sure that all your camera settings are dialed in where you want them to be.

5. **Take photos:** Get to the nitty-gritty of photography. Frame up the shot, take it, and then have a look at it on the back of the camera. If something isn't right, analyze what happened and correct it. If the photo's a keeper, continue to the next one.

Geek alert: I put checklists (based on this one) in each following section. At times, you should customize their order to suit the way you want to work. For example, I suggest turning on your camera before removing its lens cap. If you want, you can remove the lens cap before turning on the camera. As long as you complete the process of setting up, configuring the camera, getting your settings dialed in, and focusing before you press the shutter button, you'll be okay.

Planning Ahead

To save yourself loads of time and potential frustration when you go out to take photos, make sure that you have all these items before you leave your house:

✔ **Batteries:** Charge your camera's battery (or batteries) the day or night before you leave. (If you leave charged batteries lying around, they slowly discharge). I have at least two camera batteries for all my dSLRs. That way, I always have a fresh battery in the bag in addition to the one in my camera. If the in-camera battery is low the day before a big shoot, I recharge it so that I have two fully charged batteries.

✔ **Memory cards:** Transfer photos before you pack up and then format the card using your camera to wipe it clean; see Book I, Chapter 3.

Formatting erases photos and cleans the card. Make sure that you first transfer photos (see Book VI, Chapter 1) to your computer.

✔ **Lenses and filters:** Clean lenses and filters before packing them; see Book I, Chapter 4 for more information. As long as you don't stick your finger on the glass, you should only need to dust them off when you're on location.

✔ **Sensor:** Some time before important shoots, see if your camera's sensor has a lot of dust. If so, consider getting your camera's sensor professionally cleaned. Otherwise, you can blow dust out of your camera and activate the camera's self-cleaning mode, if it has one. You may also want to take a dust registration shot. See Book I, Chapter 4 for more information.

✔ **Basic camera options:** Make sure that the day and time settings are correct. Ensure that fundamental photo options are set, such as the file format you want to use, filenaming conventions, photo quality, auto ISO, and review time. You may benefit from resetting all the camera options. Check the menu to see if you can do that automatically. Alternatively, you might have a basic setup stored in a custom shooting or memory mode.

Some people use a checklist to return all camera settings to their defaults, or to return to a personal default. If that's you, take notes of your favorite settings and return them to their proper position now.

✔ **Camera bag and its goodies:** Check your camera bag to make sure that you have all the items you need. For me, that includes one or more camera bodies, lenses, extra batteries and memory cards, external flash unit, extra batteries for that, flash accessories, something to clean my lenses with, reading glasses, a remote shutter release, filters, my cellphone, business cards, model release forms, and my white balance tool. White balance is covered later in this chapter.

At times I carry different tripod heads (ball, pan, or panorama) and my tripod or monopod, and I occasionally pack bug spray, kneepads, waterproof boots, extra socks, a rain cover for the camera, and a tub to put wet boots in.

Attach to the camera body the lens you plan to use now. That's one way to minimize the amount of dust and debris that can get into your camera on location. If the lens doesn't fit in your bag, don't put it on the camera. Rather, put a body cover on the camera and carry the lens in another compartment or in a separate carrying case.

Setting Up

When you have your gear and you're on the scene, follow these steps to prepare yourself to take pictures with your dSLR:

1. **Unpack your camera.**

 Yes, it's tough taking photos while your camera is still in the bag.

 Don't unpack everything and spread it around on the ground. Wait until you need something to take it out of the bag.

2. **Attach or swap the lens.**

 Either attach your lens now or swap out the lens you have mounted for the one you want to use. Don't forget to keep track of the rear lens cap. See Step 5 in this list for pointers on cap tracking.

3. **Now is a good time to mount the camera on your tripod or monopod.**

 You can choose to perform this much step later if you like. Some people prefer to have the camera secured before they dial in all the settings.

4. **Turn on your camera. See Figure 5-1.**

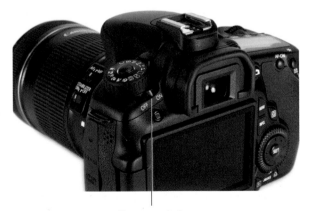

Power switch

Figure 5-1: Must have power.

5. **Remove the lens cap.**

 Be consistent. Pick a place to
 store your lens cap when it's
 unattached, and don't change the
 location. Something like your
 right-front pocket or a particular
 place in the camera bag. You
 won't lose many lens caps this
 way, and you can more quickly
 grab and reattach them if you're
 always taking caps from the same
 place.

6. **(Optional) Attach an external
 flash and turn it on. See
 Figure 5-2.**

 You won't need to complete
 this step if you're shooting
 landscapes or sunsets. For other
 shots (portraits, still life, casual
 photography indoors), this step
 can be important. You may
 always rely on your camera's
 built-in flash, if it has one.

Figure 5-2: External flash. Check!

7. **(Optional) Attach the remote shutter release.**

 Keep the cord out of the way, unless it's a wireless remote.

8. **Cross-check and prepare for departure.**

 Make sure your tray tables are stowed and your seat is in the upright
 and locked position. Then prepare the camera to make exposure
 decisions, and shoot some pictures. See Figure 5-3.

 Quickly run through this list to make sure that your camera is working
 and set up properly:

 - *Power:* Make sure that your camera and its flash are turned on.

 - *Physical damage:* If you haven't inspected your camera, lens, and
 flash for physical damage, do so now.

 - *Battery level:* Quickly note the battery level to make sure you didn't
 accidentally load a bad battery. Replace it, if necessary.

 - *Exposures remaining:* See if you're starting out with an empty memory
 card (like you should be). If not, you might swap out or format the
 card, if you are absolutely positive that you downloaded the photos.

- *Knobs and buttons:* Make sure that all knobs and switches are set to their default settings (even if they're *your* defaults).

- *Lenses:* Speaking of which, check any switches on the lens. Check for things like VR/IS (vibration reduction), auto versus manual focus, focus range, and macro.

Current mode

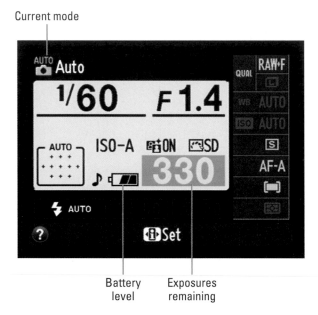

Battery
level

Exposures
remaining

Figure 5-3: Check to make sure everything is in the right ballpark.

Choosing a Shooting Mode

After you set up, it's time to decide on a shooting mode. What you decide affects how much control you can exert over the camera, and to what purpose. There isn't a wrong choice here. Some people prefer to let the camera handle most of the work. Others prefer exercising more creative control. Choose a mode from the following options.

Option 1: Selecting point-and-shoot

Automatic shooting modes are fantastic helpers. The camera takes most of the load off your shoulders and lets you concentrate on framing up the shot and having fun. Whether you're more experienced or just beginning, I encourage you to try out your camera's automatic modes, including scenes.

Most automatic modes are right on the camera's mode dial, as shown in Figure 5-4. Simply dial them in and start shooting. Here's a rundown of the types of automatic modes you might run across:

- **Basic Auto:** This mode probably needs the least explanation. You point the camera. You press the shutter button halfway to focus, and then press the shutter button down fully to take the photo. The camera does the rest. Simple.

- **Flash Off:** This mode is Auto without the flash. It may even be called Auto (Flash Off) on your camera. Easy. Use it when you want to be in Auto and want to keep the flash from firing.

- **Advanced Auto:** Several cameras have advanced auto modes that are smarter than basic Auto. Sony calls theirs Auto+. Canon cameras may have a Scene Intelligent Auto mode. The camera senses the shooting conditions, not simply the exposure, and sets up the camera as you take the photo.

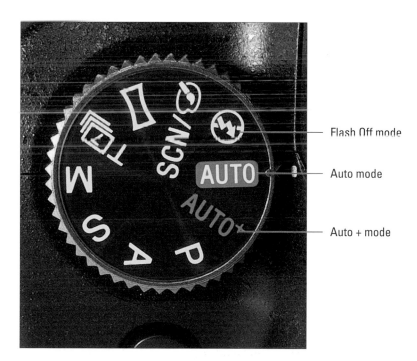

Flash Off mode

Auto mode

Auto + mode

Figure 5-4: The main Auto modes are usually tinted.

Ego is the number-one reason people bypass an Auto setting in favor of something more complicated. That's a shame, because no matter how smart or technically driven you are, it can be fun to just take pictures. Figure 5-5 shows a typical Auto mode display.

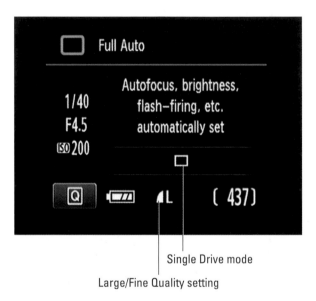

Single Drive mode

Large/Fine Quality setting

Figure 5-5: In this Auto mode, most options are set for you.

Option 2: Guided creativity

This section features different modes that share an important feature: They help guide your creativity. You don't have to do a lot of camera-wrangling when using these modes.

These modes are often located on the mode dial, but you may have to make several selections or choices before you can start shooting.

Guided/Creative Auto

Guided Auto and Creative Auto modes are automatic, but give you several options for how the photos should turn out. New Nikon cameras have a Guide mode that walks you through a series of situations (similar to scenes) or goals (soft backgrounds and the like) to get to the right camera setup; this mode is highly interactive — not hands-off like a standard Auto mode at all. Canon's equivalent is the Creative Auto mode. It's less interactive than Nikon's Guide mode, but has some of the same goal-driven choices.

Scenes

Basic automatic modes have a significant drawback: The cameras doesn't know what you're photographing. You could be taking a photo of a running child or a potted plant and the camera may not be able to tell the difference.

Scenes — often represented on the Mode dial by small symbols — are different. You can see some of the symbols in Figure 5-6. They can be small, which means you may need to refer to your camera manual to decode them the first few times.

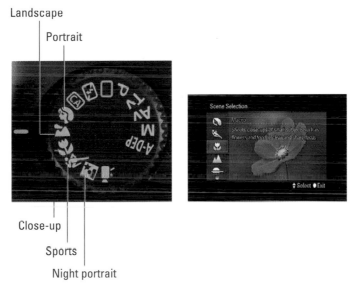

Landscape

Portrait

Close-up

Sports

Night portrait

Figure 5-6: Scenes are often packed onto the mode dial. Sometimes you select scenes from a menu.

Some cameras have a Scene mode position on the mode dial. Select this mode on the dial and then choose a specific scene from the camera display.

Here's a menu that represents many of the scenes you have to choose from:

- ✔ **Portrait:** Take photos with nicely blurred backgrounds and sharp subjects, as shown in Figure 5-7.
- ✔ **Landscape:** Scenic scenes full of scenery, processed to make the colors stand out. Use Landscape mode to photograph cityscapes as well as traditional shots of nature.

✔ **Macro/Close-up:** A close-up.

✔ **Sports Action:** Optimized to photograph moving subjects with a fast shutter speed, as shown in Figure 5-8. You can also use Sports Action when *you're* moving.

✔ **Child:** A cross between action and portrait. Use when photographing children.

✔ **Sunset:** You got it. This scene is ideal when photographing sunsets. It brings out the red, orange, and yellow colors well.

✔ **Night View:** Think landscape at night with city lights. The point is to leave the scene dark but have something bright in the scene to see.

✔ **Handheld Night/Twilight:** Shooting at night without a tripod.

✔ **Night Portrait:** Shoot portraits in the dark.

Specialty modes

Sony cameras have a few specialty modes that deserve consideration:

✔ **Sweep Panorama:** Instead of manually photographing several frames of a panorama and then using software to stitch them together (so they look like a single, large photo), Sweep Panorama handles everything. All you do is point, shoot, and pan. A finished photo is shown in Figure 5-9. Sony also has a special 3D Sweep Panorama mode, which saves the panorama in two files: a standard JPEG and a 3D data file.

Figure 5-7: A classic outdoor portrait with soft background.

Figure 5-8: A classic sports shot freezing the action mid-dribble.

Sweep panoramas are unique to Sony and saved as JPEGs only. You can't get raw files. Individual frames from the panorama aren't saved.

Figure 5-9: American farmland panorama.

- **Continuous Advance Priority AE:** This Sony-only mode sets the camera up to rattle off photos as fast as possible. It's great for sports, but also when someone's opening a present or blowing out the candles. Photograph pets or children as they play.

Other cameras have these types of specialty modes:

- **HDR/Dynamic Range:** When shooting a high-contrast scene, see if your camera has a special mode to capture more of it than you can with a single photo. *High dynamic range (HDR)* modes combine auto exposure bracketing and processing to produce a finished photo. Book V, Chapter 4 has more information on shooting HDR images from scratch.

- **Multiple exposures:** Shooting multiple exposures is a creative trip. It's fun and might just break you out of a shooting rut. The real challenge is experimenting with different scenes to come up with something that effectively takes advantage of merging multiple exposures together. Figure 5-10 is an example of a dual exposure shot using the Canon 5D Mark III.

Figure 5-10: Creative use of multiple exposures.

Option 3: Using the classic creative modes

Three classic creative modes are shown on a mode dial in Figure 5-11. They all evaluate the exposure automatically. The main decision you're left with is what aperture and shutter speed to use. Although classic modes allow you control over most of the camera's features (metering, white balance, drive, and so on), they aren't that difficult to use.

Aperture priority mode

Shutter priority mode

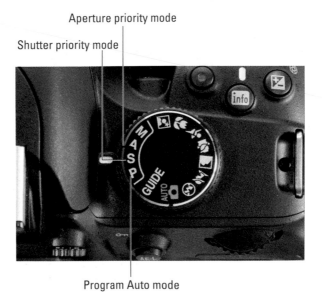

Program Auto mode

Figure 5-11: Classic creative modes are P, A, and S.

The modes follow:

✐ **Program Auto (P):** Also known as Programmed Auto or Program AE (for autoexposure). Program Auto is like Auto mode, but you have much more control over the camera. The camera is set on automatic exposure and selects an aperture and shutter speed combination that it thinks is best. It can be as easy as point and shoot, but you can set up the camera with the options you want (metering, drive mode, white balance, and so on).

Most cameras have modes called either Program Shift or Flexible Program mode. This mode let you choose a combination of shutter speed and aperture that will work for the conditions. Use it if you have a particular aperture or shutter speed you want to use to achieve a depth of field (for aperture) or to freeze action (for shutter speed). This enables you to have more creative input. Program Auto is great for snapshots. Figure 5-12 shows a camera display in Program mode.

✐ **Aperture priority (A):** Also known as Aperture-priority auto or Aperture-priority AE (Av). In Aperture priority mode, you set the aperture and the camera determines the other settings needed to arrive at the proper exposure. This mode is good for portraits, landscapes, and close-ups. Anytime you need to control the depth of field. Aside from autoexposure, you have total control over the camera. Figure 5-12 shows a camera display in Aperture priority mode.

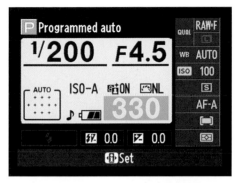

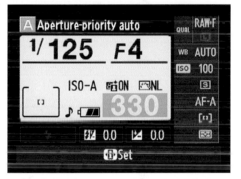

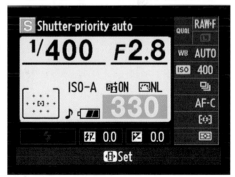

Figure 5-12: Top: Programmed Auto screen with typical options. Center: Setting you might see in Aperture priority mode. Bottom: A Shutter priority shooting screen.

✔ **Shutter priority (S):** Also known as Shutter-priority auto or Shutter-priority AE (Tv). The same as aperture priority, only you set the shutter speed instead of the aperture. Good for sports, action, and when you are moving. Use this mode when you need precise control over the shutter speed. Aside from autoexposure, you have total control over the camera. Figure 5-12 shows a camera display in Shutter-priority mode.

Option 4: Going full manual

Switch to Manual mode when you want full control of the camera. What does this mean (and what *doesn't* it mean)? You can exercise as much or as little control as you want. It doesn't mean that you're starting from a blank slate and must set up the camera as if it just came off the assembly line.

For example, you can use the camera's exposure meter for guidance if you want, or ignore it. Likewise, you can make specific white balance choices or leave the white balance setting on auto.

You have two manual modes, which are shown on a mode dial in Figure 5-13:

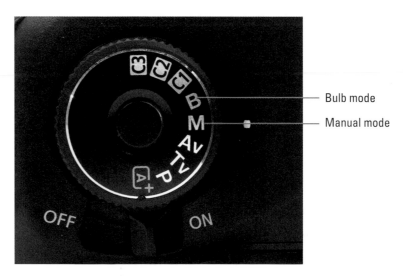

Bulb mode

Manual mode

Figure 5-13: Manual is always M; Bulb (B) may or may not be on the dial.

✔ **Manual:** This is the Manual mode where you control everything. Generally, Auto ISO isn't available in Manual mode. Manual mode is shown on a camera display in Figure 5-14.

✔ **Bulb:** Bulb mode is a special type of Manual mode. When you select it, there is no shutter speed. You are in control of when the shutter opens and when it closes. If your mode dial doesn't have a B setting, try entering Manual mode and lengthening the shutter speed until it reads B (Bulb). A camera in Bulb shooting mode is shown in Figure 5-14.

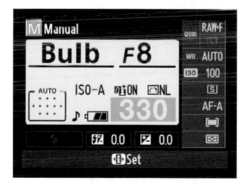

Figure 5-14: In Manual mode you can set things yourself. In Bulb mode the shutter duration is up to you.

Fine-Tuning Your Camera

After you gather everything you need for a shoot and make sure it's working, get down to some serious photography business. (Don't worry: It's fun, too!)

To fine-tune your camera and prepare to shoot, follow these steps:

1. **Set the shooting mode.**

 For tips on what mode to choose, see the section preceding this one in this chapter. Decide on mode based on your camera, experience, location, environment, creative goals, and subject.

 The decision you make now affects the rest of the checklist. If you choose a more automated mode, you don't have to do certain tasks, such as setting the exposure controls. On the other hand, if you're more inclined to shoot manually, you'll be *required* to make those settings. Not all cameras have all the same shooting modes.

 In all except Manual mode, you don't need to worry about setting the correct exposure yourself. The camera does it for you. If it can't reach the correct exposure for some reason (if it can't set the shutter speed fast enough or widen the aperture, for example), it might beep at you to get your attention. Some cameras flash the shutter speed or f-stop display.

2. **Confirm shooting options.**

 Double-check settings for image quality (see Figure 5-15), color space, noise reduction, red-eye reduction, image review, creative styles, and so forth. Your specific checklist depends on your camera.

 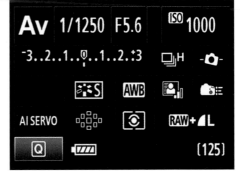

 Figure 5-15: The Canon Quick Control screen showing all the important shooting options.

 - Canon users should check Picture Style, Auto Lighting Optimizer, Creative Filters, and the like.

 - Nikon users should look at Picture Control, Auto Distortion Control, Active D-Lighting, and so forth.

 - Sony users should check settings like Creative Style, Picture Effect, and D-Range Optimizer.

These options are dependent on the shooting mode you're in. The more automatic modes keep you from changing certain settings.

3. **Choose Live view or Viewfinder mode.**

- *Live view:* If you prefer to frame and compose shots using the LCD monitor, switch to Live view, as shown in Figure 5-16. To make this choice, you may need to use the menu, press a button, or move a switch. If you have an articulated LCD monitor, swing it out to an appropriate position.

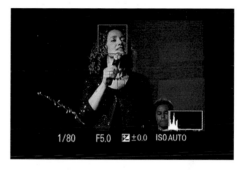

 Live view works great in the studio, where you can mount your

Figure 5-16: A typical Live view display with histogram.

 camera on a tripod and take the time to precisely compose the scene and focus. Live view, especially in tandem with an articulated monitor, makes it far easier to shoot in some funky positions where the viewfinder is inconvenient. You can hold the camera over your head and shoot over things, or hold it down without having to lay down on the ground. Be prepared to turn up your monitor brightness when using Live view outside in bright daylight. Look in your camera's menu system (see Book I, Chapter 3 for more information on menus) for Live view settings.

- *Viewfinder:* The optical viewfinder is the classic way to compose and take photos, as shown in Figure 5-17. I like it for most situations because it pulls my attention into the scene and keeps it there with minimal distractions.

3. **Configure the display.**

Cycle through the display options until you see the setting you want. Here are some potential options:

- *Shooting information:* When not in Live view, you can often configure the shooting information that appears on the back of the camera. When you're in Live view, you should be able to toggle between minimal and maximum amounts of information shown on the monitor, as shown in Figure 5-18.

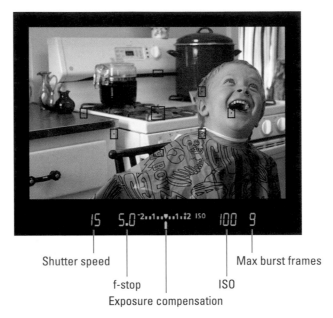

Shutter speed

f-stop

Exposure compensation

ISO

Max burst frames

Figure 5-17: Use your optical viewfinder for the classic photography experience.

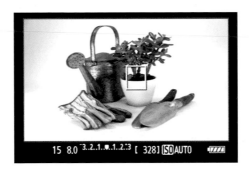

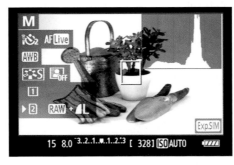

Figure 5-18: Displays run from minimal to crowded.

- *Histogram:* Decide whether you want a live histogram on or off.

- *Grid:* Set up viewfinder or Live view grid.

- *Electronic level:* Turn on the electronic level (see Figure 5-19), if your camera has one, to even things out.

Level in both directions

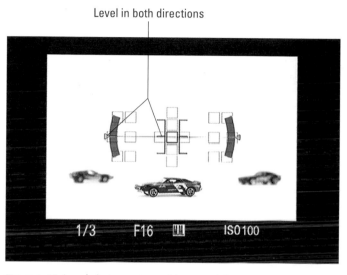

Figure 5-19. Levels help you keep things straight.

4. **Set up the flash.**

 If you're in a mode that allows you to set up the flash.

 - If you're using the camera's built-in flash, open it. For more information on setting up and using a pop-up flash, or using a flash, please refer to Book IV. I'll wait for you here.

 - If you're using an external flash, make sure it's mounted and turned on.

 - Attach any flash modifiers, such as a diffuser.

 - Set the flash type you want to use: Slow Sync, Red-Eye Reduction, or Rear-Curtain Sync. Use your experience as a guide, or take a few test shots and compare. Don't forget about using flash compensation or controlling the flash's output manually in certain situations.

5. **Set the drive (also called *release*) mode.**

 Set the drive mode (see Figure 5-20) to match the type of shooting you're doing. Not all cameras have two continuous shooting modes.

TIP

- *Single shot:* Take one shot at a time (also known as *single-frame* shooting). Use this deliberate mode whenever you want to avoid inadvertently shooting extra pictures because you released the shutter button or the remote too slowly.

- *Low-speed continuous (*a.k.a. *sequential):* This mode, which is a little easier to control than high-speed continuous, shoots as long

Figure 5-20: Setting the drive (release) mode on the Nikon D3200.

as you hold down the shutter button, but it doesn't get quite out of hand. In other words, it shoots continuously but at a fairly leisurely pace. Choose this mode when you want to capture several shots in sequence. Depending on the subject and whether you're trying to capture the perfect moment, you may have to switch to high-speed continuous.

- *High-speed continuous (*a.k.a. *sequential):* Faster is better! In this mode, photos fire super fast for as long as you hold down the shutter button. This mode is perfect for capturing fleeting moments or brief slices of action; it also works well when you're auto bracketing a scene for HDR. See Book VI, Chapter 4 for more on that.

6. **Choose a focus mode.**

- *AF:* Most people prefer to autofocus. If you do, choose an AF point selection method (manual or automatic) and AF mode (single versus continuous). Please refer to Book IV, Chapter 4 for more on setting up your camera's autofocus system.

- *Manual:* If you need to switch to Manual mode, now is a good time.

7. **Set the metering mode.**

Your camera should have at least two metering modes, and may have more. In brief, you'll find some form of Pattern mode (evaluates the entire frame), Center-Weighted, or Spot. Check your camera for specific metering modes. I go into more metering detail in Book III, Chapter 5.

8. **Set the white balance.**

Digital cameras need to be told a light's temperature so they can identify white and assign the correct colors when recording photos. Sunlight has a different effect on colors than shade, for example, as do different types of man-made lighting.

When white balance is set correctly, you won't even notice it. The photo will look good and that's that. Even when white balance isn't precisely set, it may not be a problem. When white balance is completely wrong, the photo will have a strong, unnatural color cast to it.

However important, don't confuse a good white balance setting with reality. I noticed this effect when sitting in church one day. I could see the pastor and a live video display of him at the same time. He was in warm light and had a glow to his shirt and skin. That was a color cast. The video, whose white balance had been set to counteract the color of the light, reproduced him without the color cast. As a result, the video was cooler (literally, not figuratively) than he actually was. It looked nice, but wasn't a totally accurate depiction of the scene. Don't obsess over it now, but remember this when processing your photos.

You have two main options: Leave white balance on its automatic setting or set it to a known quantity. Typical presets are described in this list (and seen in Figure 5-21). Depending on the camera, you may have more settings to select:

Figure 5-21: Setting the white balance to a specific color temperature.

- *Auto:* The camera figures out the conditions and sets a color temperature. This setting works well outdoors and when you're using a flash, but not so well indoors without a flash.

Auto isn't foolproof. The camera can get it wrong. When working with raw files, you can reset the white balance as if nothing ever happened, without any loss of image quality. This is one of the best reasons to shoot raw photos.

- *Direct sun:* Use this white balance setting whenever you're outdoors in the sunlight.

- *Flash:* When you're using flash, choose this setting.

- *Cloudy:* Use this setting on cloudy days.

- *Shade:* The Shade setting is used differently from the Cloudy setting.

- *Tungsten lights:* Use it when you're indoors, working with normal "old-fashioned" light bulbs with a tungsten filament in them.

- *Fluorescent lighting:* You may have a few options for fluorescent lights. For example, higher-level Nikon cameras offer Sodium-Vapor

Lamps, Warm-White Fluorescent, White Fluorescent, Cool-White Fluorescent, Day White Fluorescent, Daylight Fluorescent, and High-Temp Mercury-Vapor.

- *Custom/Set temperature:* Set the color temperature manually, in (geekazoid alert) degrees Kelvin.

Set the white balance based on where your subject is. If that person is in the shade and you're in the sunlight, set the white balance to shade. For landscapes, set it to the overall conditions (sun or cloudy, for example). For mixed lighting, do your best or leave it on Auto.

9. **Set the ISO.**

Use the lowest ISO you can. You'll get less *noise* (graininess). You may need to raise the ISO if you can't open the aperture on the lens any more than it is and need a fast shutter speed.

Whenever necessary, set your camera to Auto ISO and specify a maximum ISO for your camera. I cover ISO in much more depth in Book III, Chapter 3.

10. **Specify or check bracket settings.**

Set the number of brackets and any other parameters now. You may be able to shoot either white balance brackets or auto exposure brackets (AEB). Some cameras shoot other types of brackets. The Sony A77, for instance, has a special Dynamic Range Optimizer bracketing mode. For more information on brackets and HDR, please see Book V, Chapter 4.

11. **(Optional) Choose the Mirror Lockup or Mirror Up setting.**

This setting reduces camera shake. You don't need this feature unless you're using a tripod or another type of support and want the most stable, shake-free shot possible. On some cameras, you'll get a mirror lockup indicated on the camera display or top LCD panel, as shown in Figure 5-22.

Maximizing productivity

You don't have to complete a 57-point checklist before you take every photo. The process goes much faster when you start taking photos. If your subject remains the same and the lighting is consistent, you won't have to make drastic setting changes.

That assumes things are going well. Problem-solving is the task that slows you down. In that case you need to relax, focus on the problem, and find the solution. For instance, if you're taking action shots and the photos are a bit blurry, the problem may be that you don't have the shutter speed set fast enough. Reset it and try some more.

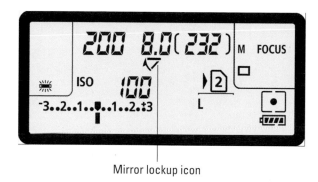

Mirror lockup icon

Figure 5-22: Notice the mirror lockup indicator on this top LCD panel.

Don't forget to revert to normal mirror operation when you finish. I've used mirror delay and forgotten about it, and then wondered why a delay occurred between the time I pressed the shutter button and when the camera took the photo the next time I went out. After four or five shots, I usually remember that I left the Mirror Delay setting on.

Snapping Pictures

Are you ready to take photos? I bet! Follow these steps:

1. **Press the shutter button halfway to focus and meter.**

 Press the shutter button halfway to initiate metering and establish autofocus. Don't stab at the button — press it smoothly. Practice a bit to know what halfway feels like, and how much more pressure causes the camera to take a photo. If you're focusing manually, use the focus ring.

 * If necessary, change focusing modes or focus points if you're using autofocus and there is a problem. If shooting manually, dial in your final exposure now.

 * If you're using AE lock, make sure to center your subject and press the AE lock button.

 If you use a remote shutter release, it will feel different than the camera. Know your equipment and what to expect.

 * If you're in Live view mode, focus according to the procedures for your camera. That may involve moving a focusing frame over the subject you want to be in focus. You may also be able to zoom in and check manual focus very precisely.

- If you're in another shooting mode and want to, enter exposure correction now.

Shutter button

Figure 5-23: Press halfway to meter and autofocus.

2. **Compose the scene.**

Look through the viewfinder or at the LCD screen and frame the scene. Remember to focus before this step. Otherwise, you'll be looking at blobs and vague shapes. You want to see what you're seeing, even if you have to refocus after. If you have a zoom lens, use the ring to zoom in or out. If not, physically move toward or away from your subject.

When shooting certain types of shots (animals, people, or everyday items), this step may only take a moment. When you're setting up a portrait or shooting macros in a studio, you'll spend more time perfecting the scene.

3. **Reality check.**

Check focus indicators, exposure settings and, if possible, depth of field. See Figure 5-24.

4. **Press the shutter button fully to take the photo.**

If you released the shutter button earlier, press it halfway again to focus and meter. Hold the shutter button there until the shot's focused, and then press it fully to take the shot.

5. **Review the photo.**

Although you may not need to review every photo, you should review sample shots in a photo shoot to make sure you're not wasting your time. Figure 5-25 shows the final shot.

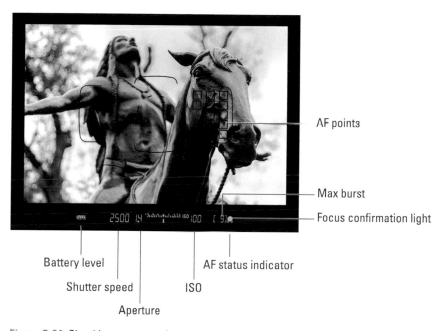

AF points

Max burst

Focus confirmation light

Battery level

Shutter speed

Aperture

ISO

AF status indicator

Figure 5-24: Checking exposure, focus, and composition before shooting.

Figure 5-25: Appeal to the Great Spirit, installed in
Woodward Park in Tulsa, Oklahoma.

Check to see that photos are in focus, well-lit, and framed the way you
want them to be. If necessary, use the zoom in or zoom out buttons to
look closely at the photo, and the left, right, up, or down buttons to pan.
This is also a good time to look at the histogram.

6. **Correct problems.**

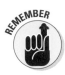

Correcting problems is an important step. If you identify problems when you review a shot, make the changes (if possible) to correct them.

You're looking to solve these general issues:

- *Composition:* Level, even, as planned.

- *Exposure:* Good, with details, or as intended.

- *Focus:* Sharp most often, unless you're after a blur.

- *Subject-related:* Eyes are open, looking at the camera.

7. **Rinse and repeat.**

Depending on how successful the shot was, you may jump back to a different step in the overall process. If you have to make dramatic changes to your setup, see the earlier section "Setting Up." If you're only recomposing or shooting the same basic subject, start again at the beginning of this section.

Book II
Going Through the Looking Glass

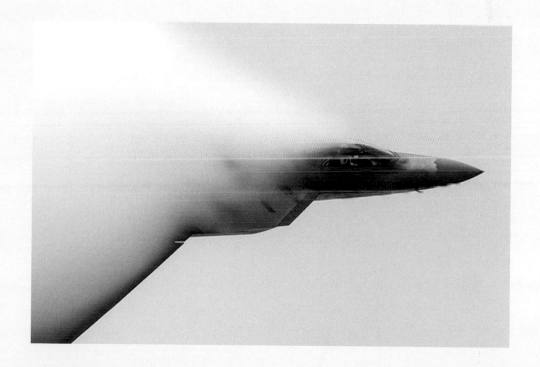

Contents at a Glance

Chapter 1: Focusing on Versatility

In This Chapter

✔ **Examining zoom lenses and alternatives**

✔ **Shooting wide angles**

✔ **Zooming in for telephoto shots**

✔ **Having fun with close-ups**

*I*f you're like me, the first digital SLR/SLT lens you'll shoot with is something called a *normal* or *standard zoom lens.* These lenses are so useful that they come with the camera when you buy the *kit,* which includes everything you need to get started.

What separates standard zoom lenses from other types of lenses (such as prime lenses or specialty lenses like macros) is their versatility. You can shoot anything from wide-angle landscapes up to "near" telephoto shots with most normal zoom lenses by twisting the zoom ring.

This chapter, then, is devoted to showing you what these lenses can do. I take you through a series of photos shot with zoom lenses at different focal lengths. I have everything from a blimp to a field, flowers to a cat, some landscapes and some portraits. There's not a lot you *can't* do with zoom lenses! (I took the shots in this chapter on a variety of cameras, from entry-level models up to and including a full-frame professional dSLR worth $3,500. The lenses ranged from inexpensive kit lenses that cost under $200 to a pro-level zoom that costs almost $2,000.)

Zooming In on Lenses

A *standard zoom* lens, also known as a *multipurpose zoom, zoom, normal zoom,* or *general-purpose zoom* lens, is designed to be — above all else — versatile. You can tell just by the name.

Standard zoom lenses are versatile for two reasons: They can zoom in and out a good amount, and they cover the focal length sweet spot that you need most of the time. This includes between 18–70mm for cropped-frame cameras and 24–105mm for full-frame cameras. The following list explains what you get for that.

- **Wide angle:** Wide-angle focal lengths are anything less than the diagonal size of your camera's sensor. Traditionally, this includes anything up to around 24mm for APS-C and 35mm for full-frame cameras. Your general-purpose zoom lens should easily cover several millimeters of wide-angle territory.

- **Normal:** Normal focal lengths are around the same diagonal size as your camera's sensor, give or take a small range. This includes the focal lengths of 26–35mm for APS-C and 40–60mm for full-frame cameras.

- **Near telephoto:** Near-telephoto focal lengths are greater than the diagonal size of the camera's sensor, but don't get large enough to be considered true telephoto. This includes focal lengths of 35–70mm for APS-C and 60–105mm for full-frame cameras.

You may not always be able to find a good spot to take photos. Having a zoom lens means that you can get those shots and many others without a hassle.

In the sections that follow, I use the focal length ranges given earlier, plus a close-up category, to organize the different photos. I list the APS-C focal length followed by a slash, then the full-frame equivalent (using a crop factor of 1.5, which may be slightly different than your camera). For example, 16mm/24mm indicates the photo was taken with an angle of view corresponding to 16mm on a cropped-frame APS-C camera or 24mm on a full-frame camera. This can be somewhat confusing, especially when discussing lenses. An 18–55mm lens on a cropped-frame body takes photos with an *entirely different angle of view* than the same lens on a full-frame body.

Standard zoom lenses come in all price ranges. Most kit lenses are relatively inexpensive. Manufactures try to keep costs down when bundling the camera and lens together. There are also mid-level zoom lenses and professional models. Pro-level lenses, like that shown in Figure 1-1 (AF-S NIKKOR 24–70mm f/2.8G ED), are better in every way except price. They have better optical qualities and construction, can stand the rigors of shooting without breaking as easily, and take outstanding photos.

Figure 1-1: A professional-level normal zoom lens.

There are other zoom lenses, of course. Some cover wide-angle or telephoto territory exclusively. Others cover a wider range of focal lengths than standard zoom lenses. They're summarized in the following section.

Branching Out to Different Lenses

Zoom lenses aren't the only type out there. While this chapter focuses in on them, you should know how they differ from the others. Here are some of the alternatives to zoom lenses in general and standard zoom lenses in particular.

Prime lenses

A *prime lens* has a fixed focal length. A lens with a *fixed focal length* can't zoom in or out. Its magnification level is fixed from the day you buy it until your grandkids sell it on eBay.

The thing with prime lenses is that you have to buy the lens that matches the focal length you most use or like the best. When you compose your shots, you have to physically move closer or further away to zoom in and out.

Prime lenses specialize. Everything is optimized for the lens to produce the best photos at its focal length. The downside to prime lenses is the major

reason why general zoom lenses are so popular: People get tired of being limited to a single focal length and the time it takes to swap lenses when you want to change it.

Wide-angle zoom

A *wide-angle zoom lens* zooms in and out, just as a general-purpose zoom lens does, but a wide-angle zoom lens has a focal length range that's limited to wide-angle territory (under 24mm APS-C and 35mm for full-frame).

There is some focal length overlap between most wide-angle zoom lenses and general-purpose zoom lenses. The wide-angle variety will extend deeper into the wide angles, however. *Ultra wide-angle lenses* give you much more coverage than standard zoom lenses.

Wide-angle zoom lenses are great at what they do, but you have to want to shoot a lot of wide-angle shots for it to be worth it.

Telephoto zoom

These lenses work similarly to wide-angle zooms, but with a different area of expertise: telephoto zoom. Generally speaking, a *telephoto zoom lens* overlaps some focal lengths that general-purpose zoom lenses cover, but they extend well into telephoto territory. There is a lot of variety between telephoto zooms, both in the starting and ending focal lengths. Starting focal lengths tend to be in the 50–70mm range, but some begin in wide-angle territory. Ending focal lengths tend to be between 200 and 300mm.

Other specialty lenses

Other specialty lenses offer creative and artistic uses:

- ✔ *Macro* lenses specialize in taking photos of close objects with a reproduction ratio close to 1:1. Most macro lenses are primes.

- ✔ *LensBaby* lenses are untraditional. They come in different types that have different creative effects. Experiment with different focus effects and qualities. These lenses are incredibly fun to play with.

- ✔ *Holga* cameras are cheap plastic film cameras that have quite a large following. They create very distinctive photos. Now you can mount a plastic Holga lens right on your dSLR. Very cool. I love mine.

✔ *Diana+* are similar to Holga lenses, but have much more zoom. For example, the fisheye lens acts like a standard lens on a dSLR. Diana+ lenses require an adapter. Once you have that, you're good to go.

✔ *Tilt-shift* change the orientation of the focal plane. Normally, it's perpendicular to the camera. Tilting the lens allows you to angle or flatten it. Shifting displaces the lens in the direction of the shift, allowing you to move the subject's location without moving the camera. The objects you photograph tend to look like toys in a diorama.

✔ *Pinhole* lenses are something you can easily make out of an extra body cap. (Just search online for **making pinhole camera**.) They have no glass. The pinhole lets light into the camera and doesn't focus. The aperture is so small and the depth of field is large enough that you don't have to worry about focus. Expect longer exposure time. Pinhole cameras create soft, dreamy photos.

You might have noticed that I have praised every type of lens I have described. That's right! I love them all. Each serves a purpose. Your challenge as a photographer (well, one of many) is to find the lens that suits *your* purpose. You will find that standard zoom lenses are so versatile, though, that they'll meet most of your photography needs most of the time. That's what they were designed to do.

Taking Wide-Angle Shots

Wide-angle photography captures a greater angle of view than normal. Sometimes you perceive it as being very expansive. At other times, you hardly notice it. It all depends on the focal length you're using.

Figure 1-2 shows a river scene that I took with a full-frame camera at 24mm. If I'd been using an APS-C camera, the same angle of view would require the lens to be set at 16mm. (Cropped-frame cameras "magnify" scenes compared to full-frame cameras due to their smaller sensor.) The scene is wide-angle, but not in the extreme.

When shooting landscapes, you will typically want to zoom out and take advantage of wide angles. In this case, the breadth of the river required it. I chose this approach instead of trying to zoom in and capture the bridge closer. This approach also gives the photo depth. The river has some breathing room after it passes under the bridge and reaches the viewer's vantage point.

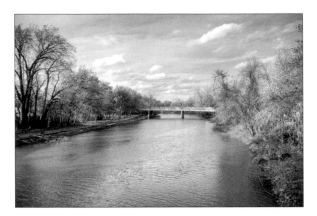

Figure 1-2: This river runs through it.

Figure 1-3 shows a different type of wide-angle shot. This time I held the camera vertically and the main subject extends far afield. The focal length is 18mm/27mm. This photo conveys not width but height and depth. There's plenty of room for the corn, the far tree line, and the sky. You can almost see forever. Had I zoomed in on this scene, it would limit either the sky or the field. That might not be a bad photo, but there'd be less room for both. I like it this way.

Don't think that you always need a super, over-the-top, wide-angle lens. If you like, you can take several shots with your kit lens set to the wider angles and create panoramas.

Not all wide-angle shots are landscapes. In Figure 1-4, I was standing behind a protective fence, photographing my youngest son running towards home plate. The focal length was 18mm/27mm. This shot has a number of wonderful elements. Sam, the coaches, the other kids, the ball in the air, and the scenery all capture the essence of the action as it was happening. Although action shots are generally better with zoomed-in telephoto focal lengths, some — such as this one — work.

If you want to tell more of a story, take some wide shots of the field, park, or court. When you're close enough, you can include action.

Figure 1-3: Corn as far as the eye can see.

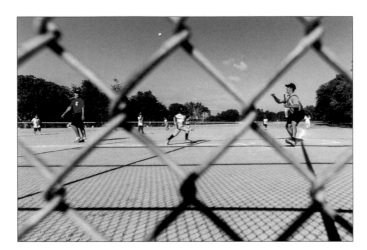

Figure 1-4: Run, Sam!

Using Normal Focal Lengths

Normal focal lengths (those about the same as the diagonal measurement of your sensor) are the bread and butter of photography. They look "normal." Figure 1-5 shows a portrait of my daughter, Grace, wearing her brother's football helmet. We were out in the backyard practicing Lambeau Leaps onto our play equipment. This photo was taken at 30mm/45mm.

Figure 1-5 was a casual, spur-of-the-moment shot. Having a zoom lens gave me the flexibility to quickly choose just how to frame the scene. I didn't have to move closer or farther away — I simply gave the lens a twist and took the photo.

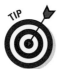

When you can, zoom in to minimize the background. Zooming out in this case would have included more background, which frankly would have made the photo much less interesting.

Figure 1-6 shows an entirely different scene, shot at 40mm/60mm. I was testing the lens at a local park during the evening Golden Hour. The light was striking the flowers from the side, producing amazing scenes.

Figure 1-5: She's ready to leap. Watch out, Lambeau.

In this scene, I wanted a lot of flowers. Therefore, I didn't zoom in. That would result in a single-flower study. Not a bad thing, but not what I wanted. If I had zoomed out you would see too much background. I wanted the flowers, and not a bunch of other stuff.

Figure 1-6: There was no tip-toeing.

Keep these things in mind when using a standard zoom lens to shoot normal focal lengths:

- **It's easy:** Using a general purpose zoom lens is easy. You walk around, point your camera at things you see, zoom to frame the shot you want, and then snap the picture. Having a zoom lens lets you flexibly frame subjects, whether they're rivers, people, or flowers, at different distances.

- **Everyday use:** Normal focal lengths are perfect for everyday photography.

- **Normal look:** These focal lengths produce the most normal-looking photos. Use them when you want a classic 35mm feel to your shots.

- **Less distortion:** Normal focal lengths tend to produce photos with less distortion than wide-angle focal lengths.

- **Use the vertical:** Hold the camera vertically at times, even when using normal focal lengths.

Zooming In

Telephoto photography is when you zoom in on a subject from far away. How much you can zoom in depends on your lens, of course. Some kit lenses extend to 70mm/105mm or even more.

When zooming in, consider these points:

- **Shutter speed:** The more you zoom in, the harder it is to take sharp photos. Camera shake becomes more of a problem. Increase the shutter speed to keep things from getting blurry.

- **Portraits:** Taking shots of people in the near-telephoto range of your standard zoom lens can result in very effective portraits.

- **Distance matters:** Using the telephoto focal lengths of a standard zoom lens at close range (often inside) will produce very tight shots. When outside or shooting something farther away, the same focal lengths will produce very different results.

Picture this: One day my family and I heard an odd sound coming from outside. We all ran out the front door (there are six of us, so that is an event in and of itself) to see what it was. Lo and behold, it was *the Goodyear Blimp*! I ran back into the house and grabbed the camera. Thankfully, the lens I was using had more telephoto capability than most kit lenses, so I zoomed in to 135mm/202mm and captured it before it flew away. See Figure 1-7.

In cases like this, you clearly want as much zoom as you can get out of your kit lens. Having a wealth of megapixels (this was shot with an 18-megapixel camera) also gives you the option of cropping out extra space without compromising the photo's quality if you decide to print it at reasonable sizes.

Figure 1-7: The blimp, the blimp!

Finally, you can use the near telephoto focal lengths on standard zoom lenses for quite effective portraits. Figure 1-8 shows my three boys (Sam, Ben, and Jacob) in costume. I used the zoom ring to frame the shot how I wanted it. The focal length was 45mm/68mm. That doesn't seem like much, but remember, normal focal lengths are approximately the same size as the diagonal size of the camera sensor. For an APS-C camera, that is approximately 28mm. For a full-frame camera, it is 43mm. That's a pretty big difference!

Figure 1-8: My boys.

Capturing Close-ups

Close-up photography is another category that you can pursue very effectively with a standard zoom lens. Keep these guides in mind:

- **Get close:** The focal length that you use is secondary to how close you are to your subject.

- **Prepare for shrinking DOF:** Close-ups have a shallow *depth of field (DOF),* even when you're using a small aperture.

- **Explore mode freedom:** You can use any of your camera's shooting modes with a standard zoom lens, from Auto to completely Manual. In fact, a shot like the one in Figure 1-10 would be a great time to use a close-up or macro scene setting. Book I, Chapter 5 talks more about scenes.

Figure 1-9 is a classic close-up of a flowering tree. I was standing close by, so I didn't need to zoom in all the way to get the shot I wanted. Rather than a single flower, I decided to capture a handful. The focal length for this show is 48mm/72mm.

Figure 1-9: Flowering trees make wonderful close-up subjects.

I think portraits that are shot as close-ups work well. In Figure 1 10, I photographed one of our cats sitting by the window. I used a focal length of 50mm/75mm. The result is that his face and head dominate the frame. He's a beautiful cat! In this case, the focal length of the lens is in the near telephoto range. More importantly, though, is the fact that I am very close to him. It helps that he was distracted and didn't notice me sneaking up on him. The result is a natural, un-posed portrait.

You want a nice, shallow depth of field in a portrait. You can get that by choosing focal lengths in the telephoto range (over 35mm APS-C or 60mm full-frame).

Figure 1-10: He's the cat's meow.

Chapter 2: Casting a Wide-Angle Net

In This Chapter

- Defining wide angle
- Shooting with wide-angle lenses
- Improving your shots
- Going overboard with fisheyes

*W*ho doesn't love to zoom in and take close-ups? But wait. Take a step back for a bigger perspective. This chapter considers the other end of the focal length spectrum, where wide angles are the norm.

The types of photos you can take with wide-angle lenses are different than those you would take using "normal" focal lengths. With wide-angle lenses you can capture sweeping vistas, large cities, buildings, big things, and small things. It's a refreshing change of pace from stalking the cat around the house with a zoom lens! Most standard kit lenses have a wide enough angle of view when zoomed out to get you started on a wide-angle journey. If you like what you see, consider investing in a dedicated wide-angle zoom lens.

Wide-Angle Whatzit

A *wide-angle lens* is a lens whose focal length is greater than the diagonal size of the film the camera uses (or, rather, the sensor). This means that if you're using an APS-C camera whose sensor is roughly 28mm diagonally, any lens with a focal length *less* than 28mm qualifies as wide angle. For full-frame cameras, the focal length needed to reach wide-angle territory is approximately 43mm because their sensors measure 43mm diagonally.

In this chapter, when I list the focal length I used for a particular shot, I list the cropped-frame value first followed by the 35mm equivalent focal length. For example, 10mm/15mm indicates that the shot could be from a 10mm lens on a cropped-frame camera or a 15mm lens on a full-frame model. This assumes an APS-C crop-factor of 1.5. Your camera might be slightly different.

If you've shot with a standard kit lens, you've already been exposed to wide angles — maybe without even realizing it.

- ✓ **Cropped frame:** Most cropped-frame camera kits have lenses that are either 18–55mm or 18–70mm. On an APS-C sensor, you're shooting wide angle on these lenses when you have the focal length set anywhere from 18mm to about 24mm. When you go over 24mm, the focal length is considered normal.

- ✓ **Full frame:** Although full-frame users often buy their cameras *a la carte* (without lenses because they already have them), you may have a kit lens. For example, the Canon 5D Mark III often comes with the EF 24–105mm f/4L IS USM lens, shown in Figure 2-1. The wide-angle end of this lens (when mounted on a full-frame camera) ranges from 24mm to about 40mm.

Figure 2-1: Full-frame cameras have kit lenses for different focal lengths.

When you're deciding whether a focal length is wide angle or not, it's important to consider the camera as well as the lens. For example, 35mm is considered a normal focal length on an APS-C camera, but wide angle on a full-frame camera.

Table 2-1 summarizes the general wide-angle lens categories and their associated angles of view and focal lengths.

Table 2-1	Wide-Angle Lens Categories	
Category	*Description*	*Focal Lengths*
Fisheye	A special wide-angle lens category. Look for lenses specifically labeled *fisheye*.	Focal lengths vary. Angle of view (measured diagonally from opposite corners of the camera sensor) for fisheye lenses is close to 180 degrees. This extreme angle of view (close to a half-circle from left to right) creates the fisheye lens's unique distortion pattern.
Ultra wide-angle	Extreme wide angles, but without the fisheye effect.	Roughly 10–17mm for cropped-frame cameras and 14–26mm for full-frame cameras.
Normal wide-angle	Wide angles with less coverage than ultra wide-angle lenses, but also with less distortion. These focal lengths can often produce very normal looking photos.	Between 18–24mm for cropped-frame cameras and 28–35mm for full-frame cameras.

Wide-Angle Fever: Catch It!

 A wide-angle lens is more versatile than you might think. It excels at shooting sweeping landscapes, of course, but can also reward you with great-looking shots of other interesting subjects, including interiors. You can easily become infected with a love for wide-angle lenses.

Looking at landscapes

You can find few better tools for shooting landscapes than a digital SLR with a wide-angle lens. Throw in a tripod and a remote shutter release and you're set. The tripod lets you take longer exposures without worrying about keeping the camera steady. I recommend using a remote in these instances to minimize camera shake.

I photographed the sunset in Figure 2-2 using just those tools. The clouds were ideal. The sun was behind them, ready to set. The glow from the sun, combined with the contrast between the clouds and sky, make this scene what it is. It's nice that the color from the sun matches the lighting of the building across the river. The reflections in the water double the ambiance. I bracketed the scene for HDR but later realized that instead of putting the camera in Aperture priority mode (this keeps the depth of field constant), I had put it in Shutter priority mode. As a result, all the brackets had shutter speeds of 1 second, but the apertures varied from f/5.6 to f/13. Thankfully, it doesn't seem to have affected the shot! To capture the scene in Figure 2-2, I set the lens to 20mm/35mm. In other words, this is "normal" wide-angle territory.

Keep these tips in mind when shooting landscapes:

- ✔ **Use your software:** Distortion, a common problem with wide-angle lenses, is less obvious when you're shooting landscapes (like the one shown here). It's less a problem here because the subject has so few straight lines and there's nothing close to the camera. If distortion is a problem in your shots (especially portraits), you can remove some in software.

- ✔ **Think outside the rule of thirds:** Wide-angle shots make you pay a heavy penalty for poor composition and framing because so much more scenery appears in the shot. Don't be afraid to break the rule of thirds, but don't bisect the frame with the horizon unless you intend to. Our brains find shots composed using the rule of thirds more appealing than those that are too symmetric. You can read about the rule of thirds in Book IV, Chapter 4.

Seeing wide-angle cityscapes

Wide-angle lenses also excel at capturing entire cities (or reasonably large parts thereof). Figure 2-3 is just such a case. While you can take good building shots in downtown Detroit, you have to be in the city to do so. If you want a broader shot of the city, you have to move farther away, even with a wide-angle lens.

Figure 2-2: A typical landscape shot with a wide-angle lens.

When you're shooting cityscapes, keep these tips in mind:

✔ **Do a walkabout:** Choosing the right vantage point is probably the most challenging aspect of capturing cityscapes. In some cases, you may not be able to find a good view at all, especially if the terrain is flat and there are no surrounding hills or heights. You can often find a good spot to shoot from if the city is bordered by water on one or more sides.

✔ **Watch the horizon:** A crooked horizon can be distracting unless it's a purposeful design element of the photo. If you can't eyeball it, use a level.

✔ **Check the foreground:** Pay attention to what's close to you as well. In Figure 2-3, the action in the foreground makes the scene more interesting.

I took this 18mm/27mm shot on Belle Isle, looking across the Detroit River. Detroit is visible in the distance. The central tower of the GM Renaissance Center stands out and is easily recognizable. Windsor, Canada, is visible on the left in the far distance, and you can just make out the Ambassador Bridge, which connects the two cities and countries together. This is the one spot where you have to drive south from the United States to enter Canada.

Figure 2-3: It's possible to capture large parts of cities from the right vantage point.

Focusing on buildings

Not every city has a good vantage point from which to photograph. Of those that do, not all are equally accessible. You should, however, be able to find some interesting buildings to photograph. Look at your downtown area from near the city center. If that doesn't work, look at other parts, perhaps well outside. These are often photogenic. Schools, museums, memorials, and government buildings are often ideal subjects. When you find the right subject, make sure you have your wide-angle lens with you, because you'll need it.

Figure 2-4 shows a small part of downtown Detroit. I am standing on Brush Street, looking southeast toward the Renaissance Center. This street reminded me of a canyon, so I got in the middle and used the buildings on both sides to frame the far end of the street. I set the lens to 20mm/30mm and took the shot.

Figure 2-4: Large buildings are a natural subject for wide-angle photography.

Notice that I'm a few blocks away from the subject of the photo. This is a testament to how tall the building is. In situations like this, you may have to physically move to the right distance for your shot to work.

Capturing interiors

Believe it or not, a wide-angle lens is indispensable when shooting indoors, whether you're in a large or small location.

I took the photo shown in Figure 2-5 from near center court in my high school basketball arena. It's known as The Fieldhouse; as you can see, we take basketball pretty seriously in Indiana. This structure is quite large, but not that tall when you see it from the outside.

Clearly, this shot required a wide-angle lens. I used a focal length of 10mm/15mm to capture one end of the court, the stands behind the goal, and the far wall beyond. This shot has a tremendous amount of detail in it and covers a great deal of vertical and horizontal space. Shooting with a normal lens would have meant focusing on one single aspect of the scene rather than the whole.

Scenes dominated by linear elements, such as this one, demand precise framing and can be prone to visible distortion. Although you should take care to align things in the frame as well as you can before you shoot, you can use software to correct mistakes. In this case, I took out some distortion and made sure everything was straight and level.

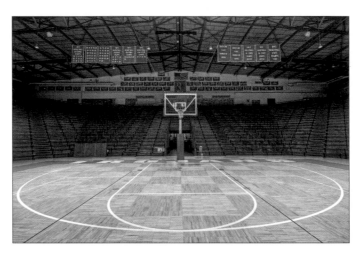

Figure 2-5: Interiors, large and small, are captured nicely by wide-angle lenses.

Wide-angle lenses can be incredibly practical. Take your digital SLR and a wide-angle lens (a kit lens may work fine) with you when house shopping. When you review the photos, you'll see *rooms* instead of corners. That will make it easier to plan how you will furnish and decorate.

Photographing small subjects

Wide-angle lenses can help you photograph subjects that you might not believe are suitable for an expanded field of view.

For example, Figure 2-6 shows an emergency call box. The box isn't tiny, but it's not as large as a building. It's bigger than a breadbox, to be sure. To get the shot, I set up my tripod close and turned the camera vertical. Afterward, I corrected a bit of distortion in software and added a cross-processed look. That brought out the texture in the concrete wall and the electrical boxes. At the focal length of 20mm/30mm, the lens was in normal wide-angle territory.

The key to using a wide-angle lens to shoot small subjects is to get up close and personal. You have to be within 5 feet or so, depending on the size of the subject. Experiment with different focal lengths and try to make the best use of the lens with the subject.

If you have a lens with particularly bad distortion, try easing up on the focal length. See if you can find an aperture sweet spot where the distortion is minimal. If not, consider returning it to the store for a different wide-angle lens.

Figure 2-6: Some wide-angle shots can look deceptively normal.

Improving Your Wide-Angle Shots

When you go out to take wide-angle shots, try to use wide-angle focal lengths to your advantage. In other words, do more than point the camera, zoom out to fit the subject in the frame, and press the shutter button. Your wide-angle lenses will reward you with special photos if you work at recognizing and then emphasizing elements of the scene that cry out to be photographed with wide angles.

Shoot from down low

You don't always have to be standing up when you take a photo. Likewise, if you continually set your tripod to the same height, your shots will end up looking similar. Shake things up, even when you're using a wide-angle lens.

I shot Figure 2-7 (10mm/15mm) crouching in the water because I wanted a different perspective. Doing so helped me emphasize the river in the frame as well as the banks without having to point the camera down.

Pointing the camera up or down when you're working with focal lengths in the wide-angle region invites more vertical distortion than you can shake a stick at. Avoid it!

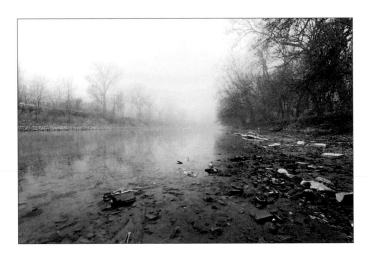

Figure 2-7: Getting down low emphasizes different aspects of the scene.

Get up close and personal

I took the photo shown in Figure 2-8 from a low perspective, but more importantly, up close and personal. The camera is about 18 inches away from the bogey wheel on this Walker M-41 Bulldog (a U.S. light tank from the Korean War era). The focal length of this shot is also 10mm/15mm.

The point here is that I was able to magnify the presence of the near wheel by getting closer, but capture most of the other wheels and track *at the same time*. In other words, you can often have your cake and eat it too if you shoot with wide angles.

Book II
Chapter 2

Casting a Wide-
Angle Net

Figure 2-8: You can get close with wide-angle lenses.

Use the vertical

Don't be afraid to switch your camera to a vertical (portrait) orientation, even when shooting wide-angle shots. The photo in Figure 2-9 is an extreme but effective example. I took this HDR shot (10mm/15mm) as I was walking down the north ramp towards the entrance to the Gateway Arch in St. Louis, Illinois. I had to look up to see the ground level, which is shown by the concrete section at the bottom of the photo. The entire arch extends up, travels overhead, and then comes down behind me, which is at the top of the photo.

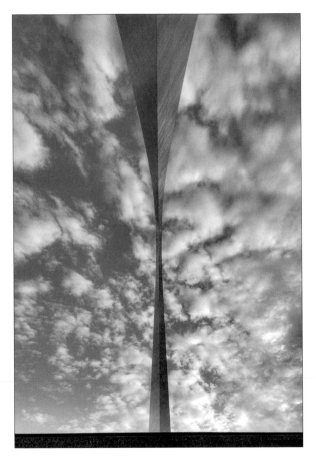

Figure 2-9: Try to frame some subjects vertically.

Emphasize height

Use wide-angle shots to emphasize height. The photo shown in Figure 2-10 is of the Cadillac Tower in Detroit, Michigan. This building is 40 stories tall and 438 feet high. Although that is 192 feet shorter than the Gateway Arch (just seen), it still looks quite impressive in this shot.

I used a wide-angle lens set to 10mm/15mm and held the camera vertically to fit the entire building in the shot. Notice, however, that I'm pointing the camera more towards the entrance than the top of the tower. That's the beauty of using wide-angle lenses. You can fit in so much more than normal lenses, including very tall buildings.

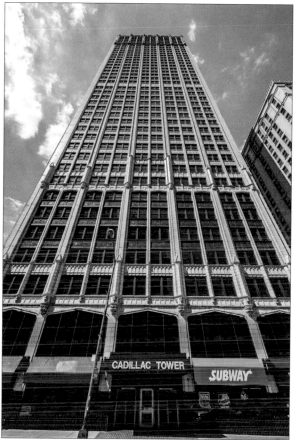

Figure 2-10: Wide-angle lenses can emphasize height as well as width.

Step back

When shooting a scene and you want to make sure and get it all in, step back and use a wide-angle lens. Figure 2-11 is another shot of the Gateway Arch. This time I'm standing to the east of it, down the stairs and across the road. The Mississippi River is about 50 feet behind me. You can see the St. Louis skyline peeking up underneath the arch. My family is posed in the center of the photo. The only way to pull off a shot like this is with a wide-angle lens. There's no other alternative. I set the focal length to 12mm/18mm to frame the shot just right.

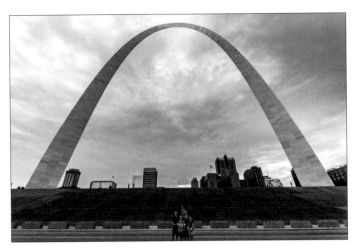

Figure 2-11: This shot features large and small subjects simultaneously.

 Some wide-angle scenes confuse automatic focus modes. If yours is complex and you have a specific point that you want in focus, consider choosing the specific AF point yourself or switching to manual focus.

Position yourself to fill the frame

 Have you noticed that some wide-angle shots make things look tiny, while others make them look large? The key to controlling this is your position. When you stand back and look out at a scene, it's going to look different than if you're close. The scene changes even more if you look up.

 Wide-angle lenses *vignette* quite often, which means their corners are darker than their centers. You can correct this problem in software. I sometimes use vignetting purposely to make the photo look interesting.

Distorting the facts

If you're shooting landscapes and other non-linear subjects, wide-angle lens distortion can go unnoticed. However, some scenes and extremely wide angles bring it to the forefront. If distortion (including odd perspectives) bothers you, try removing or minimizing it with your photo editor or raw converter. Photoshop (including Elements) has a very helpful Remove Camera Distortion filter.

New versions of Adobe Camera Raw and Adobe Lightroom come with lens presets that can automatically remove lens distortion and vignetting. This makes tackling lens distortion easier than ever before. For more on raw processing and image editing, turn to Book V.

Something Seems Fisheye

On the extreme end of the wide-angle spectrum are fisheye lenses. Just like their wide-angle relatives, they're incredibly fun to use. The (roughly) 180-degree diagonal angle of view puts a whole new twist on taking unique photos.

Unlike a macro lens, which zooms in so closely that it cuts out all else from the frame, a fisheye lens *includes* everything else.

I shot Figures 2-12 and 2-13 with the Nikon AF DX Fisheye-Nikkor 10.5mm f/2.8G ED lens on a cropped-frame camera. Figure 2-12 is a self-portrait. You're looking at my reflection and the room behind me as I take the shot. You can't hide the flash in shots like this! The distortion that fisheye lenses produce is very evident in this example. The frame of the mirror (thin brass strips on the sides) and the white door it's on both bulge outward. While sometimes that kind of distortion is a problem, it adds to the unique nature of this shot. The center of the photo is relatively normal. Had I been off-center, the effect would have distorted me much more than is apparent here.

Figure 2-12: Fisheye lenses specialize in unique distortion.

Figure 2-13 shows a completely different approach. In this case, I took a relatively traditional landscape shot of a bridge at sunset. It's a far larger scene. Because the center of the frame distorts less, the walkway looks fairly normal. The trees, sky, and cables all show evidence of distortion. This shot hides it a bit because you're not quite sure what the bridge should look like. If you look at the trees, however, you can see that they are pointing towards the top-center of the photo instead of straight up.

Don't lock yourself into one mode of thinking. Take your fisheye lens and shoot everything you can with it.

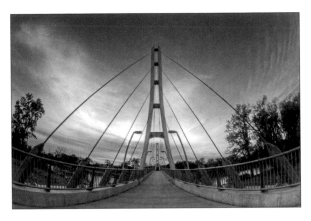

Figure 2-13: Capture scenes with fisheye lenses and compare to those shot in standard wide-angle.

Chapter 3: Going to Extremes

1 f you like to shake things up, this chapter is for you. In it, you're exposed to two different types of lenses, both of which are practical and artistic: the macro lens, which specializes in close-ups, and the telephoto lens, which specializes in far-aways.

Macro lenses focus on nearby subjects. Although they don't generally magnify, they appear to because the subjects look so much larger than normal. What they actually do is try to replicate subjects on the sensor the same size they are in real life (or thereabouts). *Telephoto* lenses, on the other hand, use their long focal lengths to magnify small or distant objects. They work just like microscopes and telescopes. You can be hundreds of feet away from subjects and a telephoto lens will enlarge them in your viewfinder. Both types of lenses are fun to work with and can create stunning photos.

Dancing with Macros

Macro photos tend to evoke "oohs" and "aahs" from people because they give us a vantage point we don't normally see. Small bugs become huge. Hidden details become visible. The mundane becomes magical. You can literally see the hair on a fly's backside.

The following sections define what macro photography is and show you several examples of it in action.

Defining macro

Technically, macro photography relies on special lenses called *macro* lenses. (Nikon calls them *micro* lenses.) Macro lenses have two defining characteristics:

✓ **Reproduction ratio:** Macro lenses focus objects on the sensor closer to their actual size than non-macro lenses. This is called the *reproduction ratio*. Ideally, macro lenses should have a one-to-one ratio. Some even enlarge objects by having a greater than one-to-one ratio. However, many macro lenses don't offer this type of reproduction ratio; if they do, it may not be available throughout the lens's entire focus range.

Not all macro lenses have the same reproduction ratios. When you're shopping for a macro lens, look carefully at its specifications. That way you avoid buying a lens labeled "macro" that falls short in the reproduction ratio category.

✓ **Close focusing distance:** Macro lenses can focus at very close ranges. Most normal lenses have close focusing distances around a foot, or between one and two feet. Telephoto lens close focusing distances may be several feet. Macro lens close focusing distances may only be a few inches.

Both of these characteristics make focal length less obviously important to macro photography than other types. Focal length is still important in determining the angle of view you will get, and therefore you should pay attention to it. However, unlike telephoto lenses, focal length isn't a good measure of how powerful a macro lens is. Therefore, you can find *macro primes* (those with a fixed focal length) in a whole range of focal lengths.

Canon's macro lens category contains lenses that range from 50 to 180mm. Nikon's micro lenses range from 40mm to 200mm! Sigma has a line of prime macro lenses that compares to these ranges, and special macro lenses in their standard zoom category that start in the teens, such as the 17–70mm F2.8–4.5 DC Macro. You'll also find macro-type lenses in their telephoto zoom lens category, such as the 28–300mm F3.5–6.3 DG Macro.

Macro versus close-up

Purists will tell you that close-ups aren't macros and macros aren't close-ups. That's true. However, if you don't have a macro lens and would like to see what all the fuss is about, feel free to shoot close-ups. Many of the techniques are the same or similar.

When you're shooting a close-up with a non-macro lens, the depth of field is smaller the closer you get to your subject. You can counteract that by choosing a smaller aperture with your camera.

What you won't have is a lens that has a reproduction ratio in the range of a true macro lens or that can get as close to your subject. These problems aren't insurmountable. The photos you take can be quite captivating.

If you're using a normal lens, I recommend picking up and using some additional equipment. Any of the following gadgets will make your normal lens feel more like a macro lens. Each of the approaches has its own pros and cons:

Book II
Chapter 3

Going to Extremes

- **Teleconverter:** You insert this optical element between the lens and your camera. It increases the focal length of your lens by a set amount — normally between 1.4 and 2 times. Because light must pass through another lens, you may need to raise the exposure to offset the loss of light if shooting in Manual mode.

 Teleconverters can be finicky. Make sure your lens and camera are compatible. Better versions communicate information between the camera and lens. Cheaper versions may not have very good optics.

 Pros: Teleconverters are perhaps the easiest to use and produce great results. *Cons:* They may limit the maximum aperture you can use with your lens as well as degrade the autofocus.

- **Extension tubes:** These open tubes extend your lens away from the camera body. Because a tube doesn't have a lens inside it, you won't have to worry about degrading the optical quality of your lens. You may experience more pronounced *light falloff* (where more distant objects quickly become darker) and *vignetting* (where photo corners are darker than the center) with the tube as opposed to without.

 Pros: You aren't putting an additional optical element into the mix. *Cons:* The lens can get ridiculously long with a tube on it, and not all tubes communicate well between the lens and camera.

- **Diopters:** Screw this lens filter onto the front of your lens. A diopter is like corrective glasses that magnify the subject.

 Pros: Diopters communicate well between the lens and camera. *Cons:* As with all filters, they can cost a lot. You either need a step-up adapter or a complete set of diopters for any lens you may want to use that takes a different filter size.

Regardless of how you take your close-ups, no law says you can't zoom in even further when you process the photo in software. That's a great advantage of having a camera with a few million pixels to spare around the edges.

Shooting at close ranges

Macro lenses can focus on objects much closer than standard zoom or prime lenses. Depending on the lens you're using, you may be able to position yourself a few inches (or fewer) from your subject.

I've done just that in Figure 3-1. This is a photo of one of my kids' toys (just like the ones I used to play with). He's the one throwing the hand grenade. I put him down on the table and snuck up on him real close to take this shot. He appears to be happy with his work and his uniform fits him like a glove.

Light and using the viewfinder can sometimes be problems when this close. If you can't see what's happening through your viewfinder, switch to Live view. This will also help if you manually focus. I took this photo in a studio setting, so I had a lot of bright lights shining from several angles.

Figure 3-1: Gung Ho for macros.

Managing depth of field

When you move this close to your subjects, you realize that aperture isn't the only factor that affects depth of field. At these ranges, the depth of field will shrink, regardless of what setting you choose. Keep in mind that the settings you're used to won't produce the same results. In general, when shooting macros or close-up work I work with apertures set to f/16 or smaller.

This increases the depth of field enough so that my subjects are reasonably sharp. The depth of field is still small, however. When it's a problem, I rely on positioning to manage depth of field. Rather than shoot at an angle, I will try to flatten my angle so that what I am interested in is on the same plane. Figure 3-1 is a good example of this.

Of course, you can have fun either way. I went outside after some rain to experiment with very shallow depths of field. Figure 3-2 shows rain droplets on a leaf. The depth of field is incredibly narrow — only a few small water droplets deep. In this case, that makes the photo much more interesting.

Figure 3-2: Depth of field is about four water droplets deep.

Working with very shallow depths of field can make focusing difficult. Add in camera weight and subjects that may not stay still for long, and you've got a real challenge. When that happens, relax and take a deep breath. Switch off your targeting computer and trust yourself, as Obi-Wan suggests. Focus the lens as best you can, then take your hand off the focus ring. Move the camera until the scene looks best, then take the photo.

Shooting handheld (with a flash)

You can set up a base camp and mount your camera on a tripod to shoot flowers, but bugs move. They flit here and there. When I set up my camera

on its tripod and zeroed in on a flower, all the bugs chose the other flowers to land on. Hmm. After waiting for a few minutes, I ditched the tripod and began stalking bugs on foot.

Figure 3-3 illustrates a good example of a handheld shot where everything seemed to work. The image of the fly is sharp, colorful, and in focus. If you look carefully, you can see my reflection in the fly's body segments. The brighter spots are from the flash. I used an external flash to help light the scene. I shot this late afternoon. I set the aperture to f/11 as a compromise between having a decent depth of field and needing more light, plus I raised the ISO marginally. Even with those changes, the shutter speed was a paltry 1/60 second. Thankfully, the macro lens had vibration reduction.

Exposure can sometimes be a problem when you *stop down* (set a smaller aperture).

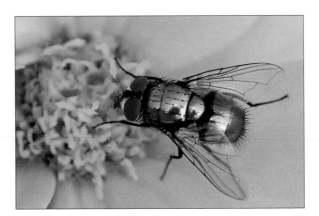

Figure 3-3: That is one hairy-bottomed fly!

Take breaks more often when you're shooting handheld macros, especially if you're outside in the heat. The weight of the camera and macro lens will tire you out faster. While this may not seem like such a big deal, remember that you're focusing on such tiny items that any camera movement can knock you out of the focal plane. Keeping elements steady is difficult, even with fast shutter speeds and vibration reduction turned on.

If you're patient in the right situation (for example, you have a bird feeder within close range that gets regular visits) you can set up your camera on a tripod and pretend that you're on safari in Africa.

Maximizing shutter speed

If you're shooting bugs, you have to handle movement. One bee I tracked moved diligently from flower to flower to flower. (That's what bees do.) Every time she landed, I had to locate her, position myself and the camera, and then frame, refocus, and shoot before she buzzed away.

If you're shooting either inanimate or slow-moving objects, tracking, framing, and focusing get easier. Figure 3-4 shows a bug that moved more deliberately. I was able to follow him for quite some time before he left. I stopped down to f/22 to maximize the depth of field and increased shutter speed to 1/400 second. This kept most of the beetle in focus and froze his movement. To make up for the lost light, I increased ISO to 1600. I didn't use a flash. The morning light was very strong.

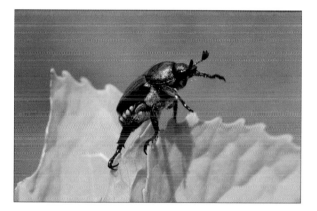

Figure 3-4: Because it's there.

Shooting under controlled conditions

When you're working inside your studio (refer to wherever you shoot as your *studio,* whether it's your dining room table, kitchen counter, a corner of the basement, or a 20x20 outbuilding), you have much more control over your setup and lighting. You don't have to worry about the sun, wind, flying bugs, or a camera that grows heavier with every photo you take.

Figure 3-5 shows some resistors on the circuit board of my old Marshall 9001 Stereo Valve Preamp. I took off the cover to expose the innards. These little guys are about a quarter of an inch long, not counting the leads. It's a perfect subject for macro photography.

When you're in the studio, mount your camera on a tripod to ensure stability. This also lets you make the shutter speed as slow as you need.

My preferences when shooting in-studio run like this:

- **Continuous lighting:** I've rigged up several homemade *soft boxes* (a soft cover than diffuses light) to light the scene. I know exactly what the ISO, shutter speed, and aperture need to be before I even turn the camera on. This comes from shooting hundreds of shots in the same location with the same lighting and setup.

- **Manual focus:** The best way in this situation is to switch to your camera's Live View mode and zoom in using the LCD monitor's controls. This enables you to very precisely focus using whatever part of the scene you wish. If you use autofocus, you should select and use a single AF point. Position it over the spot that you want to be in the depth of field that is in focus.

- **Dusting:** I always brush and blow dust off my subjects, but you will hardly ever remove all traces of dust and miscellaneous fibers. When you're shooting small subjects like this, be prepared to remove a lot of dust using your favorite photo editor.

Figure 3-5: Use Live view to focus precisely when shooting in controlled conditions.

Your other challenges are mainly lighting and depth of field. Here are some additional lighting pointers:

- **No flash:** You can shoot macros in a studio without using a flash. The character of the lighting is different than with a flash, though, and you may struggle to find the right white balance. Try setting a custom white balance or take several test shots to get it right.

✔ **Pop-up flash:** Don't even bother unless you have a very short macro lens. The longer the lens and the shorter the distance to the subject, the more distance you need to move the flash away from the camera to keep the lens from casting a huge shadow over everything. Pop-up flashes won't work in these cases.

✔ **External flash:** Seriously consider investing in an external flash or Speedlight/Speedlite. When you mount one on your camera's hot shoe, the flash can clear the lens in most situations. You can also get a *ring light,* specifically designed to light close subjects unobtrusively.

Ideally, you can position the flash away from the camera but stay connected using a sync or flash cord. (Wireless is even better.) From there, creatively design the photo and the flash away from the lens. When you're working at very close ranges, it can mean the difference between lighting your subject or not.

✔ **More complicated lighting setups:** The possibilities that arise from using extra gear are endless. You'll be able to patiently work your craft and *design* the shots you want. It's incredible fun and very rewarding!

Because your goal is to shed light on your subject, be as flexible as possible.

Relaxing your angle of view

Not all macros need to be microscopic wonders. Depending on the lens you're working with and the distance you are from your subject, you may shoot something that's more or less a close-up. Figure 3-6 is a shot of my son's Raspberry Pi, an amazing little computer packed onto a small circuit board.

Figure 3-6: Step back for a change of pace.

Using extension tubes

Extension tubes are simply that. They extend the lens away from the camera by a certain amount to increase the reproduction ratio of the lens. Using extension tubes isn't as simple as increasing the lens's focal length. That's what teleconverters do. It also isn't like putting a magnifying glass up to the lens. That's what diopters do. Extension tubes increase the magnification ratio by physically moving the camera closer to the subject. It is magnified more because the subject appears larger to the camera. When you move closer to something, it gets bigger. Simple, yet profound. One cost of using an extension tube is that it limits how far you can focus.

Figure 3-7 shows an inexpensive extension tube set from Zeikos. Most sets come with three different size tubes. This set has a 12mm, 20mm, and 36mm. You can mix and match them to create different magnification ratios. For example, if you use the 12 and 36mm tubes with a 50mm lens, the magnification ratio is just over 1.0 if the focus is set to half a meter. Figure 3-8 shows a macro taken with a 50mm lens on a cropped-frame camera and extension tubes. It's George Washington's face from a dollar bill.

Figure 3-7: Extension tubes turn any lens into a potential macro lens.

Oddly enough, one consequence of how the magnification ratio is calculated (I won't bore you with the formulas) is that the magnification factor decreases as you increase the focal length of your lens. In other words, if you use the same extension tube with a 35mm lens and then a 50mm lens, the 35mm photo will have a greater magnification ratio when you compare them to each other.

Use shorter lenses to get greater magnification ratios when paired with extension tubes.

Figure 3-8: He cannot tell a lie: Macros are worth shooting.

Using diopters

If you don't want the hassle of putting extension tubes between your lens and the camera, try screwing in one or more diopters. They have upsides in spades:

✔ They work on any lens you have.

✔ They won't mess with your shooting modes, autofocus, or other camera features that rely on communicating with the lens (unlike teleconverters and extension tubes).

✔ They can be mixed and matched to increase the amount of magnification.

Figure 3-9 shows a Hoya close-up filter set. It came with three filters of different strengths: +1, +2, and +4. In this shot, one is mounted on a Nikon 18–55mm lens with the help of a step-up ring. This allows me to standardize all my filters to 77mm. All I need to do is get another *step-up ring* (an adapter that mounts a larger filter on a smaller lens) if I get a new lens that doesn't match what I already have.

As you can see, diopters *do* contain optical elements. The glass is very important. Take care of them by always keeping them in a protective case and cleaning them regularly. Cheaper filters will degrade your photos more than a high-quality set.

Figure 3-9: Diopters are like corrective lenses for lenses.

Figure 3-10 shows the power of adding diopters to a lens. This shot is individual wires from a cable. At this magnification, you see not only each wire very clearly, but how the copper was distorted when the wire was cut.

Figure 3-10: Even wires look interesting from this vantage point.

Go on with your bad self

I can't possibly show you all the ins and outs of macro photography in half a chapter. I hope you can see what's possible, though, when you use these fantastically cool lenses. The deeper you get into macro photography, the

more you'll discover different equipment and techniques such as using bellows, single lens reversal, and more advanced flash and lighting techniques.

Letting Telephoto Ring Your Bell

Who doesn't love to zoom in? Be honest and admit it: You love to crank up the focal length and get a nice close-up.

Digital zoom, which is popular on compact digital cameras and as a software option, isn't the same as zooming in with a lens. The latter actually increases the level of detail you see.

Dedicated telephoto lenses abound, but there are just as many everyday kit lenses that can shoot in the telephoto range. Whether a lens can shoot telephoto or not depends on what focal length (or range of focal lengths) it has available.

Traditionally, "normal" focal lengths are equal to the diagonal measurement of the film or sensor being used. The following are considered telephoto:

- Full-frame dSLRs: 43mm
- Cropped-frame dSLRs: 28mm

Both of these focal lengths produce photos that have diagonal angles of view of approximately 54 degrees. I imagine that you're shaking your head. Twenty-eight millimeters for cropped-frame cameras? That doesn't seem right! Given some leeway, it is. The problem is that we think of 50mm as the classic 35mm camera lens, and it is. However, a cropped-frame dSLR doesn't have a sensor the same size as a 35mm camera. It's much smaller. The smaller sensor results in a more limited field of view for these cameras, which makes lenses feel "zoomier."

Given that you aren't a robot, you aren't restricted to a single focal length that's considered normal. Table 3-1 gives the telephoto ranges.

Table 3-1	Telephoto Ranges	
Name	*Focal Lengths*	*Notes*
Normal	Cropped frame: 28–35mm Full frame: 40–60mm	—
Near (aka medium) telephoto	Cropped frame: 35–50mm Full frame: 60–70mm	Where you begin telephoto shots. The most practical and least expensive region. A kit lens usually has this capability.
Telephoto	Cropped frame: 70-200mm Full frame: 135–300mm	Considered "proper telephoto." Available in zoom and dedicated telephoto lenses.
Super telephoto	More than you can shake a stick at. Over 200mm (APS-C) or 300mm (full frame)	Have a single focal length.

Figure 3-11 shows a reasonably affordable telephoto lens that straddles the super telephoto border — the AF-S NIKKOR 300mm f/4D IF-ED lens. For this photograph I mounted it on a monopod so you can see that the lens itself attaches to the pod, not the camera. Most long lenses work this way. It keeps the center of gravity over the monopod, not in front of it. This brand of monopod has a handy strap attached to it. I always use it. It's protection against losing an expensive lens.

Hold your monopod at all times!

LensRentals.com

Not everyone has a stable of macro or telephoto lenses. If you want to experiment with them, try renting. Rent that 300mm lens you've always dreamed of for a week to see whether it's one worth budgeting for. If you've never tried a macro lens, or if you need a better zoom lens for a wedding, rent one. You can rent a camera body that's different from yours and an all-purpose zoom lens to check out the competition. If you have a Nikon, for example, rent a Canon. Or, if you have a Canon, rent a Sony.

I use www.lensrentals.com for most of my rental needs. The site's employees are polite, professional, and trustworthy. Their services are timely and the list of available gear is impressive. The site offers flexible plans based on the amount of time you rent items. I recommend getting the insurance.

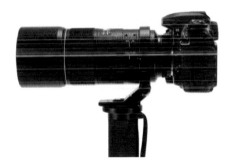

Figure 3-11: Telephoto lenses can be large and bulky.

Shooting telephoto action

You've probably noticed professional photographers at professional sporting venues shooting professional athletes in action. You can too, in a manner of speaking. For example, Figure 3-12 is my daughter heading home to score a run.

A telephoto lens is your ticket to success when shooting action. You can stand pretty far back and still get good photos.

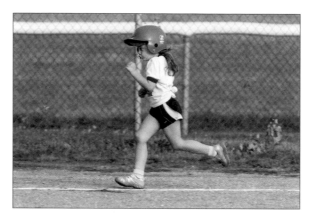

Figure 3-12: Telephoto lenses are natural for action shots.

The great thing about using a telephoto lens is that you can be far away from the action and still feel like you're right in the middle of it. (That last sentence is brought to you by Mr. Obvious.)

As you might expect, action shots require fast shutter speeds. You can read more about action in Book VII, Chapter 3.

Figure 3-13 shows a shot from an air show. I captured an F-22 Raptor as it was pulling hard through a turn. The moisture in the air is condensing into mist as the plane compresses the air and moves it out of the way. I love the fact that you can see the pilot and the kneeboards on his lap. Remember, I was standing on the ground, several hundred feet below and away from the line of flight. This kind of moment is when you want the best telephoto lens you can get your hands on.

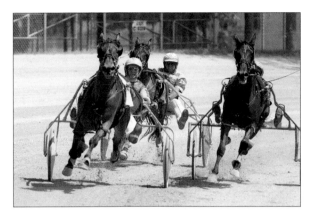

Figure 3-13: Panning and tracking subjects can be hard, but worth it!

Using telephoto lenses for portraits and close-ups

Telephoto lenses are very useful for portraits. They separate the subject from the background well and often have a nice *bokeh* (the unfocused area in the photo). Having a blurry background in photos means not having to worry about what it looks like. I took the photo in Figure 3-14 of my oldest son, Ben. It's a marvelous portrait taken with a 300mm telephoto lens (the same one I used at the races).

Many photographers like using 85mm telephoto lenses in portraiture.

Even if you use something like an 85mm lens, you'll have to stand back from your subjects unless all you're after is a head shot. Many telephoto lenses are *prime* lenses, which means that you have to zoom in and out with your feet. Be prepared for that. If you're using a general-purpose zoom lens, you have much more flexibility.

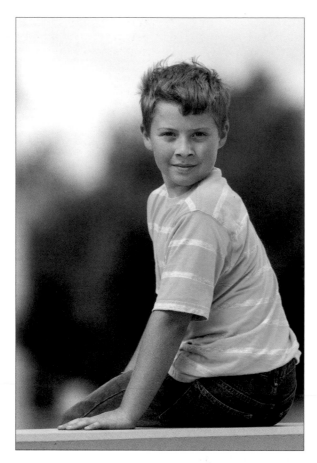

Figure 3-14: Telephoto portraits make for very attractive bokehs.

Operating in the near-telephoto range

If you can get away with *not* lugging around a 300mm telephoto lens, do it. If your kit lens has enough power, use it to capture nice close-ups in the near-telephoto range. I took Figure 3-15 with this idea in mind. It's a close-up of a cactus plant shot with a full-frame camera at 105mm. (That equates to 70mm on a camera with a crop factor of 1.5x.)

It feels like "normal photography" when shooting at these focal lengths. Follow the same rules and set up the camera as you would for any other shot. The only difference is that you're zooming in more.

Figure 3-15: Telephoto lenses make close-ups easier.

Figure 3-16 shows an action shot in the same focal length range. I took this at 85mm on an APS-C camera (128mm full frame). My cousin loaned me his AF Nikkor 85mm f/1.4 lens. It seemed the perfect lens to take bowling, as you need a lot of light and the lens must be able to zoom in from *behind* the action. I captured Sam right as he was hefting his ball down the lane. The bokeh produced by this lens is truly outstanding.

Figure 3-16 shows you what an 85mm/128mm lens will do at reasonably close distances. This isn't action from across the court, runway, or field. However, you can't begin to capture this type of shot using normal focal lengths unless you're standing right on top of people. Even 85mm allows you to stand back and let people enjoy themselves without you breathing down their necks.

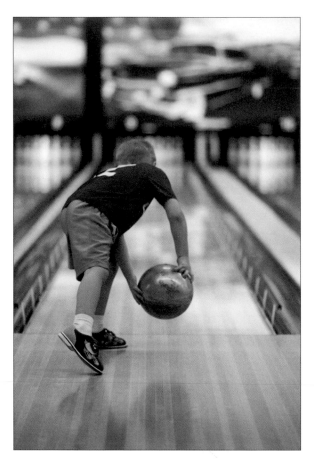

Figure 3-16: I shot this in the near-telephoto range.

Milky Way fun

I wanted to see if I could photograph Saturn without any special astrophotography equipment. I used a 300mm lens and 1.4x teleconverter on a cropped-frame camera, which brought the total focal length to 420mm. In full-frame terms, that equates to 630mm. I mounted the camera on a tripod and attached a remote shutter release. I pointed the camera towards Saturn and, with some difficulty, got it in the frame. Exposure calculation was hit and miss. I started with a long exposure and shortened it until I hit a combination that worked. The exposure settings were f/5.6, ISO 100, and 1/15 second. I included here the photo, which is mainly black, and cropped versions so you can see Saturn. I was pretty surprised that I could easily make out the rings in the photo, when magnified. It really is Saturn.

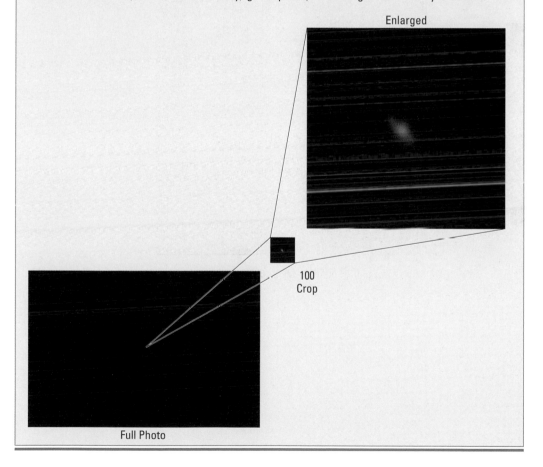

Enlarged

100
Crop

Full Photo

Book III

Hey, Your Exposure's Showing

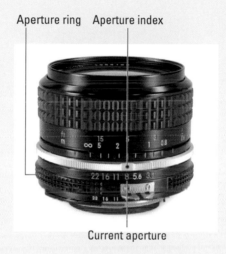

Aperture ring Aperture index

Current aperture

Contents at a Glance

Chapter 1: Working with Apertures

In This Chapter

- ✔ **Understanding apertures**
- ✔ **Setting the aperture**
- ✔ **Discovering depth of field**

*W*hen you're determining exposure, one criteria to keep in mind is something called an aperture (the other two criteria, covered in upcoming chapters, are shutter speed and ISO sensitivity). The *aperture* is the opening in the lens that lets light pass into the camera body.

In this chapter, you read about not only how they affect exposure, but also how apertures work, what to call them, and how you can control them. You also read about the side effect aperture has on a photo. Namely, it contributes to defining the scene's *depth of field (DOF)*. Armed with this information, you can move beyond your camera's automated shooting modes (if you like) and purposefully take photos with different creative goals in mind.

Stick with the material in this chapter, even if it seems confusing at first. As you shoot and evaluate your own photos, it'll make more sense.

You Have a Hole in Your Lens!

Did you know that your lens has a hole in it? Every lens has one. It's called the *aperture,* and it's supposed to be there. The aperture is what allows light to pass through the optical elements of the lens and into the camera. If it weren't for the aperture, you'd have a useless block of metal, glass, and plastic.

A large aperture lets in more light while a small aperture lets in less light. Apertures are always expressed as f-numbers, a concept I explain next.

An aperture is part of the lens, not the camera body. This is one reason the lenses you choose are an important part of your overall dSLR experience.

The f-stops here, buddy

The numbers f/5.6 and f/8 and f/16 describe apertures. Why are apertures defined in terms of f-numbers? The answer is that f-numbers are an elegant way of condensing things to make exposure the issue (versus the diameter of the aperture or the lens's focal length). The long and the short of it is that f-numbers are a shortcut.

An *f-number* is the relationship between a lens's focal length and its aperture diameter. In plain(ish) language, you can calculate the f-number by taking the current focal length of the lens (in millimeters) and dividing that by the aperture's diameter (in millimeters). If you know the lens's focal length and its f-number, you can figure out the diameter of the aperture by dividing the focal length by the f-number. By convention, f-numbers have two digits. That's why you see f/4.0 and f/8.0 here in the book and displayed by your camera, but not something like f/11.0 or f/16.0. The latter is shown as f/16.

In photography, apertures are described in terms of *f-numbers,* also known as *f-stops.* The larger the f-number is, the smaller the physical size of the aperture. Conversely, the smaller the f-number is, the larger the aperture.

Figure 1-1 shows this concept. The same lens is set to four different f-numbers: f/2.0 (the largest aperture shown), f/4.0, f/8.0, and f/16 (the smallest aperture shown).

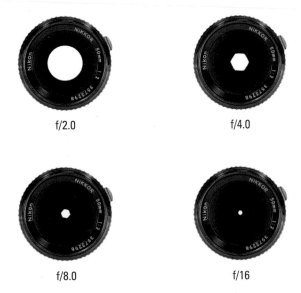

f/2.0 f/4.0

f/8.0 f/16

Figure 1-1: As f-numbers increase, aperture sizes decrease.

To show you that focal length indeed matters, Figure 1-2 shows a 35–70mm lens with the aperture set at a constant f/3.5. The focal length was changed in each shot. The effect on aperture size? Aperture size increased the more the lens was zoomed, even though the f-number stayed the same.

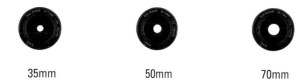

| 35mm | 50mm | 70mm |

Figure 1-2: The aperture size changes as the focal length increases, but the f-number stays the same.

Putting the gnome in nomenclature

Because apertures are described by f-numbers, it stands to reason that lenses should tell you something about their capabilities, and those capabilities should be shown in terms of f-numbers. That's exactly how it works.

Standard dSLR lenses list their maximum aperture as part of their name.

I explain the two ways you'll see it in the following sections:

- ✔ Constant maximum aperture
- ✔ Variable maximum aperture

Constant maximum aperture

Many lenses list a single maximum aperture in their name. This means they have a *constant maximum aperture,* regardless of the focal length. Two types of lenses have a constant maximum aperture:

- ✔ **Prime lenses:** All prime lenses have constant maximum apertures. They never change focal length. For example, the maximum aperture of the AF-S NIKKOR 50mm f/1.4G prime lens is f/1.4. (The *G* in this lens's name indicates it is a G-series lens, or one without an aperture ring.)

- ✔ **Zoom lenses:** Some high-quality zoom lenses have a constant maximum aperture across their focal length range. These lenses cost more and are better than those with variable maximum apertures because you can collect the same amount of light whether you're zoomed in or out. The Canon EF 24-105mm f/4L IS USM shown in Figure 1-3 is a good example. Although it's a zoom lens, the maximum aperture is f/4.0. It doesn't change, no matter what the focal length is. (The *L* in this lens's name

identifies it as a high-quality Canon L-series lens, priced for serious enthusiasts and professional photographers.)

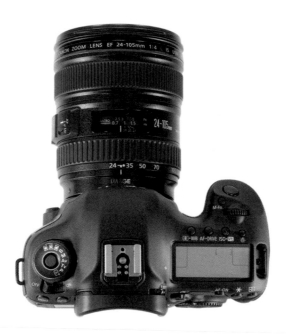

Figure 1-3: Zoom lenses with a single aperture listing have a constant maximum aperture.

Variable maximum aperture

Lenses with *variable maximum apertures* list two f-numbers in their name. For example, the Sony DT 18-55mm f/3.5–5.6 zoom lens sports both f/3.5 and f/5.6. What gives? See Figure 1-4. The maximum aperture changes depending on the focal length the lens is set to. You're given the two extremes: At 18mm, the maximum aperture is f/3.5. At 55mm, the maximum aperture is f/5.6.

You may look down at your camera, after having set the aperture to f/3.5, and see that the camera has changed it without your permission. You've zoomed beyond the range where it can support your chosen aperture.

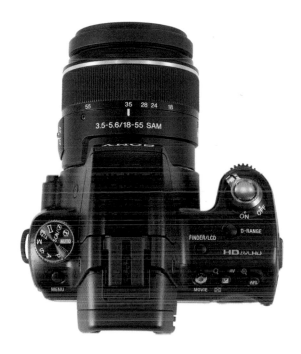

Figure 1-4: This lens has a variable maximum aperture.

Because you can't zoom a prime lens in or out, its maximum apertures must be *constant* or *fixed*. High-quality zoom lenses often have a constant maximum aperture; most others have a variable maximum aperture.

To find the minimum possible aperture, you have to look into the specification sheet or manual for each lens. Common values range from f/16 to f/32.

Fast lenses

Lenses with small f-numbers in their name (hence large maximum apertures) are known as *fast* lenses. They let in a lot of light, which lets you use faster shutter speeds. Fast lenses excel in low-light situations. When using large apertures, backgrounds are often pleasantly blurred.

✔ Set a reasonably fast shutter speed and keep the ISO (sensitivity to light) relatively low. This helps you avoid camera shake, blur, and noise.

✔ Set a slow shutter speed, maximize the ISO, and take extreme shots in low-light situations that would be impossible with a slower lens.

Table 1-1 puts lenses into speed categories based on their maximum apertures. Table 1-1 applies to most lenses below 400mm. When you're working with super telephoto lenses at 500mm and 600mm, f/4 is considered fast. For super-duper-ooper-schmooper telephoto lenses (800mm), f/5.6 is considered fast.

Table 1-1	Fast Versus Slow Lens Speeds	
Speed	*F-number range*	*Notes*
Very Fast	f/1.8 and below	Very fast compared to all other lenses; companies often field a professional-level f/1.4 prime lens and a less-expensive but still capable prime with a maximum aperture of f/1.8
Fast	f/2 to f/2.8	Very costly telephoto and zoom lenses; very good in low light; professional caliber
Medium	f/3.0 to f/4.0	Moderately expensive; expensive, but still reasonably affordable compared to faster versions; can be tough to use in low-light conditions but is tempting; very good outside
Normal	f/5.6 and above	Often inexpensive; come as kit lenses on entry and midrange dSLRs; hard to use inside without elevating ISO or using flash

Setting the Aperture

You can set the aperture on standard dSLR lenses using one of two methods:

- Aperture ring
- In camera

Aperture ring

All older lenses (manual focus lenses without a computer chip) have an aperture ring, which you can see in Figure 1-5. Turn it to set the aperture.

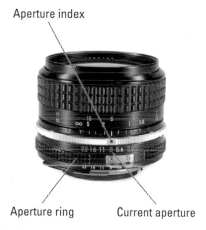

Aperture index

Aperture ring　　Current aperture

Figure 1-5: This lens has an old-school aperture ring.

Canon has done away with aperture rings altogether. Nikon, on the other hand, still offers elements of old (aperture ring) and new-school (computer chip) technology in its D-series lenses. To use D-series lenses on new camera bodies, lock the aperture ring on the lens to its highest f-number (smallest aperture), then control the aperture from the camera. Ignore the aperture ring in this configuration.

More advanced Nikon dSLR bodies such as the D600 let you enter the focal length and maximum aperture of even older lenses (check your manual for the specific type) into the camera's menu. These lenses are called *non-CPU* lenses. Entering the data enables the camera to meter, recognize the aperture set by the lens, and control the flash better.

In camera

Most modern lenses *don't* have aperture rings.

Set the aperture with these methods:

✔ Enter your camera's Manual or Aperture priority modes and dial in the aperture of your choice (as shown in Figure 1-6). Use one of the controls (normally the front or rear dial).

✔ Use your camera's Program Mode and then shift the aperture/shutter speed combination via Program Shift or Flexible Program.

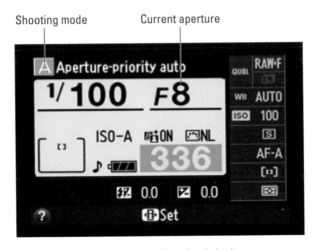

Figure 1-6: The aperture is displayed only in the camera.

If you're using a more automatic scene or mode, you choose the depth of field you want and the camera selects an appropriate aperture. For example, if you choose Landscape, you're telling the camera that you want a large depth of field. It'll stop down accordingly. When you understand why certain scenes call for certain depths of field, you might want to start setting the aperture directly yourself.

Some cameras, like the Canon EOS 60D and Nikon D3200, have shooting modes that let you select the amount of background blur you want in the photo. Canon calls its mode Creative Auto, while Nikon uses a shooting mode called Guide.

Lenses like those from LensBaby are an exception to these rules. If you're using these lenses, you change aperture by swapping aperture rings with a special magnetic tool.

Digging into Depth of Field

Each of the three primary exposure elements (aperture, shutter speed, and ISO) has an effect on the photo's exposure. They also have a side effect that has nothing to do with exposure.

The aperture's side effect is *depth of field (DOF)*. Depth of field is the area of the photo that you see as in focus. Everything outside the DOF, whether foreground or background, will look blurred.

Figure 1-7 illustrates depth of field with a shot taken at f/1.4. The white knight in the center was the point of focus. It, and the brown pawn to the right of it, are in the center of the depth of field. The board and pieces nearer to the camera are out of focus because they're in front of the depth of field. The background is also out of focus, beyond the depth of field.

Figure 1-7: Illustrating a shallow depth of field.

Controlling the depth of field

One of the aspects of photography that makes it so interesting is that you have control over the size of the depth of field. You can, with relative ease, make it larger or smaller.

Several factors determine how large or how small the DOF is:

✓ **Circle of confusion:** The circle of confusion is, frankly, a circle of confusion. It's a subjective value that decides, essentially, how out-of-focus something has to be before you notice it. If there were no circle of confusion, the DOF would be infinitely small because you could spot the least little bit of blur.

Unless you want to calculate depths of field yourself, you can completely ignore the circle of confusion. DOFmaster (`www.dofmaster.com`) has online and downloadable DOF calculators.

✔ **Distance to subject:** This is the distance at which the lens is focused. Focusing on nearby objects results in *shallow* depths of field. Focusing on faraway objects gives *greater* depths of field. Most older and many new lenses have distance scales on them, as shown in Figure 1-8.

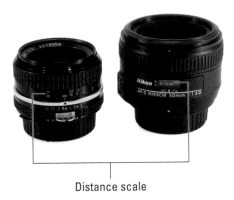

Distance scale

Figure 1-8: Although somewhat archaic, distance scales can be useful.

✔ **f-number:** You may be most familiar with this factor.

- Smaller f-numbers (large apertures) result in shallow depths of field.

- Larger f-numbers (small apertures) result in deeper depths of field.

At very close ranges, however, even very large f-numbers (small apertures) have shallow depths of field. Figure 1-9 shows the difference between using shallow and larger depths of field. I took both photos from the same distance with the same lens and focal length (the round candle with blue in its interior). Notice that at f/5.6, the far background and foreground are very blurred, resulting in a nice bokeh. At f/16, everything has sharpened up.

✔ **Focal length:** For all practical purposes, telephoto lenses (lenses with longer focal lengths) produce shallower depth of field than normal or wide-angle lenses. Telephoto lenses create wonderful *bokehs* (out-of-focus areas of the photo, discussed later). This, in turn, makes medium telephoto lenses (70–105mm on a cropped-frame APS-C camera) very effective portraiture and wedding lenses.

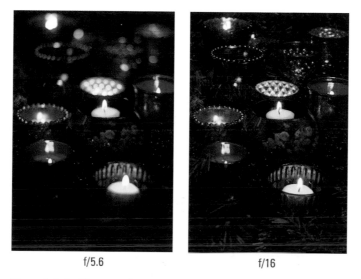

f/5.6 f/16

Figure 1-9: In this case, the aperture has a large effect of the depth of field.

Previewing the depth of field

Wouldn't it be neat if you could see what the depth of field is going to look like before you take picture? You can, through something called *depth of field preview*.

Many digital SLRs have a depth of field preview button somewhere on the front, either on the right or left side near the lens mount. Reach around to press it after you focus on your subject. Figure 1-10 shows the DOF preview button on the Canon 5D Mark III. I removed the lens to show the button better.

DOF preview button

Figure 1-10: The depth-of-field preview button is often located near the lens mount.

TIP

Checking the DOF is most effective when the aperture is set to a value *smaller* than the lens's maximum aperture.

While not a preview, many prime lenses have DOF scales printed right on the lens, somewhere near the distance scale. This gives you a quick estimate of how large or small the depth of field will be. The depth is based on your current f-number and the focus distance. Pretty handy! Figure 1-11 shows an older lens compared to a new one. The DOF scale on the older lens is nicely color coded. You can tell where the near and far points of the DOF are by matching the color of the lines with the color of the aperture and reading the distance at those points. The new lens DOFscape is, frankly, a disappointment!

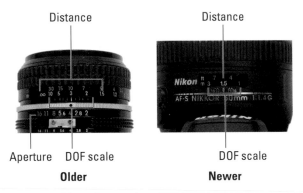

Figure 1-11: These lenses show DOF based on aperture and distance.

WARNING!

One caveat: Be careful when you're using a full-frame compatible lens with a DOF scale on a cropped-frame body. The DOF scale on the lens will overestimate the actual depth of field by a factor equal to your camera's crop factor. For example, if your camera has a crop factor of 1.6x, then the DOF on the lens will be 1.6 times larger than it should be. This is enough to throw off a carefully planned shot and produce photos with DOFs much larger than you intended. To get the proper value, divide the DOF distance given by the lens by you camera's crop factor.

Paying attention to the blurry parts

REMEMBER

What lies outside the depth of field is generally called the *bokeh*. Technically speaking, bokeh refers to the aesthetic quality of the blurred area, not its size. You either have *good bokeh* or *bad bokeh,* not large or small bokeh. However, many people refer to the blurred area in general as *the bokeh*. The size of the blurred area, or the blurred area in general, may be referred to as *that blurred area in the photo.*

Photos with great-looking bokeh are very desirable. Figure 1-12, shot with the AF-S NIKKOR 24-70mm f/2.8G ED, has a bokeh that looks like a painting. Lights and reflections also make good bokeh. A great bokeh is a tell-tale sign that a photographer is using a high-quality professional lens. When it comes to bokeh, the lens really does matter.

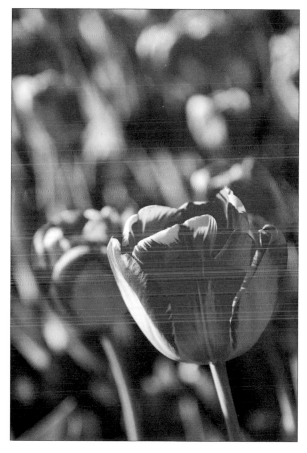

Figure 1-12: Nice bokehs are creamy and dreamy.

The bokeh depends mostly on the following:

- Unique characteristics of the lens
- Background lighting
- Scene content

Photos with deeper depths of field may have no blurry parts. Landscape photos, for example, generally remain in focus from a distance reasonably close to the camera to infinity. Figure 1-13 shows a river shot at sunset. The depth of field is infinite. Everything from the rocks in the foreground to the trees in the far distance is in focus.

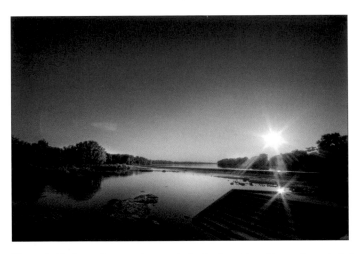

Figure 1-13: A smaller aperture and shorter focal length create an infinite depth of field in this scene.

Being realistic

Beware of obsessing over miniscule depths of field. Small depths of field make focusing much harder. You may also end up with a photo of a person who has one eye in focus and the other, which is slightly out of the DOF, blurred.

The reverse is also true. When the aperture is very small (depending on the lens, aperture smaller than f/22), diffraction starts to become a problem. *Diffraction* happens when light waves get bent as they go around the edges of the aperture. This results in softness or fuzziness in areas of the photo that should be sharp.

If you're shooting at close distances (food or product shots, for example), take test shots at different f-numbers and compare sharpness. Choose the photo that best meets your DOF (small aperture) and sharpness (an aperture not so small that you run into diffraction) needs.

If a shallow depth of field is giving you fits, try this:

✏ **Step back from the subject.** Don't just zoom out. That doesn't increase the distance between you and what you're shooting. Actually step back.

✏ **Zoom out.** If you can't step back, try zooming out.

✏ **Stop down.** For example, if you're shooting at f/1.4, try f/2.8 (or f/3.0 or an even smaller aperture). Not many people care what aperture you used; they're interested in what your photo looks like.

If you're after a shallow depth of field, do the opposite: Step in, open your aperture more, and zoom in.

Designing with Depth of Field

I encourage you to play with different situations and camera settings to discover your favorites. Experiment with different depths of field:

✏ Change apertures.

✏ Use larger or smaller focal lengths.

✏ Move closer to or farther away from the subject.

A soft background with a nice bokeh separates the subject from the rest of the photo. Figure 1-14 shows how your subjects will almost pop out of the photo if they, and nothing else, are in focus. I shot this with a telephoto lens at f/4.0. The fact that the background is very far away helps tremendously. Table 1-2 gives you some starting f-stop points.

This isn't to say that you can't shoot a landscape with a shallow depth of field or an action shot with a large depth of field. You be the judge. Although these guidelines will serve you well, there are always exceptions.

Book III
Chapter 1

Working with
Apertures

Figure 1-14: Shallow depths of field make portraits look even better.

Table 1-2	Different Shots and Their Ideal f-stops	
Type of Shot	*Try This f-stop*	*Notes*
Portraits	At least f/2.8 if your lens can handle it	A kit lens may be limited to f/5.6. Move closer and zoom in.
Action	f/4.0 or smaller	Depending on your lens and the light.
Still lifes and close-ups	f/2.8	Most still lifes will look better with either a blurred background or an obviously shallow depth of field.
Macros	f/22	Macros require smaller apertures to be practical. At f/22 you'll still have a very shallow DOF.
Landscapes	f/8	Aperture isn't the only factor that determines depth of field. If your focal distance is far enough, the depth of field can be large.
Cityscapes	f/8	Photos with large depths of field are best if they contain a lot of interesting detail in them.

Chapter 2: Go, Shutter Speed, Go!

In This Chapter

↙ **Opening and closing the shutter**

↙ **Translating speeds**

↙ **Catching the blur**

↙ **Managing the shutter**

↙ **Dealing with slowpokes**

I used to look down my nose at shutter speed. I was in love with aperture and only thought of that as I composed and took my photos. And that approach worked — when I took landscape photos using a tripod. However, when I tried to take other shots, I got frustrated fast.

I finally realized that shutter speed is very important, but for reasons that have little to do with exposure. Shutter speed isn't unique in terms of how it contributes to exposure. You can trade stops of exposure between aperture, shutter speed, and ISO, or use a flash or extra lighting if need be. Shutter speed is important because of its side effect: preventing blur.

Shutter speed is one of the most important settings on your camera. If shutter speeds are too low, and someone is moving, photos that could have been sharp won't be. Blurriness is hard, if not impossible, to correct in software.

This chapter explains how dSLR shutters work, demystifies different shutter speeds, explains how to set the shutter speed, and then discusses how to combat blur caused by camera shake or subject movement. It briefly discusses using slow shutter speeds for creative purposes and concludes with a shutter speed gallery.

Don't Shudder at the Shutter

Shutter speed is how long light is allowed to strike a single spot on the sensor.

The shutters used by dSLRs are mechanical devices in the body of the camera that keeps the sensor hidden until you expose it to light by pressing the shutter release button. (For technical reasons, the shutter speed is how long each pixel of the sensor is exposed to light.) Figure 2-1 shows the shutter of a professional-level Canon 5D Mark III full-frame dSLR. You don't normally see your camera's shutter because the mirror is in the way.

Shutter

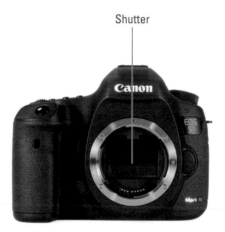

Figure 2-1: The hidden dSLR shutter.

The shutter isn't a monolithic door that opens and shuts. Focal plane shutters (named thusly because of their proximity to the focal plane, where the sensor is) are made up of shutter *curtains*. These curtains act a lot like moving horizontal blinds. During an exposure, the front (also called the *first*) curtain moves down, which starts to uncover the sensor. At the right time, the *rear* (or second) curtain follows and covers the sensor back up. The elapsed time between when the front curtain uncovers and the rear curtain covers the same spot on the sensor is called the shutter speed.

Slow shutter speeds fully expose the entire sensor all at once. Faster shutter speeds don't. Instead, a small slit moves down the sensor, exposing a piece of it at a time. (This is why the camera has a *flash sync speed,* which is the fastest speed that exposes the entire sensor at once; see Book IV, Chapter 1.)

Shutter speed values are standardized. They range from 1/4000 second to 30 seconds for entry-level dSLRs and 1/8000 second to 30 seconds for more advanced models. Slow shutter speeds may be limited to approximately 1/60 second if you're in an automatic mode, depending on the camera. You

should use Bulb mode and time the exposure if you need a shutter speed longer than 30 seconds. See "Using Bulb mode" later in this chapter.

Reading the Speed

In the days of film SLRs, shutter speeds were printed on the shutter speed dial. Although somewhat cryptic, they were pretty easy to understand. You could easily see each shutter speed in relation to the others. Today, shutter speeds may appear in any one of several formats and pop up in different displays. You also can see them while you're playing back photos.

A few twists sometimes make it confusing to interpret and understand shutter speeds. The following sections translate for you.

Fractional

Shutter speeds less than a second in length are most often displayed as fractions of a second. For example, 1/30 equals 1/30 of a second. If you're scared of fractions, think of it this way: If you divide a second into 30 equal parts and set aside one of those parts, you'd have 1 out of 30 equal parts of a second, or 1/30 second, as shown in Figure 2-2.

To make things confusing, fractional shutter speeds often appear as a single number. The first number of a fractional shutter speed is always 1, so you can assume it's there. You would see 1/30 displayed as 30. This shortcut often happens in viewfinders where space is at a premium. If you don't see a quotation mark (covered shortly), assume what you're seeing is a fractional shutter speed.

Figure 2-2: The fractional number 1/30 second is one of 30 equal parts of a second.

Fractional shutter speeds are the most common shutter speed, whether they're in fractional form (1/30) or not (30).

Seconds

When you see quotation marks after a number, read the shutter speed in seconds, not as a fraction of a second. For example, 4 seconds is shown as 4". Two and a half seconds is displayed as 2.5", as shown in Figure 2-3.

Decimal

When some cameras get near a one-second shutter speed, they start to flake out and go decimal on you. Remember that 0.5" means a half a second (1/2), not 1/5 of a second; see Figure 2-4.

Book III
Chapter 2

Go, Shutter
Speed, Go!

Seconds indicator

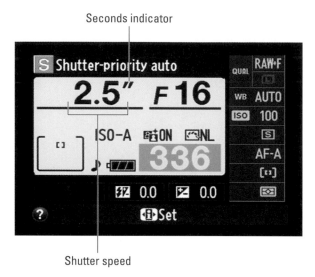

Shutter speed

Figure 2-3: Always look for the seconds indicator.

Seeing 1/2.5 can be confusing. Is it a fraction or a decimal? Both. It represents one out of two-and-a-half (divide 1 by 2.5 on a calculator), or four-tenths of a second (0.4").

Numerator may not be present

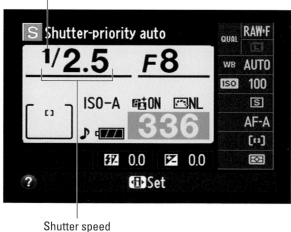

Shutter speed

Figure 2-4: This fractional speed has a decimal denominator.

Bulb mode

One shutter speed (technically not a speed, but an exposure mode) is different from the rest. *Bulb* is named for the way old camera shutters were operated with a pneumatic bulb. Your actual shutter speed when in Bulb mode is undefined. You determine its length by pressing the shutter button as long as you want the shutter to remain open. Release the shutter button to close the shutter and end the exposure.

Use a locking remote shutter release cord if you're using Bulb much. It can save your finger.

Shutter Speed and Exposure

Shutter speeds have the same effect on exposure that a lens's aperture and the camera's ISO have: A stop of shutter speed either doubles or halves the amount of light entering the camera.

Full-stop shutter speeds from 1 second to 1/4000 second are shown in Table 2-1. Each shutter speed is *half as long* as the one before it and *twice as long* as the one after it. This is the essence of being a full stop apart.

Table 2-1	Full-Stop Shutter Speeds
Fractional second	*Also Shown As*
1	1"
1/2	.5"
1/4	.25"
1/8	8
1/15	15
1/30	30
1/60	60
1/120	120
1/250	250
1/500	500
1/1000	1000
1/2000	2000
1/4000	4000

You'll often see shutter speeds 1/2 or 1/3 stop apart. Fractional stops give the camera greater precision and make it more likely to hit the exact exposure you need. You can often set this difference in the camera's menu. Look for a setting called something like *EV Steps* or *Exposure Level Increments*.

Saying a Tongue Twister: Setting Shutter Speed

If you want to control the shutter speed yourself, you have to get into a shooting mode that lets you change it. Two modes are best for this task:

- **Shutter priority:** The quintessential mode for the shutter speed aficionado. Set your camera to Shutter priority mode and then set the shutter speed yourself. Your camera meters the scene and then adjusts the aperture and ISO (if you're in Auto ISO mode) to set the proper exposure. It's simple yet effective.

- **Manual:** It's a bit harder to juggle shutter speed in Manual mode, but you can do it.

 1. **Choose Manual shooting mode.**

 2. **Set the shutter speed based on the conditions and how fast you think it should be.**

 3. **Meter.**

 4. **Choose an aperture and ISO that reach the right exposure.**

 5. **Take a shot and review it.**

 If you see blurring, set it to a faster speed and then readjust your aperture and ISO.

Enabling Long Exposure Noise Reduction

Many dSLRs have grain, or *noise*-reduction routines that automatically kick in to clean exposures you've taken with long shutter speeds (a second or longer, normally). Canon and Nikon call it the same thing: *Long Exposure Noise Reduction.*

Noise reduction only works if you're saving JPEGs. It doesn't apply to raw files.

The one drawback to this form of noise reduction is timeliness: It can delay your return to shooting. However, if you want a more-or-less finished product right out of the box (JPEGs), keep it turned on. Turn off long exposure noise reduction in your camera's menu system. See Figure 2-5.

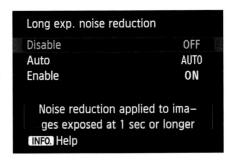

Figure 2-5: Long exposure noise reduction kicks in if you're using longer shutter speeds.

Combating Blur

Shutter speed is just like other exposure elements: It has a *side effect* that has nothing to do with exposure. In this case, the side effect is preventing blur. The shutter speed has to be fast enough to capture moving objects sharply, and if you are shooting hand-held, your shutter speed has to be fast enough for you to keep the camera steady during the exposure.

Blurry photos or subjects are caused by movement. Either you or your subject, possibly both, is moving enough that the light the camera sensor collects is *smeared*.

Camera shake, rattle, and roll

Camera shake, a form of blur that affects the entire photo fairly uniformly, is caused by motion on your part. Although long shutter speeds are a major culprit, instability in your grip or stabbing the shutter button like it's the last button you'll ever press also makes for camera shake.

The following sections explain ways to fight camera shake.

Faster shutter speeds

For basic hand-held photography, a good rule is to set the shutter speed at least as fast as the reciprocal of the focal length you're using. In other words, put a 1 over the focal length you're using to get the fractional shutter speed.

If you're shooting with a 50mm lens, keep shutter speeds at 1/50 second or faster to counteract shake. By the same token, if you zoomed in to 100mm, you should make your shutter speed 1/100 second or faster.

If you want to be particular about it, this rule was developed for 35mm film SLRs, not cropped-frame digital SLRs. If you're using the latter (most people are), you may want to use the 35mm equivalent of the focal length you're using instead of the direct reading. For a camera with a 1.5x crop factor, with a lens at 70mm, use the 35mm equivalent focal length of 105mm (70mm × 1.5). The closest shutter speed to 1/105 second (round up all ties) is 1/125 second.

Sony cameras have a camera shake warning that flashes when you're in an automatic shooting mode and the camera sees that the shutter speed may be too low for a steady shot. Sony also has a SteadyShot scale, which is a series of bars that appear when the camera shakes. More bars indicate more shakery.

We were driving home from church one Sunday morning when I say the digger shown in Figure 2-6. He was working away, moving dirt from the big pile he's on and loading it into a dump truck. I jumped out of the van (after parking it; the kids had a blast watching everything) and went over with my camera to take some hand-held shots. This is a good example of come-as-you-are photography. Thankfully, everything lined up for this shot. The light was good, I was able to get close (which meant that I was only at 55mm focal length for this shot) and keep the ISO at 100. The shutter speed was a relatively fast 1/800 second. In this case, it was plenty fast enough to counter most of my movement as well as freeze the action in front of me.

Figure 2-6: When you're running around with a camera, keep shutter speeds high.

Vibration reduction (VR) or image stabilization (IS)

These features also help reduce camera shake. When you turn them on, these features may let you slow your shutter speed from one to three stops without blurring the photo. While Canon and Nikon rely on stabilization built into certain lenses, Sony dSLRs and dSLTs have SteadyShot image stabilization built into their camera bodies. See Figure 2-7.

To turn on VR/IS, switch the button (on the side of the lens) to On.

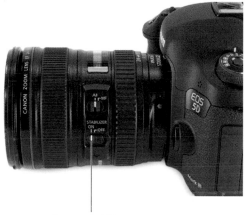

Image stabilizer

Figure 2-7: When you're shooting hand-held, turn on VR/IS.

Mirror lockup

One source of camera shake that isn't your fault is caused by the mirror. Digital SLR (not dSLTs) mirrors rotate up out of the way to unblock the sensor. It flips back so powerfully that it can shake the camera. This is a problem when you're using a telephoto lens or shooting macros.

Use your camera's mirror lockup feature (also called *Mirror Up mode* or *Exposure Delay*) to combat this type of camera shake. If your camera has a mirror lockup option, turn it on from the menu system; see Figure 2-8. Putting your camera on a tripod and using mirror lockup with a timer or a remote is a sure-fire way to avoid camera shake.

Steady the camera

You have a couple options:

- ✓ **Remote shutter release:** If your finger is causing the camera shake, increasing shutter speed won't help solve the problem. Connect a remote to your camera so you can activate the shutter button without touching it. You can also switch to the self-timer and try that if you don't have a remote.

- ✓ **Buy some legs:** You should always work to steady the camera. You may use your own grip, a monopod, a tripod, or other type of rest or support. They all work.

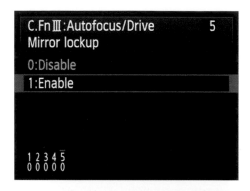

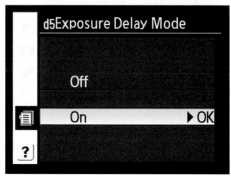

Figure 2-8: Raising the mirror early lets the vibrations settle before you take the shot.

Shooting moving targets

You get *motion blur* (also called *subject blur*) when your subject is moving too fast for the shutter speed to freeze. The subject looks blurred. Unlike camera shake, this type of blur affects only the subject, not the background. Avoid this effect by choosing a faster shutter speed, if possible.

You can get good shots of a fast-moving subject:

- ✔ Pan with that person as you shoot. *Panning* means you follow the subject with the camera as it moves across your field of view. You wind up blurring the background instead.

- ✔ Move to another spot. It's harder to capture a race horse moving directly across your viewfinder than one traveling towards you.

- ✔ Try catching moving objects in moments when the action pauses, like a tennis player at the height of her backswing. Every time a moving object changes direction, you can time your shot to the moment your subject's relative motion is smallest.

✔ Pay attention to your camera's autofocus (AF) modes. Set AF to Continuous-servo (also called AI Servo AF) rather than Single. You may be able to select a specific AF point and place it on your target, or you may want to use zone AF if something is moving erratically. Regardless of which method you use, practice before it counts.

Focal length matters when you're shooting moving targets, because your field of view is narrower and the subject is magnified greater than normal focal lengths. This tends to emphasize herky-jerkyness. Whatever's in your viewfinder can jiggle, jostle, and move much more than when you're using a normal or wide-angle lens, which causes blurring. Try a higher shutter speed.

When shooting moving targets, focus will be as much of a challenge, or more, than getting the right shutter speed. Pay attention to your camera's autofocus (AF) modes. Set AF to Continuous-servo (also called AI Servo AF) rather than Single so that you'll be able to track a moving target. You may be able to select a specific AF point and place it on your target, or you may want to use zone AF if something is moving erratically. Autofocus modes, points, and capabilities are where more expensive dSLRs differentiate themselves from entry- and mid-level consumer models. The Canon 5D Mark III has no fewer than two focus modes (manual and auto), three AF modes (One-Shot AF, AI Servo AF, and AI Focus AF), six different AI Servo cases to choose from, and several AF Area Selection modes. Just setting up the AF system can take your breath away! Regardless of which method you use, practice before it counts.

In Figure 2-9, I photographed a friend playing basketball. I set the shutter speed at 1/500 second, which was perilously slow. The trouble was the dim light in the gym. I had the lens open and the ISO elevated, and didn't want to push the shutter speed any faster. It's barely fast enough.

Figure 2-9: Faster shutter speeds stress exposure, especially inside.

Shutter Speed Gallery

In an ideal photography world, you could set your shutter speed to 1/4000 or 1/8000 second and never worry about camera shake or motion blur again. You'd only need to slow it down when you wanted a special effect. In the real world, being able to set the right exposure *and* choose a fast shutter speed without raising the ISO too far is often a real challenge, even when you're using a fast lens. The exception is when you're shooting outside on bright days.

- **It's cloudy outside or you're inside under bright lights:** Fast shutter speeds are more of a problem. If you're shooting action, you'll probably have to push your lens by using a very wide aperture. Expect to raise ISO if you want 1/1000 second or faster.

- **You're inside in dimmer light:** Prepare for an even bigger challenge. You'll need a fast lens and will surely have to raise the ISO. If the lighting is poor, even a professional-level lens will have problems if you don't significantly raise the ISO.

As you experience different conditions, you'll see how specific shutter speeds, f-numbers, and ISOs will differ from scene to scene. You should be able to quickly trade off aperture and ISO for shutter speed to solve exposure problems.

Shooting crisp photos

Always be on the lookout to shoot crisp photos, regardless of your subject. If your subject's moving or you're moving, pay attention to shutter speed and closely review your photos for blurring.

Figure 2-10 is a shot of a groundhog from our local zoo. What you can't tell from this is that he was scurrying to and fro rather quickly. He stopped and sniffed the air for a moment, and I quickly grabbed this shot. The shutter speed was 1/1000 second. That's overkill for many situations, but animals move unpredictably. Complicating matters, I was shooting hand-held with a telephoto lens. Thankfully, the light was bright, so I could shoot with a fast shutter speed and low ISO, ensuring a crisp, noise-free photo.

You won't have bright light for every photo. Figure 2-11 is a shot I took during a concert, and I just barely made it. The trouble was twofold. First, the singers and band members were moving, which required a fast shutter speed. Second, the light wasn't the best and I was working with a lens whose maximum aperture was only f/5.6. I opened the lens up, pushed the ISO to 1600, and got away with 1/125 second shutter speed. This photo is borderline crisp. I would rather have had a faster shutter speed.

When you're shooting in low-light conditions, you need a faster lens or the willingness to raise the ISO even more. The good news about high ISO is that you can often fix its noisy effects in software. It's harder (if not impossible) to correct a blurry photo.

Figure 2-10: Must be Groundhog Day.

Figure 2-11: Low light will push your camera and lens if you want to maximize shutter speed.

Capturing fast action

Faster action requires faster shutter speeds. There is no compromising. You must dial in the speed you need to avoid blurring. Set your shutter speed high and don't worry about ISO or aperture. Maximize them, in fact. See Figure 2-12.

Aside from the lens, what's the secret to capturing fast action shots? Dialing in a *fast shutter speed*.

Figure 2-12: Jets make fantastic subjects, but you had better catch them quickly.

Freeze-frame for effect

You can have fun with fast shutter speeds. Freeze-frame moments often produce very distinctive photos. Figure 2-13 is a photo of my daughter leaping off some steps at an outdoor mall. I was testing a new lens and looking to capture the kids in action. For this shot, I used an external flash with *high-speed sync* (flash mode that lets you use much faster shutter speeds; see Book IV, Chapter 1) turned on. That lit her face and let the shutter speed climb to an amazing 1/1600 second. Had the shutter speed been much slower, she wouldn't have been frozen mid-leap, which is one of the elements that makes this photo so interesting.

The photo in Figure 2-14 has the fastest shutter speed of all the photos in this chapter: 1/2000 second. The liquid is captured in mid-pour and the splashes and bubbles are frozen in mid-sploosh. A few small drops are escaping up and to the right. Shutter speed. Say it loud: shutter speed.

Figure 2-13: Fast shutter speeds can freeze the action for effect.

This shot took some planning and extra gizmos. I used an off-camera flash literally off-camera. Because I couldn't use high-speed sync if I connected wirelessly, I resorted to fooling the camera into thinking the flash was mounted on top (when it wasn't) by connecting the flash to the camera with a coiled off-camera flash cord (Nikon SC-29 TTL Coiled Remote Cord). I held the flash low and to the left by hand and pointed it at the center glass. I also attached the Gary Fong PowerSnoot spotlight to concentrate the light from the flash directly at the glass and candles and not the background. I dimmed the rest of the lights and shot this entirely with the flash. The aperture was f/1.4 and the ISO 100.

Figure 2-14: Super-fast action caught in mid-stream.

Using slow shutter speeds

When I took most photographs in this chapter, I used a fast shutter speed. On the other hand, using slow shutter speeds can be practically and artistically effective.

REMEMBER

Try shooting water, fog, or clouds with slow shutter speeds. The movement is smoothed and look very dreamy. While you can often shoot fast action hand-held, slow shutter speeds require a tripod or other stable support.

Figure 2-15 is a shot over the Dr. Martin Luther King, Jr., Memorial Bridge. I set up the camera on a tripod and turned it away from the oncoming traffic so I could catch the vehicles' tail lights as they travelled over the bridge. I had to time the shot to the traffic flow and experiment with different shutter speeds. This one, at 5 seconds, is spot on.

Figure 2-15: Moving lights are classic subjects for slow shutter speeds.

Using Bulb mode

Here's an homage to your camera's Bulb shooting mode. This mode is great for shooting fireworks or lightning. See Figure 2-16.

1. **Set up your camera on a tripod with a remote shutter release.**

2. **Set the shutter speed or shooting mode to Bulb.**

3. **Open the shutter and wait for the flash, then close it.**

Figure 2-16: Pyrotechnics are good clean photographic fun.

Chapter 3: Hi-Ho, Hi-Ho, Choosing an ISO

In This Chapter

✏ **Dialing in ISOs**

✏ **Keeping a rein on ISO**

✏ **Peeking at an ISO gallery**

*I*SO *(International Standards Organization),* the camera's sensitivity to light, is one of the three ways you can control a photo's exposure. Working together, ISO, aperture, and shutter speed let in light and react to that light.

ISO sensitivity is a subject that can get lost in the mix. Controlling your camera's ISO speed doesn't offer you the same creative possibilities that you get by setting the aperture. Nor does ISO play the same role as shutter speed in capturing a crisp photo. However, you'll find that ISO is just as important.

This chapter is devoted to ISO: explaining what it is, what effect it has on exposure, and how you can manage it. You see some examples of photos with lower and higher ISOs, and I share some tips on keeping ISO speed and noise levels under control.

Turning Up the Volume on ISO

The term *ISO* used to mean something else, but has changed so that it now describes how sensitive the digital camera sensor is to light. ISO is sometimes called *ISO sensitivity* or *ISO speed.*

Varying ISO speed

The amazing thing about having a digital sensor with a varying light sensitivity is that it gives you a third *real-time* exposure control.

You or your camera can react to changing lighting or creative impulses by adjusting the ISO sensitivity on the fly — from picture to picture, if you want. All you have to do is press a button; see Figure 3-1 or access the camera's menu or shooting display.

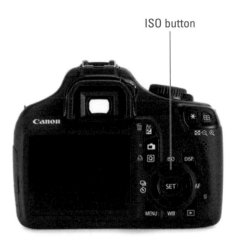

ISO button

Figure 3-1: Most new dSLRs have ISO buttons.

TECHNICAL STUFF

ISO a.k.a. ASA

When you're talking photography, ISO (sometimes referred to as *ASA,* but that's another story) was originally a measure of *film speed* — the speed at which film in a camera reacted to light when exposed. Film that was more sensitive to light, hence needing less light to expose the photo, was called *high-speed* or *fast.* Fast film had higher ISO numbers. Film that was less sensitive to light, thereby needing more to expose the photo, was called *slow.* Slow film used lower ISO numbers. Fast film tended to look grainy, because it literally was. The size of the light-sensitive crystals in the film had to be larger to catch the light faster. Slow film was created using much smaller grains, and therefore had a very fine-grained, attractive look that captured small details. The accompanying figure is an ISO dial on an older 35mm film camera.

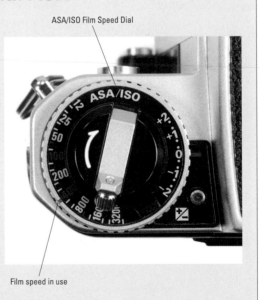

ASA/ISO Film Speed Dial

Film speed in use

This power, good as it is, comes with a certain amount of danger to it. ISO sensitivity isn't free. Every time you or your camera ratchet it upwards, you're also turning up the bad with the good: noise! *Noise* means small, often discolored specks that show up in the photo. Noise takes away a photo's clarity and roughs up smooth areas of color.

Up to a certain point (that point differs from camera to camera), you can't notice increased noise. There's an inevitable tipping point, however, where noise begins to compromise the photo until it overwhelms the shot.

Inside the numbers

In terms of exposure, ISO works just like shutter speed and aperture — only the numbers are different.

Every stop of ISO equals a stop of exposure (1.0 exposure value or EV). Raising ISO a single EV, or photographic stop, doubles the sensitivity of the sensor. By the same token, lowering the ISO a single EV, or a stop, halves the sensor's sensitivity.

Table 3-1 shows ISOs from 50 to 204800 in whole stops. (Native ISO and ISO expansion are explained here and in Book I, Chapter 1.)

Table 3-1	ISOs from Low to High in Whole Stops
ISO	*Notes*
50	Lowest ISO expansion setting on some high-end cameras (like Canon EOS 5D Mark III and Nikon D000). Generally unavailable on entry-level and mid-range cameras.
100	The most common low native dSLR ISO setting.
200	Used by some older but not quite obsolete Nikon dSLRs as lowest native ISO setting.
400	A good starting place for indoor shots.
800	Rarely used outdoors unless you need high shutter speeds.
1600	—
3200	—
6400	Highest native ISO setting on most entry-level dSLRs.
12800	Highest ISO expansion setting of some mid-range dSLRs (like Canon EOS Rebel T4i).
25600	Highest ISO expansion setting of some high-end amateur dSLRS (like Canon 60D and Nikon D7000).
51200	—
102400	Highest ISO expansion setting on some pro and semi-pro dSLRs (like Canon EOS 5D Mark III and Canon EOS 6D).
204800	Highest ISO expansion setting of professional dSLRs (like Nikon D4 and Canon EOS-1D X).

Book III
Chapter 3

Hi-Ho, Hi-Ho,
Choosing an ISO

Unlike shutter speed or aperture, ISO is very peculiarly related to the camera body. What model you have, by whom, and how old will influence what ISO settings you can use and what affects they'll have.

Take some time and look through your camera's manual. Keep these tidbits in mind as you do so:

- ✔ ISO speeds don't have commas or other punctuation. For example, ISO 12800 *isn't* shown as 12,800.

- ✔ ISO speeds are one way to tell one dSLR category from another. For example, native ISO speeds for current entry-level cameras don't rise above 6400. At the upper end of the ISO scale, however, you can find expanded ISO speeds up to 102400 or 204800. Those speeds are found in higher-level cameras. You know you have a winner when a camera in one category jumps up a level in comparison to its peers and acts as if it were a more expensive model. For example, a mid-range camera with a maximum native ISO of 25600 would be ahead of the game, given the current marketplace. Most cameras *start* at ISO 100, but not all.

- ✔ ISO speeds are a good way to judge performance of cameras in the same general price range. For example, if you're shopping for an entry-level dSLR, take a look at ISO performance between the cameras that interest you. If one clearly stands out as a winner, give it more serious consideration. ISO probably isn't the single most-important specification when shopping, but it can be a tiebreaker.

- ✔ Read the fine print when it comes to ISO capabilities. For example, many cameras restrict ISO to a certain range when you're in Auto modes. In addition, you may be able to expand ISO speed beyond the native values.

- ✔ Some dSLRs have something called *ISO expansion,* which is a way to boost the camera's ISO capability. You must turn on ISO expansion in the camera's menu system, as shown in Figure 3-2.

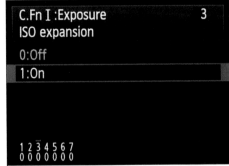

- ✔ Some cameras use numbers to identify ISO speeds from beginning to end. Some don't. For example, the Canon EOS 5D MkIII has L, H1, and H2 ISO settings, which are the *equivalent* of ISO 50, 51200, and ISO 102400, respectively. Some Nikon dSLRs also use identifiers other than numbers for low and high ISOs. For example, the D800 has multiple Lo (Lo 0.3 to Lo 1) and Hi (Hi 0.3 to Hi 2) settings.

Figure 3-2: Turning on ISO expansion lets you get to the really high ISOs.

✏ You can often adjust the ISO speed step value from a full stop to 1/3 (as shown in Figure 3-3) or 1/2 stop.

✏ Some cameras let you reprogram the ISO button to other functions. You can read more about customization in Book I, Chapter 3.

ISO speed setting increments	
⅓–stop	1/3
1–stop	1/1

INFO. Help

Figure 3-3: Changing ISO increments.

Generating noise with high ISOs

The effect of raising ISO is *noise* (small artifacts in the photo generated by the camera and sensor). Too much noise causes the photo to look grainy when you put it onscreen or print it at larger sizes.

Figure 3-4 shows the same scene shot at ISO 100 and ISO 16000 using a Sony Alpha A65, a decent high-end amateur camera. Notice that at ISO 100, the photo looks perfect. The colors are bright and there is, for all intents and purposes, no noise. At low ISOs, noise is essentially invisible. You can't detect it, unless you have super powers. However, when I raise the ISO to 16000, the photo turns into a noise-fest. The colors, sharpness, and quality of this photo are all compromised.

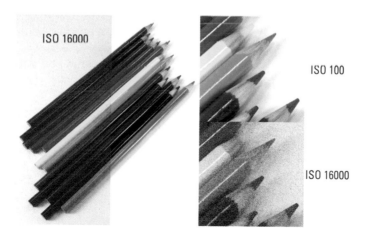

ISO 16000

ISO 100

ISO 16000

Figure 3-4: The difference between ISO 100 and ISO 16000 is loud.

Book III
Chapter 3

Hi-Ho, Hi-Ho, Choosing an ISO

Acceptable ISO speed and noise performance depend on the camera body. It gets technical, but *photo site* size (the tiny little light-catching "bucket" on the sensor), sensor size, operating temperature, and other engineering and manufacturing factors come together to make some cameras very resistant to noise while others have more of a problem with it.

I took the photo in Figure 3-5 at ISO 12800 with a Canon EOS 5D Mark III, which is a full-frame professional camera. You can see noise, but it doesn't ruin the photo. With moderate amounts of software-based noise reduction, I could even blow up the shot.

Figure 3-5: This full-frame dSLR has outstanding ISO performance even at ISO 12800.

ISO performance is one area where investing in a dSLR really pays off compared to traditional digital compact cameras — even expensive ones. Digital SLRs have larger, less noisy sensors that work at much higher ISOs than their smaller counterparts. The new crop of mirrorless interchangeable lens compact cameras with dSLR sensors in them (micro four-thirds Pen and OM-D systems from Olympus, Pentax's hybrid cameras, the Canon EOS M, and the Nikon 1), however, have closed the noise gap considerably.

The funny thing about noise

Photos get noisier the higher you have your ISO. Sometimes it doesn't matter. Sometimes it does matter: It may be there, even though you can't see it at first. You may only see it when you heavily *process* (edit) a photo (like brightening a photo considerably) or if you try to print it very large. See Book V, Chapters 2 and 3, for more about editing.

I took the photo in Figure 3-6 at our zoo. I had the camera set up with a fast shutter speed so the animals would be nice and crisp. The dim lighting in

this cage, however, forced me to bring the ISO up to 1600. Even when I zoom in, the noise in this photo isn't that much of a problem. I can't tell it from a distance.

Figure 3-6: Sometimes noise is hard to see, even when using higher ISOs.

Don't let noise scare you. Try to keep a tight rein on it, but know that some times you can ignore it or make it work for you.

Setting and Managing ISO

Unlike the other exposure controls (aperture and shutter speed), ISO doesn't have a dedicated shooting mode. That means you should always be thinking of ISO and how it will affect your photos.

You can do that in one of two ways. Both approaches have their strengths and weaknesses.

- Turn control of ISO over to the camera via Auto ISO.
- Control ISO speeds yourself.

When you know exposure isn't a problem — it's bright or the camera is on a tripod and you can use slow shutter speeds to collect more light, regardless of the aperture — keep ISO as low as possible (using either method). This strategy ensures that you shoot the least noisy photos possible. But, when getting a good exposure with my chosen shutter speed or aperture becomes a problem, ISO comes to the rescue. In these cases, I raise it without feeling guilty. It makes no sense to lose the shot because you're afraid of raising the ISO. A grainy, noisy photo that can possibly be made better in software is much better than no photo at all.

Using Auto ISO

Using Auto ISO is very simple: Make sure it's on and start shooting. The camera will raise or lower the ISO based on the scene and the other exposure settings. When you're concerned with getting the shot and don't mind that the ISO might rise dramatically or change from shot to shot, Auto ISO is a great solution.

Get familiar with some particulars:

- ✔ **Shooting modes:** Check your camera's manual to see what shooting modes have Auto ISO and if restrictions exist. When your camera is in an Auto mode, Auto ISO is on by default; see Figure 3-7. When you're shooting in a Scene mode, you may be able to set Auto ISO or switch to manual. You should be able to use Auto ISO or switch to manual ISO when you enter Program, Aperture priority, or Shutter priority shooting modes. When you're in Manual mode, you may not be able to use Auto ISO. See Book I, Chapter 5 about scenes and modes.

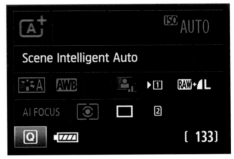

Figure 3-7: ISO is set to Auto in this mode and cannot be changed.

- ✔ **Auto ISO limits:** Most cameras limit the ISO range in Auto ISO mode. In other words, the camera's entire ISO range isn't available when you're in Auto ISO mode. You may or may not be able to expand or contract this limited range. Check by looking in the menu.

- ✔ **Configuring Auto ISO:** Most dSLRs allow you to set up Auto ISO by setting a maximum (and possibly a minimum). You may also be able to set a minimum shutter speed; if it hits bottom, your camera will start raising the ISO. Setting up Auto ISO is covered in an upcoming section.

- ✔ **Display peculiarities:** In Auto ISO, some cameras round the ISO to the nearest round number (200 or 400, for example) when displaying the setting in the viewfinder or on the LCD screen. When you review the photo, you'll see the exact ISO.

- ✔ **Auto ISO tips:** When you're shooting action (inside or out), try switching to Shutter priority shooting mode and turning on Auto ISO. This strategy puts a premium on allowing an adequate amount of light into the camera while keeping shutter speeds high enough to avoid blurring everything. If you need more ISO, switch out of Auto ISO (you may have to change shooting modes to do this) and set the ISO yourself.

Enabling and configuring Auto ISO

Take some test shots and see how much noise your camera shows at different ISOs. You may decide that you simply won't ever use photos taken at or above a certain ISO. In that case, you can restrict Auto ISO by changing its bounds. This gives you some control over an otherwise automated process.

Depending on your camera, you might be able to modify some or all of these settings:

- **Turn on Auto ISO:** This is where you turn Auto ISO on or off. See Figure 3-8.

- **Minimum sensitivity:** You can sometimes specify the minimum ISO. Raise this only if necessary. For example, you may want to limit the total range to keep the noise level relatively uniform.

- **Maximum sensitivity:** The highest ISO that you want the camera to use. Set this to a value that reflects how much noise you're willing to work with, as shown in Figure 3-9.

- **Minimum shutter speed:** I encourage you to use this fantastic setting. It tells the camera the minimum shutter speed you're willing to accept before it raises the ISO to keep the photo from being underexposed. The camera lowers the shutter speed below the minimum only if it can't raise ISO enough to get the necessary exposure. You can leave it on Auto in some cases, or specify a specific value. Figure 3-10 shows an example of setting the minimum shutter speed.

 - Use a fast shutter speed if you're shooting action shots.

 - Use a slower shutter speed if you're shooting relatively static photos.

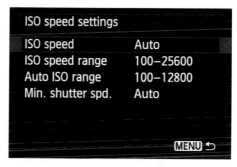

Figure 3-8: Turn on Auto ISO.

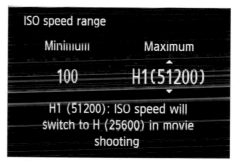

Figure 3-9: Set a maximum speed.

Min. shutter spd.			
Shutter speed Auto			
AUTO	1/250	1/125	1/60
1/30	1/15	1/8	1/4
0"5	1"		
INFO Help			

Figure 3-10: Often, you can set a minimum shutter speed.

Book III
Chapter 3

Hi-Ho, Hi-Ho, Choosing an ISO

Setting ISO manually

Manual ISO mode takes the camera out of the ISO loop. You have to set it yourself.

Setting manual ISO is easy:

1. **Enter an appropriate shooting or exposure mode.**

 You're normally not allowed to set the ISO yourself in the various Auto modes.

2. **Press the ISO button.**

 Or press its equivalent; Canon offers a Quick Control mode and Nikon uses an Information Display for quick access to ISO settings.

3. **Dial in the ISO you want.**

 You may be able to set ISO in whole stops, half stops, or even thirds of a stop. Check your camera's menu system to see what your options are. Figure 3-11 shows the ISO being set to 100.

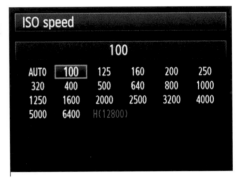

Figure 3-11: Manual override engaged and ISO set to 100.

If you're particular about ISO, manually control it when you can. This will help you be aware of what ISO you're using and know that it isn't changing from one photo to another. This control is critical if you want all photos from the same photo shoot to have the same noise characteristics.

What if you simply must get the photo and you need to rely on ISO to take up the slack (you've maxed out your aperture and are struggling to get shutter speed)? By all means, set the ISO to Auto and get the shot in the can.

Using High ISO Noise Reduction

Many dSLRs have noise-reduction routines that automatically kick in. Canon calls it *High ISO Speed Noise Reduction;* Nikon calls it *High ISO NR.*

Only JPEGs get high ISO noise reduction; raw files don't.

Unlike long exposure noise reduction, you can set up high ISO noise reduction's strength. Typical Canon settings are Standard, Low, Strong, and Disable, as shown in Figure 3-12. Nikon prefers Off, Low, Normal, and High. The curious thing about ISO noise reduction is that it's always applied, even if you tell the camera to turn it off; it's just applied less in that case. Maybe Off should be renamed Very Low. Some cameras (the Nikon D3200 is one example) may have only one customizable noise reduction setting.

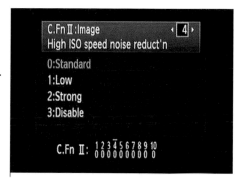

Figure 3-12: Check out your camera's high ISO speed noise reduction options.

The drawback to high ISO noise reduction is that it can delay your return to shooting. However, if you want a finished JPEG right out of the camera, use the Standard/Normal setting. Turn off long exposure noise reduction in your camera's menu.

Knowing When to Hold 'Em: ISO Strategy

Your photography will improve if you know how to minimize ISO versus when to raise it, and have a general sense of what ISOs work in a given situation.

Use these tips to keep ISO low:

- **Shutter speed:** Lower the shutter speed to let in more light. Every stop of shutter speed that you can slow down saves you a stop of ISO. For example, rather than raise ISO from 400 to 800, try lowering the shutter speed from 1/250 to 1/125 second.

- **Aperture:** Enlarge the lens's aperture (lower the f-number) to let in more light. Every full f-stop of aperture saves you a stop of ISO that you would otherwise have to raise. For example, rather than raise the ISO to 400 from 200, change the f-stop from f/8.0 to f/5.6.

- **Image stabilization:** This feature helps you lower shutter speeds and prevents blurring from camera shake by one or more stops, depending on the camera and lens. For every stop you can lower the shutter speed without shaking, you save yourself a stop of ISO.

✔ **Tripod or monopod**: If your subject lends itself, mount your dSLR on a tripod or monopod. This eliminates camera shake and opens up slower shutter speeds and lower ISOs.

✔ **Flash:** Using a flash changes the game quite a bit. Raise ISO if you need to extend flash range and to brighten the background.

✔ **Reflectors:** If you've ever had your photo taken professionally in-studio, you probably saw large light reflectors (that look like umbrellas or screens) pointed at you. These reflectors bounce light onto the subjects. You can use reflectors to balance light and brighten a scene. Brighter light means a lower ISO.

✔ **Shoot outdoors during the day:** You can't always do this, but try taking photos outdoors in nice daylight. You won't have to raise the ISO as much, if at all.

✔ **Other lighting:** If you're indoors, open the drapes and turn on the lights. All the light you can bring into the room helps lower the need to raise the ISO.

✔ **Limit Auto ISO:** Set your camera's Auto ISO settings to a range you're comfortable with. If it's between ISO 100 and 400, make it so. If you're comfortable going to ISO 1600, then by all means set the high end of your Auto ISO range there.

✔ **Invest in fast lenses:** If you're shooting indoors a lot, ditch your slow lens and get one with a lower f-number. If you're shopping for zoom lenses, try finding an affordable one that you like that has the same performance throughout the focal length range. For example, if you're using the Canon EF-S 17–85mm f/4–5.6 IS USM, consider moving to the Canon EF-S 17–55mm f/2.8 IS USM or EF 24–70mm f/2.8L USM. If you can't afford a new Canon lens of this caliber, look for a used lens or one from a third-party lens manufacturer (Sigma or Tamron, for example).

✔ **Get a newer and better camera:** This step may seem dramatic, but you can often buy a brand new dSLR with improved ISO performance for less than the price of a good lens. If you're able to spend more and jump up a category (for example, from entry-level to mid-range), you'll gain even more performance.

Test your camera to evaluate its noise performance and determine where your limits are. Shoot a number of photos of the same subject in the same lighting with different ISO speeds. Compare the photos on your computer. You'll be able to quickly see where noise becomes a problem.

Knowing that cameras, lenses, and situations can lead to different ISOs, Table 3-2 offers some general ISO pointers by situation.

Table 3-2	Setting ISO by Situation
Situation	*ISO Setting Considerations*
Sunny	ISO can stay low, even for action.
Clouds or shade outside	ISO may have to go up, especially for action.
Night	ISO depends on what you're shooting. ISO can be low if the camera is stabilized and you're shooting with longer shutter speeds. ISO speed may need to be high if you're working hand-held and need to set faster shutter speeds.
Inside	ISO speeds can vary from low to high. Things that push it up: shooting hand-held, low light, not having a fast lens, and needing fast shutter speeds to avoid blurring people.
Flash	ISO can stay low. However, raising the ISO will make the background brighter.
Studio	If you're shooting under controlled conditions with bright continuous lights or strobes, try keeping ISO very low unless it's absolutely necessary to raise it.

Looking for Noise

The photos in this section show a few examples of how using higher ISOs in different situations affects photos. I divided the need to raise ISO into two categories: low light and action.

Figure 3-13 shows a nighttime bridge heading toward downtown. Although the bridge is lit and some other lights are present, it's still a very dark scene. I wanted a relatively fast shutter speed of 1/60 second to artificially limit the amount of light entering the camera, which meant that the ISO had to take up the slack. I raised it to 6400 and hoped for the best. As you can see, it's a pretty noisy photo!

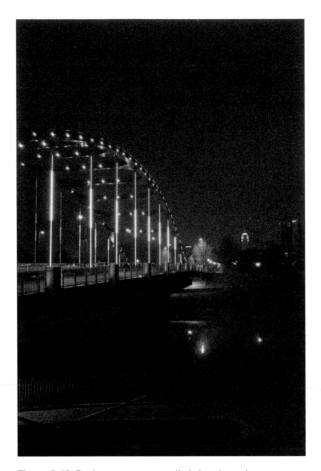

Figure 3-13: Dark scenes can really bring the noise out.

However, noise reduction can rescue you. Figure 3-14 shows the same photo after a bit of smoothing. The sky and lights look a lot better. It's not terribly sharp, but that's okay.

In Figure 3-15, I had the opposite problem. The light was decent (not great), and I couldn't open the lens more than f/5.6. I wanted a decent shutter speed but didn't want to raise the ISO higher than 1600. As a result, the photo has a mixture of noise and softness (the softness is visible when you zoom in dramatically, as opposed to the motion blur of the performer's hands and guitar

head, which is part of the performance). I like the result, but I wish I had loosened up on the ISO and raised the shutter speed more. I would have gotten more noise, but a sharper photo.

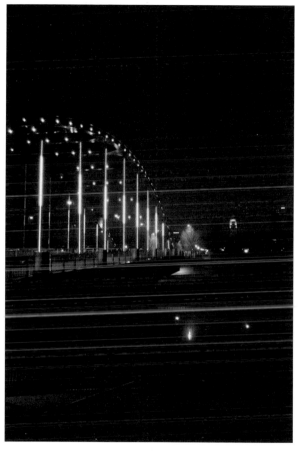

Figure 3-14: In this case, noise reduction helped quite a bit.

When you're choosing between noise and blur, set your camera to reduce blur. You can always try reducing noise in software later.

Figure 3-15: Don't be afraid to raise ISO to capture the action.

Figure 3-16 shows that principle in action. I raised the ISO to 12800 while photographing friends shooting hoops. That ISO was high for the camera I was using. I captured this scene with a shutter speed of 1/500 second. The action was frozen, but had quite a bit of noise. In this case, the main challenge was the dim gym lighting. Shooting action inside will push ISOs up higher than you want! You may even have to raise the ISO even when you're shooting outside in daylight.

Figure 3-16: Capturing action inside in dim lighting is a real challenge.

Chapter 4: Fabulous Filters

In This Chapter

- Finding out about filters
- Deciding on a filter system
- Browsing filter types

*I*n digital photography, everything seems to revolve around advanced computer technology. I'm not necessarily complaining. It's just that this reality can lull you into thinking that there was never any other way to take a picture. There were, and there are, and it has nothing to do with the Stone Age. Filters, although decidedly analog, are *real*. You can hold them in your hand. They clink musically and take up space in your camera bag. When light passes through them, something physical — not modeled, simulated, or programmed — happens to the light. I don't know about you, but that fascinates me. I want to know more.

The trouble is, standing in front of a large filter display in a camera shop, or going online and browsing, can be highly intimidating. Questions course through your gray matter. What are these gizmos? How do they work? Should I bother? Which ones are best for me? I hope to answer these questions in this chapter about fabulous filters and help you explore your options.

Weeding Through Filter Information

In many ways, filters are decidedly simple. You put a filter on your camera's lens and then take photos. Grasping the entire range of possibilities, however, is more of a challenge.

Looking at how filters work

Filters (sometimes called *optical* or *physical filters*) work by literally getting in the way. You stick filters on the front of or in your lens so that light from the outside world has to pass through on its way to the camera's sensor — simple stuff. As light passes through a filter, something magic happens, as shown in Figure 4-1.

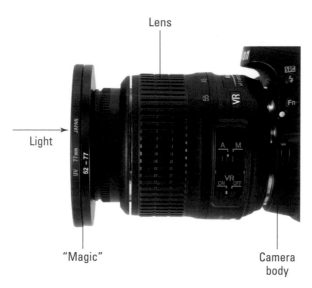

Figure 4-1: Light must pass through the filter for it to work its magic.

That magic something is different for each type of filter. Knowing what filters do will help you decide whether to invest the time and energy required to use them. They may solve one or more problems you've been having with your photography.

- **Change color, tone, and contrast** by holding back certain wavelengths of light. Filters can either enhance contrast or reduce or soften contrast. When used in black-and-white photography, color filters transform some colors into dark tones and other colors into lighter tones in the black-and-white image.

 Red filters look red because they partially block light from the other side of the color wheel. Red light is allowed to pass through. Blues, greens, and yellows are not, to different degrees.

- **Darken a scene** by making it harder for all light to pass through. You can reduce or balance the exposure. ND filters do this.

- **Enhance color and contrast** by blocking polarized light. A polarizing filter makes it harder for reflected light to pass through by reducing glare and reflections from water, metal, glass, and other smooth surfaces.

- **Reduce haze** by absorbing UV light.

- **Create different special effects** by diffusing or diffracting light.

- **Other effects:** Among a bunch of other effects, filters can soften focus, add mist, add a radial zoom, mask areas, add lens reflections, and magnify.

Color Filters for WB

It's debatable whether using color filters on a dSLR for white balance is necessary. After all, you have perfectly good white balance controls on your camera. However, some people feel that correcting select light sources improves your camera's dynamic range and reduces the chance of overexposure. This has a ring of truth to it because unfiltered light does have an effect on metering and exposure, which happen before you take a shot. White balance is a processing step that happens after the fact, even when performed in the camera.

If you're familiar with software filters and effects, and with common photo editing tasks, you can make the switch to physical filters quite easily. Think of the tasks you perform using software, then match that up with the physical filter that does the same thing.

Going over filter pros and cons

You don't have to go out and buy every filter at once. Start with one or two different filters and see what you think.

Having a circular polarizer filter to block annoying reflections is a good first choice if you shoot a lot of these subjects:

- Landscapes with water
- Buildings with glass sides and windows
- Portraits of people who wear glasses

Book III
Chapter 4

Fabulous Filters

If you shoot inside, or shoot mostly portraits, you'll benefit from filters that correct white balance.

Consider these pros to using filters:

- **They work:** *Neutral density (ND)* grads actually affect the balance of light in the scene. (*Grad* is a fancy shortening of the term *graduated*, which means the filter transitions from clear to shaded.) It's real and not emulated, which means you're getting the actual effect. Someone didn't have to program it to come *reasonably close* to the real thing in software. Having said that, there may be quality differences between filters and brands of filters that affect how well they perform.

- **Time:** Using the right filter on the scene means that you can often spend less time processing and editing your photos.

- ✔ **Creativity:** The amount of creativity you can express with filters is staggeringly large. It's like having a Hollywood special effects division supporting your photo shoot.

And consider these cons (not to be confused with convicts):

- ✔ **Quality:** Many question the benefit of putting a $20 (or even a $100 filter) in front of a $1,500 lens. Think about it.

- ✔ **Compromise:** Some question whether it's worth potentially degrading a photo by making light pass through more stuff to get to the camera's sensor when you can perform most filterlike adjustments in software.

- ✔ **Convenience:** You have to carry filters around and they take up space in your camera bag. Software filters are much lighter by comparison.

- ✔ **Fragility:** Optical filters (unlike their software counterpart) get scratched or break. If you have some, invest in some sort of filter case. I've picked up a variety of cases; you can see them in Figure 4-2. All offer reasonable amounts of protection, just in a different package. Some filters come with these soft cases. Others are shipped in hard plastic cases. In my experience, it's harder to fit more than a few hard plastic cases in your camera bag and get at them with any ease. Soft cases are better for long-term storage or for extra filters.

Figure 4-2: Buy the type of case that fits your needs and fits into your camera bag.

- ✔ **Cleanliness:** Filters can get smudged and dirty. Fingers are a filter's worst enemy, as shown in Figure 4-3.

Figure 4-3: The one photo I didn't have to dust for you.

✔ **Cost:** Filters cost money, which always seems to be in short supply. You're limited in the number of filters you can buy, the number of lenses you can support with filters, and the number of times you can replace or upgrade them. With programs like Photoshop, you buy it once, and the filters work on every photo in your collection, whether you took it today or five years ago.

✔ **Interoperability:** Different lens sizes need different filters.

✔ **Time:** Setting up and swapping out filters takes time and effort. Don't underestimate this. To use filters, you really must want to.

✔ **The X factor:** When you're using a real filter, you have one chance to get it right. In software, you can try a lot of different filters and effects with the same photo until you're happy with the result.

Using filters with dSLRs

Using filters is easy enough. You may spend a few moments getting set up and deciding what filter you want to use, but you'll soon start taking shots. When you get the hang of it, you get faster with filters.

Clean your filters at home before heading out on your shoot.

1. **Evaluate the scene and choose a filter.**

 • If you go out during the *golden hour* (the hour before sunset or after sunrise) and shoot landscapes into the sun, a neutral density (ND) filter or an ND grad filter works well.

 • If you shoot portraits and like warm skin tones (and you don't use reflectors or gels for that task), you might choose a warming filter almost all the time.

 • If you're experimenting, try something different. Choose a filter first and dedicate your shoot to exploring its potential.

 • If you're problem solving (exposure, for instance), you should know what filters are in your bag and pull them out when needed.

 Most people agree that using more than two (three at the most) filters at the same time degrades image quality. Every pane of glass, resin, or polyester is another layer between your expensive lens and the sensor.

2. **Slide or screw in the filter.**

 Depending on your filter system, either screw your precleaned filter to the end of your lens or slide it in the holder. More on the different filter systems later.

3. **Meter and adjust exposure.**

 Your filter's documentation might give specific metering instructions. Experiment and take test shots to fine-tune the exposure.

**Book III
Chapter 4**

Fabulous Filters

For graduated filters, the center of the scene should be properly exposed, even with the filter in place. If you're using spot metering, you may see better results from pre-metering the scene and then mounting the filter. Be prepared to review your photos and adjust, if necessary.

4. **Take the photo and review the photo.**

 - If you're using a filter with an evenly distributed effect, such as an ND filter, examine the entire photo and make sure it has the right exposure or effect.

 - If you're using an ND or color grad, make sure the filter is lined up properly with the horizon and that no halos (bright outlines) appear around buildings or objects near the horizon.

 - If you're using a color filter, check the hue.

 - If you're using a polarized filter, check for glare.

5. **Correct and start over or stay on course.**

 If the photo looks good, you're good to go. If not, try to figure out what's causing the problem. Is the filter on the lens? Is the filter on correctly? Is this filter right for this scene? Reexamine your starting assumptions, if need be, and question whether you need *this* or *any* filter.

Taking Shape with Filter Systems

Filters come in two main flavors:

- ✔ Circular filters screw into the lens.
- ✔ Rectangular filters slide into a frame mounted on the lens.

Circular (screw-in)

Circular filters are quite popular and easy to work with. Figure 4-4 shows my small collection of Hoya 77mm black-and-white filters. (I suppose that the terms *circular* and *screw-in* are redundant. Can you even turn a square or triangular screw?)

Circular filters have three main characteristics:

Figure 4-4: Each filter produces a differently toned black-and-white photo.

✔ **They are round:** This circular piece of glass (some filters are made from other materials) is mounted in a frame. Higher quality filters use metal frames that are quite sturdy.

✔ **They screw in:** Circular filters screw into the front end of dSLR lenses. Don't incorrectly thread a filter when you're mounting it. You might ruin the filter or, worse, strip the threads on your lens. Take your time and, if necessary, back out the filter by turning it counterclockwise until you feel it correct itself. Then get back on track.

If your hands are slippery and can't grip the filter, get a gripper from a kitchen store and use its better traction as you grip the edges of the filter. Or, buy a filter wrench; see Figure 4-5 for a filter in a filter wrench.

Figure 4-5: This filter wrench is for larger filters; it's holding one right now!

✔ **They have a size:** Filter are sized by their diameter (the distance across, going through the center), which is measured in millimeters. This is important. *You must match your filter size with your lens.* Many lenses have their filter size printed on the front or top. If it's not in either of those places, check your manual.

If you want to use filters on multiple lenses that require different filter sizes, buy a single, large filter size and use step-up rings to modify their size. This means you buy a step-up ring for each differently sized lens, but only one size filter. I have four step-up ring sizes (52–77mm, 55–77mm, 58–77mm, and 62–77mm) that let me fit one filter size (77mm) on several lenses, as shown in Figure 4-6. If you go this route, make sure to get step-up rings that are large enough to fit your largest lens.

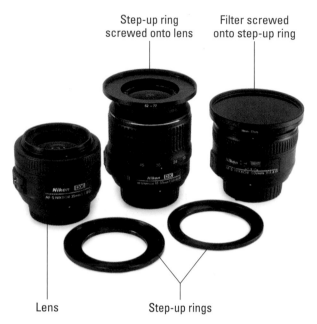

Step-up ring screwed onto lens

Filter screwed onto step-up ring

Lens

Step-up rings

Figure 4-6: Buying several sizes of step-up rings is cheaper than buying several filter sizes.

Rectangular frame slide-in

The other main filter type relies on a frame mounted to the lens that enables rectangular filters to slide in and out; see Figure 4-7. The advantage of this system is similar to that provided by step-up rings. You buy the frame and enough adapters to mount it on your lenses, and one set of filters. As long as you have the right adapter ring, you can use the same filters on lenses of many different sizes.

Figure 4-8 shows a Cokin system (`www.cokin.com`) attached to my 35mm lens with an extra adapter and filter. Rectangular filter systems have these main parts:

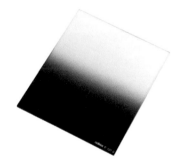

Figure 4-7: Rectangular filters can get rather large.

✔ **Adapter:** This piece screws into the filter ring on your lens and has fittings to slide on the filter holder and make a secure attachment. Simply

buy the correct adapter for each of your lenses and you're ready to rock. Read the manual to make sure this type of filter system works with the lenses you want to use it with. Most normal dSLR lenses work fine. You may have to buy a different system for wide-angle lenses.

✔ **Filter holder:** This element holds one or more filters. The holder slides onto the adapter. Filters slide into the holder rather than screw into the lens, which makes changing them extremely easy. It also makes the filters compatible with many different lenses. Notice in the figure that there's room for three filters in this particular adapter.

✔ **Rectangular filter:** The reason for the entire setup is the filter. It's larger than a screw-in filter and is rectangular. Most rectangular filters don't have frames around them, so be careful when handling them. You can buy filter wallets, sleeves, and boxes for storage. Figure 4-8 shows the entire setup, complete with an extra filter leaning against the lens.

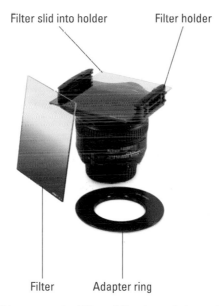

Filter slid into holder Filter holder

Filter Adapter ring

Figure 4-8: This rectangular ND grad filter is ready for action, with backup standing by.

All in all, the rectangular system is ingenious if you have several lenses that take different filter sizes. Having a rectangular filter holder makes a robust filter library more cost effective. However, the size of the mount with filters is bigger and bulkier than the traditional circular screw-in variety.

Tackling Trouble with Different Filters

This section has information on several different filter types. Browse through them to see what excites you. Think about the photos you normally shoot as you consider whether a filter type is right for you.

The sheer number of filters and filter types can be overwhelming, and getting this straight in your mind can take some time. I summarize many of the problems that filters help solve in Table 4-1. In each case, I try to compare the filter to a pair of glasses that do the same thing. When you realize how similar they are, it takes away a lot of the confusion surrounding filters. Have fun experimenting with different brands, makes, models, and strengths!

Table 4-1	Problem Solving with Filter Types	
To Do This	*Try These Filters*	*Notes*
Protect your lens	Clear or UV filter	UV filters also cut haze.
Control exposure	ND filter	Available in different strengths.
Balance exposure	ND or color grad	Use ND grad for a neutral effect, or a color grad to emphasize certain colors.
Reduce glare or reflections	Circular polarizer	Rotate to dial in desired effectiveness.
Reduce haze	UV filter	Can also keep on the lens to protect it.
Enhance color	Color or color grad	Effect depends on the color of the filter.
Correct color	Warming, cooling, balancing, or color compensating	Use to adjust white balance or correct tints.
Tone black-and-white photos	Black-and-white filters	Special colored filters that control how colors are translated into black-and-white tones. Common colors include red, green, yellow, blue, and orange.

To Do This	Try These Filters	Notes
Alter contrast	Contrast or other filters	Many filters affect contrast. There are also contrast-specific filters.
Special effects	Fog, haze, stars, mask, close up, mist, diffusion, and more	Experiment with many different types of filters for a range of special effects.

Protective

Using a protective filter is similar to wearing shop glasses. You don't do it because it's pretty — you do it to protect your eyes. A *protective filter* is clear, high-quality glass that protects the lens. You can leave it on your lens all the time. As long as the filter is clean, the photo shouldn't be affected. The filter essentially serves as a clear lens cover.

Is putting a filter on your lens that does nothing like buying a box of air? You bet. If a clear protective filter is in place, you don't have to constantly clean your lens. You clean the filter instead, which keeps the lens (and its irreplaceable coating) from accidentally being scratched.

Circular polarizer

Polarized filters act like a good pair of polarized sunglasses: They filter out distracting reflections and glare. The details of how this type of filter works and why are somewhat technical and, honestly, irrelevant to using them. Polarized filters block *reflected* light (which can even happen in the sky) while allowing natural light to pass through them.

You have to tune, or *dial,* a polarizing filter by rotating it so that it rejects the reflections you want.

Figure 4-9 shows two photos. I took two shots in a river bed, looking down at the water. With the polarizing filter, the photo shows the reflected sky despite my pointing the camera at the water. In the other photograph, I dialed the circular polarizer so that it blocked the reflections of the sky, showing the riverbed itself. I find the difference between the two shots amazing. Digital SLR metering and autofocus sensors are compatible with circular polarizer filters, not linear polarizers.

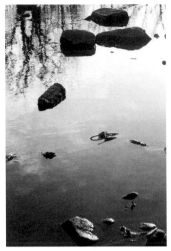 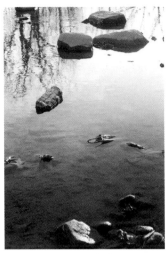

With polarizer Without polarizer

Figure 4-9: Polarizer: The blue sky is reflected in the water. Sans polarizer: Details are underneath the water's surface.

Ultraviolet (UV)

Sunglasses with ultraviolet (UV) protection are better for your eyes because they block a lot of haze. If exposed to too much UV radiation for too long, you can damage your eyes. Ditto for UV filters: They block UV light, which causes blue haze when you're shooting around water, into the air, or into the distance. (Think of the phrase *purple mountains majesty* in the hymn *America the Beautiful*.) As Figure 4-10 shows, UV filters appear clear. That's because people can't see ultraviolet light.

Figure 4-10: This filter specializes in blocking light that you can't see, but can cause haze.

UV filters aren't the same as polarized filters. There's some debate as to whether digital cameras respond to UV filters, because most manufacturers build UV and IR protection into their sensors. In addition, many lenses are coated to reject UV wavelengths. There's no doubt UV filters work at blocking UV light, but if the lens and the camera can do as good a job, you may not need the filter.

Neutral density (ND)

Neutral density (ND) filters act like normal sunglasses: They darken. ND filters come in different strengths; some darken a lot, and some darken only a little. For Figure 4-11, I attached ND filters and took a ten-second exposure at f/5.6. I couldn't shoot this any other way than by using ND filters to tone down the light. They acted like negative ISO.

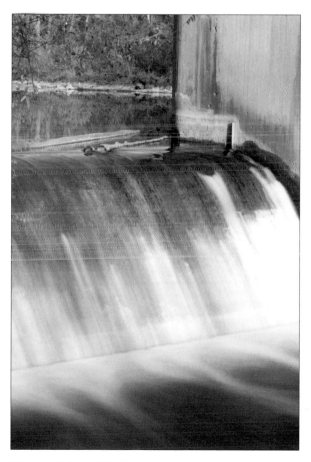

Figure 4-11: I used ND filters for a long exposure in bright daylight.

ND graduated

ND graduated (or *grad*) filters resemble cool-looking aviator sunglasses with a gradient. They're darker at the top to tone down light from the sky, and they're clear toward the bottom so that you can see your instruments. This

is the filter Maverick would use if he were a photographer instead of a fighter pilot.

With an ND grad filter, you can set longer exposure times for the land.

Figure 4-12 shows (an admittedly artistic rendering of) a sunset scene looking out across a lake. The sky is too bright; the water is okay. This is a pretty good application for using an ND grad filter. It evens the exposure between the sky and water. The other photo in Figure 4-12 shows the same shot taken with an ND grad filter. The sky, which has far more detail, is now balanced with the water. In this particular case, I wasn't concerned with the distant shoreline. I preferred to keep that in shadow. The night was very colorless.

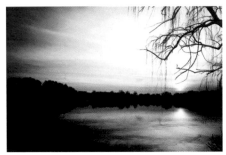 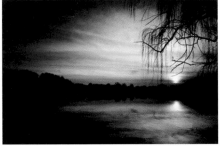

Without ND grad filter With ND grad filter

Figure 4-12: Blown-out sky versus a balanced exposure thanks to the ND grad filter.

Color filter

Look through these rose-colored glasses to change the color of the scene. I include *cooling* (making things look bluer) and *warming* filters (making a scene look more golden) in this color category. Think of them as white balance correction on the front end of your lens.

Color grad filter

A color grad filter combines elements of both color and ND grad filters. Imagine an ND grad filter that isn't gray, but in color. Tiffen makes color grads designed to add color to normal or washed-out shots. Many work at sunrise or sunset, but you can use them to create special color effects.

Other filters

A ton of filter types are available, in addition to the ones I describe earlier. If you catch the filter bug, visit a store in person or online and check them out. Download a brochure to see before-and-after photos for each type of filter.

In-camera filters

Many dSLRs offer in-camera processing options that mimic optical filters or *software filters* (some are computerized imitations of photo filters, others are more creative special effects) and retouching techniques that you might do in programs like Photoshop. Software filters are normally found in an Effects or Filters menu.

Sony's Picture Effects has several filterlike effects, including High Contrast Mono, Soft Focus, and Rich-Tone MONO. Some Canon dSLRs use Creative Filters, which aren't identical to most filters, but nonetheless creative. Nikon also has post-processing options called Filter Effects.

Black-and-white filters

Originally used for black-and-white film photography, they enhanced contrast and emphasized certain tones (which ones depend on the filter color). You can get the same effects with your dSLR by using this type of filter and setting your camera to produce monochrome JPEGs; see Book I, Chapter 3 for more on JPEGs. You can use a color image with the same filter and convert it to black and white yourself; see Book V, Chapter 6 for more on black-and-white photos.

Figure 4-13 shows the color image of a scene I shot with a red filter. The other photo in Figure 4-13 shows what the final photo looks like. Rather than use the black-and-white JPEG, I processed the RAW image.

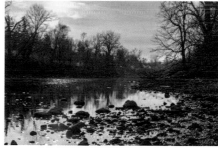

Red filter Processed RAW photo

Figure 4-13: What's black and white and red all over? A photo shot with a red filter before it's converted to black and white.

You'll have a whole lotta red in your photo unless you have your camera set to produce black-and-white photos. Raw images will be saturated with red no matter what. Don't panic. You can use the black-and-white JPEGs or process the raw image as black and white (see Book V, Chapter 6).

Infrared filters

Infrared (IR) filters are like X-ray goggles. Use an IR filter to get rid of all light except infrared. They turn your photos into surreal works of art. That's the good news. The bad news is that new digital cameras, including dSLRs, are made to filter out infrared light and reduce their sensitivity to it. This defeats the purpose of putting an IR filter on your lens.

If you're curious about IR filters, you can experiment by mounting your camera on a tripod, using long exposure times, and raising ISO through the roof. Your lens/dSLR combination may make IR photography impractical, however.

As an alternative, the folks at Life Pixel Infrared (`www.lifepixel.com`) will convert your camera so it can shoot hand-held IR photos (much like standard photography). They take your camera apart and replace the filter that covers the sensor. If you feel up to the do-it-yourself challenge, they also have conversion kits.

Creative filters: Stars, mist, or haze

Use these filters to exercise your creativity. The sky is the limit. (If you ever saw Elton John in his heyday, you know what glasses to compare these filters to.)

Figure 4-14 shows a photo I took with a Hoya Star-Six filter. The filter is engraved. When light strikes the lines, it produces six-sided stars. I took this shot at night looking out at a well-lit bridge heading into downtown. The filter has transformed the lights on the bridge, the distant buildings, and the water reflections.

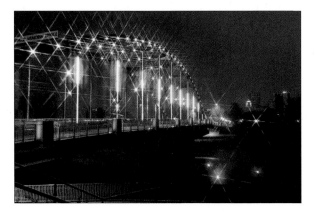

Figure 4-14: Star effects are very cool; use them wisely.

Chapter 5: Strategizing Exposure

In This Chapter

✏ **Reading meters**

✏ **Trading units of exposure**

✏ **Employing exposure tricks**

✏ **Reading a histogram**

*I*t's easy to tell if a photo is under- or overexposed. All you have to do is review it on your camera's LCD monitor. Is it too bright? Too dark? If so, you can apply a corrective influence one way or another. Sort of like when you let go of the bowling ball and lean to influence its path.

The technical aspects of accomplishing this: learning what to call different elements (*exposure value*), tracking exposure on your camera, knowing the different metering modes, playing back photos, reading histograms, knowing how to use AE Lock, and applying other troubleshooting techniques.

Revealing Exposure

In one sense, *exposure* is the amount of light that enters the camera when you take a photograph. Three settings together determine how bright or how dark your photos are:

✏ **Aperture** and **shutter speed** decide how much light hits the camera's sensor. Read Book III, Chapters 1 and 2, respectively, to know more about aperture and shutter speed.

✏ **ISO** decides the sensor's sensitivity to light. Read Book III, Chapter 3, for more about ISO.

Figure 5-1 represents each exposure setting with an arrow. The arrow can be larger or smaller — representing that setting's individual contribution to the overall exposure. The combination of the three result in the actual exposure. Where it lands depends on the lighting. The same settings that produce an award-winning shot may be totally inappropriate in another scene.

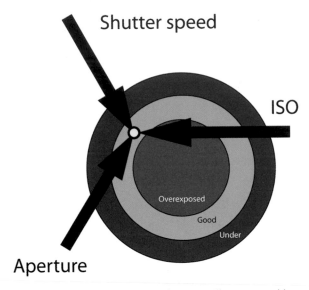

Figure 5-1: Each of the three settings contributes something to exposure.

Is it under or over?

In another sense, exposure isn't unlike Goldilocks. Photos can be under-, over-, or perfectly exposed. Figure 5-2 shows an example of each.

- **Underexposed:** Too dark. The photo shows trees as dark silhouettes and the fog barely visible behind them. I was experimenting with a Holga lens mounted on my Nikon D3200 and searching for the right exposure. In this case, the aperture (not adjustable on a Holga) and ISO contributed too little light. I couldn't lengthen the shutter speed because I was shooting hand-held and was already on the edge of blurring the scene.

- **Overexposed:** Too bright. I overreacted by elevating the ISO to 6400. The result is an overexposed photo.

Overexposed photos often have *clipped* or *blown highlights*. When this happens, the color component of the pixel is pure white. There are no details at all.

✔ **Properly exposed:** Just right. In the last photo, all three exposure elements combine in the proper amounts to capture the light in the scene and produce a good photo.

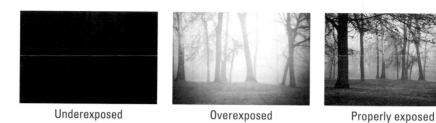

Underexposed Overexposed Properly exposed

Figure 5-2: You can see two extreme examples and a nice in-between exposure.

Choosing an exposure mode

The exposure mode you put your camera in (see Book I, Chapter 5) determines who does what: you or your camera. Figure 5-3 shows a dSLR Mode dial.

Manual exposure modes Advanced autoexposure modes

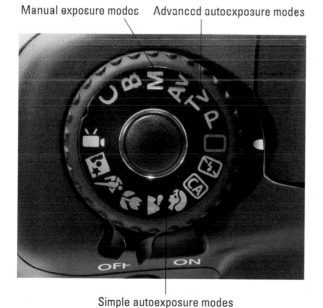

Simple autoexposure modes

Figure 5-3: Your camera's mode dial is dominated by autoexposure modes.

Letting the camera decide what the best exposure is called *autoexposure*. (Sometimes the camera gets it right. Sometimes it's off. That's why there is an exposure troubleshooting section at the end of the chapter.)

Your camera has different types of autoexposure modes:

- Auto and Scene modes take all control.

- Aperture priority and Shutter priority mode let you set one or more of the exposure controls and have the camera figure out the rest.

- You have total control only in Manual (M) mode. The camera meters the scene and suggests what it thinks the right exposure is, but it's up to you to change the settings to reach that, or whatever other exposure you want.

Regardless of the mode you're in, the camera's *light meter* works behind the scenes to measure how much light is in the scene. This happens when you press the Shutter button halfway. Using the information it gathers, the camera comes up with an exposure solution. You can adjust what parts of the scene the camera uses to measure the amount of light if you need to (more in "Lovely Rita, Meter Reading Maid," later in this chapter).

EV talk

You measure exposure in photographic stops, which double or halve the amount of light for every stop you raise or lower. If you raise the exposure by a stop, you've doubled the light. How you doubled the light can vary, based on how you've set the exposure controls. You may have lowered the shutter speed or shrunk the aperture. You could also have lowered the ISO.

Exposure is also measured in *exposure value (EV)*, which is the numerical equivalent of a stop. Exposure values are normally relative to 0, which is considered the standard exposure.

- If you overexpose a photo by a stop, then the EV is +1.0.

- If you underexpose the photo by a stop, then the EV is -1.0.

Stops and EV are so powerful because you can exchange units of exposure without worrying where they came from. A stop is a stop, whether it comes from changing the shutter speed, aperture, or ISO. In terms of exposure, it doesn't matter if you get a 1.0 increase by opening the aperture up, slowing the shutter speed, or increasing the ISO.

Figure 5-4 shows the settings display, complete with the shutter speed, aperture, and ISO. Each of these settings contributes to the photo's exposure, as shown on the exposure index. The exposure index is measured in EV (not

stops of aperture, shutter speed, or ISO speed). I cover the exposure index later in this chapter.

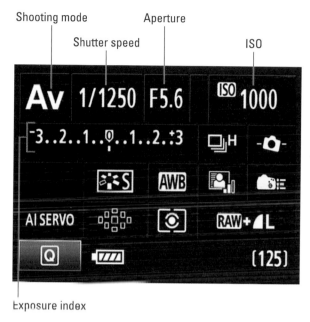

Shooting mode Aperture

Shutter speed ISO

Exposure index

Figure 5-4: Stops are distilled into exposure value (EV).

Book III
Chapter 5

Strategizing
Exposure

For the most part, you'll use one form of autoexposure mode or another. The only time you'll need to step in is if you have problems. The only way to tell if there are problems is to review the photos you take at the scene and confirm that they're correctly exposed.

Keeping an Eye on Exposure Settings

You have to be able to read and understand all your camera's exposure tools.

Finding your settings

Press the shutter button halfway to see the current shutter speed, aperture, and ISO speed appear in several places. Shutter speed and aperture are often paired; ISO tends to be off on its own:

- ✔ **Viewfinder:** The exposure settings often appear prominently at the bottom of the viewfinder, as shown in Figure 5-5.

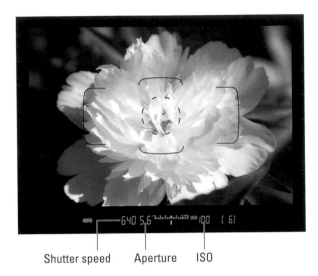

Shutter speed Aperture ISO

Figure 5-5: The shutter speed, aperture, and ISO speed all appear in the viewfinder.

✔ **LCD monitor:** The exposure settings also appear in the various information-tion displays, as shown in Figure 5-6. In this case, the shooting information display is along the top. When you're in Live view or shooting movies, exposure data often appears at the bottom of the monitor and looks similar to what you see in the viewfinder.

Shutter speed Aperture ISO

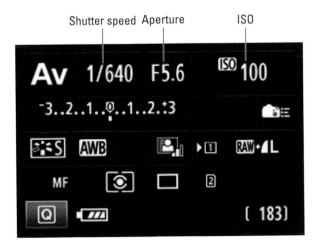

Figure 5-6: This is known as a shooting information display.

✔ **LCD panel:** If your camera has a top LCD panel, you can also check the exposure settings there. See Figure 5-7.

ISO Shutter speed Aperture

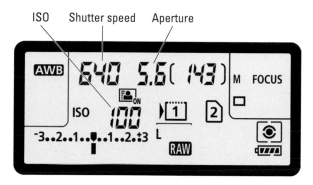

Figure 5-7: Don't forget to look at the LCD panel, if you have one.

Exposure scale details

As you can see, all the displays have an *exposure level indicator* scale (a.k.a. *exposure scale* or *exposure meter*), shown in Figure 5-8. The center of the scale (sometimes labeled with a 0 but often not) indicates a *standard exposure* — the combined exposure value with inputs from all the camera's exposure settings that the camera thinks will produce the best photo.

Standard exposure

Darker ◄————————|———————► Brighter

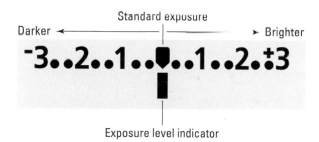

Exposure level indicator

Figure 5-8: The exposure level indicator scale shows you the exposure.

The numbers to the left and right of center tell you how many stops — or levels of exposure value (EV) — you are away from the center.

✔ Negative numbers indicate underexposure.

✔ Positive numbers indicate overexposure.

The size of the scale may vary, but cameras usually show a minimum of +/- 2.0 EV from the center. Some cameras have displays that read +/- 5.0 EV. Normally, the bar under the scale, known as the *exposure level indicator,* predicts a photo's exposure, relative to the standard exposure, taken with the current meter reading and using the current exposure settings.

In autoexposure modes, the exposure level indicator stays pegged in the middle. After all, that's the point of autoexposure. In Manual shooting mode (when you haven't set ISO to Auto), the exposure level indicator moves depending on your exposure settings, in relation to how far you're going to under- or overexpose the photo. If you set your exposure settings so that the exposure level indicator is on 0, you'll take the standard exposure.

After you set the exposure in Manual mode, the settings won't change between shots, even if the meter displays a slightly different light level. Shooting in Manual mode is an excellent way of making sure that your photos consistently use the same exposure settings, which is to your advantage when processing them the same way later.

The indicator can move left or right by a process known as exposure compensation (described later in the chapter). When you're shooting with auto exposure bracketing, each bracket's exposure is often marked with a tick mark.

Your camera may have several exposure-related warnings. Pay attention to the warnings. If the camera says it can't reach the right exposure, it may blink. See Table 5-1 for solutions.

Table 5-1	**Exposure Warnings and Their Solutions**	
Setting	*What's Happening*	*Solution*
Aperture and shutter speed	If both the aperture and shutter speed values blink, the camera can't select a combination that will properly expose the image. This most often happens in Program autoexposure mode.	Adjust the lighting or change the ISO setting.
Aperture only	The aperture blinks if the camera can't set the aperture to expose the image properly at the selected shutter speed. This happens in Shutter priority mode.	Change the shutter speed or ISO.
Shutter speed	The shutter speed value blinks if the camera can't select a shutter speed that will produce a good exposure at the aperture you selected. This happens in Aperture priority mode.	Choose a different f-stop or adjust the ISO.

Lovely Rita, Meter Reading Maid

Metering is the process of sensing how much light is in the scene in front of you. It answers the question, "How bright is it?" The answer helps determine what aperture, shutter speed, and ISO sensitivity you or your camera need to set in order to take the proper shot.

There are two different ways to measure how much light there is in a scene. They are:

✏ **Reflected light** bounces off stuff and then finds its way into your camera or light meter. Reflected metering is also called *spot* metering. Cameras use this metering method exclusively, while many external light meters have spot-measuring capabilities in addition.

 • *Downside:* Reflected metering is that *not everything reflects the same amount of light.* The classic example: Separately photograph a black, gray, and white plate using the same light. Because the colors reflect light differently, your camera will think the exposure is different. The problem is, it isn't!

 • *Upside:* They work great when you point them at distant objects. They're also very good at targeting a specific object and using that for the exposure setting (like a person's face or something very reflective).

✏ **Incident light** meters work differently. Rather than sensing reflected light, an incident light meter sits in the scene and measures how much light is falling on the scene. Most incident meters have a white-colored dome or disk that bulges out from the meter's body, as shown in Figure 5-9. Ambient light passes through the dome and is measured by the meter. Cameras can't do this without special attachments.

 • *Downside:* They don't take reflectivity into account. If you're photographing something very bright and reflective, an incident light meter doesn't take that into account, and may recommend setting the exposure too low.

 • *Upside:* You can extend some, and that's best when photographing objects with depth. Some are used flat, and that's best when photographing flat subjects.

REMEMBER

The long and the short of it is this: Your camera has a reasonably good reflective light meter built right in, but it's not perfect. Be aware of the limits mentioned for both types and be able to switch metering modes accordingly (or manually compensate for poor exposure). If you want a more realistic gauge when shooting portraits and other studio-type shots, as well as many landscapes, consider buying a light meter.

**Book III
Chapter 5**

**Strategizing
Exposure**

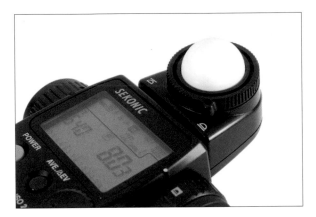

Figure 5-9: The dome measures incident light.

Tripping the light meter fantastic

To start the light meter in your camera, follow these steps:

1. **Frame up the shot you want to take.**

2. **Press your shutter button halfway.**

 You don't have to hold it. The camera remembers the light measurement for a moment (this is called the *metering timer* or *AE Lock time*) and suggests exposure settings based on your current shooting mode. However, most of the time you'll want to continue keeping the shutter button pressed halfway so the camera will autofocus and you won't lose the reading if it times out.

Some dSLRs meter when you press other buttons as well as the shutter button. This lets you meter without focusing. You may also be able to reprogram the metering/autoexposure function to a new button of your choice. See Book I, Chapter 3 for more on that topic.

If your metering mode isn't working well, consider changing it. You can control how your dSLR measures light by switching among one of several metering modes, described here:

Pattern

Camera manufacturers call their scene-based metering modes by different names: 3D color matrix metering II (Nikon), evaluative metering (Canon), digital ESP metering (Olympus), and multi segment metering (Pentax and Sony).

For *pattern mode,* the camera divides the scene, and each area's brightness is evaluated separately. The more zones on the list, the more the scene is broken apart and each area evaluated discretely.

Pattern mode is the best general-purpose metering mode. You don't need to switch from it unless you specifically want to measure light reflecting off of specific objects or areas in the scene.

Center-weighted

Center-weighted mode meters the entire frame but gives more weight to elements in the center than around the edges. Though the weighting ratio varies, it's in the range of 70 percent center to 30 percent edges. Some cameras let you change this size of the center area.

Use center-weighted metering for portraits so that your subjects — not the background behind them — dominate exposure analysis.

Spot

Spot metering measures light in a narrow circle and ignores everything else. This feature is useful if you want to use a specific point in your frame to calculate the exposure. Photographers use spot metering frequently to meter a bright area, to keep it from being overexposed.

Spot metering is good when you're photographing performers or musicians lit by bright spotlights. To measure incident light, use a light meter.

Letting your external light meter shine

An *external light meter* (most often simply referred to as a *light meter*) is a separate gizmo that measures the amount of light in a scene. That's all it does. It doesn't take pictures. More expensive light meters can measure reflected and incident light. Some light meters only measure incident light. While not strictly necessary, a light meter can be a valuable addition to your kit.

Look up your light meter's manual for specific instructions. In the meantime, I can provide a general sense of how they work.

1. **Turn on your light meter and set it up.**

 Set the measuring mode, if necessary (some measure flash as well as ambient light). Extend the dome if you're using the meter incident mode, as shown in Figure 5-10.

If you're using the meter in spot mode, sight what you want to meter through the meter's eyepiece before you press the measure button, and you can keep the light dome retracted.

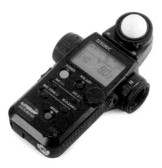

Figure 5-10: The Sekonic L-758DR light meter is ready for action.

2. **Choose a shooting mode.**

 Select the shooting mode that lets you enter the setting you want fixed. For example, if you want to set the meter to use f/8 as the aperture, set the meter to Aperture priority mode. This has nothing to do with your camera. You won't be using this mode anyway, as Aperture and Shutter priority modes on your camera are *autoexposure* modes.

3. **Enter the value.**

 Enter the appropriate fixed value, such as the aperture or shutter speed, that you want to use.

4. **Enter an ISO speed.**

5. **Hold the meter so that nothing is in its way.**

 If you're shooting a landscape, hold the light meter out or up to keep your body from blocking the light. If you're shooting a portrait, go over to your subject and hold the meter with the light dome pointing towards the camera.

6. **If necessary, press the measure button.**

 This meters the scene.

7. **Read the measured exposure setting value.**

 This isn't the setting you entered in Step 3. It will be the floating exposure setting that you haven't accounted for.

8. **Switch to Manual mode on your camera and enter the values indicated by the light meter.**

Taking a Look at Your Work

Don't look down at your nose at this section. Reviewing photos is one of the most important aspects of digital photography. You've got that fancy three-inch monitor on the back of your camera: Use it to check your photo exposure.

If you don't review your photos, you can't use any of the troubleshooting techniques described later in this chapter; you won't know what's wrong.

Setting up Auto Review

To automatically review photos right after you take them, make sure your camera's Auto Review feature is turned on. You can customize it by shortening or lengthening the time each photo is played back, as shown in Figure 5-11. This initial review is often good enough to quickly check the photo's exposure and color. However, if you don't zoom in and carefully inspect your shots later, you'll often miss details like whether they're sharply in focus.

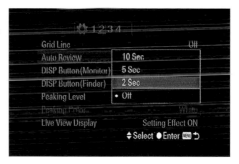

Figure 5-11: Make sure to set up Auto Review to your liking.

Delving into photo playback

There's more to photo playback than you might think. You should begin by pressing your camera's playback button, if you can find it. Figure 5-12 points out the playback button, as well as other buttons you might use during playback.

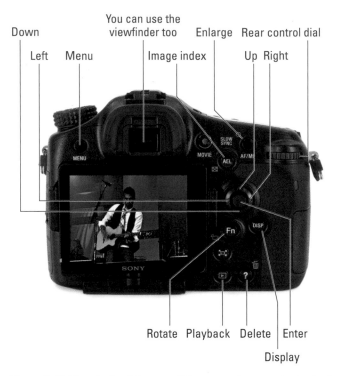

Figure 5-12: The playback button will be somewhere on the back of your camera.

I hit the highlights in this section. Please read your camera's manual to see how to use specific features. Pressing the playback button should do the following:

✔ **Display different amounts of data:** You can change what information you see during photo playback by pressing your camera's Display or Info button. If you want a general sense of the photo, turn off everything. If you want a reminder of the settings you used, increase the amount of information, as shown in Figure 5-13.

✔ **Zoom in and out:** Press your camera's zoom button to go in and closely inspect your photos.

✔ **Pan back and forth:** When you're zoomed in, use your camera's controller to move back and forth in the photo.

Figure 5-13: Less (left) and more (right) information is available.

✒ **View indices:** You can often show small thumbnails of your photos: 4, 6, or 9 at a time.

✒ **Check the histogram:** Examine the photo's histogram to check general exposure and color. See the next section, "Unlocking the Secrets of the Histogram," for more details.

✒ **Check for clipped highlights:** See whether you have clipped highlights with the Highlight Alert (Canon) or Highlights (Nikon) display during photo playback. When this feature's on, overexposed areas will blink. If you see large areas (and that isn't your creative goal), rethink the camera's exposure and take another shot.

There is one caveat to this feature: Areas of the photo that are clipped in one or two color channels, but not all three, may not register as clipped highlights. This means they won't blink. Examine the photo's color histograms for exposure across the board. (All photos have three layers of color information: red, green, and blue.)

✒ **Delete the bad ones:** Don't save obviously bad photos. Delete them from your camera's memory card asap. This should involve pressing your camera's Delete or Trash button and confirming.

✒ **Protect the good ones:** Alternatively, you can protect the photos you want to keep so they don't accidentally get deleted. You might be able to press a specific button to protect a photo.

✒ **View playback on a TV (HD or otherwise):** Depending on your camera, you may be able to play back photos (and movies, but that's another story) on a television. Look at the terminals on the side of your camera. They're protected by a rubberized cover. If you see an HDMI terminal (see Figure 5-14), you can connect your camera to an HDTV. If not, your camera may only work with standard-def televisions or HDTVs with older audio/video inputs. Please read your camera's manual for specific details.

**Book III
Chapter 5**

**Strategizing
Exposure**

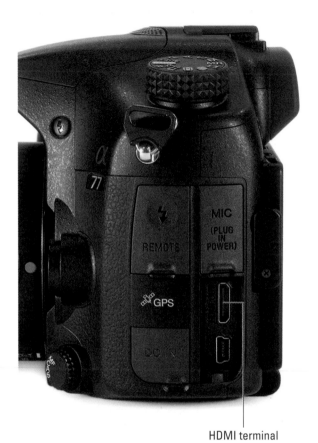

HDMI terminal

Figure 5-14: The HDMI terminal on the Sony Alpha A77.

Unlocking the Secrets of the Histogram

Histograms are brightness charts. They show you how pixels relate to other pixels in the same photo. They show a big picture. If your histogram is *live,* one that shows you the scene before you take the shot, you have the added benefit of seeing this picture before you take the photo.

Histograms can be important exposure and color-related proofing tools. They tell you quickly and easily, despite the limitations of 3-inch LCD monitors on the back of dSLRs, whether the photo has the overall characteristics that you want, as well as if the photo's properly exposed and whether the color is balanced.

You have to know what you're looking at for it to make sense. Go forth and know!

Decoding histogram properties

Histograms have two axes and four directions. See Figure 5-15.

- **Horizontal axis:** Each point on the horizontal axis represents a brightness level. To the left are dark pixels and to the right are bright pixels.

- **Vertical axis:** The height of the chart at each brightness level represents how many pixels share that brightness. Higher points represent more pixels; lower points mean fewer pixels.

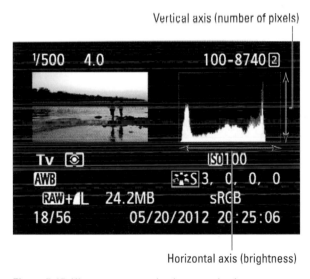

Vertical axis (number of pixels)

Horizontal axis (brightness)

Figure 5-15: Histograms are a basic two-axis chart.

Histogram shapes give you important information about your photo. Knowing how to interpret these shapes is central to effectively using a histogram. A later section in this chapter, "Putting it all together," shows examples of these key histogram characteristics:

- **Big bumps** tell you a lot of pixels are that brightness. If the bump starts to look more like a peak, the pixels are concentrated over fewer brightness levels. If the bump looks more like a mound, then the pixels are spread out.

Book III
Chapter 5

Strategizing
Exposure

✒ **Dips and valleys** tell you there are fewer pixels at that brightness. These shapes can be concentrated (tall peaks that stand out from the surrounding pixels) or spread out.

✒ **Empty areas** tell you there are no pixels at that brightness.

✒ **Squished edges** tell you that those pixels are clipping. The chart has run out of room to display their brightness, whether dark or light.

Different people use different terminology to refer to clipping. Some say that details get *lost in shadows* and that highlights are *blown out*. Each can also be described as *clipped* because the chart looks cut off, or clipped, at that point.

Histograms may also be in color. When you see a red, green, or blue histogram, you're looking at a histogram of that color channel. You can't always tell what type of histogram you're looking at if the histogram is black and white. Refer to your camera's manual. Typical convention, however, is to display brightness histograms this way.

Understanding different histogram types

Digital SLRs use two broad types of histograms: brightness and color. They show you different things and the terms can sometimes be confusing. Here's how their approaches differ.

Brightness histogram

Brightness histograms chart brightness. Although there are two types, dSLRs tend to use the luminance histogram more often than the combined RGB histogram.

✒ **Luminance histograms** weigh the brightness information of each pixel close to how the human eye sees a scene. Each pixel (red, green, and blue) has a weighted brightness, and the histogram charts those values. See Figure 5-16.

You can check a photo's overall look this way, but not the precise exposure level. Luminance histograms don't always provide adequate warning against color clipping.

If you look only at a photo's luminance histogram, you may be tempted to think that you have plenty of exposure headroom, when in fact you're close to overexposing one or more of the separate color channels.

Cameras that have luminance histograms warn of clipped highlights only for pixels that have clipped highlights in all three color channels simultaneously. If that clipping is spread out across different pixels (for example, some pixels have clipping in the red channel but not the green and blue), you don't see any exposure problems with a luminance histogram.

Luminance histogram

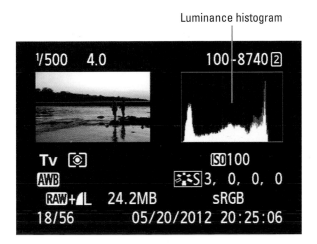

Figure 5-16: This histogram charts brightness.

↙ **Combined RGB histograms** chart brightness by creating separate color channel histograms (red, green, and blue) and adding them together. RGB histograms aren't weighted. Each channel is as important as the other. The problem with this approach is that each pixel's spot in the histogram is skewed toward the strength of any one of three component colors, not by the perception of its brightness. In other words, a pixel that's close to blowing out the red channel will show up as very bright, even if the green and blue components are next to nothing.

Therefore, combined RGB histograms are better at showing you if any of the three color channels are clipping, not the photo's perceived brightness. To know which channel(s) is in danger of being overexposed, you must examine the individual color channel histograms.

You may also see combined RGB histograms referred to as *three-channel RGB histograms* or even *RGB histograms*. The latter can be confusing, as color channel histograms can collectively be referred to as *RGB histograms*.

Book III
Chapter 5

Strategizing Exposure

Color histogram

These histograms chart the brightness or saturation in each color channel (red, green, and blue). An example is shown in Figure 5-17. *Saturation* describes a color's purity or vividness. The less vivid a color, the closer to gray it is. When it becomes gray, the pixel has no color information — it's completely desaturated. When the color (red, green, or blue) is more vivid, it becomes brighter, cleaner, and more vivid. When it's as bright as it can possibly be and there's no place for it to go, it's fully saturated.

Color histograms

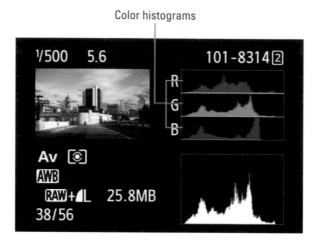

Figure 5-17: In this case, the color histograms are colorized to match the channel.

Individual color channel brightness histograms are sometimes called *color histograms*. Collectively, they may be called *RGB histograms* because they show the three color channels. This fact leads to a lot of confusion.

Your camera will have one brightness histogram (luminance or combined RGB), not both. To see which one it is, compare histograms of photos displayed by the camera versus Photoshop or Photoshop Elements.

1. **Transfer some photos to your computer, but keep copies on your camera for this experiment.**

2. **Open a JPEG and look at the histogram panel.**

3. **Compare the RGB channel to the Luminosity channel.**

 The RGB adds the red, green, and blue channels together, while the luminosity channel has something entirely different.

Shedding light on luminance histograms

If you remember one thing from this section, let it be this: Luminance histograms *aren't* good at predicting exposure. (Combined RGB histograms are marginally better exposure tools, but not by much.) Luminance is based on perception, and exposure doesn't run on perception (although maybe it should).

I can hear you now, because I've asked myself the same question: If you shouldn't use luminance histograms to check exposure, then what are they good for? Use them to check a photo's brightness and to dissect how that *tonality* (a fancy word that brings to mind that you can use subjective terms like dark, medium, and light to describe brightness) is distributed.

Here's what different luminance histogram shapes suggest about the photo's perceived brightness:

- ✔ Since dark pixels are on the left, a histogram that has more pixels in that direction indicates a dark photo.

- ✔ Likewise, if there are more pixels on the right side of the histogram, the photo is bright.

- ✔ If the histogram consists of a big mound that stretches to both sides, it is an evenly lit, normal photo.

With luminance histograms, *brightness* and *overexposure* aren't interchangeable concepts. A photo that may not look too bright to you may still have lost data because of clipping in one or more color channels. As a result, the color may be off, even if the brightness is okay. Scenes with strong primary colors (red, green, or blue) make brightness and exposure less likely to match. Scenes with strong *midtones* (more neutral colors in the middle of the histogram) make brightness and exposure match up better.

Interpreting color histograms

If you can read a luminance histogram, you shouldn't have trouble reading color histograms. Remember, though, that these histograms display color brightness or saturation.

Keep in mind some key color histogram pointers:

- ✔ Color channels that are heavily weighted to the left (the dark side) have little color information. They're dark and not very vibrant.

- ✔ Color channels that are heavily tilted to the right (the light side) may have too much color and be overly saturated. Red sweaters will look like blobs of red with no detail. A bright sky might not blend smoothly.

- ✔ Color channels with clipped lows or highs suffer just as much as when that happens in a brightness histogram. Details are lost forever.

- ✔ Color channels that should have the same relative brightness but don't may mean a white balance problem. If the photo is largely neutral, the prominent red, green, and blue humps should line up together.

Putting it all together

I want to share several real histograms with you and talk about what they show.

Figures 5-18 through 5-27 are histogram displays. To save space, they aren't full sized. The point is to quickly compare the histograms with the photo thumbnail, as you would on your camera, and to see at a glance what is going on. You don't need to zoom in 1,000 percent when evaluating histograms.

✓ **Underexposed:** Figure 5-18 is a shot taken from a riverbank, looking up toward a nice old bridge and into the sky beyond. As you can tell from the heavy concentration to the far left side of both histograms, this photo is underexposed (although it still has a nice quality to it).

✓ **Low key:** Although Figure 5-19 is dark, it's not underexposed. The histograms don't go off the left edge. This means that shadowy detail is present, but dark.

✓ **High key:** The still life in Figure 5-20 is presented very brightly. The histograms don't go off the far right edge. This means that I haven't lost any data, even though everything looks white.

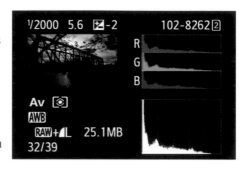

Figure 5-18: Details are lost off the left edge of the histogram.

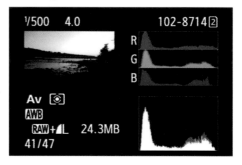

Figure 5-19: Dark, but no loss of details.

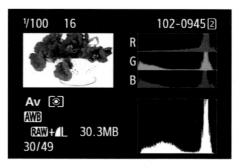

Figure 5-20: Bright, but everything is here.

✔ **Overexposed:** In Figure 5-21, I'm shooting into the sun. Two people are sitting on benches inside a gazebo. The sun overpowers the bright side of the histogram, resulting in clipped highlights.

✔ **Low contrast (mid-tone heavy):** Figure 5-22 is a photo of a rough concrete path. It's almost perfectly gray. The large hump in the middle of both histograms, combined with little extremely bright or dark areas, indicates low contrast.

✔ **Even contrast using full histogram:** My wife is making a salad on our picnic table in Figure 5-23. The scene has a nice mixture of reds, greens, and blues, as well as brightness values. The histograms are wide and the photo shows good, but not overpowering, contrast.

✔ **High contrast:** Figure 5-24 introduces more contrast. Notice the lack of mid-tones in the center of the histograms. Most of the data in this picture is on one end or the other, without being clipped. That there's no lost data is key to preserving detail, and typical of a well-executed high-contrast photo.

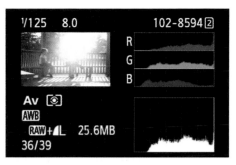

Figure 5-21: This photo is overexposed because of the bright sun.

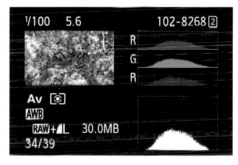

Figure 5-22: The histogram indicates low contrast with plenty of gray

Book III Chapter 5

Strategizing Exposure

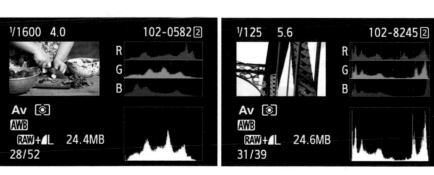

Figure 5-23: In a blue shirt, cutting radishes that have green leaves.

Figure 5-24: This scene has a wide dynamic range without losing details (show with clipping).

✔ **Extreme contrast with loss of detail:** I shot Figure 5-25 from the inside of a garage. I had to use Manual shooting mode and set the aperture and shutter speed to maximize contrast. I was able, despite the impressive dynamic range of the camera I was using (the Canon EOS 5D Mark III), to blow out details in the window and push the dark areas of the photo off the left side of the histogram.

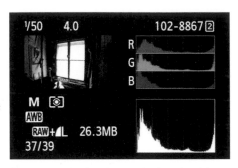

Figure 5-25: Losing data on both ends of the spectrum.

✔ **Good color:** Figure 5-26 shows a nice range of color and brightness. The main reason I include it is to compare with the next photo and prove that histograms can display similar properties while the photos are very different.

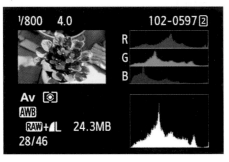

Figure 5-26: The colors are nicely distributed in this photo.

✔ **Color imbalance:** In Figure 5-27, two of my kids are having fun bowling. Although the pins in the distance look white, the overall color balance is skewed toward an ugly yellow. One look at the RGB histogram confirms that the photo has too few blues. Although Figure 5-26's blues are primarily dark, they extend throughout the brightness range. In this photo, they drop out early.

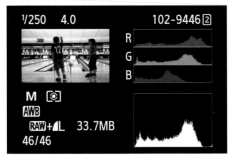

Figure 5-27: This photo is too yellow.

Troubleshooting Exposure

If everything always went as planned I wouldn't have to write this section. The good news is that you can review your photos and look at their histograms to decide whether they are under- or overexposed. You don't even have to be that precise. "A little" or "A lot" are valid answers!

Diagnosing why the camera may have it wrong may be more difficult (it may be a metering issue, a backlight problem, or something else), but you can bypass that entirely and jump to the solution. This section lists some different exposure techniques to try (or to make sure they are on) to right the ship.

Setting the exposure manually

One of the most powerful exposure tools in your arsenal is you. Given an understanding of what you want to accomplish creatively, combined with the limitations of your equipment and the lighting on hand, you can effectively troubleshoot exposure by bypassing the camera's autoexposure modes and handling it yourself.

Each photographic stop has the same effect on exposure, whether it comes from shutter speed, aperture, or ISO. You can swap one for another to get to the exposure you need.

Here are some suggested steps to setting exposure manually:

1. **Choose Manual mode.**

2. **Decide what exposure control you want to set first.**

 Let your creative goals guide you to limit one of the three exposure controls:

 - *Aperture:* Smaller is better for landscapes. Larger is better for portraits. Read Book III, Chapter 1 for more about aperture.

 - *Shutter speed:* Set a fast minimum (this is the point you are not willing to shoot slower than) for action and dim light when going handheld. If you try another mode first and the shutter speed is too low, limit shutter speed. Set the shutter speed high enough to avoid blurring.

 - *ISO:* For shooting still subjects from a tripod, set to lowest ISO and slow shutter speed. If your camera shoots relatively noise-free photos up to ISO 800, use anything from ISO 100 to ISO 800.

3. **Set the first value.**

 After you've decided which side effect is most important (limiting depth of field, limiting blur, or limiting noise), lock down that control by choosing a value.

4. **Set the second exposure control.**

5. Adjust the other exposure controls to get the right exposure.

The exposure scale tells you whether the camera thinks you're under- or overexposing the photo. When you're troubleshooting, you may need to ignore the camera. If you've already taken a shot and it was too bright, tone down the exposure by a third, a half, or a whole stop. Raise the exposure if the photo was too dark.

Don't make wild changes unless the other photos were significantly off. Keep changes small and try to be methodical about it.

6. Take a photo.

7. Review it.

This is the most important step. I know you want to get back to shooting, but you can't rush this step.

- Look at the photo on your monitor and decide if it's too dark or too light.

- Check the color histograms to see if any colors are clipping.

- Zoom in, if necessary, to check details.

If the exposure looks good, you're basically done. You may be able to use the settings for more photos, provided the scene and lighting don't change much.

8. Continue adjustments, if necessary.

If the exposure is off, return to Step 5 and work with your floating exposure control. You may also return to Step 4 and revise the second control. If your exposure solution won't work for more drastic reasons — you can't set the right shutter speed to avoid blurring or you're concerned about too high an ISO, go back to Step 2 and reset your priorities. You may have to live with more noise or a smaller depth of field.

Shutter speed is generally the least forgiving exposure element if you set it too slow. It's easier to accept different depths of field or noise levels, but camera shake and motion blur provide little artistic leeway.

Using AE Lock

Autoexposure (AE) Lock lets you meter and focus on one area of the scene, lock the autoexposure reading into the camera, recompose the shot, and then take the photo with the original exposure settings. Sounds fun!

You'll benefit most from AE Lock in these cases:

▸ **You're photographing backlit subjects.** You can meter using a spot or center-weighted metering mode, and then compose the picture the way you want it (not what was necessary to meter it). Metering modes are discussed earlier in this chapter's "Lovely Rita, Meter Reading Maid" section.

▸ **You want to take several shots with the same exposure settings.** AE Lock keeps the camera from metering between each shot and possibly changing the exposure settings. This is necessary if you're in an auto-exposure shooting mode; in this case, the metering mode is less relevant.

Here's how to use AE Lock:

1. **If you plan on recomposing the shot, select spot or center-weighted metering.**

 AE Lock is very effective when you're photographing backlit subjects. You can force the camera to very selectively meter the scene. That's why you need to switch to a spot or center-weighted metering mode.

2. **Center the subject (center-weighted metering) or place it under the selected autofocus point (spot metering).**

 Read your camera's manual for how to change metering modes and select and use autofocus points. Changing metering modes (and whether you're using manual or automatic autofocus point selection) may change which autofocus points are used.

3. **Press the shutter button halfway down and hold it to meter and autofocus.**

 When it's focused, you can let go of the shutter-release button, because the AE Lock button also locks the focus. If you're focusing manually, you can focus when you like.

4. **Press the AE Lock button, shown in Figure 5-28.**

 You might feel like you have too much to do with too few fingers.

 • Hold the camera with the help of your right palm and fingers.

 • Press the shutter button with your index finger.

 • Press the AE Lock button with your thumb.

 • Possibly rotate a dial or two in between.

**Book III
Chapter 5**

**Strategizing
Exposure**

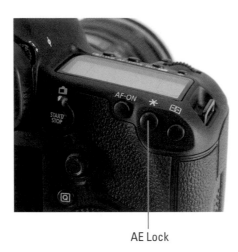

AE Lock

Figure 5-28: Press the AE Lock and hold it with your thumb.

5. **(Optional) While holding down both the AE Lock button, recompose the shot.**

Put the subject where you want it in the frame.

6. **Take the picture.**

To lock in the exposure for more shots, keep holding the AE Lock button. You can also note the shutter speed and aperture, switch to Manual mode, and dial in those values yourself.

Figure 5-29 shows a photo I metered using AE Lock. I entered my camera's spot metering mode and metered on the statue of General Anthony Wayne. This told the camera that I wanted him and his horse to be exposed correctly, regardless of the bright sky beyond.

Auto exposure bracketing (AEB)

Despite recent trends, your camera's *auto exposure bracketing (AEB)* feature isn't useful solely for *high dynamic range (HDR)* photography. If the scene's exposure is giving you fits, try turning on AEB and shooting several exposure-bracketed photos.

Figure 5-29: General Wayne approves of using AE Lock.

Set up AEB; then tell your camera how many exposures you want to shoot and how much to vary their exposure, as shown in Figure 5-30. It may seem haphazard, but sometimes it's the best you can do. If you can't get the perfect exposure with one shot, bracket the daylights out of it. You can choose the best one later.

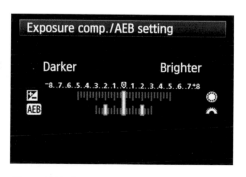

Figure 5-30: Setting up autoexposure brackets.

For more information on bracketing (within the context of HDR), see Book V, Chapter 4. The mechanics of using AEB are the same, whether you use AEB for HDR or not.

Overriding autoexposure with exposure compensation

Exposure compensation (EC) is the ultimate autoexposure override. It can be a real problem-solver if a photo's exposure doesn't come out the way you want it to.

Here's how it works:

1. **Review each photo after you take it and look to see how it's exposed.**

 You don't have to get too technical about it. Does someone's face need to be brighter? The photo's underexposed; raise the exposure. Is the sky too bright? The photo's overexposed; lower the exposure.

2. **Press and hold your exposure compensation button while you dial in exposure compensation. See Figure 5-31.**

 - Choose positive EC to raise the exposure and brighten the scene.

 - Choose negative EC to lower the exposure and darken the photo.

3. **Release the EC button and take another shot.**

4. **Review it to see if it's closer to what you want.**

 Exposure compensation stays locked in many cameras even after you turn them off, so be careful to reset EC to 0 after you've taken the shot.

Dialing in +1.0 EV Exposure compensation button

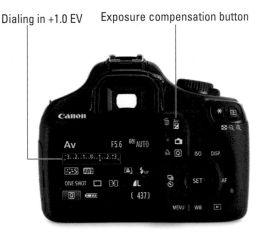

Figure 5-31: Exposure compensation moves the exposure up or down.

Most cameras give you at least two stops of correction to work with. Some have as many as five! If you have to take that route, carefully review the exposure settings and make sure you can't set the aperture any wider and can't raise the ISO any more; recheck the metering mode to find out what's happening to make the photos so far out of whack.

Using other exposure tricks

Camera makers use several other exposure tricks to (try to) solve exposure problems. Most have to do with overcoming a camera's limited capability to photograph very high-contrast scenes. The world is a complex place!

The names of the tricks differ from brand to brand, and not every camera in every company's lineup will have all the features. However, after reviewing them, you'll see that most of these exposure solutions are similar.

Look for these features on Canon cameras:

- ✓ **Highlight Tone Priority** improves details in highlights by expanding the camera's dynamic range from mids to highs. You literally capture more information in bright areas.

- ✓ **Auto Lighting Optimizer** automatically adjusts brightness and contrast. You can modify the strength.

- ✓ **HDR mode** takes many shots and combines them into a single finished image.

Nikon dSLRs have these features:

- ✓ **Active D-Lighting,** when on, adjusts exposure to maximize the camera's dynamic range, protecting highlights and shadows in high-contrast scenes.

- ✓ **HDR** automatically takes exposure-bracketed photos to increase the camera's dynamic range and then combine them into a single, tone-mapped image.

Sony cameras also have several tricks up their sleeve:

- ✓ **D-Range Optimizer** is Sony's method of protecting highlights and shadows in scenes with high contrast. You can choose from several strengths.

- ✓ **Auto HDR** combines AEB with auto tone mapping to provide a single-step HDR capability.

**Book III
Chapter 5**

**Strategizing
Exposure**

Book IV
Lighting and Composition

AF-assist illuminator

Wireless sensor Wide-angle adapter Flash Body

Mounting foot LCD panel Release button

Controls Ready light Tilt index Battery cover

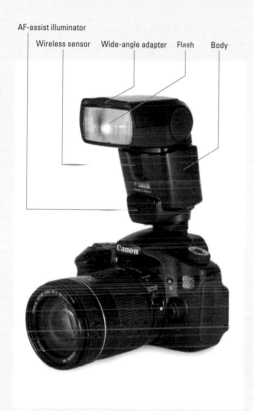

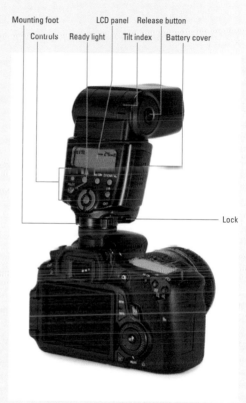

Lock

Contents at a Glance

Chapter 1: Flash Fundamentals

In This Chapter

↙ **Turning on the built-in flash**

↙ **Popping the flash manually**

↙ **Using flash compensation**

↙ **Exploring advanced flash settings**

*U*sing a flash unlocks photos that would otherwise be impossible. Most of the time, these photos are indoors, where lighting is notoriously dim, but think about using flash more often when you're outside, too. A good flash makes sure that your subjects are properly lit.

This chapter is devoted to demystifying why flash is necessary and walking you through the basics of how to use your camera's built-in flash. It also covers some items that apply no matter what kind of flash you're using, built-in or external. You see how to use flash compensation and decode some of the more advanced flash settings.

Flashing Someone

Photography gets more enjoyable if you know when and how to control your camera's flash. You can turn on your camera's built-in flash two ways:

Automatically

When you're using an automatic shooting mode (except for Flash Off), the pop-up flash automatically pops up and shoots when the camera senses it needs more light.

You may have some control over the flash in some automatic or semi-automatic modes. For example, if you're using Canon's Creative Auto mode, you can force the flash to fire, leave it on auto, or disable it. Nikon follows a similar approach, even in full Auto mode. You can leave the flash on Auto (see Figure 1-1), set it to Auto plus Red-Eye Reduction, or turn it off.

Current flash setting

Figure 1-1: Know where things are on your camera's information display.

Some automatic modes don't let you disable the flash. If the camera thinks you need it but you don't want it, choose a shooting modes where you can disable the flash. For example, if flash photography isn't allowed, you have to be able to turn it off.

If the flash doesn't look right, try this:

- ✐ Move away from (when too strong) or toward (when too weak) your subject.

- ✐ Dial in flash compensation, discussed later in this chapter.

Manually

When you're in advanced autoexposure and Manual shooting modes, you get to turn on the flash yourself. The camera might suggest it when the shutter speed gets too low, as shown in Figure 1-2.

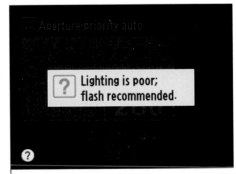

Figure 1-2: This Nikon dSLR recommends flash when the lighting is poor.

Knowing when to flash

If you don't know whether to pop the flash, consider these scenarios:

✔ *You need more light:* Most of the time this happens indoors, where the lighting rarely compares to the natural light of the sun. Figure 1-3 shows what happens if you take the photo anyway. The camera can't increase the ISO, open the aperture any more, or lengthen the shutter speed. The only way around this, save for increasing the overall light in the room, is to use a flash.

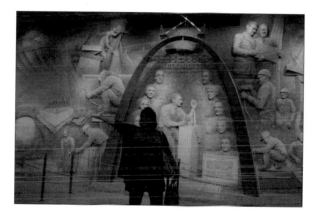

Figure 1-3: Hello from underneath and inside the Gateway Arch.

✔ *The subject is backlit:* When your subject is standing in front of something bright, it's *backlit.* What happens is that the backlighting fools the camera's sensor into thinking the exposure is fine, when it isn't. It will naturally choose not to overexpose the sky, which leaves your subject in darkness. To correct this problem, use the flash. Even a low-powered burst will be able to light your subject and save the photo. (You could switch to spot metering, but that won't add any light to the scene. It will rearrange what looks bad from the subject to the background, but not solve the problem.)

✔ *The subject's face is in shadow:* This is similar to backlighting, but there's a difference between strong backlighting and general lighting that results in dark faces. Shadowy faces are the result of more than backlighting only. Most often, something is shading the person's face — maybe a tree and she's wearing a hat; see Figure 1-4. Even if it's not a dark shadow, you should activate the flash in that case.

Try flash outdoors. It seems strange, but *fill flash* helps keep faces out of shadow. Watch your exposure, though. You may have to turn on high-speed sync (covered in this section).

**Book IV
Chapter 1**

Flash Fundamentals

Figure 1-4: You can improve this shot by raw photo software, but flash would be better.

> *You want better light:* The flash is a nice, clean, pure burst of light that can look very good compared to some interior lighting. If you're in a room with strong yellows or reds, your photos turn out with strong color casts if you don't use a flash. A flash can clear all that up.

Popping it up

A caveat: This section doesn't apply to you if you're using an automatic mode where the camera pops the flash for you. If you're in an automatic mode that allows you some control over the flash, check your camera manual for specifics. Canon users can go through the Quick Control screen. Nikon users can use the Information display. Sony users push the Function button to see shooting functions.

Using a pop-up flash is technically quite easy. To turn on and use auto flash, follow these steps:

1. **Choose a shooting mode that allows manual flash control.**

 Most often this includes Program Auto, Aperture priority, Shutter priority, and Manual shooting modes. Cameras tend to disable the flash button if you're in an automatic mode.

2. **Make sure you don't have anything attached to the camera's hot shoe.**

 Also make sure there's enough space for the flash to pop up without hitting anything.

3. Press the flash button. See Figure 1-5.

The flash button is, on most cameras, on the left side of the built-in flash.

Pop-up flash button

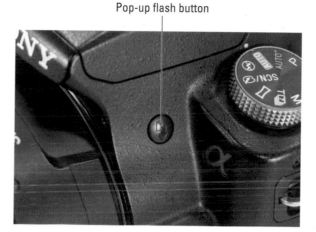

Figure 1-5: Press for flash.

4. Set up the flash.

Use your camera's method for selecting flash options, such as Enable or Fill Flash. I cover more flash options later in the chapter.

5. Press the shutter button halfway to meter and confirm flash is ready.

Wait for the sign that the flash is ready. Figure 1-6 shows one through a Sony dSLT viewfinder. Yours may be different. In this case an orange dot appears next to the flash option.

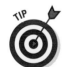

When you're working with flash, the shutter speed is limited by something called the *sync speed:* the maximum shutter speed you can use with the built-in flash.

6. Take and review your photos.

Your flash should fire and light up your subject or the scene.

7. Use flash compensation, if necessary, for follow-up shots.

- If the scene is too bright, turn it down with flash compensation or lower your ISO (if possible, given the shooting mode you're in).

- If the scene is too dark, make sure you're metering correctly and turn up the flash or ISO.

Flash mode Flash ready indicator

Figure 1-6: Flash is ready for action.

Flash dos and don'ts

Here's a quick list of things that will help make your flash photos better:

- **Don't get too close:** Using a flash can mean harsh lighting and stark shadows if you're too close to your subject. Don't get right up into someone's business, like I did for the photo in Figure 1-7. Back off a bit.

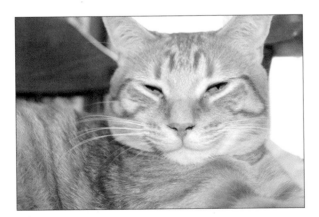

Figure 1-7: Sneaking up on a sleeping kitty with a blinding flash.

- **Separate subjects from background:** A flash is a powerful burst of light. If your subject is standing too close to a wall (or a fancy photography background), he'll cast unflattering shadows. Figure 1-8 shows an example. To

correct it, move your subjects away from the background, use a light diffuser (softens the light like a lampshade does; see Book IV, Chapter 2), or use an off-camera flash and angle it so that the shadow is hidden.

Figure 1-8: Notice the strong shadow cast on the background.

- ✔ **Use slow sync to brighten a dark background:** When the flash lights someone, often the camera thinks the overall exposure is bright. It compensates by underexposing the background, which leaves it dark. If you don't mind the effect, it can work — and even hide a messy or unappealing background. However, to reduce the effect, dial in negative flash compensation or use slow sync (discussed later).

- ✔ **Work with your subjects:** At a certain age, all my kids became experts at flash blocking. Whenever I approached them with my camera and flash, they would throw an arm over their eyes. Work with your subjects to try and prevent this.

✔ **Avoid lens shadows:** Pop-up flashes aren't tall enough to shoot over large or long lenses and lens hoods. The lens casts an ugly shadow that ruins the photo. Know which lenses you can use with your pop-up flash, or which focal lengths are safe to use with your zoom lens.

✔ **Use flash compensation:** This simple solution is effective for solving many flash problems. See "Compensating for Your Tiny Flash" next in this chapter.

✔ **Consider an external (hot shoe) flash:** Buying an external flash unit (Canon calls them Speedlites and Nikon calls its external flashes Speedlights) that mounts in your camera's hot shoe is the next step into the larger world of flash photography and lighting. It opens a number of creative possibilities, such as off-camera and wireless flash. It's also easier to direct, diffuse, and bounce light from external units. Most camera makers offer two or three external flash units in a range of prices and capabilities. External flash is covered in Book IV, Chapter 2.

✔ **Practice:** Knowledge, combined with practical experience, is an unbeatable combination. Keep working with your flash to become an expert in using it.

You don't have to become the end-all, be-all Master of Flash. You just have to know how to work your gear to create the photos you want. Start practicing in the situations you shoot most.

Compensating for Your Tiny Flash

Sometimes you want your flash to be big and strong, but sometimes you want it to be gentle and forgiving. *Flash compensation* is a quick and easy way to adjust the strength of the flash without having to be in manual flash mode. In fact, it's the only way you can adjust the flash when your camera doesn't have a manual flash mode.

Knowing how to manage flash compensation is necessary if you plan on taking flash photos. Put yourself in the quality control loop and you'll enjoy flash photography much more.

When you take a flash photo, review it before taking more photos. Note whether your subject is too dark or too bright. Compensate based on these factors:

✔ **Dark subject:** Raise flash compensation or move closer.

✔ **Bright subject:** Lower flash compensation or move farther away.

Check your camera manual for precise flash compensation details. You may be able to press a button and rotate a command dial to set it. With Canon

cameras, you can also use the Quick Control screen. Press the Quick Control button and highlight Flash Exposure Compensation. After you press Set, the Flash Exposure Compensation screen appears, as shown in Figure 1-9. After you set it, you should see an indicator on your LCD monitor or viewfinder.

Always look for telltale signs like the indicator shown in Figure 1-10 to remind you that you've made exposure adjustments. When you move on to another subject or different lighting, reset it.

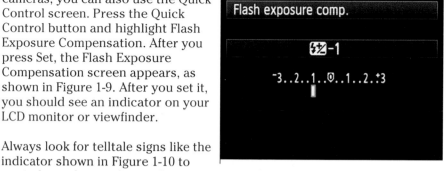

Figure 1-9: Negative numbers reduce the flash strength; positive numbers increase it.

Current flash compensation

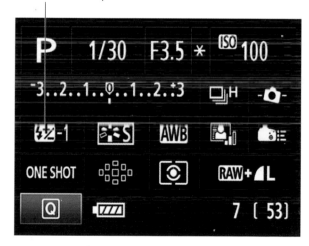

Figure 1-10: I set flash exposure compensation to reduce its strength by one stop.

Going Fancy with Flash

Setting up your flash isn't hard, but these settings go beyond putting your camera on Auto. Here is a list of possible options worth knowing about:

✔ **Red-eye reduction** forces the flash in an effort to keep people from having red-eye in photos. This option is normally located in the camera's menu system. See Book I, Chapter 3.

✔ **FE lock** isn't a setting as much as a technique. Use *flash exposure (FE) lock* as you would autoexposure lock (AE Lock). Meter the subject off-centered, press the FE lock button, and then recompose. The flash strength and overall exposure is locked until you release the button — even after taking multiple shots.

✔ **Slow sync** slows the shutter speed so that the flash fires and ends the exposure. The result is a brighter background. Slow sync works well indoors if you're shooting casual shots or portraits with still subjects. You can also take some great shots with movement in the background and a clear subject.

Try this tip for indoor photography: Pay attention to shutter speed and blur. If you don't want blur, try switching out of Slow Sync mode or use a tripod.

✔ **Rear-curtain sync (or second curtain)** flashes just before the exposure ends, as opposed to when it begins (normal, front curtain, or first curtain). You can shoot some creative scenes using rear-curtain flash and moving vehicles or people with lights. The lights will move through the scene and the flash will freeze things to finish the shot.

✔ **High-speed sync (HSS)** normally requires an external flash unit. Basically, it bypasses the camera's sync speed and lets you take flash photos with much faster shutter speeds. The flash pulses throughout the exposure. Figure 1-11 shows this very practical purpose in action. The shutter speed was 1/2000 second, which was made possible by HSS. This compensated for the wide-open aperture, bright conditions, and fill flash.

High-speed sync doesn't take you into some sort of super slow-mo, action-freezing mode. HSS lets you use fill flash outside on a bright day (or in a studio with bright lights) with a wide-open lens. This is an especially effective technique when shooting portraits.

Figure 1-11: Use high-speed sync on a bright day to limit exposure for fill flash.

Flash sync speeds

Using the pop-up flash limits the maximum shutter speed your camera can use. This speed is called the *sync speed* or *flash sync speed.* During an exposure, the front shutter curtain races down, uncovering the sensor. At the right time, the rear curtain follows and covers the sensor. The time distance between when the front curtain uncovers and the rear curtain covers the sensor is the shutter speed.

At slow shutter speeds, the entire sensor is uncovered at some point during the exposure. The flash can fire at any point during this time and be synced. When the flash fires just after the first curtain uncovers the entire sensor, the

flash is called a *front* or *first curtain flash.* This is the default flash mode for all dSLRs. When the flash fires just before the rear curtain follows and covers the sensor back up, the flash is called *rear* or *second curtain sync.*

At higher shutter speeds, the curtains are travelling so close together that the sensor is never fully exposed. Although the flash could fire and brighten the entire scene, it's recorded by only *part* of the sensor.

If you need to use a faster shutter speed than your camera's sync speed, you have to buy an external flash and turn on high-speed sync.

✏ **Repeating** makes smaller, miniature flashes spread out over time. You can create some good special effects this way. Figure 1-12 shows what happens. I threw some colorful dice on the table and triggered the pop-up in repeating flash mode. It caught the dice as they rolled away from me.

Figure 1-12: Special effects with a repeating flash.

 Wireless (or Commander) lets you take flash photos with external flash units that don't have to be hard-wired to the camera (see Book IV, Chapter 2). The wireless setting uses infrared or radio signals to control the external flash. When acting as the *commander,* the camera's internal flash fires a low-powered pulse to set off the external flash. If possible, set up the camera to become a wireless master. Not all cameras can be a wireless master.

 Manual mode lets you set the flash intensity yourself. Through the lens (TTL) metering (and variations thereof) that takes the flash into account isn't available.

For the most part, stay in automated TTL mode and use distance and flash compensation to tweak the flash.

 TTL flash meters through the lens. You'll see pre-shot pulses that help set the exposure. You may have the option of setting your built-in flash to something other than *TTL (through the lens)* mode. For example, you can set the flash to Manual or Commander mode, or choose another type of TTL. (Makers tend to call their latest version of TTL flash by different names. Canon uses E-TTL and E-TTL II. Nikon uses i-TTL. Sony uses ADI [Advanced Distance Integration]. Some use P-TTL.)

Chapter 2: Using an External Flash and Accessories

In This Chapter

- ✔ Naming names
- ✔ Examining an external flash
- ✔ Controlling an external flash
- ✔ Making connections
- ✔ Exploring external flash techniques

As good as built-in pop-up flashes are (they're certainly better than nothing), they have some limitations. They're attached to your camera. You can't tilt or swivel them. An *external flash* is a flash you can mount on your camera's *hot shoe* (the bracket on the top of your dSLR/dSLT).

An external flash opens up a world of creative lighting possibilities: umbrellas, soft boxes, snoots. You get the idea. The trick is knowing what those possibilities are and how to take advantage of them. This chapter describes how to attach and get the most from an external flash.

Shedding Light on Flash Parts

A lot of good lighting kits combine stands, strobes, umbrellas, and soft boxes into one, often portable, collection. I'm a big fan of kits. With them you know that everything in them works together. A kit is a helpful way to start getting serious with lighting.

Physically, most external flashes are very similar. Figure 2-1 shows the front of a typical midrange flash from Canon — the Speedlite 430EX II. Figure 2-2 shows the rear of the same flash unit. As you can see, the flash has several parts. I describe them starting with the flash's front.

Putting an external flash unit should keep the camera's built-in flash from popping up.

AF-assist illuminator

Wireless sensor Wide-angle adapter Flash Body

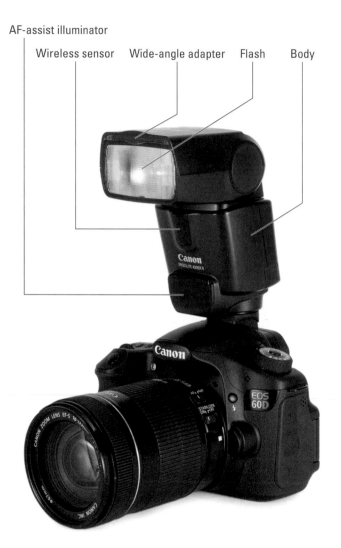

Figure 2-1: Midrange practicality and affordability.

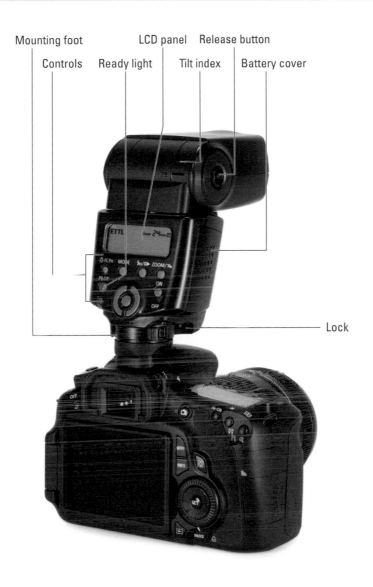

Mounting foot LCD panel Release button

Controls Ready light Tilt index Battery cover

Lock

Figure 2-2: That's a flash back.

Using an External Flash and Accessories

What's in a name?

Different companies call their external flashes by different names. I use the general term *external flash* or *flash* unless I'm referring to a specific flash name. You might run across some of these names:

- Canon: Speedlite
- Nikon: Speedlight
- Olympus: Flash
- Pentax: Electronic Flash Unit
- Sony: Flash, flash unit, external flash

Front of flash

The front of the flash contains all the elements needed to light the scene. It may also contain different helpers.

- **Flash head:** The part that holds the flash. All but the most basic models rotate up and swivel from side to side. Most lock in place; set them free with the release button. Some snap into place or move under resistance.

 Not all flashes bounce or swivel. Some heads (entry-level models, normally) sit on top of the body and point straight ahead.

- **Flash:** Here comes the light. Pay attention to where it's pointing. Small differences in positioning can make big differences in photos.

 Snap or push Sto-Fen–type diffusers directly on the end of the flash. Other accessories, such as small soft boxes, also fit over the end of the head. Some accessories rely on hook-and-loop fasteners. Wrap the loop around the head and fix it securely to itself. The piece with the hook part attaches to it.

- **Built-in wide-angle adapter:** A built-in wide-angle adapter is a handy aspect of many external flashes. In this case, the adapter slides out and drops over the flash, directing the light from the flash into a wider area. Most flashes have adapters, but some aren't built in. If that's the case, the flash case should have a place to store the adapter. Snap it on the flash head to use it. Pop it off when you're done.

 Flip the wide-angle adapter down over the flash when you're using a wide-angle lens. When you put the adapter down, the flash should automatically set itself to that focal length. If not, set the proper zoom on the flash. When you finish, lift up the adapter and slide it back in.

- **Body:** Here are the guts — the controls, batteries, connections, and mounting foot.

✔ **AF-assist illuminator:** This feature helps the camera autofocus when the lighting is too dim for the camera's normal autofocus sensor to work. You can usually set boundaries for this feature in the camera's menu.

When the flash is mounted *off-camera* (it's wired to the camera, but not connected directly to the hot shoe), AF-assist doesn't work unless you're using a cord that supports the feature.

✔ **Wireless sensor:** The sensor that detects signals from the camera that tell it what to do and when. Pay attention to the direction the sensor faces and be sure not to block it.

Flash back and sides

You'll see a lot more of the flash sides and back. The back is where you will control the unit. The sides typically contain important features that help you operate or set up the unit.

✔ **Tilt/swivel release button:** Press this button to unlock the flash head and change the angle. The button pops back out when you release it, locking the head in that position.

If your unit has a locking button, *don't force the head* — you might break it.

✔ **Tilt index:** Raised marks on the head show you the flash's bounce angle (the angle the flash is pointing at when not looking straight ahead). Knowing the angle helps you repeat photos (or avoid it, if you're experimenting).

✔ **Swivel index:** A swivel index shows how far from center you've swiveled the head.

Swiveling is useful when you take vertical pictures and want to bounce the flash upward. *Tilting* the flash points the flash away from the subject in vertical position. *Swiveling* the flash points it toward the ceiling. You may also find it helpful to swivel the flash to bounce light off a reflector or neutral-colored wall when you're holding the camera horizontally.

✔ **Battery compartment cover:** A plastic piece covers the area where you insert batteries. To open the battery compartment, press the cover and slide it toward the bottom of the unit to release the catch. The cover (which can fit tightly) reveals the batteries. Be sure to slide down the cover completely and exert the force necessary to open it.

✔ **Battery compartment:** Put your batteries here. Four AA batteries seem to be the standard for larger flash units. Smaller, entry-level models may need only two.

Make sure you point your batteries the right way. Sometimes the orientation marks are inside the compartment instead of the door, which makes it tougher to see them.

✔ **Ready light:** Your flash may have a ready light on it. This tells you that it's ready to fire (when mounted on the camera), or successfully linked to your camera and ready to fire when in Wireless mode.

✔ **Mounting foot:** A metal or plastic plate that slides into the camera's hot shoe. The mounting foot is one of the more critical parts of an external flash. Make sure that the foot is clean and not bent. Most cameras use a standard *hot shoe,* a metal guide that sits on top of the camera. Sony has a different type of connection (the two types aren't compatible with each other) than the other manufacturers, but it serves the same purpose.

✔ **Hot shoe contacts:** Contacts connect the camera to the flash and send electrical signals.

- Don't try to place a flash unit on an incompatible camera. You can short out the flash or the camera.

- When mounting the flash on an external light stand with a shoe adapter (as opposed to using a mini-stand that has built-in protection), protect the contacts from touching metal by covering them with a bit of electrical tape.

✔ **Lock:** You may use a locking lever or ring to secure the flash on top of the hot shoe. Turn or slide the lever one way to lock the flash. Turn or slide it the other way to release the flash. A flash may also click into place.

- **Controls:** Most flashes have several buttons and controls on the backs of their *bases* (the bottom of the flash, not where the mounting foot is). Among those listed here, there may be a high-speed sync button, flash level button, or light buttons to illuminate the LCD screen:

- *Jog wheel* is for navigating or choosing options.

- *Mode* changes the flash mode.

- *Power* turns the unit on and off.

- *Test* flashes a sample light.

- *Up and down indicators* are for navigating or choosing options.

- *Wireless* lets your flash go off-camera without wires.

- *Zoom* the flash in and out to match the focal length of the lens. You shouldn't need to zoom the flash to the correct focal length in Auto mode.

✔ **LCD panel:** Most midrange and above flashes now have large LCD screens. They show you all the details of how your flash is set up and which mode you're in so you can glance at the flash and see what's going on.

⮡ **Other indicators:** The back of the flash always seems to have room for another light or indicator.

Flashessorizing

If you're only interested in casual photography and/or landscapes that don't require a flash, your camera and pop-up flash are all you really need. But consider these scenarios:

⮡ **You're frustrated with the built-in flash:** Consider buying an add-on pop-up flash diffuser or an external flash. This means you're getting serious.

If you upgrade to an external flash, you don't immediately need to accessorize it. You may be happy with what you have. However, your photos will benefit from some form of diffuser or reflector. From there, you can consider gels, a snoot, and other add-ons.

⮡ **You're ready to step up from flash-mounted accessories:** Look into studio-style lighting modifiers like umbrellas and soft boxes. By this point you may need a background and extra lights. As your setup gets more complicated, you will need to connect everything together (wirelessly or wired).

You can customize and tweak your flash, in-camera and external, with several kinds of accessories:

⮡ **Diffuser:** A flash diffuser softens the light emitted by the flash, (ideally) getting rid of harsh shadows on your subjects. Diffusers come in a couple of varieties:

- *Hard plastic:* You can see mine in Figure 2-3. It's just a little plastic cover, but it works. Make sure to buy one that's compatible with your flash unit; see whether the brand you like comes in different colors. Push it onto the head so that it fits securely and doesn't fall off the first time you take a step.

- *Soft box:* Fits on the flash head. Assembly is often required. The box slips over the end of the flash and extends some distance in front. I don't normally use it when the flash is mounted on the camera, because the box dips down a little. Mounted on a stand or sitting on a table, it's ideal. An alternative to a soft box is shown in Figure 2-4.

- *Pop-up flash diffusers:* Several types of diffusers attach to pop-up flashes. It has a mounting bracket that slides onto your camera's hot shoe. The diffuser attaches to the bracket and acts like a hard plastic diffuser that you would put on your external flash.

Figure 2-3: A plastic cover works just fine.

The LumiQuest Soft Screen works like this: One end slides into your camera's hot shoe and the other slips over the flash. The result is a nice diffuser that's like a soft box or umbrella. It's so portable that it can fit into your pocket.

- **Mini stand:** Some flashes come with a mini stand, also known as a *flash stand*, *mini stand*, or *Speedlight stand*. You can mount the flash on this small, plastic stand. If your flash doesn't come with one, you may be able to buy one.

The stand is useful for taking the flash off-camera (if it can go wireless) and putting it on a table or the floor. Plus, its light stand socket underneath gives you an easy way to mount the flash on a larger light stand.

- **Wide-angle adapter:** Buy this adapter if your flash has no built-in adapter. It helps spread the light from the flash out to cover the additional angle of view that wide-angle lenses capture.

- **Gel or filter:** Look for colored gel filters to add ambiance to a scene or use them for color correction.

- **Adapter, bracket, cord, coupler:** The number of ways you can connect your flash to other gear is dizzying. Look for all these pieces of equipment to get connected. Check the manual that came with your flash for additional guidance.

- **Case:** Flash cases are useful. They protect the flash and hold small accessories.

Although most external flashes are pretty similar, some, like ring flashes, look very different. A ring flash is a specialized type of flash unit designed to

mount on your camera and shoot around the lens. These flashes are well suited to macro, close-up, and portrait photography.

Figure 2-4: This diffuser is soft and very portable.

Working the Flash

This section briefly describes the common Speedlight controls. Figure 2-5 shows the back side of the Canon Speedlite 600EX-RT. It's Canon's top Speedlite and one of the newest available.

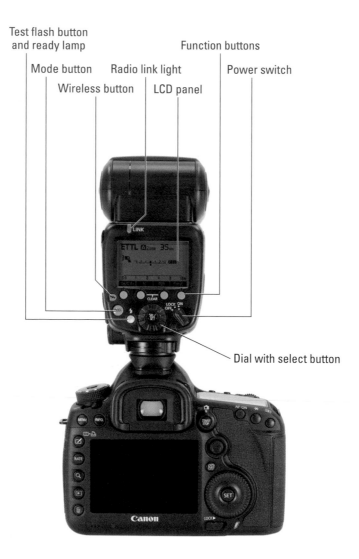

Test flash button
and ready lamp

Function buttons

Mode button Radio link light Power switch

Wireless button LCD panel

Dial with select button

Figure 2-5: These controls are common.

Read your manual for detailed instructions for working your flash. Your flash will have controls similar to these:

✔ **Power switch:** In this case, the flash combines a power switch with a locking mechanism that keeps you from accidentally jogging the dial and changing values.

✔ **Mode button:** Most Speedlights have several shooting modes. Use the Mode button to switch between them. Read your flash manual for details.

✔ **Function buttons:** Pressing these buttons either turns things on or off or cycles through various settings. The settings, in millimeters, should match the focal length of your lens (or come close if they're midway).

✔ **Wireless button:** Puts the flash in wireless mode. Very handy.

✔ **Test flash button and ready lamp:** On this model, the lamp that tells you the flash is ready (and the button to test it) are in the same button.

✔ **Dial with select button:** Use the dial to scroll through options. Press the Select or Set button to choose them.

✔ **Increment/decrement button or dials:** Your flash may let you increase or decrease setting values (like focal lengths) or scroll through options. If so, use the increment/decrement buttons or dials to adjust the values.

✔ **Other controls:** As mentioned in an earlier section, some flashes have other controls and indicators that aren't listed here. Some work for a single purpose and some work for multiple purposes.

✔ **Two-button controls:** Some flashes require you to press and hold two buttons simultaneously in order to access certain settings and information.

✔ **Navigating:** Your camera manual will tell you how to get around the menu. Some buttons switch options; some buttons change the value of the option you're looking at.

Hooking Up

This section details some of the camera-to-flash connections you can make with your flash. There's the tried-and-true hot shoe method, but also several other wired and wireless options for you to consider. Each has its own rationale.

Connecting an external flash to your camera

Connecting an external flash to your camera is easy. If you're not used to it, practice a few times. Use a camera strap or tripod for additional support. Whatever you do, be careful. Don't force the flash onto a hot shoe if it seems to be sticking and be careful when threading items onto a stand or adapter.

These steps can help:

1. **Turn off the flash and your camera.**

 Don't rush. You don't want to short anything out.

2. **Hold the camera in one hand and the flash in another.**

 Keep the camera strap around your neck for support.

 Experiment until you find the most comfortable method for you. I like to hold the camera with my left hand underneath and work the flash with my right hand.

3. **Bring the flash in line with the hot shoe and slide it in.**

 Line up the mounting foot with the camera's hot shoe. This process takes place mostly by feel. When you slide the flash straight onto the shoe, you should hear a click.

4. **Lock down the flash, if you have a lock.**

 Don't forget this step!

5. **Turn on the camera and flash.**

6. **Make any necessary settings or adjustments.**

 You're ready to rock!

Taking the flash off your camera

Removing the flash from your camera is the reverse of putting it on. Follow these steps:

1. **Turn off the camera and flash.**

2. **Grip the camera with one hand.**

3. **While supporting the flash, release it.**

 This step may involve turning a ring, moving a lever, or pushing a button.

 Keep one hand on the flash at this point so that it doesn't drop out.

4. **Slide the flash out of the shoe.**

 Slide it straight back. Don't twist it! It will bind in the rails.

5. Secure the flash without banging the camera on anything.

A camera swings around when it's attached to a strap. If you bend over to put away the flash, it swings away from you and bonks itself on whatever is in front of you.

Remote flash triggers When you move your external flash off-camera (whether wired with cords or connected wirelessly via infrared, optical, or radio signals), it's called a *remote flash* or *strobe*. Unless you're telekinetic, you're going to need a way to trigger your off-camera flash. Depending on your camera model and flash, you might be able to choose among one or more of these *remote triggering methods*. Make sure everything's compatible; not all cameras support all methods of off-camera flash and not all external flash units can be controlled in every way.

If your camera and flash are compatible, setting up a wireless shoot is *easy* Set up the camera and flash to work wirelessly and make sure they're on the same group and channel. Within a few button presses, you'll be in business.

Wireless IR or optical pulse

Most midlevel and advanced flash units support one of two types of connectivity. Technically, they're different, but practically speaking, they act the same.

- ✔ Wireless infrared (IR)
- ✔ Optical pulse

Check the manuals for your camera and external flash to make sure they use the same method. Wireless IR and pulse aren't compatible with each other.

Using either system is as easy as eating cake, and you don't have to buy anything extra to get it to work.

1. Set up your flash on a light stand or a small flash stand.

2. Set up your camera and flash for Wireless mode.

Both types of wireless units can only go so far (and bend at certain angles) from the camera.

3. Make sure the flash and camera are on the same group and channel.

Remember to consult your manual for specifics on how to check and change these settings. The group and channel assignment should be visible on the back of the flash unit. You'll have to find the camera's settings in the menu.

Book IV
Chapter 2

Using an External
Flash and
Accessories

You can also buy a dedicated wireless transmitter, as shown in Figure 2-6. This unit replaces the built-in flash as the method of communication (with enhanced features), or provides the capability for cameras without a flash.

If you don't want your camera's built-in flash to affect the scene, but *do* want to use the built-in flash as a wireless trigger, consider buying an IR panel. These panels block the light from the internal flash but allow the infrared signal to pass and trigger the external unit.

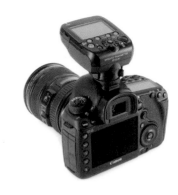

Figure 2-6: This is a dedicated wireless transmitter.

Wireless radio

You can try wireless radio remote flash triggers. In this case, transmitters send out radio signals that connect your camera with an external flash. Put the transmitter on your camera's hot shoe, and put the receiver on your flash unit. Third-party makers such as PocketWizard offer wireless radio. Camera manufacturers are following suit.

Radio systems can support multiple flash units as long as you have enough receivers, but wireless radio can get expensive the more flashes you have to control. Radio has a longer range and better placement options (it doesn't have to be in front of the transmitter) than wireless IR.

Wireless optical slave

This wireless option relies on a *slave unit* sensing the optical flash (in this case, you can see it; you can't see infrared or radio waves) from a *master* (or another flash) unit and then triggering the flash it's attached to. Figure 2-7 shows a unit that's built into a strobe light.

Cords galore

Not all of us can go wireless. For those photographers who are still physically connected:

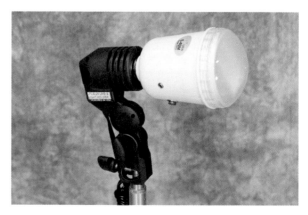

Figure 2-7: This slave strobe responds to a flash signal or a sync cord.

✔ **Sync cord:** One solution (it's getting rare) to connecting your camera to an external flash is to wire them together using *sync cords.* Not all flash units have sync cord sockets. Most often, you have to buy the most expensive unit a manufacturer makes to get one.

✔ **Off-camera cord:** You can buy different types of cords that let you take your flash off the camera. Although technically they aren't *sync cords,* these cords serve the same purpose: Attach one end to the camera's hot shoe and the other end to the flash's mounting foot. Presto — they're connected. This type of cord is a workaround for not having a sync cord terminal on your flash.

This setup is useful when I want to use fast shutter speeds with my external flash unit but want to position it off-camera, like the one shown in Figure 2-8. Wireless setups may not support the shutter speed you need. If not, use an off-camera cord. Shorter cords let you mount your flash on a bracket that attaches to your camera.

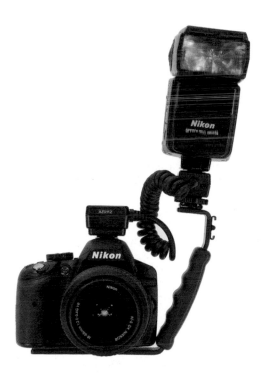

Book IV
Chapter 2

Using an External Flash and Accessories

Figure 2-8: This off-camera cord is one of my favorite flash accessories.

Setting Up Your External Flash

Because each flash is different, I can't show you specifics for every option. Please turn to Book IV, Chapter 1 for general information on flash modes, and read your flash manual.

I can make some general observations about two main parts: your settings and your standings.

On the flash or camera

Look for these options in your camera or flash menu:

- **External control menu:** Look for an external flash control in your camera menu. Figure 2-9 shows the menu on a Canon EOS 5D Mark III, with a Speedlite 600EX-RT connected to the camera.

- **Main flash menu:** You should see a new menu after you select the external flash from the main menu.

	AF	▶	♀	⌂	★
					SHOOT1

Image quality RAW+⏍L
Image review 2 sec.
Beep Enable
Release shutter without card ON
Lens aberration correction
External Speedlite control
Mirror lockup OFF

Figure 2-9: Select the Speedlite control menu first.

- **Functions:** Spend a lot of time reading your camera and flash manual; your options may include changing the metering method, the focal length, adding flash compensation, or controlling flash exposure bracketing.

- **Custom functions:** Maybe you never could get conversions down and just have a general feeling of high-school dread when faced with the metric system; you may be able to change the distance display from meters to feet. Check into every nook and cranny for useful ways to work the way you want. You don't always have to leave things on their defaults.

On the ground or table

Moving the flash off the camera has some advantages:

- The lighting looks more natural.

- You can come at the subject from different angles with light. You can light the subject and background, enhance or eliminate shadows, and do all sorts of other things — with *one* flash.

Lights need stands. *Light stands* can hold reflectors, soft boxes, strobes, umbrellas, diffusers — you name it. Some *heads* (the part that flashes or shines) come with a stand, but you can also buy them separately.

Keep these points in mind when you shop for a light stand:

- ✔ **Watch your weight.** Some stands are big and beefy. Some are flimsy. Make sure to buy a stand that's made for the weight you're going to put on it.

- ✔ **Learn to adapt.** Your flash needs an adapter because its bottom has nowhere to attach to a tripod. A *mini stand* is the easiest adapter for mounting a flash to a light stand.

To mount the flash on a mini stand like the one in Figure 2-10, follow these steps:

1. **Make sure that the flash is turned off.**

2. **Connect the mini stand to the flash.**

 - If the stand isn't attached to anything (such as a light stand), hold the flash body in your hand and slide the mini stand onto the mounting foot.

 - If the mini stand is already mounted on a light stand, slide the flash onto the stand rather than sliding the mini stand onto the flash.

3. **Lock down the flash, if you can.**

 To mount the mini stand to the light stand, screw it on.

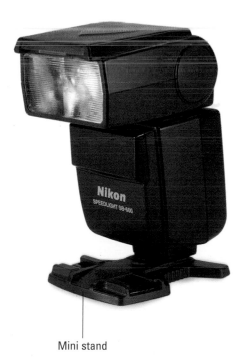

Mini stand

Figure 2-10: At attention.

Using an External
Flash and
Accessories

Trying Different Techniques

An *external* flash (the flash unit that you can attach to your camera, not where you mount it) is useful and a lot of fun. Although built-in flashes are capable, an external flash

- ✔ Offers more flexibility.
- ✔ Has more power.
- ✔ Gives you a greater range of freedom.

This section covers some of the techniques that are possible using *one* external flash. You can add more. The more you add, the more creative you can be.

Using a balanced fill flash

A flash is a useful device to have, even when you don't think you need one. Forcing the flash to fire, called fill flash, will often make your subjects look better and balance the brightness of the foreground and background better. Figure 2-11 shows a portrait I shot outside with an external flash. The flash keeps my wife's face well lit and not in shadow.

If you can't face your subject toward the light, make sure to use the flash. It also helps when you can use high-speed sync (HSS), which I did here. Book IV, Chapter 1 details HSS.

Figure 2-11: Using a flash for fill light.

Bouncing and diffusing

Bouncing, the flash softens its light and makes shadows less prominent. To bounce your flash, tilt or swivel the head so that it points at the ceiling or wall.

If you're shooting in an area with high ceilings, switch to a diffuser and point the flash straight at the subject.

The great thing about bouncing the flash is that you can do it even when you have no other gear with you. It's the ultimate fail-safe solution, provided you have an external flash unit attached to your camera with a tilt/swivel head.

Using a bounce diffuser/reflector

Although you can find several types and brands of flash bouncers, LumiQuest (www.lumiquest.com) is the most notable. This product bounces, reflects, and diffuses light from your flash, all at the same time. It attaches to the front of your flash with the help of a hook-and-loop strap, which you aim upward (your flash must be able to point up), and has the shape of a fan. Light from the flash hits the surface of the bouncer and is reflected toward the subject. In the process, it's softened.

Figure 2-12 shows my Pocket Bouncer. Notice that you rotate the flash head straight up and let the bouncer do the bouncing. The downside to this setup is that you have to ensure enough headroom to use it, and there's the danger of coming across like a superflash freak.

Using an umbrella

Umbrellas are just what you'd expect, except they won't keep rain off your head. *Umbrellas* diffuse light from the flash even better than bouncing or using a diffuser. The catch is that you have to set up the umbrella on a stand with the flash. That limits how portable and spontaneous you can be. However, the results are almost always fantastic.

To control your flash on a light stand (which looks something like a tripod, but isn't meant to hold a camera) with an umbrella, you can make it wireless and use your camera's built-in flash for a trigger. Or, you can buy an off-camera cord that extends the range of your hot shoe.

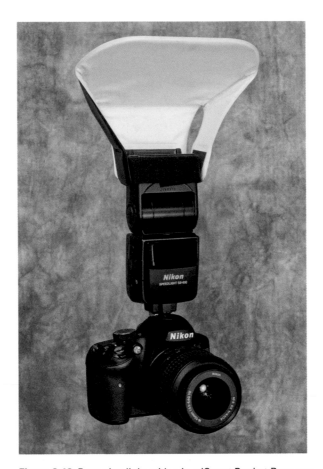

Figure 2-12: Bouncing light with a LumiQuest Pocket Bouncer.

The shadow knows: They can be fun

Most of the time you use a flash to remove shadows, but not always. You can have a lot of fun with shadows. For the photo in Figure 2-13, I took pictures of a Godzilla figure in front of a white background with different colored blocks in the foreground. The room's *ambient* lighting (all the light sources except the flash) was pretty bright, but I also used a flash to cast a shadow from left to right. It makes the whole scene feel more alive than a straightforward flash.

Figure 2-13: Godzilla on the attack.

Getting snoot-y

Have you ever watched an old *Star Trek* episode where Captain Kirk sits in the captain's chair and his eyes are brightly lit but the rest of his face isn't? They created that effect with a *snoot,* a tube or rectangle on the end of the flash; it keeps the flash tightly focused on the subject. The longer the snoot, the more focused the lighting. The shorter the snoot, the more it expands. You can even make your own snoot out of things you have on hand (high-tech things like cardboard and tape).

I took the photo in Figure 2-14 with Gary Fong's Collapsible snoot with PowerGrid. I also moved the flash off-camera to the left of my son's face. The flash is much farther away than the camera. The result is a portrait that has a lot of close-up detail (impossible to capture with a straight shot of the flash), creative side lighting, interesting shadow, and a dark background.

Figure 2-14: Snoots are wonderful tools to use.

Lightsphere

Gary Fong's Lightsphere Collapsible Pro kit has a soft, collapsible diffuser that fits on the end of your external flash. It diffuses and softens your flash. You can customize the Lightsphere with different domes and gels. The kit also has a snoot with an optional grid (that divides the snoot into sections that further tighten the light beam).

Your mileage may vary, but I've been completely impressed with every aspect of this kit. A lot of ingenious people out there are devoted to making your flash photos the best they can be. If Gary Fong isn't for you, look at other products by other makers.

Elevating flash with a bracket

I was skeptical at first about flash brackets. They make your dSLR look like an old-fashioned press camera with the flash on the side — the type you see in old movies. I stuck with it and it started making sense.

Photographers who mainly hold their cameras vertically know that when you attach an external flash to the camera's hot shoe, the flash sticks out to the side, not on top. Even if you can swivel the flash, it's no longer elevated. By putting the flash on a bracket, you can position the flash so that it works more like a traditional flash on the hot shoe. I think that's a great idea.

You need a short flash cord for this to work. Buy one that supports the features you need to work on your flash.

Chapter 3: Deconstructing Design

In This Chapter

✏ **Working with foregrounds and backgrounds**

✏ **Designing with patterns, shapes, and shadows**

✏ **Using light and color**

✏ **Developing your timing**

1 continually ask myself how I can take better photos. The answer almost always comes down to design, combined with the proper framing.

Good design is a fundamentally important aspect of photography. Without it, photos just sort of sit there and do nothing. With good design, something leaps out and grabs your attention. You notice something about photos that are well designed, even if you don't realize why. *Design* refers to the elements that are in the photo, not necessarily how they're arranged. (Their arrangement is what I call *framing*, or *composition*, which is in the next chapter.)

I want to show you how the right combination of elements makes a photograph work. In this chapter I explain why each photo is successful from a design standpoint. I also want to move design from out of your subconscious. After you get a sense of how to design a scene by reading this chapter, you can move to framing, which is covered in the next chapter.

Going Out into the Elements

This chapter is organized around several photos that have a key design element that I want you to focus on. However, I list a number of other important design criteria within each critique:

Telling design from framing

When you design a photo, you choose what to include. The elements might be anything: objects in the foreground, the background, different lighting, color, signs, and other things. You also choose what *not* to include in the photo. That's design, too.

This, to me, differentiates design from framing. When you're *framing,* you take the elements that you've decided on and rearrange them into different compositions. When designing, you change the elements themselves between photos.

That's how I decided what to include in this chapter versus the next. When I talk elements that might have changed or been different between photos, I include it in this chapter. When I talk about how to arrange the same elements, I put it in the next chapter.

A great deal of crossover occurs, of course. I won't show you a poorly framed photo as an example of good design, nor will I show you a badly designed photo as an example of good framing. Crossover also happens when you talk about a key design element. Many times, light or timing creates the right conditions to take photos.

- ✔ **Key design element:** This is what makes the photo work.
- ✔ **Framing:** How I chose to frame the scene.
- ✔ **Subject:** Notes about the subject.
- ✔ **Foreground:** How the foreground contributed to the photo.
- ✔ **Background:** How the background contributed to the photo.
- ✔ **Light:** What the lighting was.
- ✔ **Darkness:** The role darkness, or shadows, played in the photo.
- ✔ **Color:** How color was used.
- ✔ **Texture:** Comments about texture.
- ✔ **Lines:** Lines are very important in some photos.
- ✔ **Regions:** This is how space affects the final photo.
- ✔ **Timing:** Whether or not timing the shot was important to design.
- ✔ **Space:** Feelings of expansiveness or intimacy.

Use criteria such as these to analyze your own photos. When you find out why you like your favorites, you'll be able to do it again and again.

Designing a Scene

The photo in Figure 3-1 is contrived. It's not a real place setting. I'm not sitting down to have a piece of coconut cream pie. My wife cooked the pie and I arranged the scene. I *designed* it by choosing what elements to include.

I had to work at it, of course. I took plenty of other photos during this session. I started out with the pie by itself. I framed it this way and that, taking several photos. Then I cut a piece and photographed that. Eventually, I added the coffee cup, fork, and plate. Finally, my wife sat down at the end of the table. Although there are many elements, they all contribute to making the pie the centerpiece of the photo.

Figure 3-1: I designed this photo so you want to take a bite of pie.

Think about these factors as you look at the photo in Figure 3-1:

- **Key design element:** Setting the table. This photo works because every-thing in it makes you want to sit down with someone and share a scrumptious-looking coconut cream pie. This photo isn't just about a piece of pie — it's an entire window display.

- **Framing:** I framed the photo with a portrait orientation because I wanted to use the space behind the piece of pie in the foreground. It takes up about a third of the shot.

- **Subject:** In this case, almost everything is the subject. It's the idea of picking up the fork and having a bite of pie, followed by a sip of coffee, with a friend. However, the most important element in the shot is the single piece of pie, sitting in the foreground.

- **Foreground:** The piece of coconut cream pie is in focus and the center of attention. When you're shooting off-centered subjects, manually focus or use your camera's manual AF point selection mode to select an AF point on your subject.

- **Background:** The background, although out of the depth of field, the-matically supports the foreground. I used a relatively large aperture (f/2.8) to limit the depth of field.

- **Light:** Natural light is coming in from a window to the right of the photo. This is more important than it seems. Natural light makes this photo look, well, natural.

- **Darkness:** The shadow cast by the table sets the front edge of the photo. The plate also casts a shadow, which isolates it from the table. The far background is also in shadow.

- **Color:** The wood table, mug, and plate add rich hues to a photo other-wise dominated by whites and creams.

- **Texture:** The crust of the pie is rough while the pie itself had a lot of folds and interesting elements. Otherwise, the scene has a lot of smooth surfaces. The coffee mug stands out in this respect.

- **Lines:** The photo's mixture of horizontal and vertical lines is subtle enough not to dominate the photo. The fork and plate form the most prominent lines. The horizontal lines of the plate, cup, charger, and even the pie seem to separate the photo into different regions based on their depth.

- **Regions:** The light regions inside the photo almost appear carved out of the dark table: the piece of pie, the coffee cup, and the pie in the background.

✔ **Timing:** The time of day required to produce this type of natural light (coming in from a westward-facing window) dictated the timing of this photo.

✔ **Space:** The orientation of the photo and the table add depth to this scene.

Taking a Background Check

Maybe you don't think of the background as an important design element in photography. Look at your photos and examine the backgrounds. Do they contribute to the photos or take away from them? Often, the most compelling photos have backgrounds that either disappear in a creamy bokeh or are somehow visually appealing. *Bokeh* is the area out of focus in a shot.

In Figure 3-2, I added the background on purpose. I wasn't photographing a tree; I'd done enough of that the day I took this, and was frustrated with my shots. Instead, I stood close to my subject and then *offset* the subject in the frame so that the background took up half the photo and extended into the distance. This added depth and contrasted with the blossoms of the tree. On the whole, it makes the photo more interesting. Rather than being a simple shot of a tree, this photo pulls you in and invites you to explore. However, the fact that the background is out of focus limits your perception of it. It's meant to be in the background, after all.

Figure 3-2: This photo includes a tree, but it's not just about the tree.

Analyze this photo with respect to these elements:

- **Key design element:** Adding the background. The tree in the foreground is the subject, but what makes the photo interesting is that you can see into the far background. If you remove that element, it's just a photo of a tree three feet away.

- **Framing:** I used the *rule of thirds* (a way to line things up in the frame; see Book IV, Chapter 4) in two ways. First, the tree is off center. It takes up the right third of the photo. The sky makes up the top third of the remaining space. I chose this spot to capture the curve of the river.

- **Subject:** The foreground tree is the subject. It was a gorgeous crabapple tree and I wanted to capture its glory but make it more interesting.

- **Foreground:** Although I used a manually selected autofocus (AF) point, I could have used focus lock to focus on the tree, then recompose so that the background extended into the distance. Read more about AF in Book I, Chapter 5.

- **Background:** The background is very important to this photo. It opens up the photo and gives it a sense of depth, suitable for a landscape-type shot. On the other hand, it is blurred, which isn't typical of most landscapes.

- **Light:** The blossoms of the tree really stand out because they're bright white. They and the bright sky make this photo feel open and cheerful.

- **Darkness:** The dark grass and river help separate the tree from the rest of the photo.

- **Color:** This photo, like many landscapes and exterior shots, is dominated by greens and blues. The white tree provides a welcome break.

- **Texture:** The individual tree blossoms make for a very detailed texture. This contrasts with the grass, water, and sky, which all appear smooth. The greenery on either side of the river is also rough, but it has a different character than the tree blossoms.

- **Lines:** This photo is dominated by the arc of the river and sidewalk.

- **Regions:** On the whole, the photo is almost divided into three distinct areas. Using the rule of thirds, the tree is off to the right making up the largest area. The grass, river, and background foliage make up a smaller, but still large area. The sky is the third and smallest area.

- **Timing:** I shot this photo during the evening *golden hour* (the hour before sunset or after daybreak). The sun is coming from the left and is shining brightly on the tree. The light was amazing.

- **Space:** Although the subject is right in your face, this photo also has a nice feeling of depth to it. The darkness and lines contribute to this effect.

Using the Foreground

I've discovered that a really great way to make a photo interesting is to put something between you and your subject. Figure 3-3 is one of my favorite shots. I'd been meaning to get up early and capture this bridge with the morning light reflecting off the water. I knew that wasn't going to happen, but this day knew I had an even better opportunity: fog! Something about the branches also made me want to shoot through them. I did, and am happy I listened.

Figure 3-3: The branches help frame the photo.

Look at this photo with these things in mind:

- ✔ **Key design element:** Adding the foreground. Although the fog is very important in setting the mood for this photo, the branches in the foreground make this scene what it is. Without them, the photo would lack a sense of artistry.

- ✔ **Framing:** I framed the shot generally so that the bridge dominated close to two-thirds of the frame and the water underneath took up about a third.

- ✔ **Subject:** I'd been looking for ways to photograph this bridge for some time. Nothing seemed to work until I climbed down the riverbank one foggy morning and saw this through my viewfinder.

- ✔ **Foreground:** Sometimes it's important to leave stuff in the way. In this case, I could have walked through the branches and taken a picture of just the bridge. I'm glad I didn't!

- ✔ **Background:** The fog makes the far background disappear in mystery. It's unimportant to know what's out there.

- ✔ **Light:** I took this shot early in the morning, before the sun had a chance to burn the fog off. The light is diffused. Normally, foggy skies are pretty uninteresting. In this case, it takes up little of the photo.

- ✔ **Darkness:** This shot is dark in all the right places. Shadows in the bridge and on the farther bank help define those elements, and the branches seem to cut across the scene with dark lines.

- ✔ **Color:** There isn't much color to this scene. I did, however, bring some of the blues, greens, yellows, and browns in processing.

- ✔ **Texture:** Texture isn't a significant design element in this photo, but there are differences between the rocks, the water, bridge, and sky.

- ✔ **Lines:** The curved lines of the bridge are mesmerizing, especially as they contrast to the vertical structures. This is further contrasted by the seemingly random lines created by the branches.

- ✔ **Regions:** Essentially, the photo is divided between the bridge, water, and sky. The bridge, which has intricate shapes, dominates.

- ✔ **Timing:** The time of day was important to the design because the fog and morning lighting helped create the mood.

- ✔ **Space:** The bridge angles away into the distance, pulling your eyes with it. Although the river runs from left to right, the photo doesn't feel wide, mostly because the bridge blocks that view.

Looking for Shapes

There are times when things work in unexpected ways. Figure 3-4 is a shot I took from within a walking bridge that spans several lanes of traffic. I was hoping to capture traffic from overhead, but when I got here, I knew that the bridge was much more photogenic. The challenge was capturing it. After taking a number of shots, I realized that the sun in the distance accentuated the shapes formed by the internal bridge supports. I set the camera up to capture the shapes, not necessarily the bridge.

Here are some thoughts on this photo:

- ✔ **Key design element:** The shapes. The geometric patterns make this photo special; the sunlight makes them more apparent. This is a good example of how the light makes the key design element possible. Of all the shapes, the most important one in this photo is the bright green arch that leads you out of the bridge. It's literally the light at the end of the tunnel that is the exit to the photo.

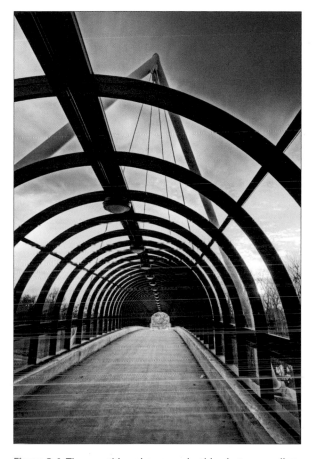

Figure 3-4: The repetitive shapes make this photo appealing.

✔ **Framing:** I framed this shot so that the payoff, which is the arch, is centered horizontally and a third of the way up in the frame vertically. Because I was standing to the side of the bridge, the structure that encloses the bridge feels anything but symmetrical. It works.

✔ **Subject:** The bridge is the main subject, but the real point is the bright green exit.

✔ **Foreground:** There isn't much of a foreground to this photo. The concrete walkway serves this purpose, but because it extends into the distance, doesn't feel like a traditional foreground.

✔ **Background:** Everything outside is the background, whether near or far. Ultimately, the sun is the most obvious background element.

✔ **Light:** The sky forms a light canvas that the bridge cuts across. The walkway is neutral.

✔ **Darkness:** The bridge frame is black, which makes it disappear. What's left are like mosaic tiles that are incomplete but comprehensible nonetheless.

✔ **Color:** The blue sky and the golden sun add color to the outside. At the end of the bridge is a bright green arch. This sets that location apart from everything else. Within the bridge, everything is neutral or dark.

✔ **Texture:** The concrete is rough while the bridge and sky are smooth.

✔ **Lines:** The lines really make this photo. Combinations of curved and straight lines contrast with each other.

✔ **Regions:** Each space is bound by the bridge frame and exterior suspension; those boundaries separate this photo into a number of small areas. The walkway, however, is large and inviting.

✔ **Timing:** I took this photo during the evening golden hour. Aside from the character of the light being good, this meant that the sun would be positioned low (visible) and make the darker elements feel like they're in silhouette.

✔ **Space:** The bridge restricts the movement of your eyes from side to side. The only way out is forward.

Designing with Shadows

Be on the lookout for anything that provides contrast. Contrast can be between colors, textures, shapes, content, subjects, and other design elements. In Figure 3-5, the contrast is between light and shadow. Think about design so you know *what* to capture when you see it.

This photo is a great example of design versus framing. Without the shadows, I could return to the same spot, frame it the same way, and capture a completely different scene. The *design element* is the interplay between light and dark: the shadows. Take away that interplay and the photo changes. In this case, I took a photo of shadows, not a staircase. It helps that the stairs have an M.C. Escher feel.

Figure 3-5: These stairs and shadows evoke M.C. Escher.

It's important to think of these elements when looking at this photo:

- **Key design element:** The shadows caused by the lighting in this scene produce a compelling photograph. The framing and sun are important, but without the shadows, it would just be a concrete staircase.

- **Framing:** I framed this shot very carefully to take advantage of the direction of the shadows and to balance the proportion of light to dark spaces in the shot. Although the stairs are in the center of the frame, they only take up two-thirds of the vertical space and one-third of the horizontal space.

🖎 **Subject:** Initially, you think the subject is the staircase. However, the shadows are the real star of this photo.

🖎 **Foreground:** The foreground is dark and featureless. The lack of detail works in this photo, whereas it might look horrible in a traditional landscape shot.

🖎 **Background:** This photo has two backgrounds. One is to the right of the stairs. The other is to the left. They have different tones and are at different distances.

🖎 **Light:** Two large light regions balance all the darks. This is important for this photo. Not every photo has to have the same balance, of course. In this case, however, they're arranged so that no area of the photo dominates the others.

🖎 **Darkness:** Much of the photo is dark. That's what a shadow is, after all. When using them in your photos, don't be afraid to let them be dark.

🖎 **Color:** I shot this directly in black and white. I don't even have a raw image with color information to work with. I did this because I was experimenting with the camera's creative styles and wanted to see if they produced good photos. As a result, I didn't have to spend any time at all processing this into black and white after transferring the photo to my computer. It was already done!

🖎 **Texture:** The texture in this shot is mostly smooth. However, the wall to the left is mottled. That makes it stand out a bit.

🖎 **Lines:** Lines, lines, and more lines. The lines from the shadows, the railing, the stairs, the lights, the supports, the wall, and far background all contribute to this photo.

🖎 **Regions:** Because this photo is black and white, it's mostly separated into light versus dark areas. The top and bottom are dark, while both sides are brighter. The center is a mixture. The stairs have a good deal of darkness to them near the bottom but they're lighter when you see them from underneath.

🖎 **Timing:** I shot this photo during the afternoon. The sun was relatively high in the sky, but was far enough along to cast these strong shadows. This is one case where, had I waited until evening, the shadows would have been too long.

🖎 **Space:** Overall, the feeling this photo gives is one of height. There is some depth to it, which helps open the right side of the photo. There's no real breadth to this shot. That's okay.

Going Minimal

When I was young, our family helped rescue a litter of baby rabbits. I still have the pictures of us feeding and caring for them. When they were able, we released them back into the wild to lead happy rabbit lives. Life has a funny way of repeating itself sometimes. My kids and I rescued four of the little guys and tended them carefully for a few weeks before turning them loose.

I'm not one to let an opportunity go to waste, so I captured some shots of them on my studio table with a white backdrop. Although the cabbage is in the photo mainly to give the rabbit something to focus on besides us, it turned out to be a really nice addition to the shot. In fact, aside from the rabbit itself, it's the key element in an otherwise minimal design. See Figure 3-6.

Figure 3-6: Who you lookin' at?

Train your mind to spot these elements in photos:

- ✔ **Key design element:** The red cabbage. If it weren't there, this would be a cute photo, but it would lack the same visual impact. The wonderful thing about the cabbage is that it doesn't change the fact that the rabbit is the main subject. This is also an example of minimalist design and designing with light tones (called a *high-key effect*).

- ✔ **Framing:** I framed the rabbit just to the right of center, with even space above and below him. I couldn't put him on the left side, because he was looking right at me. That would have felt uncomfortable.

- **Subject:** The rabbit is the star of this show. He's alert and looking right at you.

- **Foreground:** This photo has no foreground. Most of the frame is a solid white, lacking any details.

- **Background:** Likewise, there's no obvious background. However, the cabbage does go past the rabbit and into the background. This makes the cabbage look more like a background element.

- **Light:** The white paper and lighting combine to make this a really bright shot. By designing the photo this way, I remove most of the possible distractions.

- **Darkness:** In one sense, I want you to look at the dark areas of this photo because I turned everything else white. In context, the rabbit's dark eyes stand out well, as do the darker areas of the cabbage.

- **Color:** The rabbit is naturally brown and white. This is in contrast to the very powerful purple of the red cabbage. The whiteness affects the photo by the absence of color.

- **Texture:** Although texture isn't the main design element, the rabbit and cabbage both have interesting surfaces. The cabbage is smooth and the rabbit is furry. Contrast. Also, the lack of texture in the white area makes what texture there is stand out more.

- **Lines:** This shot has few straight lines. The rabbit is a cute round fuzz-ball. The cabbage is also curved.

- **Regions:** I basically divided the photo is into halves, but it doesn't feel symmetrical because the right side is further divided into the rabbit and cabbage. The rabbit takes up a third of the vertical space, which also helps make this shot work.

- **Timing:** Timing was important for this shot. The rabbit scampered about and was sometimes tough to photograph. I captured him with a great expression on his face.

- **Space:** Photos with a lot of white space feel open and unbounded, even if the subject is staring you right in the face. The result is an odd combination of intimacy and space.

Noticing Your Surroundings

I spent a few days photographing harness races. It was terrific fun. Other classic racing shots are in this book. Their design is about making sure the

background elements don't interfere with the action, as well as pressing the shutter button at just the right time.

The shot in Figure 3-7 is different. After some time, I noticed an interesting sign next to the track. It was, not surprisingly, right beside the gate where the horses and drivers entered and left the track. I thought it would be an interesting shot if I captured the sign as the horses raced by.

Figure 3-7: Yes, watch for horses!

When you can think in design, you can shoot it:

- ✔ **Key design element:** The sign. One reason I like the sign is that you can fill in whatever message you think it brings to the photo. I see irony and humor when the sign is shown with horses racing past. You may see something different.

 Sameness isn't the purpose of good design. However, it makes this photo work.

- ✔ **Framing:** I had to carefully frame the shot horizontally to include the sign and have enough room to see the horses racing past. Vertically, I put the horses in the center of the shot. The frame is filled with action. Without the sign, this framing wouldn't work at all. It would look like I was doing something wrong, in fact.

- ✔ **Subject:** Is it the sign? The horses? Both?

- ✔ **Foreground:** In this case, almost everything is in the foreground.

Book IV
Chapter 3

Deconstructing Design

- **Background:** The background is the grass in the center of the track and the far straight.

- **Light:** The sign stands out because it is light. The visible driver and frames also stand out.

- **Darkness:** In this case, the horses are the dark element.

- **Color:** Most of the photo is dominated by greens. The brown horses stand out well against the background. The driver's purple silk make him stand out.

- **Texture:** This shot isn't about texture. The background is blurred enough to appear smooth, as is the sand in the close foreground. That helps a lot by eliminating distractions; any detail can be seen as a potential distraction.

- **Lines:** Most lines in this photo run horizontally. That helps the sensation of racing. The key vertical line is the end of the fence. I had to make sure that it wasn't in the center of the shot. When you divide a scene too evenly, it often loses its power.

- **Regions:** This photo has lots of different regions. The fence and sign divide the shot horizontally into different segments. The grass and sand divide the photo vertically.

- **Timing:** I had to take this shot at just the right time as the horses raced past. This was hard to do, as I was using a telephoto lens with a tight field of view. I couldn't line up the shot and compose it with care.

- **Space:** The horses feel very close. The background adds depth to the photo, and the lines plus action give you a sense of movement from left to right. This keeps the photo from feeling too boxed in.

Reflecting on Photos

One of the more frustrating things about photography is the inability to adequately capture some scenes that look impressive to our eyes. Skies resist photographing unless they're part of the background of a landscape or cityscape. I tricked the one in Figure 3-8. I didn't design this photo. I looked into a river and this is what I saw. However, I recognized that this combination of elements made for a great photo. That's working with design.

Sometimes design is passive. You see it and know that it's going to work. Knowing *why* is important so that you can recognize these things in the future and successfully capture them.

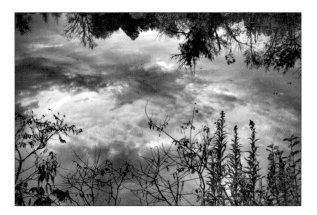

Figure 3-8: Reflections transform water into something otherworldly.

Here are my thoughts on this shot:

- **Key design element:** The reflections in the water. I've looked up and seen skies and sunsets that looked miraculous, only to take their photo and not be impressed with the shot. I've also tried to take shots of water that looked promising to my eyes, only to look dirty and brown in the photograph. In this case, the reflections in the water let me take a picture of a beautiful sky and water at the same time.

- **Framing:** I framed this shot to capture the reflection of the sky in the middle two-thirds of the frame. The greenery at the top is actually a reflection of the far bank of the river.

- **Subject:** This is another shot where the subject is open to a bit of interpretation. Is it the sky? The greenery? The water? Ultimately, the clouds and blue sky are the main subjects.

- **Foreground:** The plants in the foreground serve as a nice boundary between reality and reflection.

- **Background:** The background is all reflection.

- **Light:** The bright areas of the sky, as reflected in the water, are compelling.

- **Darkness:** The dark areas of the sky are just as important as the brighter areas. They play off each other.

- **Color:** This photo features a magical natural color palette, full of red, yellow, orange, green, blue, and purple.

- **Texture:** The clouds have a puffy texture, but the reflection seems to smooth it out. The foliage is rougher, which helps bound the photo.

- **Lines:** The plants at the bottom and the reflections at the top appear to reach towards the middle of the shot.

- **Regions:** This photo is divided into three main regions. Each takes up roughly a third of the frame. The foreground plants, the water (sky), and the top reflections of the far bank all run horizontally across the photo.

- **Timing:** I took this photo during the evening golden hour. You get the most magical light during this time. Had I taken this shot at noon, the clouds wouldn't list from the side, nor would the light have been as gentle.

- **Space:** Because the river runs across the photo and isn't bound on either side, this photo has a feeling of width and openness. You feel more restricted from top to bottom.

Waiting for the Moment

On a trip to Detroit, I went downtown several times to see the sights. One afternoon I visited Greektown. The scene in Figure 3-9 is filled with the hustle and bustle of a district devoted to entertainment. As I looked at the scene through the viewfinder, I saw a woman walking toward me. The rest of the frame was so busy and anonymous that I knew that she would add something personal. I had to wait until she got close enough and then take the photo. Design. I recognized her as an important element. Her presence was dynamic and I had to work to get it just right.

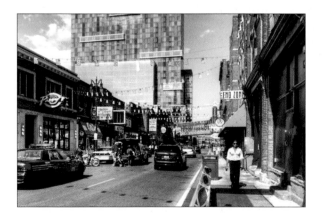

Figure 3-9: The streets of Detroit.

Look for ways like these to design your photos:

- **Key design element:** The woman walking toward the camera. I had to be patient and wait for the right moment.

- **Framing:** I tried to keep everything off center for this shot. It's just the right mix of what looks like randomness, but is very purposeful. The *vanishing point* (where all the horizontal lines in the photo seem to converge) is below the vertical center of the frame, about a third of the way in from the right side.

- **Subject:** Is this a shot of the hustle and bustle of Detroit, a family trying to get a stroller in their trunk, or a woman walking towards the camera? All of the above.

- **Foreground:** The foreground is largely empty in this photo.

- **Background:** The background is a mixture of buildings, signage, people, and vehicles. Can you find Waldo?

- **Light:** This photo has lots of light tones. It was a sunny afternoon and the light was coming from almost directly behind me. The woman's white shirt pulls your eyes toward her. The sky and building in the distance are also bright.

- **Darkness:** The buildings are a bit darker than the rest of their surroundings. This helps pull your eyes into the distance.

- **Color:** The blues in this shot are electric! They balance the warm tone of the buildings to the left and right. The street is neutral.

- **Texture:** Busy, with the exception of the sky and the near street.

- **Lines:** Most lines in this shot run into the distance. The exceptions are important: The woman nicely breaks up the lines. Almost everything about her, in fact, causes her to stand out from the rest of the action. Notice also that the blue building in the distance and the far end of the buildings on the right add vertical elements.

- **Regions:** This photo has four main regions. The buildings on both sides of the street, and the street itself, funnel your eyes to the distance. The sky and tall building (which visually is almost part of the sky because it's blue) balance out the scene.

- **Timing:** I timed this shot to photograph the woman walking toward me at just this point. She appears not so large that she's connected to the sky, and she appears not so small that she disappears.

- **Space:** This scene has a feeling of depth and distance to it, created by the funnel of the buildings and the lines leading into the distance. It's got some width as well, because the street has two distinct sides.

Capturing the Action

Figure 3-10 is a photo of my youngest son bowling. He's using a ramp that helps younger kids. Even action-oriented photos have good and bad design elements about them. In this case, quite a few things add up to make this a vibrant photo with a lot of personality. In the end, his pose is probably the most important element of this photo. It's got his personality and panache.

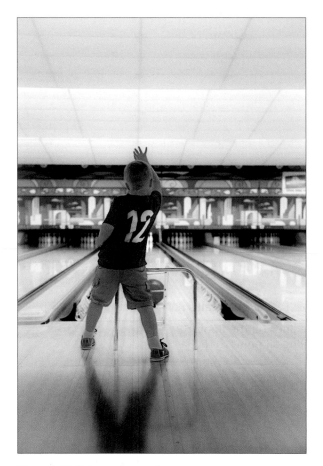

Figure 3-10: He's got the touch.

You can look at this photo several ways:

- **Key design element:** The pose. He's in control and competitive.

- **Framing:** I got down low and offset Sam a bit to the left of center. In the case of the pins, I had little choice; they're at the bottom of the far wall, which makes it seem like they aren't in the center of the photo.

 Even when you can't compose strictly according to the rule of thirds, it helps to keep things off the center lines of the photo.

- **Subject:** Working with children is always interesting. In this case, I simply observed and captured the action as it unfolded.

- **Foreground:** The shadow is a nice addition to the foreground.

- **Background:** The background happens to be patterned and visually interesting. The white pins stand out as well as the blue wall.

- **Light:** Most of the scene is bright: the lanes themselves, the pins, most of the back wall, and the ceiling. This gives the photo an ethereal feel to it. It's not what I would call a classic bowling shot.

- **Darkness:** The shadow is pretty important to this photo. Even though cut off (which helps prevent it from accidentally dominating the photo), Sam's shadow leads your eyes right to him. The dark spaces around the pins and the wall in the background pull your eyes into the distance.

- **Color:** The red shirt, pink ball, and blue wall make the middle of the photo the center of attention. Purple elements on the far wall connect to his shirt and the ball.

- **Texture:** Most things in this photo are smooth. This makes *noise* (grain) stand out more (I had to shoot this photo with an ISO of 12800 to get the shutter speed I wanted) but also makes it easier to reduce noise in software. Book III, Chapter 3 talks more about ISO and noise.

- **Lines:** The lines on the floor, the gutters dividing the lanes, and the lines on the ceiling all point to the far end of the photo.

- **Regions:** In this case, the photo is divided into three areas: The immediate foreground merges with the lanes and takes up half the photo. The lanes are divided into areas, which makes the lower half of the photo seem less dominant. The real focal point is the far wall, which occupies a sliver running across the photo, just above the centerline. The ceiling takes up the rest of the space.

- **Timing:** Timing was important here. I had to photograph Sam at the right moment, just as his arm finished its flourish. I wanted to see the ball, so I couldn't wait.

- **Space:** This photo has depth, caused by all the elements pointing at the vanishing point in the distance.

Book IV
Chapter 3

Deconstructing Design

Chapter 4: Taming the Frame

In This Chapter

- ✔ Locking onto framing
- ✔ Elevating your vantage point
- ✔ Using symmetry
- ✔ Looking at different angles

*W*hen photographers say *frame*, they can mean several things. As a verb, it means to point your camera at the scene and compose the shot. As a noun, *frame* can refer to your photograph. It can also mean your view through the viewfinder or on your LCD monitor — your windows to the world.

In this chapter, *framing* means lining up in your viewfinder or on your LCD monitor the elements that you're photographing. I sometimes use the word *composing* to mean the same thing. Framing is different from design, where you choose what elements will go in the photo. (Book IV, Chapter 3 examines design.) Framing comes after that. After you've settled on the elements, framing means finding the look that will create the best photo.

I include certain photos in this chapter to talk about how those elements are positioned and arranged. I won't show you a photo with bad design as an example of good framing, and I won't show you a poorly framed photo as an example of good design.

Picking a Portal

You may find several equally good ways to frame the same scene. The viewfinder and LCD monitor are indispensable tools when you're framing a shot.

Using the viewfinder

The large built-in *viewfinder* (located behind the built-in flash and above the LCD monitor; see Book I, Chapter 2) sets dSLRs apart from other camera types. Some dSLRs have large, bright viewfinders that make looking through them a joyful experience. It's easier to focus and compose your shots using them.

Use your camera's viewfinder whenever possible.

Figure 4-1 shows what you might see through the optical viewfinder. You may see a number of exposure settings as well as AF points (see Book I, Chapter 5) and possibly metering aids. You may be able to turn on grid lines (see Book I, Chapter 5) that will help you line things up in the viewfinder. Use everything at your disposal if you need to.

Figure 4-1: Composing through the viewfinder.

Electronic viewfinders, a new development, work much the same as the traditional optical type, but with added flexibility. That flexibility comes from the fact that you're looking at a small LCD monitor that can display virtually anything (the scene through the lens, the menu system, photo and movie playback, the effects of creative styles and other special effects, and so forth). Electronic viewfinders also perform well in low light, because you can brighten the image. Book I, Chapter 5 talks more about styles. Figure 4-2 is a scene shown through the electronic viewfinder of a Sony Alpha A77. In this case, Creative Style is set to Black and White. There is no way to duplicate this display using an optical viewfinder.

1/160 F2.8 +1.0 ISO100

Figure 4-2: Electronic viewfinders are very versatile.

In general, I find that viewfinders (electronic and optical) focus my attention better compared to when I use the LCD screen. I tend to hold the camera steadier because I'm able to support it with my body. However, sometimes I simply can't physically look through the viewfinder. When that happens, having an LCD monitor (especially an articulated one) saves the day.

Contrary to what it might look like, viewfinders don't give you a significantly smaller viewing area than LCD monitors. Test it for yourself by comparing the viewfinder (when you hold the camera up to your eye) with how large the LCD monitor looks when you hold the camera away from your face. They're close to the same size.

Going with Live view

Instead of the viewfinder, you can frame shots using the LCD monitor on the back of your camera. This is called *Live view*. Many people prefer using the monitor instead of the viewfinder, although it can be challenging to see well in bright light. Using the monitor is helpful to me in many situations, especially in the studio.

LCD monitors display different levels of information. When you're setting up your camera and working out the exposure, it helps to have all the information at your fingertips. Book I, Chapter 3 shows you what's possible.

When you're framing, turn off everything except the grid. You can get to those settings in your camera's menu or by pressing a Display/Info button (the name depends on your camera) to cycle through displays.

**Book IV
Chapter 4**

Taming the Frame

Figure 4-3: Composing with grid lines.

When you're in Live view, you can zoom in when focusing (generally by pressing some sort of zoom button, depending on the camera). The magnification, which is far more than you can get through a viewfinder, makes getting the precise focus a snap. In addition, some cameras have depth-of-field helpers. Advanced Sony dSLTs, for example, have a feature called *Peaking*. When Peaking is on, edges in the depth of field are highlighted with the color of your choice. It's a very nice visual indicator of where the depth of field lies within the frame.

Understanding coverage

Frame coverage is a comparison between how much of the scene you see in the viewfinder or LCD versus what winds up in a photograph. Full coverage is 100 percent. That means you see the entire shot, right up to the edges. This is, of course, what you want. Not all viewfinders and LCDs have full coverage. Entry-level cameras, for example, top out at around 95 percent coverage. In general, the more advanced the camera, the more coverage it has.

If you think this is a pretty big problem when you're framing a scene, you're right. However, don't obsess over it. Regardless of dSLR coverage, you can frame great shots, accounting for framing discrepancy through experience and experimentation. If that fails, use software cropping to achieve the perfect composition.

Upon closer inspection

Magnification isn't that much of an issue when you're framing a photo, but is a characteristic of your viewfinder. *Magnification* is how much the view through the viewfinder is magnified or reduced compared to the naked eye. Viewfinder magnification is normally expressed as a fraction that you can convert to a percentage. If the viewfinder reduces the scene, the magnification is less than 1. If it's magnified, the value is more than 1. For example, magnifications of 1.09x and 0.74x magnify the scene so that you see it as 109 percent and 74 percent of

its true size, respectively. Your camera's specifications tell you at what lens and focus distance the magnification factor was measured.

While top-end dSLRs often have 100 percent coverage, they pay for it by reducing the magnification. The Canon 5D Mark III has 100 percent coverage, but only 0.71x magnification. Lower-level dSLRs tend to have less than 100 percent coverage but more magnification. The Nikon D3200 has about 95 percent coverage and a magnification of 0.8x.

If your camera has less than 100 percent frame coverage, pay attention to how you frame your shots versus how they turn out. You can immediately check by reviewing the photo and comparing how much space surrounds your subject in the photo versus your composition. Use a subject you're familiar with. I prefer people, because it's easy to remember where you put things in the frame when you position their heads consistently in the viewfinder.

Learn to counteract framing errors. For example, I have a camera that makes it seem like I put too much space above my subjects. The reduced coverage fooled me into thinking that I was composing correctly. Over time, I adjusted so that I framed my scenes better, even with the coverage shortcoming.

Break It Up! Using the Rule of Thirds

There's a tried and true framing rule you should know about. It's called the *rule of thirds*. The rule suggests that you divide the frame vertically and horizontally into thirds — like a Tic-Tac-Toe board. The idea is to place dominant vertical or horizontal lines in the scene (like building edges, the horizon, people, and so forth) on the dividing lines. You should place important objects at the intersection of those lines. The Live view display earlier in this chapter in Figure 4-3 has just such a grid.

**Book IV
Chapter 4**

Taming the Frame

Figure 4-4 shows a river scene that I composed with the rule of thirds in mind. I placed the water in the lower third of the photo. The trees and brush on the far bank divide the river from the sky. The sky takes up about two-thirds of the top of the photo. It's a classic and effective framing technique.

<table>
<tr><td align="center">A</td><td align="center">B</td></tr>
</table>

Figure 4-4: A: Placing the water in the bottom third of the photo. B: Placing the sky in the top third of the photo.

To emphasize the foreground (the bottom of the photo) instead, I shifted my look down. In version B, I applied the rule of thirds differently, emphasizing the reflections in the water rather than the sky.

Do you have to use the rule of thirds? No. Should you? Mostly. Although there are always exceptions, humans find it more visually pleasing when things are arranged this way. As I show you examples in this chapter, I bring up the rule of thirds and tell you whether I applied it or not. Most often, I have.

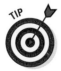

An advantage of using the rule of thirds is being able to align or balance objects in the scene against each other and the empty space. When I think in terms of thirds, I'm able to level the shot better.

One word about balance before continuing. Balancing a scene involves weighing things in the frame (take size, shape, color, brightness, texture, and other factors into account) and positioning them so that most things average out. You can train your eye to see balance well enough that it becomes more of a gut feeling than a conscious act. You'll start to frame photos with balance because they "just feel right." To summarize the salient points on this photo:

 ✔ **Rule of thirds:** I framed both photos using the rule of thirds. Each shot emphasizes a different element. One makes the river in the foreground more prominent; the other emphasizes the sky.

↙ **Symmetry/balance:** In Figure 4-4, the water and sky are basically mirror images of each other. The autumn foliage provides a welcome contrast and divides the two blue and white areas very effectively. The reds and yellows keep things from being monotonous.

Taking a Knee

Most people tend to take photos standing up. When you look at their photos, you see objects from the same height. And the horizon is in the same place in the photo frame.

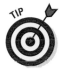

Vary the height from which you take your photos. Take some standing up. Take others from a crouch. To get even lower, get down on one knee and look up at the scene. I did just that in Figure 4-5, a motorcycle in the parking lot of a heavy equipment rental business. In fact, a pair of kneepads gave me a little extra support and comfort when I kneeled.

Figure 4-5: Shooting low really increases the drama in a scene.

Choosing this angle shows how I distinguish between design and framing. The design would have been the same had I been standing, kneeling, or lying down because the basic elements would've been the same: motorcycle, building, pavement, and sky. In this case, I chose a different framing technique.

You can also use different lenses to accentuate the composition. In this case, I used an ultra wide-angle lens, which allowed me to get low and close and still get a lot of background in the frame.

Consider these final points before moving on:

- ✔ **Rule of thirds:** I framed this photo in general accordance with the rule of thirds. The pavement makes up the lower third of the photo, the building the next third, and the sky the last.

- ✔ **Symmetry/balance:** It doesn't have any obvious symmetries, except for the sky and pavement balancing each other. There's roughly the same amount of space on all sides of the shot.

Framing Vertically Versus Horizontally

One of your more important framing decisions is whether to hold the camera in *landscape* or *portrait* (vertical) orientation. Often, the subject determines the orientation you should use.

- ✔ **Tall or narrow subjects** look best in portrait orientation. Quite often, this applies to portraits. Vertical photos often impart a feeling of depth.

- ✔ **Wide subjects,** or those that appear wider than tall, look best in landscape orientation. Photos shot horizontally often convey a strong sense of width.

For the next example, I chose a scene that looks equally well in both orientations. I was outside looking through a tall grove of trees. Although both photos contain the same elements, they evoke different feelings. (I shot both versions using a Holga lens, which accounts for the style of the photo.)

Figure 4-6 shows a vertical shot and horizontal shot. The vertical shot captures the tall trees very well. The building beyond extends across the narrow frame. The building looks pretty far away. I shot the other version horizontally and positioned myself a few feet to the left. As you can see, the height of the trees isn't obvious in this shot; the building's width is more obvious. The building looks much closer in this version.

Ponder these framing elements:

- ✔ **Rule of thirds:** Both shots represent a good use of the rule of thirds. The green grass, the building, and the sky all take up roughly a third of the vertical space in both photos.

- ✔ **Symmetry/balance:** The random trees are a great example of natural placement. Some are to the left and some to the right, both near and far.

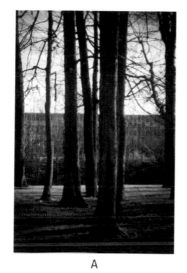
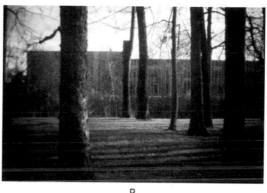

A B

Figure 4-6: A: Vertical creates one frame. B: Horizontal creates another.

Getting Up High

The example in this section shows an extreme change in vantage point. Remember, this is about framing. The elements in the scene remain the same. Hence, the designs are equivalent. What changes is how I chose to frame them. Technically speaking, I did this by moving between different vantage points.

Figure 4-7 shows a conventionally framed shot in the sanctuary of a local church. I took this photo straight down the main aisle using the rule of thirds. I put the camera low on a tripod. I composed the other photo in Figure 4-7 differently. In this case, I moved to the highest corner of the balcony. The resulting shot shows off the room's depth and space. From this spot, you get a sense of the enormity of the interior. (I used a Sigma 10–20mm f/4.0–5.6 ultra wide-angle lens set to 10mm for both shots; the field of view is comparable to using a 15mm lens on a full-frame camera. The different vantage points make the same lens set to the same focal length perform very differently.)

**Book IV
Chapter 4**

Taming the Frame

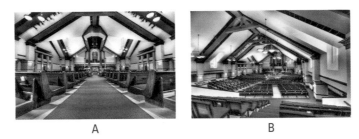

Figure 4-7: A: Shooting low. B: Shooting high.

This list summarizes the main framing elements in this example:

- **Rule of thirds:** The traditional shot represents a classical application of the rule of thirds. The photo taken from the balcony uses the rule as well, but the rule isn't as obvious in that case. The stage area takes up about a third of the photo both horizontally and vertically.

- **Symmetry/balance:** The first photo is very symmetrical horizontally: The ceiling, far wall, and pews look the same on both sides of the frame. The second photo has an amazing lack of symmetry.

Avoiding Symmetry

When you walk up to a building to photograph it, your natural inclination might be to line yourself up with the front door and frame a photo that has bilateral symmetry: the same on both sides.

Compose a shot where you're not right in front of the door. Step aside and shoot from an angle and see what you can come up with.

I did that in Figure 4-8. I came upon this charming auditorium during the evening golden hour; the sun was hitting the red bricks and grass from the left side of the frame. I tried variations, and to be honest, wasn't that happy with a head-on shot. In this case, avoiding symmetry seemed to work best.

Keep these things in mind as you review this photo:

- **Rule of thirds:** I shot this thinking of the rule of thirds. The grass is the bottom third of the photo, the building takes up the second third, and the sky is the last third.

✏ **Symmetry/balance:** Although not symmetrical, this photo feels balanced. This is, in part, a consequence of using the rule of thirds. Plus, the building sits in the horizontal center of the frame with equal space on either side.

Figure 4-8: Avoiding symmetry.

Using Symmetry

The thing about rules is that sometimes you have to break them. While I sometimes avoid obvious symmetries, other times the subject calls for it.

Figure 4-9 is the interior of a bank. It was built in the 1930s in the Art Deco style, and is positively stunning. The shape of the lobby is reminiscent of an old-fashioned mailbox (the type that sits on a post and opens from the end). I shot it from the second level, towards the main entrance. I think this shot works well because there are intricate details throughout the scene. The mural on the far wall is intriguing, as is the ceiling. The light from outside fills the entryway with a bright blue glow, which offsets the earthy palette of the interior.

This photo was framed in ultra wide-angle using these principles:

✏ **Rule of thirds:** Vertically, the rule is hard to see here. Horizontally, however, it is more apparent. I lined up both sides of the wall to take up a third of the photo each. The far wall takes up the center third. On the whole, the ceiling, far wall, and floor divide the photo into different regions.

✏ **Symmetry/balance:** There is an amazing symmetry and balance to this photo. I love looking at it.

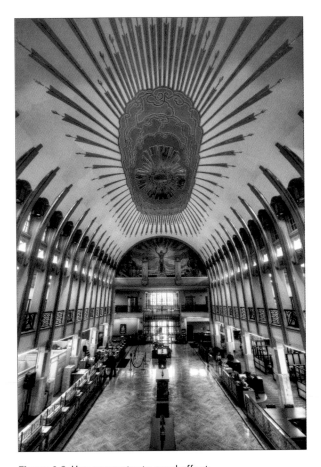

Figure 4-9: Use symmetry to good effect.

 When you're shooting pictures of vehicles and people, angles are quite important. When a person or a vehicle is pointing, facing, or moving away from you, the photo is much less interesting. They look much better from the front, so when you get a chance, frame them this way.

Stepping Up

Don't be afraid to step up and shoot a tight shot. Figure 4-10 is just such an example. I wanted to capture the detail of the upper level railing of a local bank. This type of detail was lost in the more scenic compositions. Aside from getting the details, what makes this shot is that the background shows

through the spaces in the railing. As a result, I was able to get the best of both worlds.

Make background evaluation a conscious part of your shooting routine. If it's ugly, try to find ways not to show it. If it's nice, as in this case, try to use it somehow.

Figure 4-10: Framing to see close details as well as the background.

Keep these framing points in mind as you finish this example:

- **Rule of thirds:** The railing in this shot doesn't quite have the ratio of the rule of thirds, but it's close. The top and bottom elements take up about a fifth of the vertical space each. The gazelles take up about two-thirds of the space. Horizontally, the background looks divided into thirds: the sides and the far wall.

- **Symmetry/Balance:** Although the foreground isn't totally symmetrical (there are elements, but they're slight), the background is highly symmetrical.

Angling the Background

You might be tempted to think that backgrounds should always be directly across from the camera, like the backdrop in a portrait — straight on, in other words. If you can break out of the "right angle" mindset, your photos will improve. The photo in Figure 4-11 is one of several that I took of an ivy-covered bridal shop. It's the most interesting, though, for a simple (yet profound) reason: I framed the photo so that the background angled away from me.

Figure 4-11: Nixing the traditional view of a building in favor of an angled close-up of a single aspect.

Here's my take on how this photo was framed:

- **Rule of thirds:** The left side of the photo is one third; the windows are the center, and the ivy takes up the right side. Not all photos need three components like this. You can use two. In this case, I could say that the building takes up the right two-thirds of the shot and the far background the other third.

- **Symmetry/balance:** The building angles away, allowing you to see further into the background than if this were a straight-on shot. This perspective is creative and interesting. Being in focus, the ivy carries more weight than the rest of the scene. That's why I positioned it well to the right. If it were in the center of the photo, there'd be symmetry problems and the ivy would overpower the shot.

Framing the Subject

This section illustrates a technique that I love using: framing the subject. I took the photo in Figure 4-12 from across the street, just beneath a tree. My subject is the rotunda of the county courthouse, which has a statue of Lady Liberty on top. It's a scenic, rather than detailed, photo. I used a wide-angle lens to fit what I could in the frame. Book II, Chapter 2 talks more about wide-angle lenses.

Trying some farming: Rotating and cropping

Sometimes you just can't avoid alignment problems in your photos, regardless of how good you are at framing. These problems happen most often in action shots, which tend to be spontaneous and hand-held. Sometimes you realize after the fact that you set the tripod up a little off. When that happens, don't be afraid to fix the problems in your raw software processor (see Book V, Chapter 2) or photo editor. The advantage is being able to crop and rotate photos at your leisure.

I used the leaves to create a frame circling around the top of the courthouse, effectively framing it. I've used this technique on a number of shots. Don't limit your imagination to using leaves (although they're often present and convenient). Shoot through arches, from under bridges, through fences, or out of windows. Use whatever you can. (And see the previous chapter where I talk about including the foreground in your shots.)

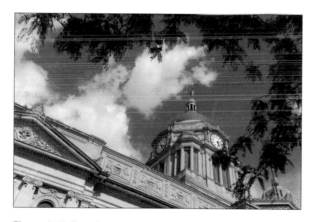

Figure 4-12: Framing the subject with leaves.

Pay attention to these framing principles:

- ✔ **Rule of thirds:** In this case, the rotunda sits at an intersection.
- ✔ **Symmetry/balance:** This photo is dominated by the angle of the courthouse roof, the projection of the rotunda, and the circle of leaves. There's nothing symmetrical about the photo, but everything balances out well.

Book V
"Spiffifying" Your Shots

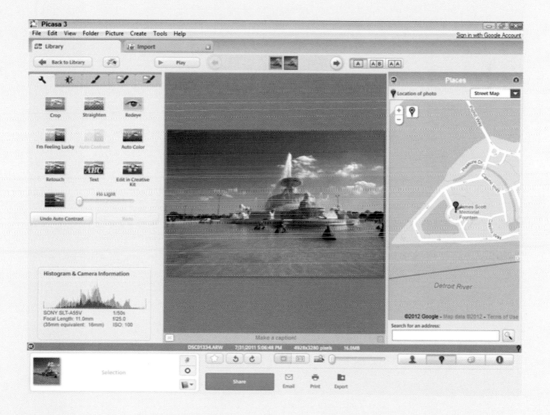

Visit www.dummies.com/extras/digitalslrphotographyaio for help creating a panorama.

Contents at a Glance

Chapter 1: Blue-Collar Photo Management

In This Chapter

- ✓ **Downloading photos**
- ✓ **Managing your collection**
- ✓ **Making necessary edits**
- ✓ **Publishing your best photos**
- ✓ **Archiving all your photos**

*P*hoto management — yikes.

You probably bought a dSLR camera to *take* pictures, not to *manage* them. (I did.) I realized early on, though, that hundreds of photos quickly turn into thousands of photos and thousands multiply into tens of thousands. Photos are like rabbits, I tell ya!

At some point, you have to get serious and start laying down the law of photo management, which is the subject of this chapter. I show you which software to use, how to track your photos, and how to establish a big-picture workflow.

Getting a Workflow

Workflow is a hot topic among digital SLR photographers because they do more than simply toss photos from their cameras into their computers. This type of photographer often develops, processes, edits, and perfects photos saved in RAW file format them before converting them to a standard finished image file format such as TIFF or JPEG.

A photography *workflow* has a couple of meanings. In a larger sense, it describes the process you follow as you work with your photos, beginning when you take them to when you're ready to archive them for long-term storage. *Workflow* also means the more limited process you follow to edit and publish your shots.

Workflow is a huge topic of debate, and the more detailed the workflow, the more people love debating it. Favorite topics include whether you should sharpen before you reduce noise or whether you should adjust brightness and contrast before you correct color. No universal workflow exists — all are based, in part, on opinion.

The following general workflow is a good one to start with:

1. **Take photos:** Although it starts here, you've already made decisions (camera, lens, file format, software, and so forth) that affect later steps.

2. **Transfer (and import) photos:** Moving photos from your camera to the computer is to *transfer.* In many cases, this means simultaneously *importing* them into your photo management software. I like to immediately back up my photos after I transfer them to my computer. Backup is explained later in this chapter.

3. **Manage:** Organize, sort, rate, geotag, filter, delete, and add keywords to your photos.

4. **Standard processing:** Develop and perfect the photos that you think are worth spending time on. For example, adjust exposure, white balance, color saturation, clarity, brightness and contrast. Sharpen and reduce noise, if necessary. Crop and straighten. This step applies to RAW images as well as JPEGs.

5. **Complex editing:** Perform more complex edits, if necessary. Some photos (especially HDR and panoramas) need more work than you can make with all-in-one software solutions.

6. **Publish:** The entire point of the workflow is to create materials worth publishing, such as a JPEG to place on your web page or Flickr photostream, or a high-quality TIFF file to print.

7. **Archive:** Save your work for long-term storage.

You can tailor this workflow example to suit your needs. In fact, you'll do a lot of tailoring, depending on several factors:

✔ **Movies:** Do you need to change your workflow to work with movies that you've shot with your dSLR? That means more software and a substantially different editing and publishing process.

✔ **Other people:** Do you have to fit into a process created by other people? Does someone else need to view or approve your work? Are you doing the approving?

✔ **Time:** How much time do you have? Do you want to spend a lot of time or as little as possible per photo?

✔ **Photos:** How many photos do you take? Must your workflow be able to handle tens of photos a week, or thousands?

✔ **Hardware:** Do you have the camera and computer hardware to manage your workflow and run the software? Do you need to be able to take your computer with you, power, or volume?

✔ **Software:** What applications are you using? Are they current? Can they handle raw files from your dSLR? Do you need anything else (panorama or HDR software, noise-removal plug-ins, other creative solutions)?

✔ **Priorities:** In the end, deciding what to do (and what not to do) has a lot to do with your priorities. What's most important: speed, quality, compatibility, mobility, or something else?

The rest of this chapter walks you through each step.

Taking Photos

Do it. Have fun doing it. I don't describe taking photos in depth in this chapter because that's what much of this book talks about. In addition to perusing the other minibooks on photography, lenses, exposure, and composition, don't forget to check out Chapters 5 and 6 of this minibook.

Transferring Photos

Transferring (also known as *downloading*) photos and movies to your computer is a pretty simple process. You can transfer several different ways. Each has its pros and cons. Some methods require additional hardware, such as using a card reader.

Connecting

Before you start transferring photos to your computer, you have to make a connection. This connection can be between your camera and a computer or, if you'd rather use a memory card reader, between the card reader and your computer.

Direct USB connection

Directly connecting your camera to your computer is the most straightforward, easy method. Connect your camera using the USB terminal, which is probably on the left side of your camera (see Figure 1-1). *Upside:* The only thing you need, besides your camera, is the USB cable that came with the camera.

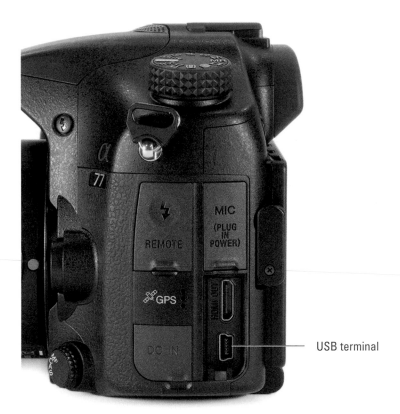

USB terminal

Figure 1-1: Look for your camera's USB terminal.

Downsides:

- ✔ Your camera has to be on. If your battery is low and you have no backup, recharge the battery a bit so your camera won't die in the middle of a transfer.

✔ When you put your camera on a table and connect it to a computer (see Figure 1-2) with a cord that can be snagged, tripped on, pulled, or yanked (by you, your kids, your cats, or your dogs), you risk pulling the camera off the table. That will ruin your day.

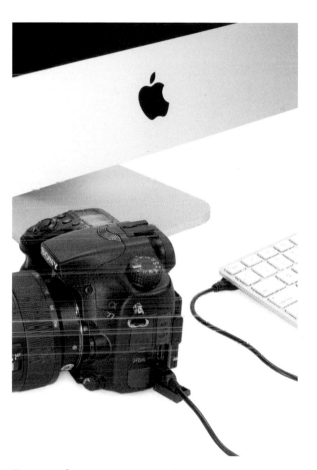

Figure 1-2: Secure your camera when it's connected to a computer.

External USB card reader

External USB card readers take the camera out of the transfer equation. The card reader (see Figure 1-3) plugs into your computer. You feed the memory card into it and it handles the transfer. *Upsides:* You don't have to use your camera's battery and you don't have to worry about running out of juice in the middle of the transfer. You aren't endangering your camera. Also, if the card reader goes bad or gets broken, you can replace it quickly and cheaply.

Downsides:

- ✔ You have to either buy a card reader that handles multiple card types or buy a card reader for each type of memory card you have. (For example, the Sony A65/A77 shown in the figure can use either Memory Stick PRO Duo or SD cards, and other cameras may use different types.)

- ✔ External readers can litter your desktop. They also tend to fall off , forcing you to get on your hands and knees and look behind the computer to retrieve them.

- ✔ If you have multiple computers to transfer files to, you must either buy more card readers or walk the one you have back and forth.

Figure 1-3: Card readers that can use different card types are very helpful.

Built-in card reader

Some computers and printers have built-in card readers. New iMac desktop computers, MacBook Air, and MacBook Pro notebooks have built-in SD cards. If you own a Windows computer, it might have come with an internal card reader. If not, you can install one. *Upsides:* Built-in models aren't as slippery as portable card readers, and can't fall off your desk.

Downside:

- ✔ Internal card readers aren't portable, unless you're using a portable computer.

Wireless file transfer

Canon's Wireless File Transmitter and Nikon's Wireless Mobile Adapter let you wirelessly transfer files from your camera to a computer or smart device (such as an iPhone). *Upsides:* Get files off your camera when you want without tripping over cords.

Downsides:

✔ You have to buy more hardware.

✔ Wireless transfer sucks up lots of battery power.

Wireless memory card technology

An Eye-Fi card (www.eye.fi) transfers files from your camera to your computer. *Upsides:* It's portable, doesn't require additional hardware (beyond the memory card), it's cool, and it gives you an unlimited amount of storage while you shoot.

Downsides:

✔ Eye-Fi cards use your camera's battery to transfer, are slower than the other methods, and require a wireless network.

✔ You have to install software installation and set up.

✔ You must buy the right type of card.

✔ Not all Eye-Fi cards transfer raw photos.

✔ Using Eye-Fi locks you into the Eye-Fi Center, which is software that enables Eye-Fi.

Downloading

After you've decided on a connection type, you choose a download method.

Automatic download

You can use a small computer program that automatically downloads the photos to the location you choose. Some are built into your computer's operating system. Others are extra software applications that come with your camera (such as Canon EOS Utility) or part of your image editor applications (such as Adobe Photoshop Elements). These programs often run in the background. They're ready to bounce into action the moment they sense a camera or card reader with a memory card. The programs normally have options for where photos are saved (plus folder name and whether to erase the photos from the card when you're done). I may be in the minority, but I can't stand these automated applications.

Similarly, you can import photos by selecting a program when you insert a disk into an external card reader or connect your camera to the computer, as shown in Figure 1-4.

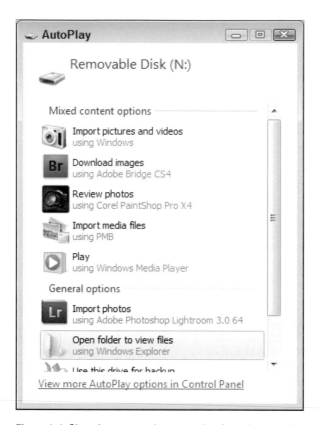

Figure 1-4: Choosing an auto import option from the operating system.

Manual download

You can do it yourself.

- ✔ Drag the folder from the card reader to your drive and rename it.
- ✔ Create folders for photos using your operating system and then select the photos and drag them to the appropriate folder.

I'm a hands-on kind of guy. I like to create folders and drag files myself. I organize my photos by camera and then by the date I downloaded them. I like to complete this process myself so that I can transfer and back up the photos immediately.

Getting a Grip on Your Pictures

Managing your photos involves finding the best way to name, store, process, edit, and keep track of the photo files on your computer. The more photos you have, the more you'll find it helpful to have a program assist you. I've split this section into several parts. One, which is quite short, discusses manual management. (Don't do it.) The next section is a software review. You should be aware of which software is available and know what each one can do. Although I can't describe single applications in depth, I can offer enough information to establish a general starting point as you decide where to spend your time and money. Knowing what you need and having a list of candidates is half the battle.

Manual management

If you like to start fires by rubbing two sticks together or you like to catch fish with your bare hands, this solution is right up your alley. File under R for ridiculous.

Media management software

You have a lot of choices, ranging from pure media managers to applications that focus on raw photo workflow and development. Also, plenty of photo editors have built-in basic management tools.

Adobe Bridge is one of the best (Adobe devotees would say *the only*) pure media managers. It's big, credible, versatile, well supported, and backed by a powerful company. Bridge is truly a bridge. It links your photos to your other applications in a way that lets you manage thousands of photos seamlessly. You can create and manage collections, rotate photos, apply different Camera Raw settings, and more from within Bridge, but you call on other applications to complete most development and editing tasks.

You don't buy Bridge by itself. It comes with Creative Suite software and Adobe-bundled Creative Suite editions. Notably, Photoshop Elements for Windows isn't supplied with Bridge; the Mac version does include Bridge. It has its own, internal organizer.

Raw photo processing and workflow

The following applications focus on raw photo processing and workflow. This is necessary if you've set the image quality of your photos to raw in your camera; see Book I, Chapter 3 for more raw information. All have robust photo-management features as well. Photo enthusiasts can work with these applications, but they have features and capabilities that appeal to professionals, too.

Adobe Photoshop Lightroom

This Macintosh/Windows application is for photographers, not for graphic artists. It has just about everything you need in order to import, manage, develop, and publish raw or JPEG photos. Figure 1-5 shows the Library tab. (Look at all those cool photo-management tools.) From this tab, you organize, sift, sort, and select.

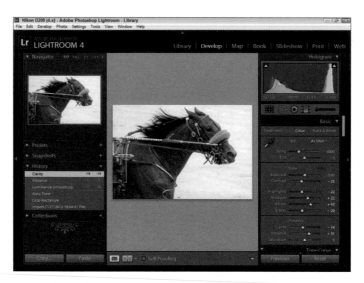

Figure 1-5: Taking a peek at the Adobe Lightroom library.

In Lightroom, you create a single massive, all-inclusive catalog or create different catalogs based on different cameras, projects, or years. When you import photos into an open catalog, they show up as thumbnails in the Library tab, where you manage them. You can view, sort, filter, rate, delete, search for, compare, create, and assign keywords, quickly develop photos, and edit metadata. You can also export photos in a number of different formats. I cover the Lightroom raw processing features (you can use them for JPEGs or TIFFs, if you want) in more depth in Book 5, Chapter 3.

To work with layers, masks, adjustment layers, panoramas, HDR images, artistic filters and effects, vector shapes, 3D support, text, frames, and other aspects unique to photo editors, you need to get a photo editor other than Lightroom.

Apple Aperture

This Mac-only application marries photo development and management. Aperture 3 is running in Figure 1-6. The Library tab is where you create projects and organize your photos. Shortcut buttons above the preview window let you change views, identify faces, and geotag. When you import photos (or working Photoshop .psd files) into Aperture, you assign them to or create a new project. Within the project folder, you can manage subfolders (or *albums*) and individual photos. (You can use Aperture 3 to create new libraries.) It also has sample projects so you can get familiar with how things work in Aperture.

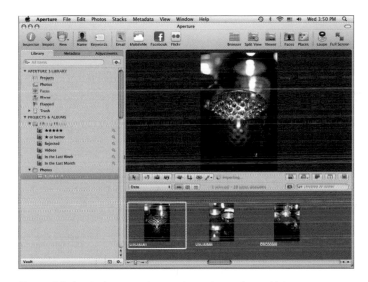

Figure 1-6: Apple Aperture is a serious alternative to Lightroom.

As you might imagine, you have all sorts of management tools at your fingertips. You can view, sort, keyword, delete, rate, export, track versions, manage and edit metadata, perform basic photo adjustments, and launch photos to an external photo editor for more advanced editing. Aperture 3 can even send GPS coordinates to Apple so that you can geolocate your photos.

Capture One Express/Pro

Capture One, by Phase One, isn't well known outside of professional circles, but it should be. It comes in two versions: Pro has a ton of features and is

priced accordingly. Express is better for casual photo-hobbyists. Figure 1-7 shows the version 7 interface.

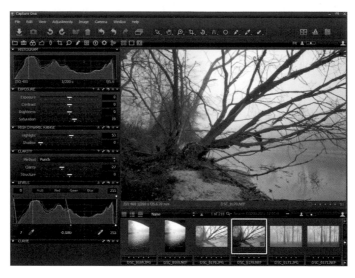

Figure 1-7: I'm in love with Capture One.

Capture One's bevy of management features are comparable to Lightroom and Aperture. Import photos and then sort, rate, preview, organize, *tag* (add keywords to), develop, and publish them. Organize your photos in catalogs or work one-on-one with photos by using sessions. Capture One also has albums, which are virtual collections. I can't say enough good things about Capture One. It's fantastic, powerful, and professional, and it focuses on workflow and photo quality.

Built-in media management

This section lists photo editors that have built-in media management capability. These relatively inexpensive editors are aimed mostly at the cost-conscious photo amateur (don't let that statement deter you — they're quite capable):

Apple iPhoto

iPhoto, shown in Figure 1-8, is a nifty little Apple-cation with lots of good organizational tools. You can import and organize photos and then view, rate, *tag* (add keywords to), title, edit, and publish them. iPhoto is an excellent application for Macophile hobbyists.

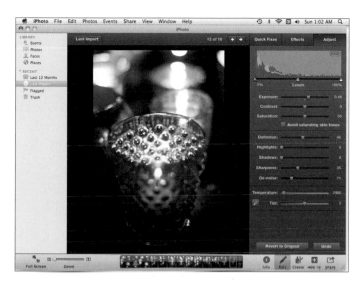

Figure 1-8: Messing with levels in iPhoto.

Adobe Photoshop Elements

The Adobe entry-level photo editor has a lot going for it, given its reasonable price. It has a photo editor, of course, and the Windows version includes a built-in organizer; Mac users have Bridge. Figure 1-9 shows a major editing project underway, complete with various layers and adjustments.

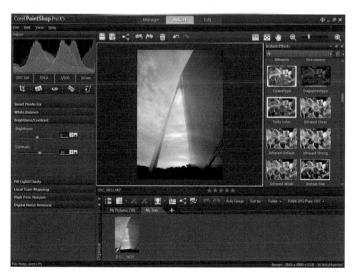

Figure 1-9: Photoshop Elements offers Instant Effects.

Corel PaintShop Pro

PaintShop Pro X5 Ultimate has three modes: Manage, Adjust, and Edit. You can sort, organize, rate, review, keyword, edit, and export photos.

Google Picasa

Even Google has an entry-level photo editor and organizer. It's free and both Windows and Mac can use it. It's Picasa, and it's cool, and it's in Figure 1-10. As you'd expect, Picasa has close ties with Google Maps and Google Earth.

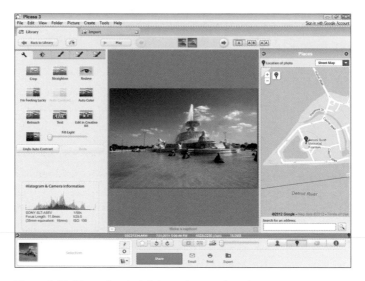

Figure 1-10: Picasa is a helpful way to organize photos.

Picasa scours your hard drive to find your files and then loads them into a library — you don't need to import them unless you want to. (You can add or subtract folders or import photos later.) You provide the organizational structure by creating albums and assigning photos to them. You can perform rudimentary editing tasks in Picasa, such as rotating, straightening, removing red-eye, and more. The main management tasks revolve around organizing photos and videos into folders and albums, by people, and then sorting, filtering, tagging, sharing exporting, blogging, and creating other types of output, such as movies or collages.

Doing the upgrade dance

Suppose that you have Adobe Design Premium Creative Suite 5, Photoshop Lightroom 3, Photoshop Elements 10, Apple Aperture 2, and iPhoto 10. Sounds like a lot of good stuff you've invested in. The only problem is that every single application is outdated!

Software isn't a one-time cost. Companies continually revise their products in light of new technology. They add new features and fix old ones. So, even when you've found a program you like, you eventually need to upgrade it to stay current.

How often you upgrade depends on a couple of factors:

✓ **Your commitment to the cutting edge:** You might want or need to have the latest software versions. In fact, you get a lot of use from the software you buy if you buy a copy soon after it's initially released. An updated program is also more likely to

work with current operating systems and hardware. At times, you *must* upgrade software in order to stay compatible with the latest dSLRs and their raw formats.

✓ **Your thrift:** Just because something has been updated doesn't mean that the old version is rendered useless. Aperture 2 is still going like gangbusters, even though Aperture 3 exists. If your photo or movie files work with your software, there's no overriding reason you must upgrade.

I don't advise being more than one version out of date. If you decide not to upgrade right away, do some research and stay in a valid upgrade path (having the programs that qualify for the upgrade you want) to save money.

Don't forget to check for *operating system (OS)* upgrades and program compatibility. If you upgrade your OS, you may have to change or update your applications.

Management tasks

Get familiar with these management tasks as you try out or invest in a particular piece of software. Think about how these tasks fit into your workflow:

✓ **Grouping** creates different structures to hold and organize your photos. It might be called a *library, catalog, project, album,* or *folder,* depending on the application. After it's created, you import photos into this structure, which keeps or separates one set of photos from another. That way, you don't have 10,000 pictures flopping around with no rhyme or reason.

✓ **Sorting** is when you identify a criterion, such as the date or time that you took a photo, or its filename, keyword, or rating; the program displays the photos or working files by that criterion.

✔ **Filtering** is similar to sorting, but weeds out photos based on the criteria you choose. You can make it so that you see only five-star photos; all the rest can be hidden.

✔ **Keywording or tagging** is a straightforward concept that's infuriating in practice. You tag every photo with descriptive keywords that help you organize, sort, find, and otherwise keep track of similar photos. The problem is coming up with a list of standard keywords and using them. For example, you might tag the same photo this way: Landscape or D3200, landscape, f/8, sunset, Sigma, ultra wide-angle.

Don't get too detailed when you're tagging.

✔ **Geotagging:** Identifies where a photo was taken. Most often, you identify where one or more photos were taken on a map and the coordinates are written to the photo file's *metadata* (helpful data, stored in the file, that isn't part of the photo itself; access it by looking at the photo's info with your operating system or photo program).

✔ **Stacking:** Some photo managers stack different versions of the same photo on top of each other, allowing you to declutter the workspace.

Processing the Good Ones

Even casual photographers rarely have the time or need to process every single photo they shoot. Process good photos, not bad ones. Don't waste your time with them unless you have no other choice. You can find more details on how to process raw exposures in Book 5, Chapter 2.

Editing When Necessary

Editing boils down to a balance between time, effort, and quality. Ideally, you shoot photos in raw format and to publish they need only standard processing techniques, such as adjusting the brightness and contrast.

That isn't always the case, for a number of reasons. First, some photos need more involved fixing, perhaps involving layers, masks, and other creative solutions. That's what photo editors do. You may be working with panoramas, HDR, black-and-white, or colorized photos that need an editor's touch to finish. No problem. You do that in this step of the workflow, after processing and before publishing. I cover editing more fully in Book V, Chapter 3. (And don't forget Book V, Chapter 6, where I discuss all things color related.)

Publishing

The process of exporting or saving your final files from your raw processor or photo editor is called *publishing*. You might need to publish your work for any number of reasons: to print, upload to the Internet, send via e-mail, or to use as a new desktop background. The sky is the limit.

General considerations

Read your software manual to find out the exact steps required to export or save your work. However, consider some general thoughts:

✔ **Preserve original material:** I can't stress this advice enough. *Never* save and overwrite original files. Always track names and versions so that when you select Save, you aren't making a big mistake. JPEGs in particular suffer from *lossy* compression — they lose some quality every time you open, edit, and save them. If you're working with JPEGs, open, edit, and save as a *lossless* file type such as TIFF or a working format such as Adobe's PSD.

✔ **Preserve working copies:** If you need to export your photo to an editor like Photoshop and create things like multiple layers, masks, and adjustment layers, do yourself a favor — save those working copies. If you *flatten* (compress all the layers into a single background layer) or delete them, you can't easily go back and change or update your work.

✔ **Consider quality:** When saving and exporting, you'll have several file type and bit depth options. (You can read more about that in Book V, Chapters 2 and 3.)

• When e-mailing or uploading to the Internet, use JPEG.

• When printing or archiving a high-quality copy, use TIFF.

✔ **Enter copyright and other descriptive information in metadata:** That's what metadata is for. If you publish your photos to the web, think about adding this hidden layer of protection to your photos.

✔ **Add a visible copyright or watermark:** This is another way to protect your photos. Whereas copyright and descriptive metadata are invisible, a watermark, mark, or copyright on a photo is visible for all to see.

✔ **Strip metadata, if you want:** On the other hand, you may want to strip out any metadata to protect your secrets. Not all applications remove data, but you can save *copies* of final files to a format that doesn't have metadata and then open and save those versions to your final format.

✔ **Resize for the web:** Unless you want your full-size photos to be posted somewhere online, such as at Flickr or SmugMug, you should resize images to make them quite a bit smaller. On the web, 14 megapixels is serious overkill. (The *pixel count* is the total number of picture elements, or dots, in a photo; in this case, 14 megapixels stands for 14 million pixels.) Some sites may reduce the size of your photos anyway.

Resizing options

Pay attention to the resizing method you choose.

For example, Photoshop has these resizing options that appear on a drop-down menu in the Image Size dialog box:

✔ **Nearest Neighbor:** Preserves hard edges. Pay careful attention when you use this method. Examine the edges at 100 percent magnification to see whether the sharp edges cause jaggedness.

✔ **Bilinear:** A good method in which colors are preserved and the image is smooth. You lose a bit of sharpness, however.

✔ **Bicubic:** Works best for smooth *gradients,* such as a blue sky that transitions from dark to light; produces results similar to Bilinear, except a bit sharper.

✔ **Bicubic Smoother:** Works best if you're enlarging an image. When you're reducing, this method looks almost indistinguishable from plain old Bicubic.

✔ **Bicubic Sharper:** Works best if you're reducing an image. Distinctly sharper than all other methods, and much better than Nearest Neighbor. It produces sharpness without creating jagged edges. Still, pay attention to whether the level of sharpness suits your needs. If not, resize using Bicubic, and then come back and apply an Unsharp Mask and sharpen the image to the exact degree you want.

To display on the web, 800 pixels wide is a good start. That number is large enough to see detail yet doesn't produce a huge file size. If you want a larger size, try 1024 pixels wide or thereabouts. Sites like Flickr accept the original photo sizes with no problem.

You often have plenty of detailed methods with which to publish photos. Choose the one that best fits your target media requirements. Table 1-1 summarizes several typical options.

Table 1-1	Publishing Options
Name	*Description*
Save As	Saves the file as a new type. Type a new name and choose other file options. Use instead of Save when you want to preserve a copy of your file or create a new type.
Save for Web	Saves a new file in a web-friendly format, such as GIF, JPEG, or PNG.
Export	Saves a copy of your file as a new file type.
Share	When set up with the proper username and password, this option saves your file online. Possible locations include Facebook, Photo Mail, Vimeo, YouTube, video to Photoshop Showcase, Flickr, SmugMug gallery, online album, e-mail attachments, burn video DVD/Blu-Ray, online video sharing, smartphones, PDF slide show, and Adobe Revel.
Print	Will print your photos on a printer connected to your computer or network.
Order Prints	Orders prints from a company.

On the other hand, you may be working in a professional environment where documents run through Adobe Bridge. You can publish PDF contact sheets or web galleries from within Bridge. In Bridge CS6, you can export JPEGs. If you use Lightroom or Photoshop, you'll likely print, export, or save archive copies from within those applications.

Archiving

Archiving preserves a copy of your photos (and working files) for long-term storage. Your digital photo collection is in some ways easier to safeguard than photo prints and negatives. The electronic files themselves are, for all intents and purposes, indestructible — as long as you ensure the safety of the medium you store them in. You don't have to worry about prints getting bent or soaked with humidity, or about boxes of them occupying an entire room.

Take time to plan your backup and archive process, and diligently carry out your plans. You can't throw a sleeve of negatives into a cardboard box and tuck them away in a closet.

Playing it safe

First, decide how you want to back up and archive your photos. You have to consider issues such as storage capacity, availability, and organization, in addition to the categories in this list:

✔ **Cost:** You want to pay as little as possible, but you have to strike a balance between being cost-effective and being simply foolish. Don't buy the cheapest (and possibly least reliable) equipment known to mankind to protect your valuable files.

✔ **Capacity:** Digital photos and movies take up a lot of space. Choose a storage medium that fits your current and anticipated future workload. Table 1-2 lays out your options.

✔ **Access:** Determine whether you can easily access your backups and whether an unforeseen circumstance (like a company going out of business and never updating its software) can prevent you from protecting your work.

✔ **Security:** Assess your security situation to determine how safe (physically, and from a computer networking standpoint) the files are. Put the appropriate safeguards on your home or local network, such as Internet firewalls and password protection. In addition, files can be easily damaged if you store them at home and your house burns down. If that's your only backup copy, you've lost them.

✔ **The future:** Consider how easy or hard it will be to transfer archived files from one storage device to another. For example, old hard drives may require a connection that will someday be obsolete unless you occasionally update your backup technology. In the very long term, provide *thumbnails* (small pictures) or a printed index or another form of inventory that, for example, your kids or their kids can easily figure out when you're long gone.

Table 1-2	Archival Media Pros and Cons	
Media	*Pros*	*Cons*
CD-ROM/DVD-ROM	Data can't be erased; price per gigabyte isn't bad; no moving parts to the CD/DVD itself.	Limited capacity; most camera memory cards have more space; questionable media longevity.

Media	Pros	Cons
Tape backup	Large capacity and longevity.	Cost for tapes, drive, and software; often uses file formats specific to one system; may require special software to back up and restore; can be "eaten" by disgruntled machines; data can be erased by strong magnetic fields.
Memory card or flash drive	Easy to use; doesn't occupy much space; no moving parts.	Cost per gigabyte makes for an impractical solution; would require 125 8GB digital camera memory cards (an average of $20 to $60 apiece) to match the storage space of a single 1 terabyte drive (a good one is $80).
Internal hard drive	Affordable; holds lots; fast; useful for temporary backups.	Moving parts; susceptible to crashing; difficult to swap in or out; data can be accidentally erased.
External hard drive	Affordable; holds lots; portability; can be stored off site; great for long-term storage.	Moving parts; not as accessible as an internal hard drive.
Solid State Drive (SSD)	Essentially a huge flash drive; no moving parts; exceptionally fast; can be internal or external.	Smaller capacity and higher price than normal hard drives.
Online/Cloud	The ultimate in off-site storage; no additional hardware needed; can be accessed from anywhere at any time.	Time and bandwidth required for initial backup; requires computer with Internet access; requires service subscription and an account in good standing; long-term viability depends on company health; theoretically vulnerable to unauthorized access.

Putting the plan into action

All the cool storage devices in the world are useless if you never use them. Have a plan for backing up and archiving your files. The key to making backups work is to develop a routine that matches the time and energy you're willing to invest. If the process becomes so laborious that you quit, it's worthless.

Follow these steps to walk through the type of plan I recommend, using a combination of extra *internal* (in your computer case) and *external* (sitting on your desktop in an enclosure of some sort) hard drives:

1. **Complete an initial photo backup.**

 Back up new photos on internal hard drives when you transfer photos and movies from camera to computer. You can't afford to lose the initial transfer. These files form the basis of your collection and can't be re-created.

 The mechanics of the initial backup are up to you. I simply copy and paste the photo folder to another location. You may want to export photos from your photo-management software or use a backup program to copy a smaller bunch. This advice applies to each of the following steps.

2. **Perform a weekly internal (on your computer) backup of photo catalogs and working files.**

 Back up catalogs (which may contain the bulk of your adjustments) and any other working files to internal hard drives. If you can't afford to lose a single day's worth of productivity, consider daily backups. For a more relaxed timeline, back up catalogs, edited, and final files monthly.

3. **Perform an end-of-month external backup.**

 Back up everything to external hard drives, a file server, or a network. For a more relaxed timeline, back up quarterly or by project.

4. **Perform a biannual off-site backup.**

 Create an off-site backup with all original photo files, catalogs, working, and final files. Put them in a storage barn on your property, rent a safety deposit box from a bank, or ask your grandparents to put them in their attic. Just make sure that they're physically separated from your computer and the building you're in. That way, if anything happens to your building, your photos and work files remain safe. For a more relaxed timeline, back up annually.

The plan I suggest may not work for everyone. One alternative, keyed toward a business environment, is to treat every job as a discrete unit and back up photos, catalogs and work files according to job number. When you transfer the initial photos, back them up. When you finish the job, back up everything and tuck things away on a hard drive devoted to that client. Depending on your workload and client list, you may have one hard drive for many clients or many hard drives for one client.

Chapter 2: Cooking Up Raw Photos

In This Chapter

- Understanding why you should use raw
- Gearing up for raw
- Digging into the raw fundamentals
- Stepping it up with advanced raw development

*I*f you want the best quality, the most flexibility, and the greatest range of creative control over your photos, you've come to the right chapter. Digital SLR cameras have an industrial-strength image quality option called RAW (in addition to several types and sizes of JPEG, the standard photo file).

The raw file has data from the camera's sensor that hasn't been messed with yet. Raw images are, in essence, unfinished (hence the name). The tradeoff to having the highest quality is that someone has to finish them. That someone is you.

You read a little bit more about raw photo files in this chapter and a lot more about some of the software you can use to process them into finished images that you can show off.

Making the Most of the Least (Processed)

Raw image files have the best *raw photo data* that your camera can produce. Therefore, raw images are considered the best *source material* with which to work from.

That fact doesn't mean that JPEGs are terrible. Absolutely not.

In fact, you'd be very hard pressed to tell a JPEG produced from a raw file versus one created by the camera, assuming the photo was well exposed and didn't need dramatic adjustments. The difference is that, within certain bounds, *you,* not the camera, decide what goes into the JPEG you create. You can also take the raw data and create other types of images,

such as high-quality TIFF format. However, raw isn't a file format (like .psd) or an acronym (such as JPEG).

The companies assign their files a three-letter extension. The following short list shows many raw file extensions from different manufacturers:

Adobe: .dng	Canon: .crw, .cr2
Minolta: .mrw	Nikon: .nef, .nrw
Olympus: .orf	Panasonic: .raw
Pentax: .pef, .ptx	Sigma: .x3f
Sony: .arw, .srf, .sr2	

Before you go to raw town, you should know some pros and cons of switching to raw images.

Benefits

The advantages of shooting raw photos are numerous. A few of the most critical advantages follow:

- **Control:** If you let the camera convert an image into a JPEG and discard the raw data (by not saving it), you're forever stuck with the result. Any additional editing must be done with the JPEG, which is a subset of the original data — not the original data itself. In the end, the JPEG file is a good end product, especially for web media. When taken right out of the camera, however, all the creative decisions that go into shaping the JPEG have already been made. By the time you look at it, the original data has been thrown out.

- **Flexibility:** When you process your camera's raw exposures into JPEG files, you still have the raw data to fall back on. You can reprocess them, if the mood strikes you, whether tomorrow, next week, or five years from now. If you come across a better raw converter, you can reprocess your raw data into new JPEGs to try to make them look better. The possibility always exists that a breakthrough can make processing raw photos easier, especially in photos with a problem that you might otherwise delete.

- **More data to work with:** Raw photos have a greater bit depth than JPEG files do. *Bit depth* describes how many bits (information) the photo uses to store color information. Modern dSLRs range from 12 or 14 bits per channel, which is better than the 8 bits per channel you get from using a JPEG file. Those extra bits are useful when it comes to reproducing fine tonal variations and shading and adjusting exposure. You can ruin a JPEG quite quickly by comparison. It also means that you can often rescue photos by using that extra data using your artistic perception (as opposed to the camera's). What looks good? At least you get to try!

✔ **You can create other file types:** If you're using raw image data, you can create other file types besides JPEGs, such as TIFFs or DNGs, with no loss of quality. Other files types come in handy when you want to publish or print them.

Challenges

Raw doesn't work for everything. There are costs associated with using the raw data files from your camera. If those costs outweigh the benefits for you, don't be afraid to move towards (or not change from) a JPEG workflow.

You may choose *not* to shoot raw photos for these practical reasons:

✔ **Limited compatibility:** You can't throw up a raw photo on Facebook or Instagram. Even if you can get them uploaded, people won't be able to look at them. You *have* to convert raw photos to something like a JPEG to share them most places online. If you want to go from camera to the world in as few steps as possible, shoot JPEGs.

✔ **They take up space:** If your memory card is tight on space, you might not have the room to store raw and JPEG files. Also consider how much hard drive space you're willing (and able) to use to store and work with photos.

The Nikon D3200 is a 24 megapixel entry-level dSLR. It's Large Fine JPEGs tend to be around 10MB, and the raw files average twice that. The Canon 5D Mark III is a 22 megapixel professional dSLR. It's Large Fine JPEGs run under 4MB, while its raw files approach 24MB. Either way you cut it, you're going to fill up your memory cards (which is a hassle, but not insurmountable) and hard drives (a much larger long-term problem) if you shoot a lot of raw images.

✔ **Slower shooting speed:** When you're shooting raw, the camera simply has to move more data from the sensor through the processor to the memory card. You'll benefit from a faster *frame rate* (how many photos you can take per second) if you shoot and store JPEGs only.

✔ **Impact on processing time:** If you don't have the time to process raw photos, JPEGs are your best solution. And remember, you can still edit JPEGs if you need to. Turn to the next chapter for more information.

If this is you, devote as much time as necessary in choosing between different JPEG processing options that your camera has. This is where you get to exercise limited creative control. You'll likely be able to adjust the photo's look by altering the Picture Control (Nikon) or Creative Style (Canon and Sony).

✔ **No need:** You may find that the JPEGs coming from your camera are just as good or better than what you can do yourself with raw. If that's the case, use the JPEGs and don't worry about it.

Workflow

Raw workflow is more flexible than JPEG (because with raw you don't make an adjustment, apply it, and move to another adjustment). Raw editors — and this includes import-to-final product photo managers and raw processors like Lightroom and Aperture — don't apply changes until you export the file.

Read your raw application's documentation to see whether it has a preferred workflow, such as tweaking exposure before sharpening. Most of the time, you can wing it.

- *Adobe Camera Raw:* Review the tabs on the right and make adjustments along the way. Don't forget the tools above the preview window for tasks such as straightening and spot corrections. The adjustments you select aren't applied until you either save the camera raw file or open it in Photoshop or Photoshop Elements.

- *Lightroom and those similar:* Changes you make on the Develop module are stored in the Lightroom database. The original files aren't affected, *even if you crop the photo.* Press the Reset button at the bottom of the Develop panel to revert to the original photo, if you need to. You can also create virtual copies in Lightroom to compare alternative settings. Only when you export are the settings permanently applied to create the new file, and even then the original is left alone. While Lightroom suggests that you follow its panel order (Basic panel with white balance, tone, and "presence" first, followed by the other panels), you can work in any order you wish.

- *Capture One:* Its recommended workflow suggests working on exposure and high dynamic range, which is its terminology for shadow and highlight recovery, and then levels and curves. But if you're working on a Mac with Capture One Pro, you can create your own interface tab and add the tools you want to work with, in the order you want to use them — total customization!

Two Minutes on the Grill: Ordering Raw

Technically, your camera always shoots using its raw file format. This is the data it creates JPEGs with. If you want to edit raw files, you have to tell the camera to save that data so you can use it too. Otherwise, all you get are the JPEGs.

To set your camera to save its raw data files, follow these steps:

1. **Press the Menu button.**

2. **Look for the Image Quality setting.**

It normally hangs around the Shooting menu. Anything but RAW means JPEG.

3. **Choose RAW or RAW+JPEG.**

 You typically have a couple of choices when it comes to saving raw data. If you don't think you need the JPEG, simply choose the RAW option. If you want the camera to save each photo in both formats, choose RAW *and* JPEG. This slows down your frame rate a bit and takes up more storage space, but I consider being able to have immediate access to both file formats worth it.

 If you choose RAW+JPEG, you'll likely get a Large, Fine JPEG. You may be able to change this.

4. **Exit the menu (normally by pressing Menu).**

 Make sure the quality setting is what you want. You'll see the image quality updated on your shooting screen, as shown in Figure 2-1.

Image quality

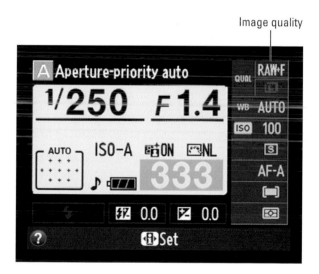

Figure 2-1: Image quality is an important setting to double-check before shooting.

Many cameras have a shortcut to the Image Quality setting. You may be able to press a single button and get to it, or (with Canons) set image quality through the Quick Control screen.

If you have a top LCD panel, it may have an image quality reminder. Figure 2-2 shows a Sony Alpha A77 from the top. Notice that it has RAW+JPEG displayed.

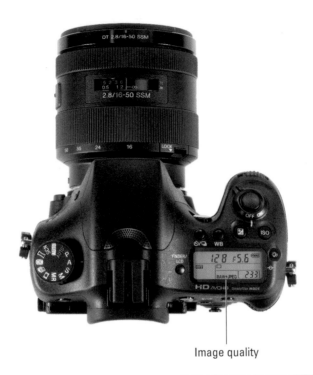

Image quality

Figure 2-2: Depending on the mode you're in, you may see image quality here as well.

Choosing Raw Software

I'm going to be blunt with you: If digital photography is important to you, and you plan on shooting more than a handful of photos (whether they be raw photos or JPEGs), go out and buy something like Adobe Lightroom, Apple Aperture, or Capture One Pro right now. Put it on your computer and begin using it. A good photo editor like Photoshop or Photoshop Elements will fill in the gaps and let you work with things like layers, masks, and panoramas, but you'll use Lightroom/Aperture/Capture One Pro or their equivalent to do most of your photo processing work.

If necessary, shop for a dedicated raw processing application to use as an alternative to your main program. You may have a specific need that only one application can fill. (Mostly this involves needing to work with other people or having access to very unique program capabilities.) Many applications are free. If you tend to shoot very few photos a month or are willing to

take what you get out of the camera except in rare situations, you have more software options to choose from.

I suggest using the camera manufacturer's raw processing application as a backup. No one knows the internals of a camera's raw files like the company that created them.

Your camera's software

The following camera raw software packages come in Windows and Macintosh versions. All are free except for the Nikon Digital Capture NX 2, which has a free trial available for download.

- ✔ *Canon:* Digital Photo Professional
- ✔ *Nikon:* Nikon Capture NX 2
- ✔ *Olympus:* OLYMPUS Viewer, ib, or Studio
- ✔ *Pentax:* PENTAX SILKYPIX Developer Studio or PENTAX Digital Camera Utility
- ✔ *Sony:* Sony Image Data Converter SR

Camera manufacturers have gotten mixed reviews on their raw conversion and image editing software. Some people love what they see, and some people don't. I encourage you to at least try them out. Nikon Capture NX 2 is the most powerful, but you'd expect that, given its price. Canon Digital Photo Professional and Sony Image Data Converter SR are both solid, if unspectacular.

Major photo/raw editing and management software

All the major photo-editing and photo-management players offer raw development. On the photo editing side, you miss out on a lot of the sophisticated management tools, but even Photoshop Elements and Corel PaintShop Pro have basic organizers built in. Conversely, neither Lightroom nor Aperture (two leading raw processors) rely on external photo editors for some tasks.

More than likely, you'll use a combination of both types — editing and management — of software. In that case, you can choose one to process your camera raw photos.

The Adobe family

Adobe integrates raw development into its two editing applications via Adobe Camera Raw (ACR). Lightroom uses the same basic functionality as ACR but with slightly different tools and capabilities.

Adobe Photoshop Lightroom

Adobe Lightroom is a joy to work in. It offers great photo management and raw processing tools. The latter are put in the Develop module, which appears on the right side of the screen. When you switch to the Develop module, you can make whatever adjustments you need to the photo. The original is preserved.

Please refer to the program manual for a more comprehensive explanation of how to use the program. In the meantime, the Develop module has the following panels:

- **Histogram:** The Histogram panel displays a live histogram (it's even draggable) as well as the camera's exposure settings. Click the triangles at the top of the histogram to turn on and off shadow and highlight clipping (see Book III, Chapter 5). See Figure 2-3.

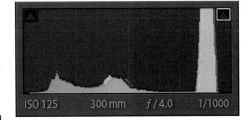

ISO 125 300 mm *f* / 4.0 1/1000

Figure 2-3: The shooting settings are displayed beneath the histogram.

- **Tools:** Five important tools are beneath the histogram; see Figure 2-4. The tools go beyond what you might expect from a raw processor. They are:

 - *Crop Overlay* lets you drag a box to identify a crop window on the photo. Also it has a straighten tool.

Figure 2-4: These tools turn Lightroom from a mere raw processor into something more powerful.

 - *Spot Removal* removes dust spots and other small blemishes. You can change between Heal and Clone modes, increase the radius, and lower the opacity of the tool.

 - *Red Eye Correction* removes red-eye.

 - *Graduated Filter* applies one or more graduated filters to the photo. You have quite a few filters to choose from, ranging from saturation to exposure.

 - *Adjustment Brush* "brushes" on adjustments. Choose from the same list of effects as Graduated Filter. You can change the brush.

- **Basic:** Contains white balance, exposure, contrast, and presence controls — your basic development settings, as shown in Figure 2-5.

- **Tone Curve:** A tool that enables you to change exposure based on specific tonal regions, as shown in Figure 2-6.

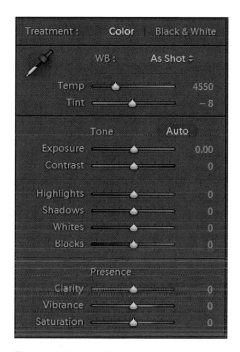

Figure 2-5: Start with the basic tone settings.

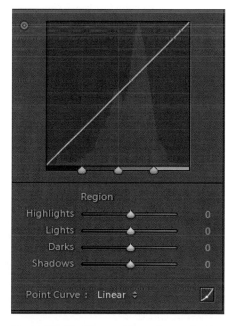

Figure 2-6: Modify specific regions using the tone curve.

✔ **HSL/Color/B&W:** Boosts, reduces, or changes hue, saturation, and lightness values according to specific color hues. You can also convert to grayscale on the panel, which is shown in Figure 2-7.

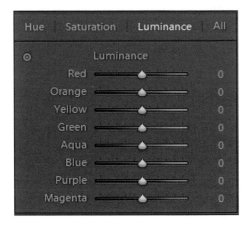

Figure 2-7: Select an option to access the specific controls.

✔ **Split Toning:** Changes the hue or increases the saturation of highlights or shadows, as shown in Figure 2-8. You can also move the mix point by changing the Balance setting.

Figure 2-8: Split Toning changes highlight and shadow hue and saturation.

✔ **Detail:** Has sharpening and noise-reduction controls, as shown in Figure 2-9. Read more about noise in Book III, Chapter 3.

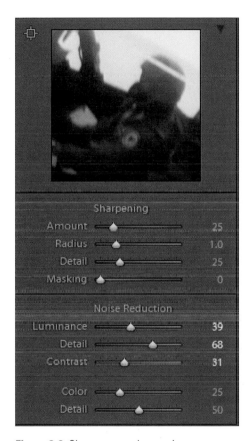

Figure 2-9: Sharpen or reduce noise as necessary from this panel.

✔ **Lens Corrections:** Correct chromatic aberration, lens vignetting, and vignette characteristics, as shown in Figure 2-10.

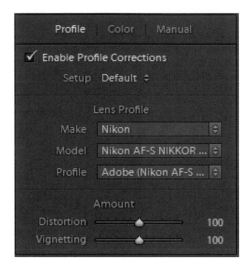

Figure 2-10: Turn on profile corrections and make sure your lens profile is correct.

✔ **Effects:** Turn on and set up post-crop vignetting and grain effects, as shown in Figure 2-11.

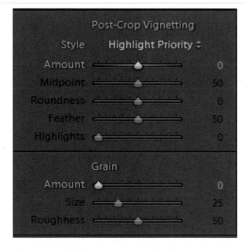

Figure 2-11: This panel controls vignetting and grain effects.

✔ **Camera Calibration:** Change the process (the internal workings of Lightroom change over time as the program is updated) that you want Lightroom to use on the photo; a camera color profile picker is there as well. This panel also lets you change overall shadow tinting and adjust primary colors. See Figure 2-12.

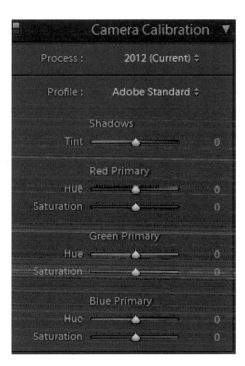

Figure 2-12: Change the Lightroom process and camera profile here.

When finished editing, export the photo, as shown in Figure 2-13. You should see consistently good results from Lightroom, no matter which camera you have or your other workflow needs.

Adobe Camera Raw

The Adobe Camera Raw (ACR) *plug-in* (ACR doesn't work alone) works within Adobe Photoshop and Photoshop Elements. The popular ACR has a clean, professional look.

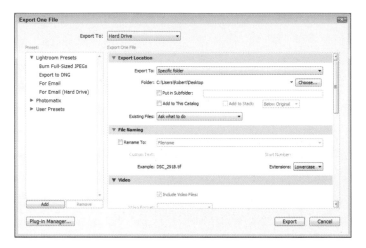

Figure 2-13: Export your photos in different formats to edit, publish, or archive.

ACR works differently within Adobe Photoshop Elements than in Photoshop. The Elements version has fewer options, bells, whistles, and doodads. The main differences between the Photoshop and Photoshop Element instances of ACR are described in this list:

✔ **Photoshop:** Photoshop has the whole ACR package, as shown in Figure 2-14. In this case, I've made several adjustments to this photo. The effect is to brighten, increase contrast, and boost saturation. For most of your work, choose from ten tabs that are essentially the same as the panels in Lightroom. ACR also has tools such as Crop, Targeted Adjustment, and Rotate.

✔ **Photoshop Elements:** Adobe Camera Raw from within Photoshop Elements has only three tabs: Basic, Detail, and Camera Calibration. See Figure 2-15. The tabs work exactly like those in Photoshop. ACR in Elements also has fewer tools, such as Zoom, Hand, White Balance, Crop, Straighten, Red Eye, Preferences, and Rotate.

Apple Aperture

Aperture is a Mac-only image-management and editing application that works, overall, like Adobe Lightroom. Apple Aperture is fun to use; it has great compatibility with the Mac OS, nice raw editing capability, and good access to *EXIF data* (non-picture information stored in the photo file, such as the date and time the shot was taken); and you can export images to HDR applications. It can do everything except mix drinks while you wait.

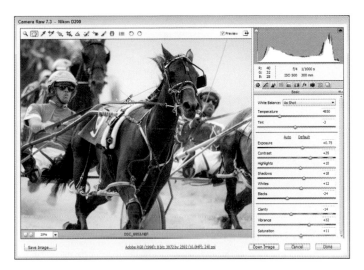

Figure 2-14: Calling ACR from Photoshop.

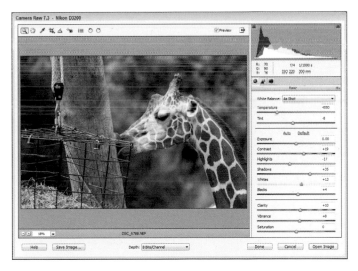

Figure 2-15: Processing a raw photo in Photoshop Elements.

Corel PaintShop Pro X5

Corel PaintShop Pro X5 is a full-featured *raster* (pixel-based images) and *vector graphics* (defined by points and lines) editor. PaintShop Pro comes with a bevy of photo editing tools and features, including a raw editor and *high dynamic range (HDR)* capability.

The PaintShop Pro Camera RAW Lab (see Figure 2-16) covers the basics: exposure, brightness, saturation, shadow, sharpness, white balance, and noise reduction controls. The program's Adjust tab also works with raw files.

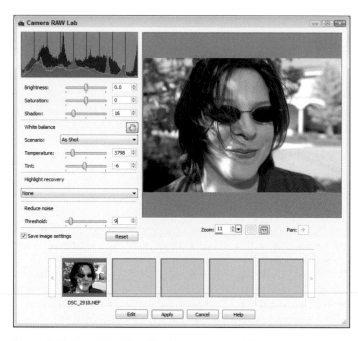

Figure 2-16: Even PaintShop Pro has a raw capability.

Processing Raw Photos

The goal is to take the photos you shoot and *process* them using raw workflow software. The technical aspects of exposure and color (and other decisions) should be guided by your artistic sensibilities. The guidance that you provide is exactly the point of wanting to be more involved in processing your photos.

I've got a secret. Once you get started, you'll realize that processing raw photos is far easier than having to work with JPEGs. If necessary, you can make stronger adjustments without degrading the photo. If you're taking good photos already, you'll be able to tweak them in your raw converter in no time at all. It's one of those rare situations where taking the seemingly tougher road (shooting raw photos and having to process them yourself) is not only better, but *easier*. You might wonder why you waited!

The following sections present a basic flow that you can follow as you work on a raw photo using the latest version of Adobe Lightroom. Your mileage may vary, based on your software.

Analyze the histogram

You must be able to read a histogram when you process raw photos. That said, never let the histogram tell you what looks good. That isn't its job. The histogram reveals the balance of lights and darks in a photo. No one histogram should be applied to all photos. See Book III, Chapter 5 for more information.

It tells you how bright, middle, and dark parts of the photo are distributed, which can help you decide whether the exposure is too dark, too light, or just right. You may see a luminance-only histogram, or one with the three color channels distinctly displayed.

Check white balance

Correcting white balance often means selecting a predefined setting to put you in the ballpark and then adjusting temperature and tint to finish the job. Most programs allow you to choose the camera setting or override it by either selecting the application default or choosing a specific lighting condition (Outside, Cloudy, or Fluorescent). You may also be able to select a white balance control and click something in the photo that should be white, gray, or black . See Book I, Chapter 5 for more information on white balance. Figure 2-17 shows the white balance picker in Lightroom.

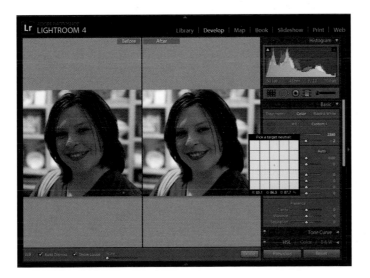

Figure 2-17: Adjust white balance by choosing a neutral spot in the photo.

Tweak exposure

An exposure control allows you to push down or pull up the exposure, which is measured in *exposure value (EV)*. Your highly developed photo-sense (akin to Peter Parker's Spidey sense) should relate to this control. See Book III, Chapter 5 for more information on exposure.

Raise or lower exposure until the photo looks right, as shown in Figure 2-18.

- ✔ Check the histogram to help you interpret what you're doing. See Book III, Chapter 5 for more on how to interpret histograms.

- ✔ Don't blow out highlights or lose shadows. If you do, you can rescue them by tweaking highlights and shadow controls.

- ✔ If you've gone too far, bring exposure back and readjust shadows and highlights. It's a delicate dance.

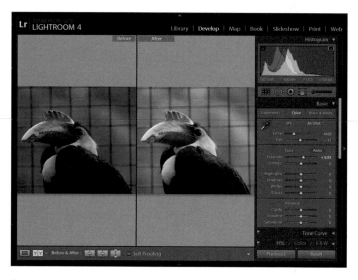

Figure 2-18: Boosting the exposure a tad.

Read carefully the documentation that comes with your software. Some brightness controls compress highlights (squeeze them together, limiting their brightness range but preserves some detail) whereas others *clip* them (turn them to white, which is bad).

Preserve highlights and shadows

This task is one of the main reasons that raw conversion rocks. I can't tell you how many times I've loaded up a photo whose sky was *blown out* (too

bright to see detail). In Figure 2-19, I'm pulling back the highlights from a shot of some candles. By doing so, I've preserved details that might have been lost by being too bright.

You don't have to eliminate all bright or dark pixels. Bring them into balance so that the photo looks good.

- ✔ Pull back the highlights so the sky isn't too bright.

- ✔ Brighten shadows so they aren't a uniform black (but watch for noise when you brighten shadows).

Figure 2-19: The red splotches on the left indicate blown highlights.

A preview window gives you an idea of what's happening to your photo before you commit. It helps you bring problems under control to see immediately how well you're doing.

Improve global contrast

Global contrast is the overall difference between white and black in a photo.

- ✔ Increasing contrast pushes apart the light and dark regions over the entire photo. Raise contrast too much and the photo looks funky. You blow out highlights and push details into darkness.

- ✔ Lowering contrast pulls them together so that there's less of a difference. Lower it too much (I'm not sure if I've *ever* lowered contrast) and the photo looks too bland.

You can often improve a photo's overall contrast by using the Contrast control, but in Figure 2-20 I'm using the white and black clipping controls for the same effect in this foggy shot.

Figure 2-20: Enhancing contrast.

Contrast affects exposure, so look at the histogram and, if necessary, retweak exposure, brightness, shadows, and highlight controls.

Adjust local contrast

Local contrast is an interesting setting that I like. This setting is often called Clarity. Whereas global contrast works over the entire photo, *local contrast* increases edge details on a smaller scale.

- ✔ *Increasing local contrast* is almost like sharpening. It brings out details. by increasing edge contrast. It can affect the tone by creating *halos* (light borders) or overemphasizing shadows and detail if you increase it too much.

- ✔ *Decreasing local contrast* softens the scene and brings out a misty ambiance.

Adjust saturation and vibrancy

These simple controls boost color intensity. *Saturation* strengthens all colors, whereas *vibrancy* only raises the saturation of weak colors. In Figure

2-21, I raised the vibrancy on a photo of a succulent to boost its color. It stands out much better without being garish. That's the beauty of vibrancy.

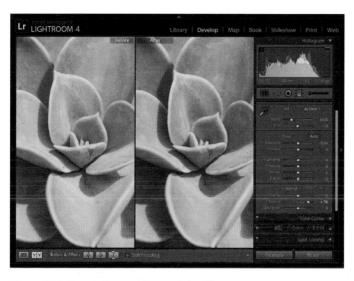

Figure 2-21: Boost vibrancy for a subtle effect.

I like saturated photos, so I don't hold back much. As I raise it, however, I'm careful to not make noise more visible or blow out highlights. Turning up *most things* while you edit or process runs these risks. When possible, I increase vibrancy first to see whether it does the trick. Vibrancy is more forgiving because you're not turning up all colors, just the muted ones.

Tweak the tone curve

The next phase relies a bit on trial and error. Look at the photo while you make adjustments using the tone curve (areas of lightness and darkness) controls. Look to see if the photo benefits from one or more adjustments. Sometimes brightening the highlights or light tones can make a photo look better.

Make sure you don't brighten tones so much that you lose details.

You may need to tweak the dark areas of the photos. It all depends on the photo. Your goal is to fine-tune the *tonality* (the distribution of lights and darks) of the photo. Think of it as emphasizing the good things and minimizing the bad things. You can use other tools to do the same thing, but the tone curve gives you a good degree of precision in that you can adjust several tonal areas, not just shadows and highlights. In Figure 2-22, I darkened three of the tonal regions to increase the contrast of this cute little rabbit.

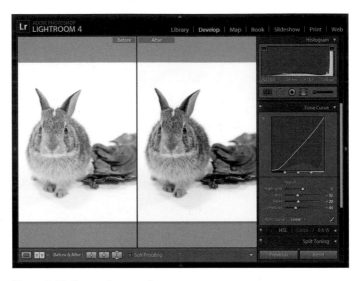

Figure 2-22: Comparing your buns.

Save, open, export

This isn't an editing task, but I do want to mention it: In Lightroom and Aperture, you don't have to do anything to save or open files. After you're done developing a photo, you can select another one or visit the Library or another module. You may export a photo anytime.

If you use ACR or another raw processor, you should have the option of saving your photo or opening it directly in an editor (and saving it later). You may be allowed to overwrite the raw photo with your new settings. I can't think of very many situations where this is a good idea, unless you're working on a copy. You should be able to save the converted photo as a JPEG or TIFF.

Photo editors with raw processing capability built in (ACR and PaintShop Pro) will let you save or open the photo. Open Image opens the converted photo in the editor. You must save it afterwards.

Advancing Your Raw Editing

After you get the basics under control, have a look at more advanced raw editing. You may not need or want to apply every technique mentioned here. At least I hope you don't.

✔ **Sharpen:** Everybody likes sharp-looking photos. Factors such as your *glass* (lens in photographerspeak), focus, camera stability, shutter speed, and distance clearly have a large effect on how sharp a photo can be. Within those bounds, you can sharpen a photo quite a bit during raw conversion.

I generally like crisping up a photo and removing lens softness in raw. If the photo has serious sharpness problems, try reshooting it with a better technique or leave it for editing, where you can use more sharpening techniques. Don't oversharpen photos. It makes the edges look artificial and makes noise more obvious.

✔ **Noise reduction:** Similarly, most raw converters have some form of noise reduction. Many let you reduce noise in the Luminance channel and/or the photo's color channels. Figure 2-23 is a close-up of some lockers at a bowling alley. I shot this with a Canon EOS 5D Mark III at ISO 12800. Despite the remarkable noise (both in the alley and the photo), there's still noise that I could take out. The result is pretty good!

Figure 2-23: Reducing noise while converting saves work later.

Too much noise reduction removes a great deal of a photo's detail. Watch how much sharpness you lose when you reduce noise. If it's too much, try backing off and reducing noise in your editor. Third-party noise reduction *plug-ins* (small add-ons that provide new or better features to the software you're using) often give you much more control over noise reduction and the ability to protect or sharpen details. You can also selectively reduce noise by using layers or masks.

✔ **Chromatic aberrations:** You know that a photo has *chromatic aberrations* when you see colored fringe along borders between high-contrast areas. What happened is that your lens wasn't able to focus all wavelengths of light on the same spot. It almost looks like a ghost image. These controls nudge those areas to where they should be — on top of the actual object.

✔ **Lens corrections and distortion removal:** More raw editors include automatic lens profiling, which includes vignetting and distortion.

✔ **Effects:** Lightroom has an effects panel that lets you add or remove post-crop lens vignetting and add artistic grain.

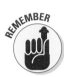

Use effects, but use them sparingly.

✔ **Cropping:** Because you can crop in many raw converters, you don't have to export the photo to an editor to crop. Instead, you can just export your work and be done with it, as shown in Figure 2-24.

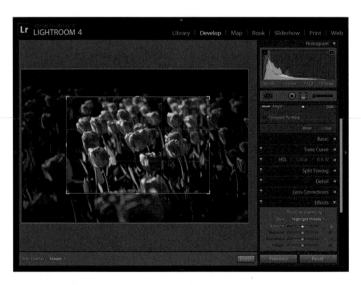

Figure 2-24: Crop to focus on your subject more closely or recompose.

✔ **Straightening:** Repeat the preceding bullet but say *straighten* when you see *crop* or *cropping*.

✔ **Spot removal:** Most raw editors can remove spots and clone out blemishes. This godsend means that you don't have to load raw photos into an editor just to get rid of a pimple.

✔ **Graduated filter:** Adobe Camera Raw and Lightroom have a cool graduated filter tool that lets you apply one or more filters to the raw photo.

✓ **Toning:** You can easily and selectively adjust the hue, brightness, and saturation in many raw editors with a slider or by clicking and dragging in the preview window. You can use this feature artistically, or to correct problems (such as too-bright reds that need to be toned down). I artificially toned an old Art Deco cover I photographed on the sidewalk in Oklahoma; see Figure 2-25.

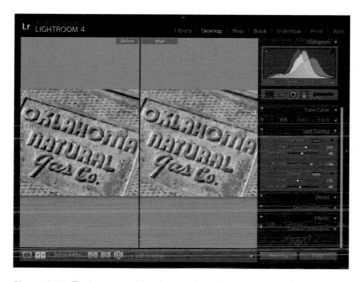

Figure 2-25: Toning can add unique color effects.

✓ **Tinting:** When you add tint, you apply a color to either the entire photo or to specific regions. I cover this topic in Book V, Chapter 6.

✓ **Black and white:** Although you can *desaturate* (take out all the colors) a photo in all raw editors, some have more complex controls that let you add input to the process. I also cover this topic in Book V, Chapter 6.

✓ **Working with multiple images:** You can work with more than one image at a time in some applications (Adobe Camera Raw, namely). In others, you have to save your work as a *preset* and apply to each photo, one at a time, or copy the changes and paste them to another photo.

✓ **Presets:** Use your own predefined settings. They simplify your job tremendously if you often shoot in similar settings. I've dialed in the necessary exposure and white balance settings I need to shoot specific types of shots in my studio, for example. They come out the same way every time.

Processing Raw Photos In-Camera

More and more dSLRs come with snazzy built-in raw processing tools that you can use at the spur of the moment and with a touch of a button. This development isn't limited to a particular price point, either. For example, the professional-level Canon 5D Mark III and the entry-level Nikon D3200 both have impressive raw image processing (also called *retouching*) options.

Using the 5D Mark III, you can change brightness, white balance, picture style, and Auto Lighting Optimizer settings; turn on high ISO speed noise reduction; set the desired JPEG image quality and color space; and correct peripheral illumination, lens distortion, and chromatic aberrations! Not bad at all. Figure 2-26 shows the raw image processing menu on the 5D Mark III. Notice that it's in the Playback tab.

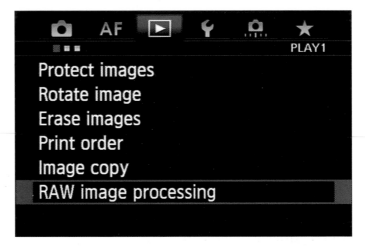

Figure 2-26: Process your raw images on your camera.

The D3200 has these similar options: Change the image quality, size, white balance, adjust exposure compensation; change the Picture Control settings; turn on high ISO noise reduction; change the color space; and change the D-Lighting settings. See Book III, Chapter 5 for more information about some of these topics. When you make an adjustment, the camera creates a JPEG from the raw data, gives it a new name, and stores it on the memory card.

Chapter 3: Showing Mad Photo-Editing Skills

In This Chapter

✏ **Following the detailed editing workflow**

✏ **Reducing noise**

✏ **Adjusting brightness and contrast**

✏ **Correcting color issues**

✏ **Cloning and retouching**

✏ **Dodging, burning, running, screaming**

✏ **Filtering, distorting, rotating, cropping, scaling, and more**

*I*deally, you take care of as many issues and make whatever enhancements you can to your photos in your raw processor (see Book V, Chapter 2) or photo manager. Use your photo editor as a powerful last resort. Its job is to handle tasks that your main photo software can't. (And to get the best start of all, visit this chapter's "Leg up" sidebar for ideas.)

This approach applies whether you have your camera set to save raw or JPEGs. The two leading end-to-end photo solutions, Lightroom and Aperture, work with JPEGs non-destructively, just as they do with raw images. Changes are locked in only when you export the file, and only to the new file, leaving the original alone. Use that to your advantage! Regardless of whether you use a photo editor as a first or second line of defense, this chapter shows you how it can improve your photos.

I use Photoshop Elements 11 for Windows to demonstrate. It's a good representation of what most other photo editors can do, works the same on both Windows and Macintosh, is inexpensive, and it's popular. I've organized this chapter according to the basic workflow I present in the first section.

Going with the Editing Workflow

If you use a photo editor only, it doesn't mean you should have your head examined. It just means that you have less flexibility. Workflow is another area where programs like Lightroom and Aperture beat the pants off photo editors like Photoshop Elements. You can make edits and adjustments in those programs without worrying about which one should go first, second, or third. Your edits are only applied when you *export* the photo (send the photo to another program), and you have no control over how it happens. You only have to think about workflow if you're done with the manager and have turned to your photo editor to finish the file. You can read more about Lightroom and Aperture in Book V, Chapters 1 and 2.

Because many people start out using photo editors first (and may belatedly move to a more a professional solution like Lightroom or Aperture — they're quite friendly and totally accessible to hobbyists!) most of this chapter assumes you're using your photo editor by itself.

Ease up, there

You're much more likely to ruin a photo by heavy-handed editing than by following the "wrong" workflow.

As you edit photos, keep these thoughts in mind:

- ✔ **Fewer changes are better:** If you're trying to create a realistic interpretation of the photo, the less you mess with it, the better. A great-looking portrait is a perfect example. Resist the temptation to overdo something just because you can.

- ✔ **Push not too hard:** You run a greater risk of ruining the photo the harder you push brightness, contrast, color, sharpness, and noise reduction adjustments. A perfect example is trying to brighten a photo too much.

- ✔ **Accepting a photo:** The sensible solution is to find the spot where you can look at a photo and accept it for what it is. Not all photos are perfect. Some have noise; some have exposure problems; some have a bit of distortion.

Workflow guidelines

What's the ideal order for tackling editing tasks? Believe it or not, there's no one way. On the other hand, some workflow decisions are just going to work better. This situation contributes to making workflow a slippery subject.

I've come up with many of my own workflow ideas over time, read many other people's opinions, tested different options, and come to the conclusion that, for the most part, *workflow doesn't matter as much as you might*

think. The bottom line is to find a process that fits the amount of time you have, your software, and the quality you want. You most likely won't find a *perfect* workflow. Use this chapter as a starting point, an ending point, or a point in between. I think it provides a reasonable balance between competing interests. Don't worry. Within the guidelines in the preceding section are many tasks you can take on to improve photos.

Speaking of which, here's a sample workflow broken into groups:

1. **Raw processing:** Make your photo adjustments here first (brightness, contrast, white balance, saturation, and so forth). Depending on the strength of your raw processing or photo-management software, most of this chapter will seem redundant to you. If you need to do more serious editing, you should have made many of these adjustments before exporting your work and continuing in your favorite photo editor. See Book V, Chapter 2 for more information on raw processing.

2. **Color profile:** When you open a photo in your editor, note the *color profile* (helps monitors and printers reproduce the same colors) and make sure it's what you want. If not, change it now before you do any editing. (In Elements, choose Image⇨Convert Color Profile.) The two most common color profiles follow:

 • *sRGB* works with everything you'll likely view, edit, or print your photos on. I set my camera to save photos in this profile. (Raw exposures don't pick up a profile until you convert and export them as a TIFF or JPEG. When I save photos for use on the web, I always select this profile for the final JPEG.)

 • *AdobeRGB* defines a wider color space and is technically better than sRGB, but there's no guarantee it will work where you need it to.

3. **Bit depth:** A practical setting is 8 bits per channel. If you're interested in the highest possible quality, use 16-bit and don't reduce it until you publish the photo as a final product (and sometimes not even then). To be honest, I think 1-bit channels are more trouble than they're worth. The photos take up a tremendous amount of space and stress your computer to its limit, and I have yet to see it really matter.

The following edits often make a huge difference in a photo's overall look. Good adjustments in this category are worth their weight in digital photos:

✓ **Correct brightness and contrast:** Look at Levels and Curves settings when you're working in Photoshop (Levels and Color Curves when using Photoshop Elements). Or, try Shadows/Highlights or Brightness and Contrast.

✓ **Correct or enhance color:** This adjustment corrects color casts from white balance (see Book I, Chapter 5) problems as well as fixing hue and saturation issues. Experiment to see what works best for you.

- **Sharpen:** I like sharpening just a bit to clarify the photo and eliminate some of the softness. This step is optional, and the amount is up to you (although it should be minimal).

- **Reduce noise:** Next, have a look at the noise level in the photo and see if it needs attention. Sometimes, a little bit of noise reduction is all you need. If so, try not to reduce the image's sharpness. If you do reduce sharpness, reconsider whether you should be doing anything at all. Do you really want to sharpen, reduce noise, then sharpen again, and then reduce more noise? The photo may be telling you something: You're trying too hard or you just didn't get the shot. In general, if you can tell that a photo's been tampered with, it's too much.

Wait to make the following types of edits until you've got the photo's brightness, contrast, color levels, noise, and sharpness under control. I've done it the other way around and been unhappily surprised when I tried to correct the photo's brightness, only to reveal everywhere that I had cloned. Ugly!

- **Clone and retouch:** Take out specks, dust, skin blemishes, and other distracting elements.

- **Dodge and burn:** Bring out highlights or selectively enhance shadows.

- **Other artistic effects:** Apply filters, effects, and other cool artistic treatments.

If you're following along with this workflow, the edits thus far haven't transformed, rotated, cropped, or scaled the photo. That's on purpose. I've had situations where I cropped, rotated, or scaled a photo and then made other corrections. At some point, I realized that I didn't like the crop or other transformation I made, and had a hard time going back and reworking the photo. As a result, I'd rather have a "finished" photo (exposure, color, sharpness, noise, and like properties) in hand before I make these types of corrections.

Finish making brightness, contrast, color, sharpness, cloning, noise, and reduction edits before you go on with these more transformative edits:

- **Correct lens distortion:** If lens distortion is particularly bad, remove it. If the photo looks okay and has no obvious distortion, ignore this task.

- **Correct perspective:** Correct obvious perspective problems. If they aren't obvious, ignore them.

- **Rotate:** Make this change after you correct lens and perspective problems. It makes no sense to try to correct lens distortion after you've

rotated, cropped, or scaled a photo. The artificial intelligence behind the lens distortion routine has no way of knowing how to accommodate your changes.

✔ **Crop or scale:** Finally, either *crop* (lop off some parts) the photo or *scale* (enlarge) a *working layer* to recompose the photo without changing the photo or canvas size. A working layer's what you use in a photo editor to make changes that can stack on top of each other; for more help, please read your photo editor manual. I like to tackle cropping as I export and publish the photo. That means I've saved my last working copy of the file, flattened all the layers, and am done editing. As an aside, this is another area where programs like Lightroom and Aperture excel. (Hint, hint: If you're serious about this, go get one and start using it.)

Take great pains not to overwrite your working files with flattened, cropped versions. You lose all the layers and the original composition in the process.

✔ **Publish:** Lastly, save a TIFF or JPEG for printing or publication. It may be resized or cropped. Please refer to Book V, Chapter 1 for more information on publishing photos.

Leg up

Taking better pictures lowers your stress level when you edit them because you don't have to do as much editing. Rather than have to continually fix bad-looking areas of your photos, you can devote your time to making good photos great and publishing them.

Here are some tips:

✔ Take your shots at the lowest possible ISO so that you don't have to throw noise reduction at everything you shoot.

✔ Support the camera so that it doesn't jiggle or jostle. That way, not every photo is blurry and in need of sharpening.

✔ Frame well-designed shots so that you don't have to crop them later.

✔ Choose a white balance setting in-camera that matches the conditions you're in.

✔ Try to keep distracting objects out of the background.

✔ Use the right metering setting for the conditions so that brightness isn't a problem.

✔ Hold the camera straight and level.

✔ Use lenses with good distortion characteristics (although no lens is perfect).

Now, do all that (take better pictures) while you watch your kids, avoid getting hit by a car, falling into a river, having an accident, answering the phone, getting into the right position, and getting arrested because you look like a suspicious photographer.

Fixing Brightness and Contrast Problems

Brightness and contrast are two of the more fundamental editing tasks worth mastering. You want photos to be bright but not too bright, and have enough contrast — but not too much. Got that?

You can correct brightness and contrast several ways because computer geeks just can't resist the temptation to program the same thing 15 different ways.

Brightness and contrast

Here's the easiest way to adjust brightness and contrast (in Elements anyway; you can use similar methods in most photo editing applications): Choose the Enhance➪Adjust Lighting➪Brightness/Contrast command to get started.

The controls are simple to use. Raise them to increase brightness and contrast. Lower the controls to decrease. I set the contrast first and then work with brightness control to balance everything. Figure 3-1 shows the open Brightness/Contrast dialog box. I've raised both settings to brighten and strengthen this photo.

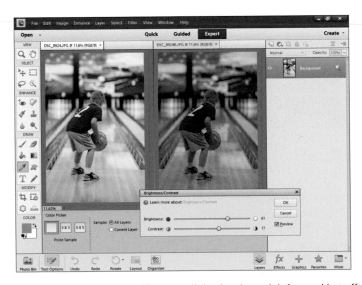

Figure 3-1: The Brightness/Contrast dialog box is straightforward but effective.

Levels

Levels is a step up from using brightness and contrast. It has more controls to master and a histogram to deal with, but the results you can get from the Levels setting are usually worth the extra effort. Figure 3-2 shows a dark photo of a P-51 Mustang I photographed at a local air show. Levels has improved the brightness and contrast.

Don't let the histogram scare you when you're adjusting Levels. The histogram shows the distribution of brightness in the photo and helps you see the effects of your actions. If you want, ignore it and just look at your photo.

- ✔ Choose Enhance➪Adjust Lighting➪Levels to begin.

- ✔ To lighten an image, drag the white triangle under the main histogram (the graph) to the left, as shown.

- ✔ To darken an image, drag the black triangle to the right.

- ✔ Drag the gray triangle to move *midtones* (areas that aren't very dark or light) up or down. Note how this gives more detail in the bright metal of the plane.

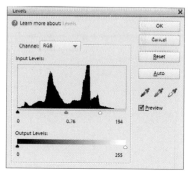

Figure 3-2: Brightening with Levels.

Shadows and highlights

Shadows and Highlights is another brightness and contrast tool. Use it to selectively brighten shadows and simultaneously bring highlights under control. This feature is often immensely helpful. Figure 3-3 shows the Shadows/Highlights dialog box, where I'm brightening the shadows under the chin of this statue as well as darkening the sky a bit.

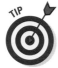

Select the Enhance⇨Adjust Lighting⇨Shadows/Highlights command to start. These are your go-to controls:

- **Lighten Shadows** is a good tool to have if your shadows are a bit dark.
- **Darken Highlights** is also a good tool, but for the reverse reason.
- **Midtone Contrast** controls contrast (but only midtones).

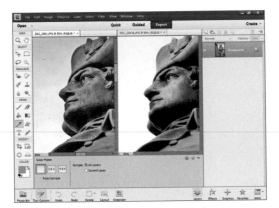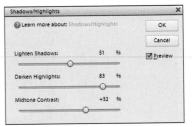

Figure 3-3: Using Shadows/Highlights to tone those areas separately.

Curves

Despite being on the Adjust Colors menu, Curves is a helpful way to alter brightness and contrast. See the dialog box in Figure 3-4. Curves has a simplified interface in Photoshop Elements (compared to other programs such as Photoshop or PaintShop Photo Pro). Curves has presets and sliders, whereas the other programs let you plunk points on the curve and move them around.

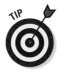

My suggestion for working with Curves: First, choose different styles (such as Increase Contrast) and then tweak the sliders to achieve the final effect.

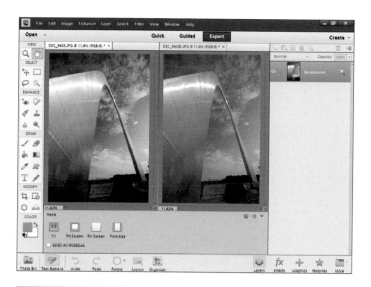

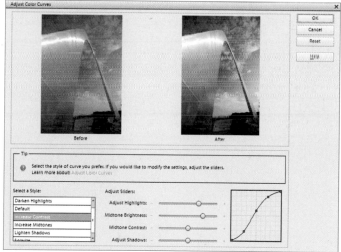

Figure 3-4: Adjusting color curves.

Busting out the Colors

When you're shooting color photos, be prepared to correct color problems.
For example, the reds might be too bright or the photo might have an
unwanted yellow tint. This happens quite often. You have several different
tools to choose from. The challenge is finding the right one for the job.

Don't forget to look for other color adjustment tools in your program in addition to the ones I have room to explain here. Manufacturers keep coming up with ways to replace colors, remove colors, automatically adjust color for skin tones, and more.

Saturation

Saturation means how strong or pure the colors are. Shabby or dingy colors make things look dull or prematurely aged. Conversely, overly bright colors can be hard to look at. Your task is to turn the right colors up or down to correct either type of problem. The following sections explain several ways to adjust saturation.

Broadband attack

The best way to attack saturation is to use the Hue/Saturation dialog box. With it, you can strengthen or weaken the entire range of colors in the photo (or selectively tweak specific hues, but that topic is in the next section).

Select Enhance⇨Adjust Color⇨Adjust Hue/Saturation to open the Hue/Saturation dialog box, shown in Figure 3-5. To increase the saturation, simply raise the level. To take it down a notch, lower the level.

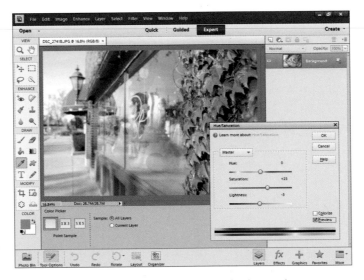

Figure 3-5: Saturating all colors simultaneously gives a photo pop.

Some editors (Photoshop and PaintShop Pro) have vibrancy controls in addition to saturation. They increase or decrease saturation in unsaturated areas, allowing you to boost muted colors without blasting out the entire photo.

Targeted color tweakery

It's possible, and often desirable, to selectively saturate or desaturate specific colors. For example, maybe you took a photo where yellow flowers turned out a bit too dark, but the green leaves were fine. You could strengthen the yellow without changing the green. Use one of the following dialog boxes when you don't want to blow out an entire image with color:

✔ **Hue/Saturation:** To target a specific hue, select it from the drop-down menu and then raise or lower the saturation; see Figure 3-6. It's as easy as pie.

✔ **Color Variations:** These *thumbnails* (small pictures) in different colors let you change the color balance of a photo by clicking a sample you like. (I tell you more about this topic in Book V, Chapter 6.)

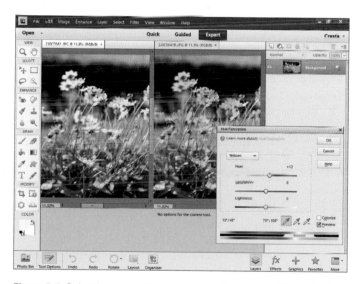

Figure 3-6: Selective saturation turns these flowers a brighter shade of yellow.

Color casts

A *color cast* is when an object takes on the color of a light source or a reflection. It is a type of color problem that happens a lot; you may not even be aware of it. Thankfully, you can use these effective methods to combat the problem. If you can, handle these in raw processing:

✔ **Remove Color Cast:** Choose Enhance⟹Adjust Color⟹Remove Color Cast. Click in an area of the photo that should be black, white, or gray; see Figure 3-7. I clicked the white knight in the center of the photo. Presto.

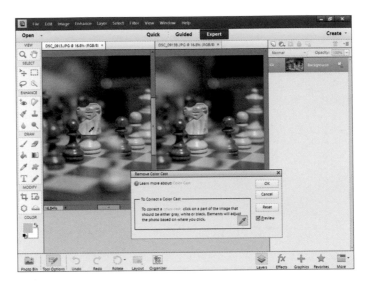

Figure 3-7: Correcting a color cast in Elements.

✔ **Levels:** Similarly, use Levels to adjust white balance and remove a color cast. This option might save you a few steps because you can correct a color cast at the same time as you fix brightness and contrast. In the Levels dialog box, click the rightmost Eye Dropper and then click an area in the image that should be white. Anything that wasn't white becomes white automatically. (Theoretically, it's a little like playing the lottery sometimes.)

✔ **Photo Filters:** Don't forget about photo filters, which I cover next. Play around with them to remove color cats — er — casts.

Photo filters

I like photo filters. They're the digital equivalent of physical filters that you put in front of your lens to filter out certain types of light or filter in ambiance. Book III, Chapter 4 talks more about physical filters.

The options in the Photo Filter dialog box are intuitive: Choose a filter type based on the description or a solid color, and then choose a density. I'm doing that in Figure 3-8 to cool down the sky in this landscape. The after photo is on the left. The sky looks bluer and the trees look sharper.

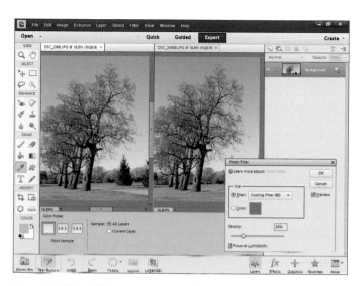

Figure 3-8: Photo filters can warm, cool, or apply a color.

Caution: Sharpness Ahead

Sharpness is often equated to quality. Sharper images look better. They tend to be more interesting because you can make out finer details.

Small amounts of sharpening brings an image into better focus and improves its appearance. You can often apply this level of sharpening to the entire image or to select areas. Too much sharpening can ruin a photo by turning low-level noise into a high-level distraction and overemphasizing everything bad about the photo.

You have different ways to sharpen photos in most editing programs. Two of the more interesting routines in Photoshop Elements are Unsharp Mask and Adjust Sharpness.

Unsharp Mask

Select Enhance⇨Unsharp Mask to open the Unsharp Mask dialog box, shown in Figure 3-9. It has only three controls to worry about:

✔ **Amount:** How much to sharpen. In this case, I set Amount to 70, which sounds like a lot but is less than you think. You can't directly equate this setting to Strength because the Radius option plays an important part in sharpening.

✔ **Radius:** How wide an area to sharpen around the edge being sharpened. Small amounts restrict the effect to closer edges, and larger amounts extend sharpening outward.

Leave the Radius value low in cases where you want minimal sharpening. Experiment with larger values to increase the sharpening effect.

✔ **Threshold:** Lets you customize the onset of sharpening. At low values, everything is sharpened; at high values, sharpening still occurs, but not over the entire image. I normally leave Threshold set to 0 because I don't have time to try to figure out the correct amount.

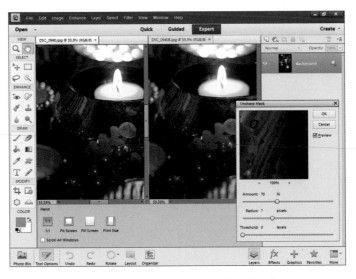

Figure 3-9: Sharpening a modest amount clarifies the photo.

Adjust Sharpness

Choose Enhance ⇨Adjust Sharpness for another sharpening method, as shown in Figure 3-10. This type has a few different options than Unsharp Mask. Select a sharpening type from the Remove list: Gaussian Blur, Lens Blur, or Motion Blur.

The former is supposed to be exactly like Unsharp Mask. I can't tell much difference between the three. Choose Motion Blur to sharpen an image blurred by camera movement. In Figure 3-10, the trees and building in the background sharpen up nicely.

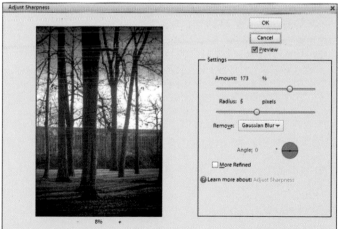

Figure 3-10: Adjust Sharpness is another sharpening tool.

Ranting about noise

I'm convinced that most dSLR photographers worry too much about noise reduction. I used to, but have successfully gotten over most of it. I'm not saying that you should stand up and cheer over your noisy photos, but the truth is that unless you're blowing up a photo to ridiculous proportions, more noise than you may realize is acceptable.

Do yourself a favor. Go get an old photography book or look online for famous older photographs. Look at their flaws and realize that they are still magnificent. Being noise free isn't what makes them great. Go take those kinds of photos, and relax about the limitations of the technology.

Experiment with *layer blending* (editing tools that stack on top of each other). Duplicate a layer, sharpen it, and lower its opacity so that it blends in with the unsharpened layer below it. Use the Eraser (or a mask) to tailor the amount of sharpness even more by erasing areas on the sharpened layer so that they have no sharpness applied to them.

Turning Down the Noise

Sometimes, in the digital photography realm, you just have to get *noise* (random, mottled specks of random pixels) under control. This section helps you do that. (To gain some perspective, first read the earlier "Ranting about noise" sidebar.)

Check your camera's manual to see if it has high ISO or long shutter-speed noise reduction built in and to see whether you like it. I do, but it kicks in when the camera saves the photo to the memory card and makes it impossible to shoot another photo until it's done, which means that I can't use it in every situation.

The obvious route

Apply noise reduction to the entire photo — the massive retaliation option. It's easy to do, too, which is a bonus.

Follow these steps to apply noise reduction in Photoshop Elements:

1. **Choose Filter⇨Noise⇨Reduce Noise to start the process.**

The Reduce Noise dialog box opens; see Figure 3-11. Although you have other ways to reduce noise in Photoshop Elements, Reduce Noise is the most practical for photo work because it's customizable and does a good job without blurring the photo. The other options are located on the Filter➪Noise menu.

Figure 3-11: Reducing noise.

2. **Choose from these options:**

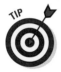

- *Strength (0–10):* Determine how strongly you want to seek out and destroy noise. The catch is that the Strength option targets noise that's gray, black, or white — luminance noise.

- Look for noise in areas that have a uniform tone. You'll be able to see it better, and therefore, know how much of a problem you're dealing with.

- *Preserve Details (0–100%):* Specify how much you want to protect edge details. This setting basically allows you to set a high Strength value and remove noise in larger areas but not overdo it on lines and edges.

- *Reduce Color Noise (0–100%):* Set this strength setting for noise that shows up in the image as variation in color. See Figure 3-11.

- *Remove JPEG Artifacts:* If you see JPEG compression artifacts, selecting this check box might remove them.

Find the balance between noise level and softness. Increase the Strength setting until the photo loses detail you want to preserve, and then boost the Preserve Details setting to see whether you can recover those details. If not (or if the result looks bad when you increase Preserve Details), decrease the Preserve Details and Strength settings until the photo looks good.

3. **Select OK.**

Complexifying noise reduction

You might not need to reduce noise everywhere at the same time and with the same strength. If that's the case, try one of these three options:

- **Select and Smack:** Select the noisy areas and apply noise reduction to those specific areas. The drawback is that selecting complex areas with any metaphysical degree of certitude is often difficult, which means that you'll end up with compromises. And, it takes forever.

- **Mask or Erase:** The next step up the ladder of sophistication is masked (or erased) noise reduction. Apply noise reduction to an entire layer, and then mask out (hide) or erase areas you don't want the noise reduction on. The un-noise-reduced layer beneath (you have one of those, right?) shows through. Figure 3-12 shows this approach in action for one of my shots. It's an interior shot that I took without a flash in a local bank. Areas that I masked out are transparent; they look like a checkerboard in the figure. Those areas won't show any noise reduction if I turn on the layer beneath the mask layer.

 If your program doesn't have masks, use an eraser.

Figure 3-12: Attacking noise with a masked layer.

✓ **Use Multiple Masks:** The pinnacle of noise reduction is to apply tailored noise reduction to specific areas of an image by using multiple layers and masks. This time-consuming and often tedious technique works only once because your head explodes afterward. Though the results are fantastic, you can't use the technique on every photo.

Hello, Dolly! Cloning

Cloning (replacing imperfections or objects with nearby material) is an important technique to master if you want artistic freedom and control over your photos after you've shot them. Cloning is often called *retouching*. Not everyone wants this control to the same degree, however. Wherever you fall on this spectrum, being able to remove dust, wayward camera straps, and other distractions is helpful.

The big difference between the Spot Healing Brush and the Clone Stamp is that the Healing Brush automatically blends in new material with the original. The Clone Stamp just plops it down. Aside from this issue, they work similarly.

Dust me gently

The occasional dust speck is an irritant to your eyes. Dust can float into your camera body and land on the sensor whenever you change lenses. Even if you're careful about how and where you open it, dust can find a way in. Your camera isn't airtight! You can read about your cleaning options in Book I, Chapter 4.

 Dust shows up as a big blob in your photo. It's most noticeable in the sky, but also appears in other light, evenly toned areas. I use the Spot Healing Brush as my feather duster in most situations.

To remove a dust spot or another small imperfection, follow these steps:

1. **Select the Spot Healing Brush and specify a size large enough to cover the dust.**

2. **Paint over the dust spot with a circular motion.**

 Try the old "wax on, wax off" technique from *The Karate Kid*. The result is shown in Figure 3-13. Notice that I'm brushing just enough to cover the spot; the red rectangle in the Navigator palette shows you exactly where I'm working in the photo. When you release the mouse button, the new material is applied.

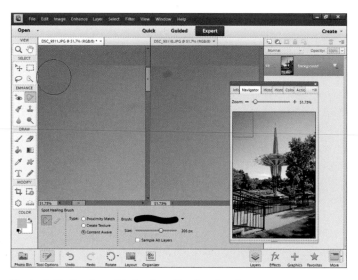

Figure 3-13: Dusting with the Spot Healing Brush.

 Sometimes, the Spot Healing Brush mangles the texture of an area or pulls in unwanted material to cover the spot. When this happens, undo and repeat. Or, if you need more control, switch to the Healing Brush or Clone Stamp tool.

Removing other distractions

Dust isn't the only distraction you might want to remove from your photos. Other objects can divert attention from your subject or make the scene less than desirable.

I prefer using the Healing Brush and the Clone Stamp tools on a separate, empty layer above the photo and making sure I've selected the Sample All Layers tool option. This way, if I don't like how it looks, I'm not stuck. I can erase it or reduce the opacity to blend.

Here are some handy steps for you to follow when removing distractions:

1. **Select the Clone Stamp Tool from the Toolbox.**

2. **Change the brush size and hardness.**

 • *Size:* The tool should cover a reasonable amount of space. If it's too small, it'll take forever and a million potential brush strokes will show up. Hold on! You don't want it too large, either. That makes your fixes easier to spot. You want it to be juuuuust right, Goldilocks.

 • *Hardness:* By the same token, a brush that's too hard can clone edges that are easy to spot. Soften it up a bit. Sometimes, you need an edge that isn't totally soft. I've found that when I clone over rocks and similar surfaces, a clone brush that's too soft makes the borders fuzzy and easy to spot. In that case, harden it up a bit.

3. **Check options and select the appropriate layer in the Layers palette.**

 You can select the Sample All Layers check box and make sure that the empty clone layer you have created to clone on is active. Apply the paint to this working layer. Otherwise, make sure to select the photo layer, should you want to clone on that.

 You have other options (including brush characteristics) in special situations. For example, Aligned returns the source to the same spot after each stroke. This option can be helpful in tight situations, but because you aren't varying the source spot, it can create a discernable, repeating pattern.

4. **Clone, clone, clone, clone, and more clone.**

 Alt+click (Option-click) to set the source location, and then paint over the destination; see this option in action in Figure 3-14, where I'm removing another duck from the foreground of the photo.

Regularly select a new source area. Mix it up, but pay attention. If the texture and tones don't match, the replacement will be visible. You want it to be hidden, and you don't want features to repeat.

Figure 3-14: Cloning away a distracting duck head.

Dodging and Burning

Dodging and burning are two (dangerous-sounding!) techniques that you can use to lighten *(dodge)* or darken *(burn)* areas with a brush. I use these tools to subtly elevate brightness in areas I want you to look at, to darken areas for drama, or to balance the photo. In Figure 3-15, I emphasized the white horse and the white of the driver's silks in order to make them pop more.

Select the Dodge or Burn Tool from the Toolbox, choose a brush size and hardness, and then select a range. The Range option lets you target specific tones in the image: shadows, midtones, or highlights. All you do is brush it on.

Dodging and burning work well to *emphasize* rather than correct. In other words, I dodge to brighten highlights in clouds, on water, or elsewhere to accentuate those elements. Quite often, I burn shadows or midtones for the opposite effect.

Figure 3-15: Emphasizing the good stuff.

Using Filters and Effects

Filters (Photoshop Elements and Photoshop) and Effects (PaintShop Pro) are a helpful way to make a photo look artistic. Check out the Filter menu in Elements and play around with some of the more creative filters. I love using them; they add a layer of artistry on top of my photography skills. Figure 3-16 shows what I mean. It's a photo of a coconut cream pie that my wife made. I photographed a piece on a plate with a cup of coffee. The photo looks great, but the additional artistry of the Cutout filter is over-the-top good!

Figure 3-16: Filters are awesome!

Making Distortion, Perspective, and Angle Corrections

Distortion happens when something that should be straight appears curved (or otherwise not kosher) in your photographs. Lenses can cause three types of distortion, and the way you hold the camera causes a few other types.

Lens distortion:

- *Barrel:* The center of the image bulges outward.

- *Pincushion:* In this most common setting, the center of the image is pinched inward.

- *Combination:* Uneven distortion of either type (barrel or cushion) generally looks worse in the center but tapers off to almost straight by the edges of the image. It's sometimes called *mustache distortion* (but is commonly mistaken for pure pincushion).

Camera position:

- *Vertical:* When vertical lines aren't straight. This occurs when you point the camera up or down, which causes vertical lines to either fall away from or fall towards you, respectively.

✔ *Horizontal:* When horizontal lines aren't parallel to the ground. This happens when you point the camera left or right of the lines, causing horizontal lines to tilt one way or the other.

To fix lens distortion, choose Filter➪Correct Camera Distortion. The resulting dialog box is shown in Figure 3-17. Pick your poison:

✔ **Remove Distortion:** Repairs barrel distortion (positive values correct bulging by pushing in the center) or pincushion distortion (negative values correct pinching by pulling out the center).

Select the Show Grid check box at the bottom of the dialog box and use the grid to line up elements. Turn off the grid to see the image better. You can change the color of the grid and zoom in and out.

✔ **Vignette:** Lightens (positive values) or darkens (negative values) the corners of the image. Use it to correct or cause vignetting (darkening the corners of a portrait adds an artistic touch). Adjust the Midpoint slider to change how little or how much the vignetting extends into the image.

✔ **Vertical Perspective:** Adjust to make vertical lines go straight up and down. You can also correct perspective problems by using Free Transform.

✔ **Horizontal Perspective:** Adjust to make horizontal lines go directly left and right. You can also correct perspective problems by using Free Transform.

✔ **Angle:** Straightens the image. I tend not to straighten photos as I correct distortion. I wait until later and then use the Straighten tool.

✔ **Scale:** Enlarges the image. My only caveat here is that, unlike transforming the image in the main window, you lose whatever extends beyond the dialog box preview window. In other words, this option crops after it enlarges.

I'm applying four different corrections to the photo of an auditorium in Figure 3-17! My goal is always to make the result look more natural than the original photo. If yours doesn't, go back and correct your settings, ease off, or rethink whether you want to remove distortion at all. It's okay to leave it in sometimes.

Figure 3-17: Correcting camera distortion.

Consider Seeing a Doctor: Cropping and Scaling

Everyone wants to take great photos, but framing a scene perfectly isn't always possible. Sometimes, it takes a while to see how a scene should be composed, which makes cropping and scaling (or *recomposing*) a helpful part of finalizing an image.

Elements has the Recompose tool, which automates some of the process. Try it out and see whether you like it. I cover cropping and scaling instead because these techniques work with every photo you have.

Cropping photos

Cropping chops off one or more edges of a photo. You're taking the scissors to it, in effect, so be careful. You have a couple of ways to approach it:

- ✔ **Crop it and forget it:** If you aren't concerned about the final size of the photo, just crop it and don't worry about its height or width. In Figure 3-18, however, I did select Use Photo Ratio to keep the aspect ratio the same.

- ✔ **Crop it and make it bigger:** If you want the final photo to have the same dimensions as the original, crop using the same aspect ratio and then resize to match. I like this strategy because I have more control, but trying to remember the photo's original dimensions can be a nuisance.

Figure 3-18: Making a crop.

Scaling layers

Follow these steps to *scale* (enlarge without resizing the file) the photo layer, rather than crop the entire photo:

1. **Choose Image⇨Transform⇨Free Transform.**

2. **Zoom out so that you can see the photo's edges.**

3. **Click and drag a corner handle outward to enlarge the layer.**

 You don't need to hold down the Shift key if Constrain Proportions is turned on. (This shortcut constrains the proportions of the material you're scaling.) I'm in the process of scaling a layer in Figure 3-19. Notice that the handles extend beyond the canvas and into the gray workspace. That's why you should zoom out.

4. **Scale the layer.**

5. **Drag the layer to reposition.**

6. **When you're done, click the green check mark to accept the recomposed photo.**

 The advantage to scaling over cropping is that you can reposition the scaled layer.

There's a practical limit to how far you can reasonably enlarge a layer without dramatically reducing the quality of the image.

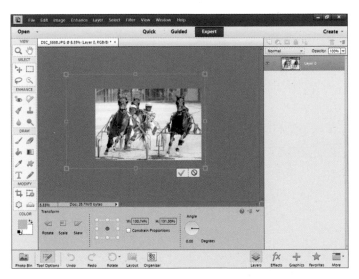

Figure 3-19: Scaling a layer rather than cropping it.

Chapter 4: Home, Home on the High Dynamic Range

In This Chapter

- ✓ Choosing HDR good scenes
- ✓ Setting up your camera for HDR
- ✓ Photographing exposure brackets
- ✓ Creating HDR images
- ✓ Tone mapping HDR images
- ✓ Trying out other software

*H*igh dynamic range (HDR) photography gets around your camera's limited capability to capture very dark darks and very bright brights in the same photo. It does this by cheating: HDR uses more than one photo to collect brightness information.

The concept of HDR is closely tied to contrast. In fact, the entire thing might more correctly be called High Contrast Photography, except that computer nerds got to the name first. *Contrast* is the difference between shadows and highlights. A foggy morning has little contrast, but a sunset has a lot. While cameras have no trouble capturing low-contrast scenes, they can't adequately capture details of high-lights *and* shadows in one photo when the scene has a high contrast ratio. To get around this limitation, you use more than one photo.

What makes HDR *dynamic* is the fact that light changes from scene to scene (sometimes moment to moment). As a photographer, that makes a lot of sense to you: You don't set the exposure the same for every photo. Photography is a dynamic exercise.

TECHNICAL STUFF

Hi versus lo

When referring to a file or image, *high dynamic range* means that the image uses many more bits per channel to encode color and brightness information. HDR images use 32 bits per channel to describe each pixel.

An image that has a low dynamic range is any normal photo file. JPEGs, TIFFs, and even raw exposures are all examples of low dynamic range images. They're limited to, at most, 16 bits per color channel to describe each pixel. The color information is divided between three *channels:* red, green, and blue. Therefore, a file that uses 16 bits per color channel to store information actually uses 48 bits per pixel. Likewise, a 32-bits-per-channel file uses 96 bits per pixel.

Although you use many of the same skills as traditional photography, HDR presents enough differences to require a chapter to explaining what it is, how to shoot it, and how to process your exposures using HDR software.

Getting the 411 on HDR

High Dynamic Range (HDR) photography terminology can take a bit of getting used to (check out this chapter's mini glossary), but the concept is remarkably simple.

Start with contrast

It's impossible to take a photograph of a high-contrast scene with a low-contrast camera without losing something. If you tone down the exposure to capture highlights without blowing them out, you lose details in the shadows. If you raise the exposure to see what's in the shadows, you blow out the highlights. Figure 4-1 illustrates the dilemma. The sky is blown out and the shadows of the trees have few details due to the bright setting sun.

The solution is to artificially enhance your camera's capability to capture high-contrast scenes by using more than one photo. That's the basic concept.

Add brackets

The photos that capture the additional details are called *exposure brackets*. They have different exposures, making it possible for them to capture a wider range of information than a single photo. They should have the same

composition. The most common practice is to take three photos for HDR, as shown in Figure 4-2: one underexposed, one correctly exposed, and one overexposed. *Side brackets* deviate from 0.0 EV.

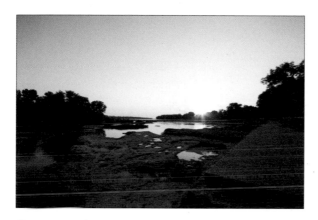

Figure 4-1: It's impossible to capture high-contrast scenes with a low-contrast camera.

Underexposed shots capture details in bright highlights. Overexposed shots capture details in dark shadowy areas. The fact that the rest of the scene looks horrible isn't a problem. Software takes care of that later. That's why they're called *exposure brackets*. They bracket the ideal exposure.

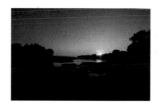

Figure 4-2: Exposure brackets capture more light than a single photo.

Insert HDR software

Special HDR software merges the bracketed photos into a single HDR image. This image contains all the contrast that was captured. It has so much contrast, in fact, that you can't display or print using anything but very specialized equipment.

To convert the HDR image into something usable, you use tone mapping. *Tone mapping* takes the high contrast data from the HDR image and squeezes it so that the end result as the same actual contrast but *appears to have more* than a single photo. In other words, it plays with your mind. Figure 4-3 shows this scene in the process of being tone mapped in Photomatix Pro.

Figure 4-3: Tone mapping is an important part of HDR photography.

Tone mapping is interactive. You make many of the decisions that affect the final brightness, contrast, and overall look of the image. After tone mapping, the final image is converted into a JPEG or TIFF and saved.

Stepping through HDR

HDR photography is a two-step process:

✔ **The first step is photography.** Select a scene and take exposure-bracketed photos. The technical details of this part of HDR revolve around setting your camera up to shoot brackets, and then shooting them. This chapter handles the setup.

✔ **The second step involves software.** You'll use HDR software to create and tone map HDR images, which are converted and saved as normal image files.

To enjoy HDR photography, you should be comfortable with both steps.

Selecting the Right Scenes

HDR photography can seem fickle at times. Don't hesitate to try it on every scene you can. However, I hope to save you some time and trouble by helping you focus on the scenes on which it works best.

Look for scenes with the following elements.

High contrast

When I realized how important contrast was to HDR, I started seeking out different scenes. For example, cloudy, dull, misty, or foggy days have less contrast than sunny days with bright features (the sky or even the sun) and deep shadows. Those cloudy days have a smaller dynamic range, which means HDR photography has less oomph.

I took the shot in Figure 4-4 facing into the setting sun; it has bright brights and dark darks. That's what high contrast means. It's perfect for HDR. The sun doesn't overpower the scene. You can see details in the sky, river, and even on the far banks.

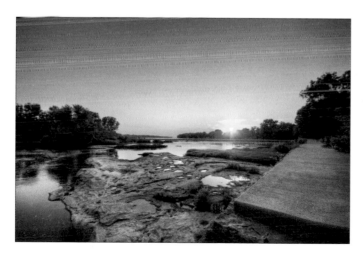

Figure 4-4: High-contrast scenes work best for HDR.

If you want to choose scenes more effectively, pay special attention to emphasizing contrast and light in all its forms. Your HDR will shine!

Good light

Look for scenes that have good light. I can't stress this simple fact enough: HDR won't turn bad shots into masterpieces. HDR works exceedingly well in the morning and evening golden hours. The light is more magical and the results look fantastic.

I photographed the brackets of the scene in Figure 4-5 during the golden hour. The sun is behind me in this scene. It illuminates the clouds and the building with a better light than during mid-day.

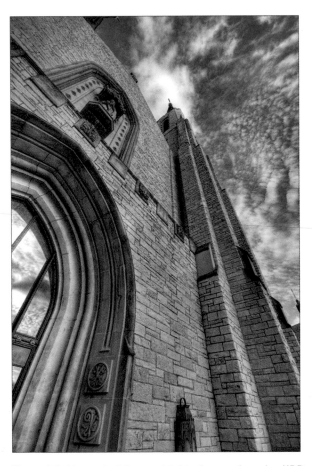

Figure 4-5: Always look for good light when you're using HDR.

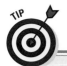

For more information

If you like this taste of HDR and want more information, pick up my book *High Dynamic Range Digital Photography For Dummies.* In it, I devote much more space to the ins, outs, ups, and downs of HDR, including such topics as choosing the proper equipment, bracketing, converting raw photos for HDR, processing, and more.

Setting Up Your Camera for a Date with HDR

Just like traditional photography, HDR requires that you set up your camera and gear. If you plan on shooting HDR, you might have to change some things, and some things you would be setting up anyway. This section quickly reviews the possible changes, and then goes into more depth in regards to *auto exposure bracketing (AEB)*.

Don't worry. HDR isn't a gigantic deal. There are a few things you'll have to do differently, but not many.

One of these things is not like the other

Make changes to these settings or setup as required (most of these are covered in Book I, Chapters 3–5):

- **Shooting mode:** Set to Aperture priority or Manual mode if you're shooting brackets using your camera's AEB feature. Set to Manual mode if you're handling the bracketing chores yourself.

- **Image Quality:** Set to raw for best results. You can use JPEGs if you like, but you'll lose a bit of detail. I set my cameras to shoot RAW+JPEG so I can use either type if I want.

- **Set Release (Drive) Mode:** If you're shooting auto brackets, set Release Mode to High Speed Continuous (or its equivalent). That way you can take the bracketed shots with one press of the shutter release button and in the shortest amount of time. See Book I, Chapter 5 for more information on release/drive settings. If you're manually bracketing, set the camera's drive to single shot.

- **ISO:** When shooting brackets with the help of a tripod, set ISO to a minimum value to keep noise down, and make sure Auto ISO is off. If you're shooting hand-held, you may want to raise the base ISO so you can get a faster shutter speed.

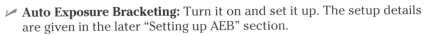

- ✔ **Noise Reduction (NR):** Turn off in-camera noise reduction to ensure a good frame rate when using AEB.

- ✔ **Auto Exposure Bracketing:** Turn it on and set it up. The setup details are given in the later "Setting up AEB" section.

When returning to normal photography, make sure to turn off auto bracketing.

No getting around these

If you go through your normal routine of deciding how to set up your camera (see Book I, Chapters 3–5), you'll be making most of the same decisions, whether for HDR photography or not:

- ✔ **Lens:** Wide-angle lenses are great for HDR photography, but only due to the fact that many people shoot landscapes in HDR. Use the lens that matches your subject. Make sure it's clean. Book II talks about different lenses at length (telephoto and otherwise).

- ✔ **Tripod:** HDR and tripods go hand in hand. The only difference is that you'll be shooting exposure brackets, not different shots. If you have a fast enough frame rate and AEB, you may want to ditch your tripod and try shooting hand-held brackets. If so, make sure the shutter speed is fast enough on all brackets to avoid blurring (you may have to shoot them first to tell; you'll know when you hit a bracket that seems to lag). Using a remote is helpful when shooting auto brackets, but not required.

- ✔ **Batteries:** Double-check your camera's remaining battery power. If necessary, change drained batteries between bracketed sets. Changing them between photos in the same set can ruin your composition.

- ✔ **Memory card:** Make sure that you have enough memory card space to store the photos. Bracketing eats up space, especially if you're saving raw photos and JPEGs!

- ✔ **White balance:** Set the white balance to match the scene. Otherwise, leave it on Auto.

- ✔ **Vibration reduction (VR):** Turn off VR if the camera is on a tripod or is otherwise solid. If you're shooting hand-held, keep VR or image stabilization (IS) on.

I've made just about every mistake possible shooting HDR, including forgetting to turn *off* anti-shake or vibration reduction. It's not going to matter that much if you forget it.

- ✔ **Metering:** You'll be capturing enough range for metering not to matter if you're off by a hair. Leave in your camera's pattern mode unless you have a good reason to change it.

If you want the 0.0 *EV* (exposure value) bracket to be as good as possible, take a few solo shots to check the exposure and dial in any adjustments. Then switch over to take the brackets.

✐ **Focus:** Choose a focus mode that works best for the given situation. Most of the time, autofocus (AF) works very well and you don't have to worry about it. If the setting's dark, you may need to switch to Manual mode. For total control, switch to Manual regardless of the conditions. This way the camera will focus on the exact same spot in every bracket.

✐ **Other photo settings:** Set size, aspect ratio, and color profile, as desired. Remember to check back to Book I for general camera setup.

Setting up AEB

Not all cameras have an auto exposure bracketing (AEB) feature. If you can't find it anywhere in the menu system, you may not have one of them. By and large, the least expensive entry-level dSLR cameras lack AEB. The Nikon D3200 is an otherwise excellent camera, for example, but doesn't have AEB.

Learn about your camera's AEB feature before you venture out intending to use it. After you know how turn it on and enter a few settings, it's easy. Should your camera have any AEB settings you can choose yourself, use the menu system to confirm or change them.

You will run across the following options. Refer to Figure 4-6 as you read the following sections.

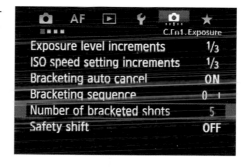

Figure 4-6: Set up AEB options before you need them.

Number of brackets

Set the number of brackets to shoot. You may be able to choose from two to nine exposure brackets. If possible, set the number of brackets based on how much contrast you need to capture. In general, the more brackets you can shoot, the larger the overall dynamic range will be. This results in more information.

✐ For normal scenes, shoot at least three brackets separated by 2.0 EV or five separated by 1.0 EV.

✐ For very high-contrast scenes, shoot anywhere from five to nine brackets.

EV difference between brackets

Set the *exposure variation (EV)* between the brackets.

✔ Normal values are either 1.0 or 2.0 EV. You may be able to select a difference anywhere from 0.3 EV to 3.0 EV between each photo. This difference *doesn't* refer to the total EV range of the bracketed set.

✔ Usually, three brackets separated by 2.0 EV works fine. You may miss some dynamic range if the scene has a tremendous contrast between lights and darks. If you're shooting five or more brackets, 1.0 EV works well.

✔ If possible, set the EV distance based on how smooth you want your images to transition from one exposure to another. This results in potentially more realistic images. Common exposure differences between brackets are 2.0 EV and 1.0 EV.

✔ **Sequence:** Set the order the shots are taken. Most often (if you can change this setting), you can put the metered exposure first, in the middle, or last. (I prefer it first. That way I can spot it from the thumbnail in Lightroom faster than having to count exposures from the darkest or lightest.) The other exposures tend to be taken from dark to light.

✔ **Auto cancel:** Most of the time, bracketing is canceled when you turn off the camera. Some cameras restart the bracketing sequence where you left off if you turn the camera off and back on. If you have a camera like this and don't like that behavior, you may be able to turn it off.

✔ **Bracketing option:** Some cameras lump several different types of bracketing together. You may have to identify that you want *exposure bracketing* as opposed to white balance or another type of bracketing.

Can You Hack It with Auto Brackets?

When you're ready to shoot, turn on your camera's auto exposure bracketing (AEB) feature. How you turn it on differs from camera to camera. Please read your manual for the precise details.

✔ Some cameras set the number of brackets from the menu, which takes some time. You can set that and often leave it alone. When it comes time to shoot, you can quickly set the EV distance between the brackets with a spin of a dial.

✔ Other cameras make you choose the number of brackets and their distance apart each time you turn on the AEB feature.

✔ Still other cameras don't let you change the number of brackets. You can only modify the EV distance between them.

Use these general instructions to get familiar with what you'll need to do:

1. **Set up AEB.**

 You should configure your camera's AEB before trying it out. Some cameras have few or no options. Some have more. Others require you to set the number of brackets from the menu system. Some make it quick and easy to set both the number of brackets and their EV distance on the fly.

2. **Choose a shooting mode.**

 Double-check with your camera's manual to see what shooting modes are compatible with the AEB feature. Depending on your camera, you may need to be in a more advanced shooting mode, such as P, A, S, or M. Being in Manual shooting mode shouldn't negate auto bracketing. Manual mode requires you to set the starting exposure. The bracketing feature handles the rest.

 TIP

 I recommend Aperture priority mode because the depth of field will be constant between shots. If you enter Aperture priority mode, set the aperture now. As a reminder, make sure to set the camera's drive to Continuous if you want to take the brackets with one button press. This is especially important when shooting hand-held.

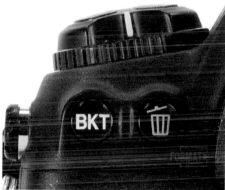

Figure 4-7: This camera has a dedicated Bracket button.

3. **Set AEB parameters.**

 Again, how depends on the camera. Here are some of the variations:

 • *Bracket button:* Some cameras have a bracket button, such as the Nikon shown in Figure 4-7. Press and hold the button, then rotate the camera dials to set the number of brackets you want and their EV range.

 • *Other buttons:* On a Canon, set AEB options from the menu or the Quick Control screen, shown in Figure 4-8. Canons in particular link the AEB display with exposure

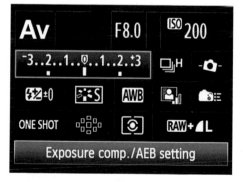

Figure 4-8: Canon makes accessing AEB when shooting easy.

compensation. In this case, all you can do is set the EV distance. Canon expects you to change the number of brackets in the menu system. On a Nikon camera, press the information edit button, whether the camera has a bracket button or not.

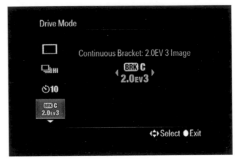

* *Drive mode:* On a Sony dSLT, AEB by accessing the Drive options. Here you set the number of brackets and their EV range, as shown in Figure 4-9.

Figure 4-9: Sony organizes AEB options with Drive settings.

4. **Compose the scene.**

5. **Meter and focus.**

 If you're in Manual shooting mode, set the exposure now.

6. **Take the photos.**

 Press and hold the shutter button to shoot the brackets if the drive is set to Continuous. If it's set to Single, press the shutter button as many times as you have brackets. Figure 4-10 shows three brackets of a set that I took of the Gateway Arch in St. Louis, Missouri. I shot them handheld using the camera's AEB feature and continuous release.

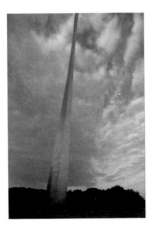
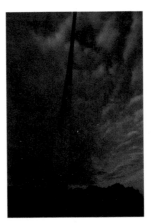
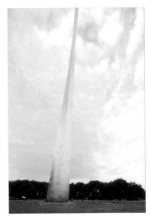

Figure 4-10: Bracketing the Arch with AEB.

The next steps are in software. Convert raw photos to TIFF at your discretion. Likewise, use JPEG, if you want. Generate the HDR image (I tell you more about this topic later in this chapter), tone map it, and edit. The finished image of the Arch (shot during the golden hour, to keep reminding you of the importance of good light) is shown in Figure 4-11.

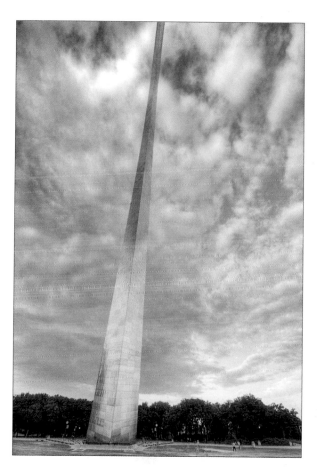

Figure 4-11: The Arch is simply a stunning national monument.

Shooting Brackets Manually

Whether you have a camera that shoots AEB or not, knowing how to shoot manual brackets is helpful. After a bit of practice, HDR photography (brackets, exposure, and the other aspects and terminology) becomes imprinted on your brain. You also get better at working with your camera this way.

Follow these steps to manually bracket a scene with three exposures taken at –2.0, 0.0, and +2.0 EV:

1. **Enter manual shooting mode.**

2. **Compose the scene.**

 Focus manually, if you want.

3. **Meter.**

 Press the shutter button halfway to see an initial meter reading. The camera then shows you what the exposure is (over, under, or perfect) given your current settings.

 If you're using autofocus (AF), get good focus as you meter.

4. **Set the shutter speed so that the EV meter reads –2.0 EV.**

 The point of this step is to change the shutter speed so that the exposure index reads –2.0 EV to be able to photograph the underexposed bracket.

 The chances are slim that your camera is set up at the perfect exposure before metering. You should have its aperture and ISO dialed in, but leave the shutter speed alone. Therefore, when you meter, the reading tells you whether you must, at the current shutter speed, increase or decrease the shutter speed.

 For most cameras, three "clicks" of shutter speed equal 1.0 EV. Therefore, if the camera says that you're at +1.0 EV, shorten the shutter speed (remember that faster shutter speeds result in less exposure) by nine increments.

5. **Shoot the underexposed bracket.**

 Figure 4-12 shows an underexposed photo of a field near a country cemetery in Pittsburg County, Oklahoma. I took this during the golden hour after visiting some of my ancestors' graves. Notice that the exposure meter on the display reads -2.0 EV. That's exactly where it should be.

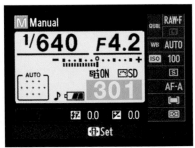

Figure 4-12: The underexposed photo captures highlights without blowing them out.

6. **Set the shutter speed so that the EV meter reads 0.0 EV.**

 You'll have to lengthen the shutter speed, as shown by the meter in Figure 4-13. This raises the exposure because the camera lets in more light.

7. **Shoot the center bracket.**

 The shot is shown in Figure 4-14. There isn't a ton of contrast, but there's enough for HDR to use because of the shadows.

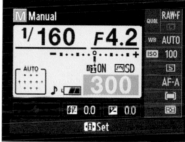

Figure 4-13: The center bracket should look like a well-exposed photo.

8. **Set the shutter speed so that the EV meter reads +2.0 EV.**

 The shutter speed slows again. The final bracket is at 1/40 second. I was shooting with a tripod but didn't want the times to get too slow, so I initially set the aperture to f/4.2. It's an odd one, I realize, but it works.

9. **Shoot the overexposed bracket.**

 The final sequence of this bracketed set is shown in Figure 4-14. The sky is completely washed out, but details in the far line of trees and field in the foreground are brought out. That's what bracketing does.

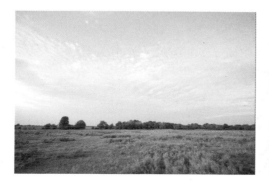
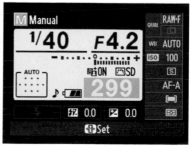

Figure 4-14: Highlights are blown out; it's okay for this bracket.

Over time, you should be able to knock out a bracket of three to five exposures fairly quickly, assuming that the shutter speeds are reasonably fast. You can then overcome some, but not all, cloud movement. The final, tone mapped image is shown in Figure 4-15.

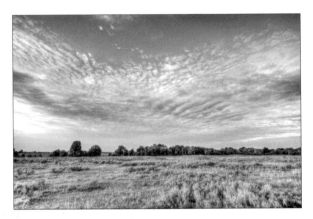

Figure 4-15: Another golden hour moment, this one in the wilds of Oklahoma.

Preparing the Exposure Brackets

You can follow one of three paths to load the exposure brackets into your HDR software. Two don't require any extra process. One does. Knowing when it behooves you to go to some extra trouble will make you a happier photographer. The paths are based on what files want to use.

As-is: Raw exposure from the camera

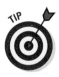

You can throw your raw photos into most HDR applications and they'll dutifully convert them into an internal data format to use in creating the HDR image. You'll hardly notice a thing. That's good if you're in a hurry and don't mind letting the HDR software handle it.

Some applications open their raw processing modules when you try to load raw exposures into them. For example, Photoshop and Photoshop Elements both launch Adobe Camera Raw, which forces your hand.

As-is: JPEG from the camera

You can load JPEG brackets into HDR applications. None of them complain a bit, even Photoshop or Photoshop Elements. JPEGs need no conversion or processing. The caveat here is quality. It may be hard to notice unless the

scene has a lot of wide gradients, but JPEGs don't produce the same quality
as raw exposures or TIFFs converted from raw exposures.

Converted raw: TIFF/JPEG

HDR applications aren't raw processors. It's as simple as that. They're more
than willing to try, but they don't do as good a job as programs dedicated to
the task: Adobe Camera Raw, Adobe Lightroom, Apple Aperture, or the soft
ware that came with your camera.

If you want the best quality and the most control over the HDR process, con
vert your raw photos to TIFF files before processing them into HDR images.
You can convert them to JPEGs if you like, but then you should just use the
JPEGs from your camera if that's the case. There's a catch, though: Don't
overdo it when you convert the raw exposures.

Making a plan of attack

A quick HDR preview using JPEGs can help you pare things down and decide
whether to pursue bracketed sets. If you like what you see as you tone map
the preview, process the file and save the settings. Use this as a concept file
to refer to as you keep working. Then you can take the trouble to use your
raw converter and aim for high quality knowing it will be worth the effort.

Here's what you might do:

- **Fast:** If you're working with a small number or brackets, toss the raw
images directly into HDR software and quickly tone map the resulting
HDR image. This gives you a reasonably fast preview so you can quickly
weed out photos you don't want to spend any more time on.

- **Faster:** If you lots of brackets (seven or more), use the JPEGs to do an
initial preview. JPEGs are smaller and take less time to load and work
with. The result isn't that much different than what you'd get from con
verted raw files, which means that you can use the settings as a baseline
for the final version.

- **Final:** When you want to create the final, high-quality image, load pro
cessed raw exposures into your HDR software. You can export them into
whatever raw processing software you like. I use Photomatix Pro from
Lightroom.

Converting the raw files

If you convert the raw files to JPEGs or TIFFs (remember, you don't have to;
and if you decide to convert files, you can choose either type), limit yourself
to the following adjustments, and make sure to apply the exact same
changes to each bracket:

✔ White balance

✔ Sharpness

✔ Noise reduction

✔ Lens distortion

✔ Vignetting

I don't mess with exposure, contrast, recover highlights or shadows, or adjust the color, tone, or saturation of the photo. I don't crop, rotate, remove spots, or add any special effects. It makes more sense to handle these tasks when finishing the tone mapped image.

If you use Adobe Lightroom or Apple Aperture, you can buy the Photomatix Pro export *plug-in,* which is an add-on that you use in Lightroom or Aperture (www.hdrsoft.com). It streamlines your workflow by letting you select single exposures or brackets and sending them over to Photomatix without leaving the friendly confines of your photo management/raw processing software. You even have the option to automatically import the result into Lightroom or Aperture. You don't have to convert the raw exposures yourself with this method. Aperture and Lightroom apply your raw development settings to the exposures as they convert them to TIFFs and send them to Photomatix.

If you need to save a converted file, you'll (likely) have three options: JPEG and two types of TIFF. TIFFs come in two flavors: 8 and 16 bits per channel. If you can't stand the thought of not having the highest possible quality, use 16-bits-per-channel TIFFs. I used to do this, but eventually grew tired of the huge files taking up more space and being harder to work with. You'll hardly ever see a discernible quality difference between them and normal 8-bits-per-channel TIFFs.

Seeing a Photomatix Pro about HDR

As you might expect, you have to use specialized HDR software. (I address Photoshop and other image editors briefly later.) After you load your brackets into the software, the HDR software takes all the data and creates a single image.

Before you start, consider this:

✔ Save your image if you can't immediately start tone mapping. Reload it at your leisure.

✔ If you know that you want to use all the same HDR settings, try *batch* processing. In this case, you set up rules for the program to follow as it creates HDR images out of any number of bracketed sets. This is very nice.

Creating HDR images in Photomatix Pro is incredibly easy. Follow these steps:

1. **Start Photomatix Pro.**

 Download the free trial from www.hdrsoft.com. If you like what you see and buy it, you won't have to put up with watermarks once you register.

2. **Select Load Bracketed Photos from the Workflow Shortcuts dialog box (see Figure 4-16).**

 You can drag and drop the brackets onto the program interface.

Figure 4-16: Your shortcut to HDR success.

3. **Select your brackets and press OK.**

 You can also drag and drop the brackets into the dialog box.

 Check the Show Intermediary 32-bit HDR image box if you want to see the actual HDR image.

4. **Set the HDR options.**

 You click your way through the Preprocessing Options dialog box in no time.

 Select from the following options that appear in the dialog box:

 - *Align Source Images:* Adjusts for slight camera movement. The two major alignment methods include perspective correction. You can also have Photomatix Pro crop the aligned image. This is pretty helpful when loading brackets shot without a tripod.

 - *Remove Ghosts:* Attempts to remove *ghosts,* which are caused by moving objects that appear in one bracket and either move or disappear from the other brackets. You can identify problem areas yourself or have Photomatix Pro handle it automatically.

 - *Reduce Noise On:* Reduces noise in a variety of ways. You can set a strength.

 - *Reduce Chromatic Aberrations:* Reduces red/cyan/blue/yellow fringing.

 The following options are visible only if you're using raw photos to generate the HDR image:

 - *White Balance:* The default setting As Shot is often adequate. Change if needed.

 - *Color Primaries Based On:* Choose between sRGB, Adobe RGB, or ProPhoto RGB. You can choose Adobe RGB or ProPhoto RGB now without much concern for portability if you plan to edit the image after tone mapping. (Set up your system and monitor to view the wider color gamut though; otherwise you're wasting your time.) Convert down to sRGB when you publish. On the other hand, if you're going to post the result directly to the web (save directly from Photomatix Pro as a JPEG), choose sRGB.

5. **Process (or press OK) and prepare to tone map.**

 The HDR image, which you may or may not see, combines all the contrast of the brackets into a single 32-bits-per-channel image. As you can see from Figure 4-17, it's not usable like this. The reason is that your monitor is incapable of displaying photos with a wide dynamic range. You have to tone map the HDR image to make something useful out of it.

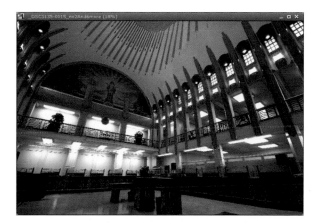

Figure 4-17: The HDR image waiting to be tone mapped.

Tone Mapping HDR Images in Photomatix Pro

When you *tone map* your HDR images (convert an HDR image into something more manageable), the software fun starts to happen. The problem is that tone mapping is sometimes so unpredictable that showing you how to do it well is difficult. Every HDR image is different. The key is to experiment with the controls and then practice, practice, practice.

Figure 4-18 shows the Photomatix Pro tone mapping interface. I encourage you to investigate its other features on your own. For now, this chapter focuses on the detail enhancer method of the tone mapping process.

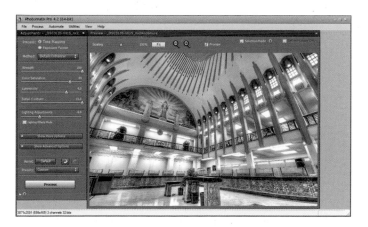

Figure 4-18: As you tone map, work using the controls on the left and the preview on the right.

General controls

The first section, shown in Figure 4-19, has the general controls. You can get to them no matter which section of the dialog box is expanded:

- ✔ **Strength:** Controls contrast enhancement strength, both local and global (see Book V, Chapter 3). Although it isn't technically the strength of the overall tone mapping effect, it acts like it. For a dramatic effect, raise Strength toward 100. Conversely, to create a more realistic effect, lower strength to 50 or lower.

- ✔ **Color Saturation:** Controls color purity (which makes colors look either strong or washed out).

- ✔ **Luminosity:** Affects overall brightness. Think of this setting partly as a shadow brightness control. Raising it brightens shadows, and lowering it darkens shadows.

 Contrast is also affected when you change the Luminosity setting.

 - Higher settings lower contrast.

 - Lower settings increase contrast.

- ✔ **Detail Contrast:** Accentuates local contrast. The default is 0.

 - Higher settings amplify local contrast and darken the image. Can boost drama.

 - Lower settings reduce local contrast and lighten the image.

- ✔ **Lighting Adjustments:** Controls the level at which contrast enhancements are smoothed out. This setting plays a large role in determining how the final tone mapped image looks. It's also responsible for much of the debate over the "HDR look," both good and bad. Smoothing comes in two modes:

 - *Slider mode:* Controls smoothing with a free-ranging slider. Higher values produce more smoothing, and lower values result in less.

 - *Lighting Effects mode:* Shows discrete buttons to control the smoothing strength.

 Each smoothing mode has its own, unique algorithm. Think of Slider mode as being beyond the maximum Lighting Effects mode setting.

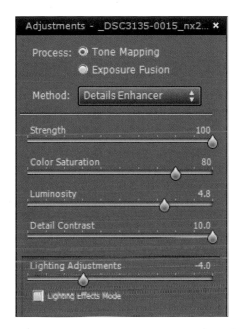

Figure 4-19: The general controls with my settings.

More options

One section of the Details Enhancer dialog box has the tone settings, shown in Figure 4-20. If you can't see the section, click the arrow beside the name.

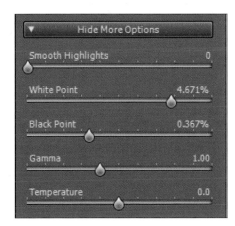

Figure 4-20: More options with some custom values loaded.

This section has basic tone controls, as described in this list:

- **Smooth Highlights:** Ignores the darker parts of the image. Use this option to blend areas where highlights and shadows meet.
 - Higher values tend to lighten the image.
 - Lower values tend to darken the image.
- **White Point:** Sets the white point, or *maximum luminosity,* of the tone mapped image (the high end of the dynamic range).
 - Higher settings produce more contrast and a brighter image.
 - Lower settings produce less contrast and a darker image.
- **Black Point:** Sets the black point, or *minimum luminosity,* of the tone mapped image (the low end of the dynamic range).
 - Higher settings make a darker, more contrasted image.
 - Lower settings make a lighter, less contrasted image.
- **Gamma:** Sets the midpoint of the tone mapped image. Not every pixel is lightened or darkened by the same amount. You're moving the brightness midpoint around, which squeezes or expands highlights or shadows into a smaller or larger space on the histogram.
 - Higher settings lighten the image.
 - Lower settings darken it.
- **Temperature:** Change the color temperature of the tone mapped image.
 - Moving the slider to the right gives a reddish cast.
 - Moving the slider to the left gives a blue feeling.

Advanced options

This section of controls contains color settings, as shown in Figure 4-21. The following list describes the controls for the image's color temperature and saturation controls for shadows and highlights:

- **Micro-Smoothing:** Smoothes details in the tone mapped image.
 - Higher settings result in a lighter, more realistic appearance and can also reduce image noise.
 - Lower settings perform little or no smoothing.
- **Saturation Highlights:** Increase or decrease the color strength within the highlights of the tone mapped image.

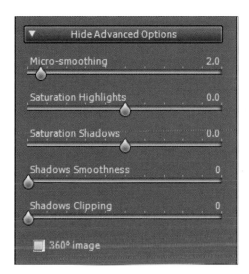

Figure 4-21: Advanced options with default settings.

TIP

I often use the Saturation Highlights control as a tool to investigate the tonal regions of an image. Lower to the minimum amount, and then raise it to the maximum to see where the highlights are. You can also create different artistic effects.

✔ **Saturation Shadows:** Does the same thing as Saturation Highlights, except as it pertains to the darker areas.

✔ **Shadows Smoothness:** Smoothes shadows and ignores the brighter parts of the image. Higher values also darken the image. Use this option to blend the border where highlights and shadows meet.

REMEMBER

Neither Shadows Smoothness nor Highlights Smoothness controls are cure-alls, but they have a good effect if properly used.

✔ **Shadows Clipping:** Sets the dark point where shadows are *clipped* (information is discarded). Raising this control can help fight noise in very dark areas by clipping them, which removes them from the tone mapped image.

✔ **360 Image:** If you're shooting a 360-degree panorama, ensures that the left and right borders of an image are tone mapped in relation to each other.

Figure 4-22 shows a final edited image. I raised the Strength and Color Saturation, Luminosity, Detail Contrast, and White Point settings quite a bit.

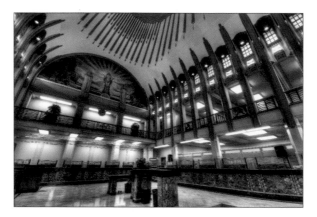

Figure 4-22: The final image.

Using Other Applications for HDR

Photomatix Pro isn't the only HDR application on the market. The top three photo editors, as a matter of fact, have HDR features now built into them. It's probably not worth buying one of them just for HDR, but if you already have one, you can experiment with how it works to create and tone map HDR images to see if you need a dedicated HDR application.

Photoshop Elements

To work with an HDR in Photoshop Elements, follow these steps:

1. **Open the brackets in Photoshop Elements 11.**

2. **Choose Enhance⇨Photomerge⇨Photomerge Exposure.**

3. **Choose All.**

4. **Choose Automatic or Manual Blending.**

 To manually blend the photos, drag exposures from the Photo Bin and select which regions of the photo you want to keep with a Pencil tool. You can also control how opaque each bracket is and fine-tune the brackets' alignment.

5. **Make a selection if you chose Automatic:**

 - *Simple:* It either looks good or it doesn't.

 - *Smart:* You can increase details in the highlights, shadows, and manage the overall saturation.

Figure 4-23 shows a bracketed set loaded into Photoshop Elements 11 with Smart Blending underway. The building is in downtown Detroit.

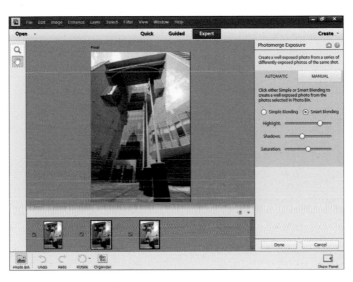

Figure 4-23: Working with HDR in Photoshop Elements.

Corel PaintShop Pro

PaintShop Pro has a feature called HDR Exposure Merge, and it's an effective tool for creating and tone mapping HDR images.

1. **Choose File⇨HDR⇨Exposure Merge.**
2. **Add brackets and then align them.**
3. **Tone map the HDR image.**

 Figure 4-24 shows the Arch again, this time from one of the bases. It looks pretty good here.

Photoshop

Photoshop CS6 has a robust HDR capability.

1. **Choose File⇨Automate⇨Merge to HDR Pro menu.**
2. **Select the brackets to merge and continue.**

 Photoshop aligns and blends them into an HDR image.

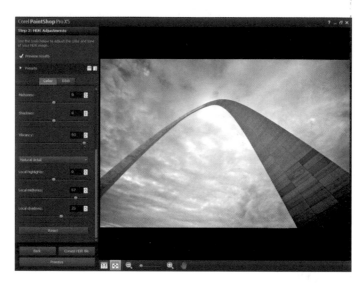

Figure 4-24: The clouds and golden-hour light contribute to the effect of this HDR image.

You can tone map the photo using the controls shown for the Local Adaptation mode in Figure 4-25. In this case, I have loaded five brackets into Photoshop. I took these inside the Gateway Arch, looking down on the north end of downtown St. Louis. I shot these brackets hand-held.

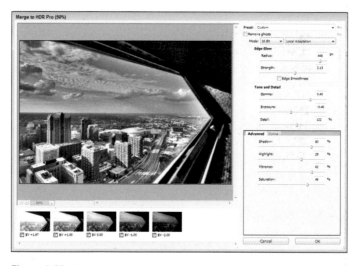

Figure 4-25: Photoshop has lots of tone mapping controls and modes.

There are several HDR presets, in addition manual controls, which change based on the mode you're in. Modes affect how much control you have over the process. The modes follow:

- **Local Adaptation:** This mode has the most options. They're similar, in fact, to other HDR applications.

- **Equalize Histogram:** No user input required.

- **Exposure and Gamma:** Adjust the image's exposure and gamma, control brightness and contrast.

- **Highlight Compression:** Again, you don't do anything in this mode. It either works or it doesn't.

Your camera

That's right! Your camera may have a built-in HDR feature. It will handle shooting the brackets, creating the HDR image, and tone mapping it, all in one go.

- Sony has a feature called Auto HDR that performs similarly. Rather than shoot a single photo and process it differently (which is what happens with Sony's D-range optimizer), Auto HDR shoots several photos with different settings and merges them into a single shot. You set the number of brackets you want to take and the EV distance between them. All you have to do is press the shutter button.

- Newer Nikon cameras also have an HDR feature, called HDR. It's located in the Shooting Menu. Set the Exposure Differential (what I have been calling the EV difference) and the amount of smoothing. The camera will use two exposures (you are limited to two and cannot change this at the current time) and merge them together for you.

- Some Canon cameras have an HDR mode or an HDR Backlight Control mode. Both settings bracket the scene and automatically produce a single photo for you.

You can see some Canon options in the menu in Figure 4-26. They're a good sample of what options you can expect now and in the future from in-camera HDR:

- **Adjust Dynamic Range:** Set to Disable HDR by default. To turn on HDR, set to Auto or choose from one of the discrete EV ranges (from +/-1 EV to +/-3 EV).

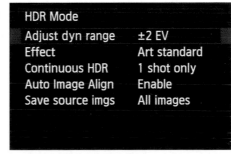

HDR Mode	
Adjust dyn range	±2 EV
Effect	Art standard
Continuous HDR	1 shot only
Auto Image Align	Enable
Save source imgs	All images

Figure 4-26: Setting up HDR mode on a Canon 5D Mark III.

- ⊶ **Effect:** Select an effect. Options are Natural, Art Standard, Art Vivid, Art Bold, or Art Embossed.

- ⊶ **Continuous HDR:** This is a neat option. Select 1 Shot only if you want to shoot one HDR sequence and return to normal shooting. Set to Every Shot if you want to keep shooting HDR.

- ⊶ **Auto Image Align:** Set to Enable (best when shooting hand-held) or Disable (best when using a tripod).

- ⊶ **Save Source Images:** Select All Images if you want to save all the source images, including JPEGs and RAW. I highly recommend this setting because you can use software to create your own HDR images using the source photos later, in case you don't like the camera's result. Only choose HDR Image if you want the take-it-or-leave-it solution.

I shot the photo in Figure 4-27 with a Canon 5D Mark III using the Art Vivid preset.

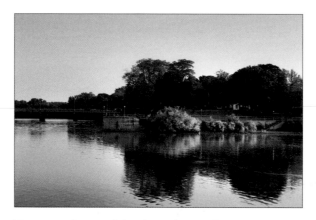

Figure 4-27: I pressed the shutter button; the camera did the rest.

Finalizing Your Images

Tone mapped images don't always look perfect when they leave your favorite HDR application. In fact, sometimes they need more editing. Some images have too much noise (a common problem with HDR), and some may have dust, moving objects, or other distracting elements that you want to remove.

Many images have lens distortion, which wide-angle lenses tend to accentuate (assuming you don't correct this in your raw processor). At times, you see color problems — too much, too little, too much of a single color, or the wrong color. On top of all these issues, artifacts can appear in tone mapped images as a result of movement in the scene.

Use the same techniques I describe in Book V, Chapter 3 to edit your tone mapped HDR images and make them shine.

Trying on Faux HDR

Many HDR applications let you tone map a single raw photo as if it were a bracketed set. I refer to the practice as *single-exposure HDR*. It's also called *pseudo-HDR*. This practice isn't technically HDR because it doesn't capture more dynamic range than any other standard photo.

The benefit of single-exposure HDR is that you don't have to set up a tripod or shoot brackets to produce something that, in the end, looks much like traditional HDR. Sometimes, shooting brackets fast enough to avoid blurring or significant subject movement is simply impossible.

Single-exposure HDR is a better solution in these situations:

- ✓ **You're moving:** In cars, trains, planes, or boats, or whenever you're simply walking around.

- ✓ **Your subject is moving:** Most people use this technique for people and moving vehicles.

- ✓ **Your camera can't shoot good brackets:** Maybe your camera has a limited or nonexistent *automatic exposure bracketing (AEB)* function (or your frame rate is too slow) and you don't have time to bracket a scene manually. Shoot the brackets anyway and use single-exposures as backups.

By tone mapping a single raw exposure, you access and manipulate the total dynamic range that's already in the shot (but often hidden) in ways that traditional raw processing software doesn't. The result can seem as though the shot has more dynamic range than it really does. Figure 4-28 is the final result of processing a single raw exposure through Photomatix Pro. I tone mapped it and then did some minor editing in Photoshop.

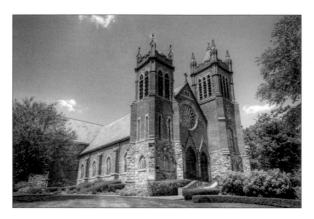

Figure 4-28: Pseudo-HDR can be a valuable processing tool.

Because of space limitations, I can't fully explore single-exposure HDR in this chapter. Here's a quick recipe to get you started:

1. **Take a good basic photo.**

 You don't want to blow out highlights or shadows in this photo. Make it a good single exposure. You may not be able to capture the same type of scenes (for example, sunsets) as you would if you used brackets.

2. **Load the raw file into an HDR application.**

 I use Photomatix Pro for this.

3. **Tone map it like you want an HDR image created from a bracketed set of photos.**

4. **Process it.**

5. **Save it.**

 You can keep editing it in your favorite photo editing application.

Chapter 5: Panoramically Speaking

In This Chapter

⮡ **Shooting panorama frames**

⮡ **Stitching, blending, and cropping**

Shooting panoramas is fun and relatively painless. Plus, they evoke oohs and aahs from all who see them. It's rewarding to find a good scene that you want to capture in a format wider or taller than a standard photo and then make it happen.

Like *high dynamic range (HDR)* photography, panorama photography means taking multiple photos of a scene and then using software to produce your final image (although some cameras now shoot and stitch panoramas together, alleviating the need for special software). You can even combine the two to make an HDR panorama.

In a panorama, though, you *pan* (move) the camera from frame to frame (up, down, left, or right; it doesn't matter). Doing so captures more scenery than your lens sees in one shot, making it possible to produce really wide-angle panoramas with just about any lens. Afterward, the individual frames (with some overlap so the computer can identify common features) are stitched together in software. The final result is a single large image.

Shooting Pan-tastic Panoramas

Remember three central points to when you're shooting panoramas:

⮡ **Set up your camera as you would normally. Mostly.** If you're shooting a landscape, enter your favorite landscape photography mode and set the right shooting functions. There are exceptions, but it's okay if you want to keep your setup simple.

✔ **Shoot and pan the camera between shots.** This is the essence of shooting panoramas. Each of these photos will be used later.

✔ **Make sure there's enough overlap between the frames.** You've got to give the software something to grab and stitch.

I cover each of these points in the following sections.

Getting your camera ready

I set up my camera before I set it on the tripod. I like holding it in my hands when I make changes. Experiment with whatever setup works best for you.

Make sure you set these things, and strive for consistency across the entire panorama. See Book I, Chapters 3 to 5 for more information on how to set up your camera:

✔ **Shooting mode:** Purists say that you should use your camera's Manual mode so that the exposure doesn't change between shots. However, any exposure modes works pretty well, even something like Auto. Make sure not to change it between shots. In most cases, I don't think you'll be able to see any real difference.

✔ **Live view:** As desired. There's nothing that says you can't frame and shoot your panoramas using the camera's rear LCD monitor instead of the viewfinder.

✔ **Focus:** Consider switching to manual focus if you want to keep a consistent focal point and depth of field (area in focus), and you're concerned that autofocus might switch to objects that are at different distances. I rarely remember to do this and have yet to run into a problem.

✔ **Exposure controls:** Ideally, set the aperture in accordance with the depth of field you want and try to keep ISO to a minimum. Use shutter speed to balance the exposure (either you or your camera's autoexposure system). However, you may need to ensure a high shutter speed if shooting hand-held, or elevate the ISO if shooting in low light. Book III has more information about aperture, shutter speed, and ISO.

✔ **Image quality:** I recommend shooting in raw or RAW+JPEG. This way you can correct many problems, should they occur, without degrading the photo. If you choose only JPEGs, I recommend setting the size to Large and the quality to Fine.

✔ **White balance:** This matters more if you plan to use JPEGs versus the raw images, because you can't easily change the JPEGs once they're made. Most people advise changing the white balance to match the conditions you're in. For example, set to sunlight or cloudy if that's the weather. However, I've never had a problem using Auto.

If you're going to use raw images, set each frame to the same WB value when converting to a TIFF using your raw processing software.

✔ **Color space:** Choose Adobe RGB. This only matters if you plan on using JPEGs; raw photos don't have an assigned color space. I normally recommend *against* using this color space, because it's less compatible with monitors and printers compared to sRGB. However, because you'll put your JPEGs into panorama software, it's nice to have a larger color range available. You can convert to sRGB when you save your final panorama.

✔ **Drive mode:** Also known as *Release mode.* This is how many photos the camera will take when you press the Shutter button. Set to Single shot. You don't need the camera rattling off shots accidentally.

✔ **Metering mode:** This sets the method the camera will use to measure the light in the scene, which helps set the exposure. Set metering as you would normally. A pattern mode generally works well. You want a good average exposure across the frames. Pattern keeps it from jumping up and down dramatically, which it might with spot or center-weighted.

✔ **Creative style:** As desired. For example, you can shoot your panorama using a landscape style, or switch to something more vibrant, or even shoot them in black and white. See Book I, Chapter 5.

Shooting the frames

After you're ready to shoot frames, grab your camera and tripod (if you're going to use it) and go find an interesting subject — the wider or taller, the better.

Then follow these steps to set up and shoot frames:

1. **Set up your camera as explained earlier in "Getting your camera ready."**

2. **If desired, mount and level your camera on a tripod.**

 This step doesn't apply if you're shooting a hand-held panorama. Although the frames may be a bit messier, it'll still work. I cover using a dedicated panorama head on your tripod later in the chapter.

 Normally, your camera should rotate about an axis that's as true to vertical as you can get it. Rotate your camera and make sure it stays level when you point it in a different direction. If you're like me, you use what you see through the viewfinder to ensure that the scene is level.

3. **(Optional) Attach the remote shutter release.**

 When I use a tripod, my remote is an important part of my antijostle, dejiggle, and unbump de-seismic-activity strategy. Just plug it in and you're set.

4. Determine a framing strategy.

This step may sound overly complicated, but it may only take you a moment.

- *Consider width/height:* Quickly (or for a really long time) consider how wide or tall you want your panorama to be and how many shots you think it'll take to capture it with your current lens. (That may just be the longest sentence in this book. A panoramic sentence.)

- *Check landmarks:* Note key landmarks along the way that will help the software stitch the frames together. Try to put them in more than one shot.

- *Center it:* Try to center the most important elements of the scene (especially the main subject) in a frame.

In Figure 5-1, I imagined making an 8- to 9-frame panorama of the St. Joseph River Dam, centering on the supports.

1 → 2 → 3 → 4 → 5 → 6 → 7 → 8

Figure 5-1: Picturing a framing strategy.

 Try to overlap each frame by about one-third, as shown in Figure 5-2. Overlap helps the panorama program *stitch* (assemble) the frames by providing good reference points. The more reference points, the greater the possibility of a successful stitch.

Figure 5-2: Plan for plenty of overlap.

5. Perform a dry run, if desired.

If you need to, visualize each shot by looking at it through your view-finder or LCD monitor, pan, and look at the next one. Check out the

landmarks that help you identify the boundaries of your frames and how much overlap occurs.

As you can see in Figure 5-3, the corners of buildings, bridge supports, stairs, trees, poles, debris, and other elements with lots of contrast make good landmarks. Look for things that stand out from the background for your landmarks. Vertical objects seem to work best.

If you have a tripod with a compass, you can make a note of the reading for the center point of each frame.

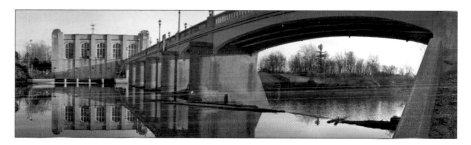

Figure 5-3: Look for landmarks to put in multiple frames.

Take a few meter readings along the way to see whether exposure varies from one side of the panorama to the other. If you like, check your camera's histogram to make sure you're not blowing out any highlights. Decide on a final exposure if you're using Manual mode.

If you're in extreme doubt, shoot a bracketed panorama (manually or automatically). Compare each bracket of each frame against the others and choose the best exposures. You can also turn it into an HDR panorama.

6. **Pan to the leftmost frame.**

 Sure, you can start on the right side, if you want. Only personal preference says that you have to shoot one way over another.

7. **Shoot the first frame.**

8. **Pan and shoot the second frame.**

9. **Pan and shoot the next frame.**

10. **If necessary, continue shooting frames to complete the panorama.**

 The photography is over after you shoot each frame of the panorama. The rest of the work (and the subject of the rest of this chapter) happens in software. Figure 5-4 shows the final panorama after I stitched it together, cropped it, and converted it to black and white in Photoshop Elements.

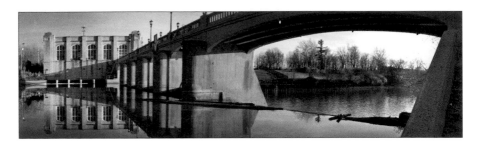

Figure 5-4: The final panorama in black and white.

Stitching Frames Together in Photoshop Elements

Unless you have a camera that does it for you (I cover this later), panoramas don't merge themselves. Specialized software combines *(stitches)* the separate frames of the panorama into a single blended image.

Photoshop Elements 11 for Windows has Photomerge, which I use to show you how to stitch together these photos. Photoshop has a similar capability (coincidentally, also named Photomerge — maybe the lawyers should look into that).

Files and formats

If you make any changes, make the same ones across all frames of the panorama. Double-check the white balance and see if there are any blown highlights.

- ✔ **JPEGs** from the camera load directly into Elements and you don't have to convert them. You can then start working immediately on your panorama.
- ✔ **Raw** must be converted to JPEGs or 8-bit TIFFs first. This process is just like converting raw photos for HDR (see Chapter 4 in this minibook for more information), so I won't rehash it here.

A stitch in time

Stitching together panoramas in Photoshop Elements isn't difficult. In fact, the process is mostly automated.

Elements doesn't work with 16-bits-per-channel TIFFs. Also, working with a new dSLR, even an entry-level model, can push your computer over the edge. Each photo set to Large size in the camera measures 24 megapixels!

When you've finished shooting the frames and transferring the files to your computer, follow these steps to stitch together a panorama:

1. **Open Photoshop Elements, choose Photo Editor, and choose Expert mode.**

2. **Choose Enhance⇨Photomerge⇨Photomerge Panorama.**

 The Photomerge dialog box appears, beckoning you toward panoramic greatness.

3. **Click the Browse button.**

 The Open dialog box appears.

4. **Find the folder that has the frames of the panorama. Select them and click OK.**

 The Open dialog box closes, and the selected files appear in a new, untitled image document as a stitched panorama.

 Alternatively, you can open the frames in Elements first, then press Add Open Files when you get to this point.

5. **Choose a layout:**

 - *Auto.* You're telling Elements to go for it, allowing it to choose between Perspective and Cylindrical layouts.

 - *Perspective:* The center of the panorama doesn't change, and outer areas are distorted so horizontal lines parallel to the ground stay that way. The *bowtie effect* in Figure 5-5 might happen with this choice; the center of the panorama looks normal but the corners are heavily distorted. You lose this area when you crop the final image. Usually, Perspective is the least attractive option.

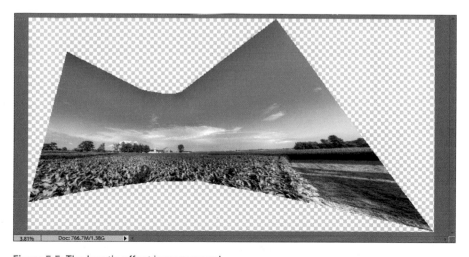

Figure 5-5: The bowtie effect is pronounced.

- *Cylindrical:* This option, shown in Figure 5-6, eliminates the bowtie effect on the corners. In fact, the corners do the opposite — they creep in. Sometimes, the sky bulges upward in the center of the image more than you see here. Everything that isn't a nice, tidy rectangle is cropped out at the end.

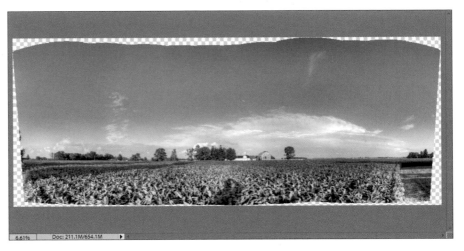

Figure 5-6: In this case, Cylindrical works well.

- *Spherical:* This option, shown in Figure 5-7, pinches the panorama inward and curves it as if it were taken from a globe.

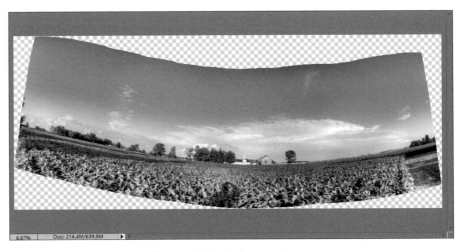

Figure 5-7: Flat scenes may suffer from Spherical projection.

- *Collage:* Throw everything together and align it. The software rotates and scales any layers, unlike the Perspective layout.

- *Reposition:* This layout aligns each frame (based again on matching reference points) but doesn't transform them in any way. The Reposition Only option can produce good-looking panoramas that don't suffer from undue amounts of distortion.

- *Interactive Layout:* This do-it-yourself option is shown in Figure 5-8. Elements opens a lightbox with your stitched panorama (the images it can do so automatically, at any rate) and gives you the control to override the existing layout.

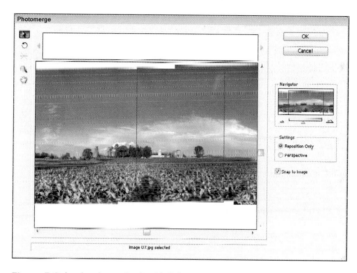

Figure 5-8: Laying it out in the Lightbox.

6. **(Optional) Zoom in and out, click and drag frames to reposition them, rotate individual frames, and change the settings.**

 If you select the Perspective radio button, you can set the photo's *vanishing point,* which is where some parallel lines in the photo appear to point to.

7. **Click OK.**

 Elements aligns and processes the images and eventually creates the panorama as a new image. Each frame occupies a separate layer, with portions *masked* (hidden) to blend together well.

8. **When you're asked to clean the edges, make a selection:**

 - Select *Yes* if you want Elements to fill the transparent edges of the image. It pulls additional imagery in from individual panorama

frames so that you don't have to crop later. The result is a physically complete panorama layer positioned at the top of the new file. The individual frames are on separate layers beneath it. This is a nice feature because it saves you the trouble of cropping later, and the extra material it uses tends to give you a bit more image than when you do it yourself.

Cleaning the edges may not work, however, if you don't have enough memory on your computer. The panorama may have too many photos or they could be too large.

- Select *No* if you want to do some blending and crop the image yourself. You don't get a merged panorama layer in this case.

9. Save the raw panorama as a Photoshop file .psd.

The .psd is for future reference before you tweak frame blending and make other adjustments. The final, finished panorama of a country scene (yes, during the evening golden hour) is shown in Figure 5-9.

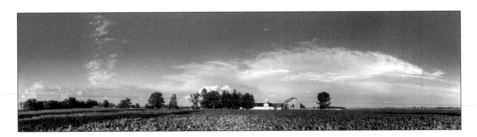

Figure 5-9: Panoramas are great for wide scenes.

Blending frames with layer masks

Blending lets you step in and try to clean things up. It comes in handy when these things are true:

- Elements had problems blending frames and layers.
- An object or area looks better on one frame but that spot has been masked by Elements in favor of the same spot in another frame that doesn't look as good.

In Photoshop Elements and other image editors, *masks* hide material on the layer the mask is grouped with. This allows the pixels underneath (on layers below) to show through. Black areas of a mask are transparent. White areas are solid.

If you see a strong border around a mask (it will look obvious), soften it by smoothing the mask edge. Or, if you like something on a layer that's masked

(a tree looks better in one frame than another, for example), *unmask* the better tree and mask over the tree in the other frames. Try to think in three dimensions.

Wherever layers overlap each other, you can choose which layer you want to see. Just follow these steps:

1. **Find the areas that don't look quite right. Click the Eye icon in the Layers palette to show and hide the layers to see where the borders are.**

 You can erase or paint black or white onto the mask to enlarge, shrink, or soften it.

 Figure 5-10 shows a border near my wife's arm (she's sitting on a couch) that looks like trouble. You can see the edge between one frame and the next. This border is a prime candidate for blending.

 Figure 5-10: This border needs a-blending.

2. **Click the layer mask you want to work with in the Layers palette.**

 Select the mask, not the image layer. The mask has a white highlight around it when selected, as shown in Figure 5-11.

Figure 5-11: Selecting the top layer mask.

3. **Set the foreground color to white and the background color to black.**

 These are the colors you need when working with masks.

4. **Select a tool to paint the mask.**

 The Brush tool works well.

5. **Paint with black (making those parts transparent) or white (making those parts solid).**

You can also use the Eraser tool if you don't like switching between black and white. You may find it helps to reduce the Opacity setting to 50 percent or so to avoid abrupt changes in tone.

6. **Save the panorama as a Photoshop Elements file (.psd format).**

Saving the panorama as a Photoshop file preserves the layers and masks and lets you keep working with those elements. It isn't meant to be the final image that you can post to Facebook.

I'm very happy with this panorama of my wife, Anne. It's completely unusual. We shot it indoors with a flash. She changed outfits and moved between shots. For this panorama, blending was important. The initial, automatic panorama blended one of her poses completely out of the picture! I had to work carefully with the masks to put her back in. Figure 5-12 shows the final image.

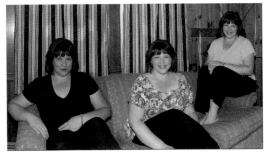

Figure 5-12: The effort is always worth it.

Cropping the final image

Cropping is often the final step in creating a panorama (this assumes you chose not to have Photoshop Elements fill in the gaps for you). Be sure to finish your other edits first: Blend the transitions, sharpen, correct the color, improve contrast, and reduce noise, for example. This workflow preserves your cropping options longer. If you crop first, you're stuck with it. If you want to go back and crop the panorama in a different way, you have to perform all the edits again to return to the same place.

To crop your panorama, follow these steps:

1. **Zoom out to see the entire panorama.**

2. **Select the Crop tool, and drag a border around the area you want to keep.**

 How much "solid" area you keep is up to you. You don't have to save every last pixel of it. Use your discretion and compose the shot so that it looks good. Unfortunately, you can't do much to rescue transparent areas. Cropping panoramas is a fact of life.

 Figure 5-13 shows the crop box positioned over the panorama.

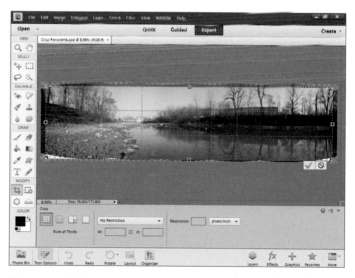

Figure 5-13: Initially positioning the crop box.

3. **Zoom in to see more precisely and then adjust the crop borders to weed out any transparent pixels.**

 Figure 5-14 shows the lower-left corner of the panorama at high magnification. The light areas show where the rough crop box was. I'm moving it into the image so that the crop box has no transparent pixels.

Repeat Step 3 on all four corners and ensure that no transparent pixels remain in the middle or on the ends.

Figure 5-14: Fine-tuning the crop.

4. **Click the check mark to apply the crop.**

5. **Save the panorama as a .psd file.**

 You can overwrite your working Photoshop file if you like, or choose another name and save the cropped copy with all the layers and masks separate from the original, uncropped version. How obsessive do you want to be? I prefer to keep all my future editing options open, so I save this as a "croppy" (da-dum, crash).

6. **Flatten the layers.**

7. **Save the image again with a new name and type as a final file to publish.**

 Save as a JPEG if you want to put the image on the web. Save it as a TIFF if you want to print it.

Stepping Up Your Game

There's nothing wrong with using what you have to shoot panoramas. Technically, you don't even need a tripod. It can be just you and your camera.

However, some ingenious people have come up with tools that are specifically for making your panoramas easier and better.

Using a specialized panorama "pano" head

If you really want to get into panoramas, consider buying a dedicated panorama *(pano)* tripod head. The only downside to using a dedicated pano head is effort. Mount your camera and lens properly. Otherwise, there's no point in using it. You may have to take test shots to get it right. And, because each lens has different characteristics, this position changes depending on your lens.

When you rotate your camera on a tripod using a *normal* head, the camera rotates around the screw that connects them together. Although this is generally acceptable, it's not the ideal solution. Rather, you should be rotating the camera around the optical center of the lens, also sometimes called the *no-parallax point,* the *entrance pupil,* or the *nodal point.* By changing the axis or rotation from the center of the camera to the nodal point (as always, there is some debate over this), your individual panorama panels will line up much better because they won't suffer from (any or as much) parallax. *Parallax* is when nearby objects move between frames in relation to a far object.

Figure 5-15 shows an entry-level Nikon D3200 with kit lens mounted on the Nodal Ninja 4 pano head (www.nodalninja.com). The NN4 is a beefy, well-made series of locking brackets that hold your camera in position, whether you want to shoot horizontal or vertical panoramas. Getting the camera mounted takes a degree of precision, but once you set your stops (explained here), you can quickly attach it again. One of the great things about the NN4 is that the unit rotates in incremental steps. You take a photo and then rotate the camera a set number of clicks to reach the next position.

Using dedicated panorama software

The best current panorama package on the market works for both Windows and Macintosh; it's PTGui. Visit www.ptgui.com. If you want to control just about every conceivable part of the panorama process and are considering displaying or selling your panoramas professionally, PTGui is for you.

This powerful all-in-one panorama application gives you customizable control points and significantly more projection types than Photoshop Elements gives you. PTGui has a developed following and robust support system on the web. If you're serious about creating HDR panoramas, download either or both trial versions and have a closer look for yourself. The Pro version even has its own HDR and tone mapping features.

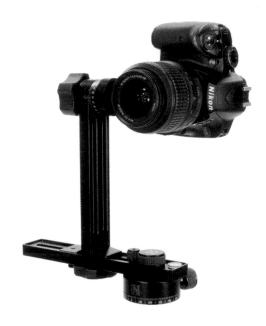

Figure 5-15: The Nodal Ninja 4 makes shooting panoramas a joy.

I shot the hand-held panorama in Figure 5-16 from up inside the Gateway Arch. It was a spur-of-the-moment idea to take a few frames.

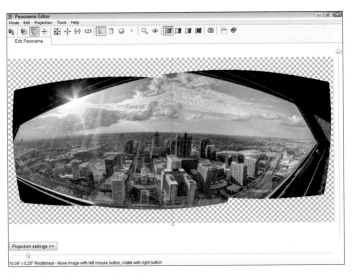

Figure 5-16: Checking the view out.

As a general rule in this program, follow these steps:

1. **Create a new project to preserve settings.**

2. **Load your photos and enter information about the camera and lens.**

3. **Edit the stitched frames.**

 I edited in the Panorama Editor.

4. **If the frames cannot be aligned, add control points.**

 Control points help the program identify identical features across different frames of the panorama. In Figure 5-17, I'm using different rooftop features in downtown St. Louis as reference points.

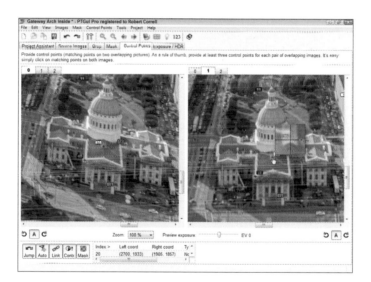

Figure 5-17: Adding control points.

The final panorama from this project is shown in Figure 5-18. As you can see, I didn't quite get the entire window frame in the panorama. Sometimes, when you're shooting on the fly, things don't go completely as planned. However, the panorama captures the moment perfectly. The sunset was fantastic and the evening golden hour light falling on the city was magical.

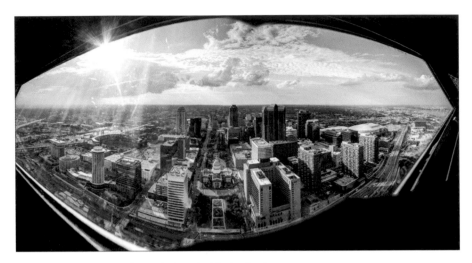

Figure 5-18: Downtown St. Louis from inside the Arch.

Shooting Automatic Panoramas

Some cameras, mostly Sony dSLTs, shoot and process panoramas automatically. Sony calls its feature Sweep Panorama (formerly Sweep Shooting), which is also available in 3D. Instead of photographing several frames of a panorama and then using software to stitch them together, the camera handles everything.

Standard panoramas are saved as JPEGs. No raw frames are saved. You get the final image only. And 3D panoramas are saved as two files.

The first file is a standard JPEG. It's not 3D, which means you can look at it on your camera, computer, or a non-3D TV. The second file has data in it to make the image look three dimensional. This file is saved with the same name but ends in .mpo. For the 3D effect to work, you must have both files.

Although the following details are specific to Sony's panorama feature, should other cameras introduce automatic panorama shooting, you'll perform similar tasks:

1. **Select the right shooting mode.**

 In Sony's case, you can choose between Sweep Panorama and 3D Sweep Panorama.

2. **Choose the panorama quality settings, such as Size and Image Quality.**

3. **Choose the sweep direction: Left, Right, Up, or Down.**

This indicates the direction you're supposed to sweep in, assuming you're holding the camera horizontally (landscape orientation). If you hold the camera vertically (portrait orientation) and chose Down, sweep to your right.

4. **Choose other photo settings.**

 Select a focus mode, metering mode, white balance mode, a creative style, and color space.

5. **Frame the scene so that you begin the panorama pointing in the right direction.**

6. **Press the shutter button and slowly sweep in the direction you chose.**

 On a Sony, you don't have to keep holding the shutter button. Once you press it, you're off and running until the end of the program. Also, the display shows a bar that tells you how far you have to go. The real awesomeness of this feature is that when you're done taking the photo, you're done. No extra computer work is required. See Figure 5-19.

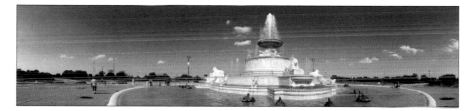

Figure 5-19: The panorama did not require me to use any software.

Keep these things in mind when shooting automatic panoramas:

▸ **Straight and level:** It can be hard to pan without tilting the camera, as shown in Figure 5-20. Pay attention to the indicators in the viewfinder, on the LCD, and in the scene.

Figure 5-20: It's sometimes hard to stay level even when you have such obvious visual cues.

- ✔ **Stitching problems:** Automatic panoramas are awesome most of the time, but when the camera has trouble stitching the frames together, it may be messy.

- ✔ **Keep at it:** It can be hard to center your subjects within the narrow side. For example, it took me three times to get a good panorama of my boys, because I kept cropping their heads or putting too much space above them.

- ✔ **Zoom and inspect:** Zoom in and inspect your panoramas before moving on! It's impossible to see small errors in a huge panorama from a small thumbnail on the back of your camera. You can't possibly tell if there are stitching problems without zooming in and panning around.

Chapter 6: Chroma Chameleon: B&W

In This Chapter

✏ **Converting color photos to black and white**

✏ **Colorizing, duotoning, and cross-processing**

✏ **Creating the same effects with your camera**

"Chroma, chroma, chroma, chroma, chroma cha mcc-lee-on" is too large for a chapter title, so I shortened it and will let you look up Boy George and the always-creative 1980s music scene (that also gave us AC/DC).

This chapter walks you through the basics of converting your color photos into black-and-white masterpieces. You also find out how to colorize photos by working with single colors or creating duotones, tritones, quadtones, and even high-contrast cross-processed photos. Finally, I show you how to shoot using your camera's creative styles.

I think you'll find this a fun and rewarding chapter. It's amazing to see how your photos transform when converted from color to black and white. You can let your creativity loose as you colorize and tint photos to age them or give them an artistic boost.

Although you're using modern technology, don't think these pursuits are new. Photographers of all eras have manipulated, tweaked, and perfected their photos using whatever they could get their hands on.

Knowing Black-and-White Words

The following list defines the key color-related terms from this chapter, all in a single convenient location:

✔ **Full color:** A normal color photo. Digital cameras capture color intensity by wavelength and store the information in image files that contain three channels: red, green, and blue. You can process, manipulate, blend, separate, or edit all channels together or separately.

✔ **Black and white:** A black-and-white photo. The process of creating black-and-white photos with modern digital SLRs (and software) is completely different than using black-and-white film. The end result is essentially the same: a photo that has no color. It is created using numerous shades of gray.

Some computer geeks and the programs they create use the term *black-and-white* to describe images that have only black-and-white pixels — no gray allowed. They would use the term *grayscale* to what photographers would call a black-and-white photo.

✔ **Monochromatic:** Literally *single color*. Monochromatic images use the shades created from a single base color (historically, an ink). Black-and-white photos are monochromatic grayscale photos. You can use whatever color you like to create a monochromatic image.

In creative printing circles, the terms *ink* and *color* are sometimes used interchangeably, as in "Monochromes are printed using a single ink."

✔ **Grayscale:** A monochromatic image composed of shades of gray. Some image editors refer to a grayscale image as one that has had the color information removed, leaving it in black and white.

✔ **Gradient map:** A gradient map is a mask that turns everything beneath it to grayscale.

✔ **Colorize:** To add one or more colors to a photo.

✔ **Sepia toned:** An aged or chemically treated photo with a dark brown appearance. It also refers to the modern process that simulates the same effect.

✔ **Cyanotype:** A blue-and-white monochrome photo.

✔ **Cross-process:** A popular film developing technique that intentionally uses processing chemicals meant for color slides on color film instead. The result is a greenish yellow photo. Software techniques duplicate the film effect without the chemicals.

✔ **Duotone:** In Photoshop circles, a grayscale image "printed" with a number of inks (one: monotone; two: duotone; three: tritone; four: quadtone). You must first convert the image to grayscale.

Elsewhere, *duotone* refers to the use of two colors in an image.

✔ **Tritone:** Just like Duotone, except that you use three colors to colorize the black-and-white photo.

✔ **Quadtone:** A double duotone — four colors. Keep in mind that you start out with a black-and-white photo and then apply four colors to colorize the photo. In a quadtone, the result is a complex mixture of shades from four colors.

✔ **Split tone:** Some applications allow you to apply colors to a photo's shadows and highlights. These are the split tones. This works to colorize a black-and-white photo or as a special effect when applied to a color photo.

✔ **Filter:** Software filters applied to photos to create special color effects. They may warm, cool, intensify different colors, add starbursts, soften the focus, create toy or miniature camera effects, and so forth.

If you need to, refer back to this list for a reminder of what the terms mean as you read the rest of the chapter.

Fade to Black and White

Black-and-white prints evoke different feelings than do their color counterparts. In a B&W, the focus is on tone, texture, and mood rather than on hue and saturation. They can be magical or somber or parts in between. This section shows you many different ways to use software to change color photos to black and white. Conversions is different than shooting directly in black and white, which I cover near the end of the chapter. The advantage to conversion is that you have more control over how your photos are changed.

I illustrate most of these techniques using Adobe Lightroom, Photoshop Elements, and Photoshop. This software is a popular example of raw processing and image-editing software, each with very representative features. If you're using different software, don't worry. The fundamentals of converting color photos to black and white are the same.

Desaturating photos

A fast and easy technique to convert a color photo to black and white is to *desaturate* it. That means you reduce the color intensity to 0 but don't change the fact that the file itself can have color information.

I don't recommend this technique, but *it's useful* when you either want to tone down the color in a photo or convert the shot into something *almost* black and white.

In Photoshop Elements, choose Enhance➪Adjust Color➪Adjust Hue/ Saturation and then reduce Saturation to 0 in the dialog box, as shown in Figure 6-1.

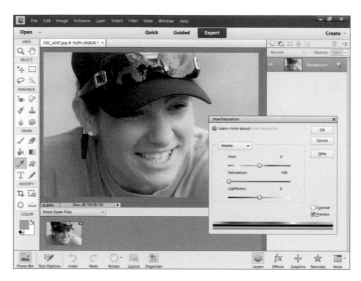

Figure 6-1: Desaturating an image.

Zapping color with grayscale

Another simple way to change a color photo to black and white is to change the nature of the file itself. In this case, you convert the photo, which is an RGB image, into something called a *grayscale image*. This type of file has no color information at all. It's simply 50 shades of gray. (I couldn't help it.) The downside to this method is that, like desaturation, you have no control over how colors are transformed.

In Photoshop Elements, choose Image⇨Mode⇨Grayscale. When asked if you want to discard the image's color information, click OK.

Although you'll probably rarely use this method, sometimes you may need to. For example, to create a Duotone image in Photoshop, you must first convert the photo to grayscale.

Creating gradient maps

Most people don't think of using gradient maps to change images to black and white, but the results are quite good.

In Photoshop Elements, follow these steps:

1. **Choose Layer⇨New Adjustment Layer⇨Gradient Map to create an adjustment layer.**

 The New Layer dialog box opens.

2. **Click OK to continue.**

3. **If necessary, select a gradient from the Adjustments panel.**

 If the gradient runs from black to white, you don't need to change it. You can see a gradient in the Adjustments panel shown in Figure 6-2. If the pre-selected gradient isn't black and white, select the Gradient Map drop-down menu and choose the third gradient — Black, White. See Figure 6-3.

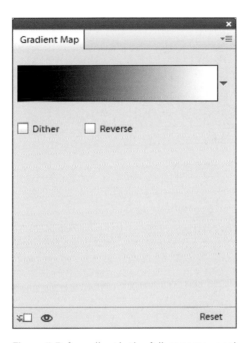

Figure 6-2: A gradient in the Adjustments panel.

4. **Click OK.**

 The dialog box closes and the gradient map is applied as an adjustment layer. An *adjustment layer is a* customizable layer that changes elements like brightness, contrast, and color saturation to the layers below them without permanently altering those layers. Your software manual gives more information.

You can create partial color and black-and-white images in Photoshop Elements by erasing areas of a Grayscale Map mask.

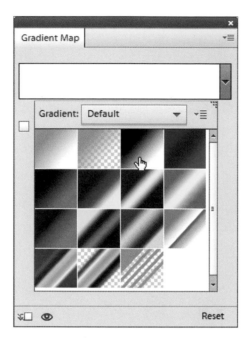

Figure 6-3: Select a black-and-white gradient map, if necessary.

1. **Select the Eraser and make sure that the background color is black.**

 Black areas of the mask allow the lower layer to pass through unaffected.

2. **Click the mask in the Layers panel to select it.**

3. **Erase areas on the image that you want to remain in color.**

 If you make a mistake, switch to a paint brush with white as the fore-ground color and paint white in the mask to reapply the black-and-white adjustment.

Using guided conversion tools

Photoshop Elements has a handy Convert to Black and White feature that gives you more creative control than its other methods. When using Photoshop Elements, this is the technique I recommend.

I prefer changing to black and white late in the editing process. If I decide that I don't like how the black-and-white photo turns out, I don't have to redo all my edits. I just go back to the saved color image that has all the edits and start the black-and-white conversion process over again.

To use the Convert to Black and White feature, follow these steps:

1. **Finish editing.**

 This includes noise reduction, contrast enhancements, sharpening, and all other applicable steps. Finish with a working layer ready to convert to black and white.

 If you like, save the color file and flatten any layers. Resave the file with a new name so you don't overwrite the original color version.

2. **Choose Enhance➪Convert to Black and White.**

 The Convert to Black and White dialog box, shown in Figure 6-4, has these three sections:

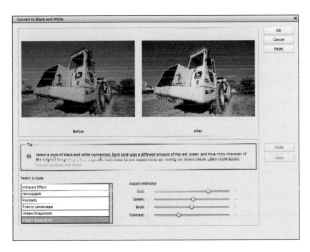

Figure 6-4: Converting to black and white in Photoshop Elements.

- *Before and After:* See the unaltered photo and what it would look like if you applied the current settings.

- *Select a Style:* Choose from a handy list of styles. Each one blends color information (intensity, not hue) from the three color channels differently. See a comparison in Figure 6-5.

- *Adjustment Intensity:* Use these sliders to adjust the percentage of each color channel (Red, Green, and Blue) used in the conversion. Alter contrast with the, wait for it, patience, steady now, ready? Alter contrast with the Contrast slider.

3. **Make adjustments to the conversion by moving the Red, Green, Blue, and Contrast sliders.**

 If you don't like the results, click Undo. If you make a mistake, click the Reset button to remove all your changes and start over.

 A little change goes a long way.

4. **When you're finished and want to approve the conversion, click OK.**

 The image is converted and appears in the Elements workspace.

5. **Save your work as a .psd file.**

 Then continue editing. In particular, black-and-white images benefit from further contrast enhancements as well as from dodging and burning.

Infrared Effect

Newspaper

Portraits

Scenic Landscape

Urban/Snapshots

Vivid Landscapes

Figure 6-5: The presets in action.

Quick-and-dirty edits

Photoshop Elements has three editing modes: Expert (which I use in this chapter), Quick, and Guided. Quick includes a Saturation control you can use to desaturate photos. It's in the Color section on the right side of the interface.

Guided has two options: Enhance Colors (which leads to a Saturation control) and Old Fashioned Photo (which helps you convert a photo to black and white and then colorize it).

Creating your own black-and-white recipe

Not surprisingly, Photoshop has a powerful tool that changes color images to black and white. It gives you lots of control over how the final image looks. For example, you can change blue skies into dark gray shades, green grass into lighter gray, and red features to medium gray.

To convert color photos using Photoshop's Black and White Adjustment tool, follow these steps:

1. **Choose Image⇨Adjustments⇨Black & White.**

 The Black and White dialog box that opens (see Figure 6-6) has many more options than you get when using Photoshop Elements.

2. **Click the Preview check box to see your changes in real time.**

3. **(Optional) Select a preset from the Preset drop-down list.**

 Options include Darker, High Contrast Red Filter, and Yellow Filter. Scroll the list to find one you like.

4. **Use the color sliders to change percentages.**

 These six colors create the tonal mixture of the black and white. For example, increasing the amount with the Blues slider increases the intensity of the blue channel during conversion, which lightens the resulting grayscale image. This action makes skies, water, and other blue objects lighter.

 You can, therefore, lighten or darken specific areas of the black-and-white image by increasing or decreasing the color percentage of one of the six colors. Choose the color that's dominant in the area you're working in.

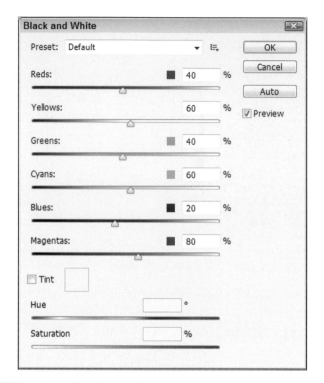

Figure 6-6: The Black and White dialog box, in color.

5. **(Optional) Click and drag the image left or right to decrease or increase the color percentage based on the source color of the area you clicked.**

 See Figure 6-7. This method is a fast and effective way to take control of the tones.

 You're not colorizing the image when you make changes to the color sliders. Instead, you're adjusting the *gray tone* of the specific color you choose. Then you can, for example, turn blues dark gray and reds light gray.

6. **(Optional) Click the Auto button.**

 Photoshop assigns color percentages based on its own best judgment.

7. **(Optional) Colorize.**

 If you want now to colorize the image, do this:

 • Select the Tint check box.

 • Click the Color Picker to select a colorizing tone.

 Or, control the color by modifying Hue; control strength with Saturation.

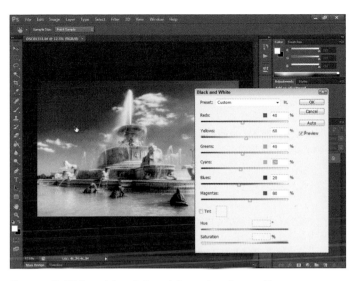

Figure 6-7: Click and drag left or right to alter the tonality.

8. **When you're happy with the results, click OK.**

 The final photo is shown in Figure 6-8. I'm happy with it. It represents a good example of how black and white can transform a photo. I was able to emphasize contrast, sharpness, tone, and the mood.

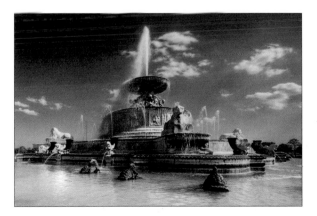

Figure 6-8: The finished conversion.

Converting in Lightroom

A fast way to convert color photos in Lightroom is to use one of the numerous Develop presets, called Settings. Many Settings change your color photos into black and white. Each preset has its own style. I encourage you to experiment with them. (You can desaturate photos in Lightroom, but I don't recommend this method. The other option produces great results.)

The most effective way to convert a color photo to black and white in Lightroom is to use the Develop module in Adobe Lightroom. Click the B&W label on the HSL / Color / B&W panel to access the controls.

It doesn't matter if the file is raw or JPEG: Lightroom handles both with aplomb. Figure 6-9 shows the appropriate section of the Develop tab. This method is similar to the one used in Photoshop (whether as an adjustment or an adjustment layer), although the colors along the side are different.

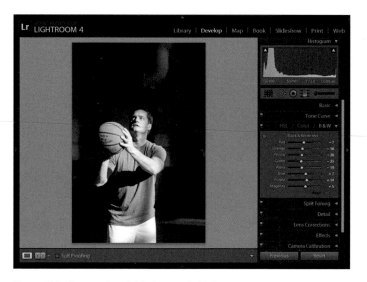

Figure 6-9: Grayscale mixing is easy in Lightroom.

Using Adobe Camera Raw (ACR)

Adobe Camera Raw (ACR) is built right into Adobe Photoshop and Photoshop Elements. Use ACR to develop raw photos when necessary. In this way you can use ACR to convert your color raw photos to black and white.

ACR behavior depends on which program you're starting it from:

 ✓ **Elements:** You have only one option: desaturation. If you need it fast, this will work. If you want more options, save or open the file as a color photo and convert it in Photoshop Elements.

✔ **Photoshop:** ACR can desaturate color photos. The real treat, however, is on the HSL/Grayscale panel. Click the icon and explore the panel, shown in Figure 6-10. You have several options to choose from:

- *Convert to Grayscale:* The Hue, Saturation, and Luminance tabs disappear and are replaced by the Grayscale Mix tab.

- *Grayscale Mix:* Click Auto or Default (sets values to 0) to apply a preset, or drag the sliders to change the tonality. The sliders target specific color ranges and let you completely customize the darkness or lightness of regions based on their original colors.

- *Targeted Adjustment tool:* Select this tool from the main ACR toolbar (or use the T keyboard shortcut), then click and drag on the preview to change the tonality of the color region you click.

 The Targeted Adjustment tool is often a *far more* effective way to control a photo, because it doesn't make you guess where the colors in the panel are in the photo. Instead, you look at the photo and decide which areas should be darker or lighter directly.

- *Hue, Saturation, and Luminance tabs:* Use these tabs to control the hue, saturation, and luminance of the same color regions. This strategy works if you want to selectively alter the photo based on the original tones. For example, you can increase the saturation on all oranges while leaving the other colors alone.

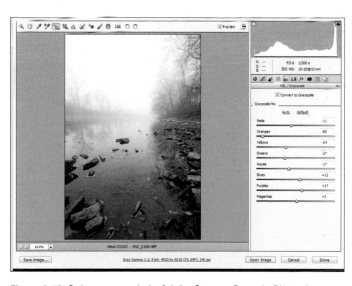

Figure 6-10: Going grayscale in Adobe Camera Raw via Photoshop.

Corel PaintShop Pro pointers

Corel PaintShop Pro has several ways to change color photos to black and white. The Channel Mixer is most effective, but the Time Machine and Black and White Film effects are also good. Here's a quick summary:

- ✓ **Grayscale:** Choose Image➪Grayscale to discard color information.

- ✓ **Desaturation:** Choose Adjust➪Hue and Saturation➪Hue/Saturation/Lightness to desaturate.

- ✓ **Channel Mixer:** Choose Adjust➪Color➪Channel Mixer, choose Monochrome, and then adjust the source channel mixture to create custom black-and-white photos.

- ✓ **Time Machine:** Choose Effects➪Photo Effects➪Time Machine to select old photo styles such as Cyanotype.

- ✓ **Black and White effect:** Choose Effects➪Photo Effects➪Black and White Film to create interesting black-and-white film (duh) effects. The dialog box is shown in Figure 6-11. Choose a color, set the brightness, and add clarity to the photo to produce the effect.

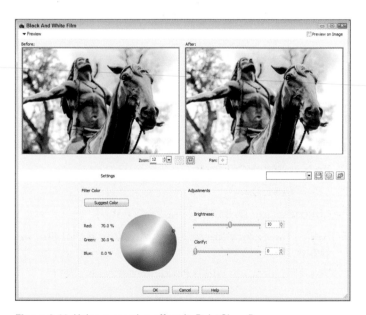

Figure 6-11: Using a creative effect in PaintShop Pro.

Using your camera's software

You can use your camera's raw processing or photo-management software to convert photos to black and white and possibly colorize them. Many applications have very rudimentary tools in these areas, however. Others have a wider variety of gizmos. For example, Nikon Capture NX 2 has a filter-based Black-and-White Conversion option. Adjust the filter hue, color filter strength, overall brightness, and image contrast to modify the effect. Or, if you prefer, change the color mode to four black-and-white settings based on different color filters.

Colorizing Your Photos

Colorizing (or *tinting* or *toning*) black-and-white images replaces black with one, two, or more colors, resulting in aged or other creative effects. You can also colorize color photos.

You can approach colorizing images in several ways, depending on the application you use to edit your images.

Using Hue/Saturation

An easy way to colorize is to use your photo editor's Hue/Saturation routine. You can use this technique for color or black-and-white photos.

In Photoshop Elements, follow these steps:

1. **Choose Enhance⇨Adjust Color⇨Adjust Hue/Saturation.**

2. **Reduce Saturation to 0.**

3. **Select Colorize.**

4. **Choose a *hue* (a fancy name for a color).**

5. **Adjust the Saturation and Brightness of the photo, as shown in Figure 6-12.**

 Lower Saturation values produce a subtler effect.

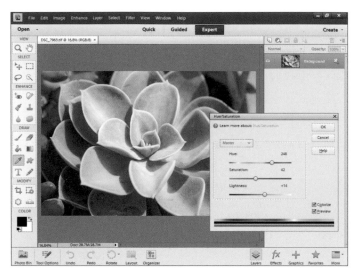

Figure 6-12: Colorize applies a single hue (in this case, number 248) to a photo.

You get more control over tonality by converting the photo to black and white first.

Using color layers

Another approach to colorizing a photo is to use color layers. You can work with color or black-and-white photos. With this technique, you add layers filled with color (either a solid color or gradient) over the photo layer. You can blend the color layer with the photo layer by lowering the color layer's opacity.

You should also experiment with blend modes. *Blending modes* affect whether (and how) layers on top allow other layers to show through. Normally, these layers don't allow other layers to show through because they're *opaque* (the opposite of transparent). You can change this behavior, which is what you're counting on to colorize the image.

You can use more than one color in more than one color layer and erase or blend them in creative ways. For example, you can create blue-tinted shadows and gold-tinted highlights. Some applications (Photoshop, but not Photoshop Elements) let you modify which portions of the color layer blend with the lower layer based on the tonality of either layer.

If your application doesn't support color blending, use opacity instead.

Here's a relatively simple example using Photoshop Elements. This technique should work in most photo editors that support layers. To use color layers, follow these steps:

1. **Create a color fill layer by choosing Layer⟐New Fill Layer⟐Solid Color.**

 The New Layer dialog box opens.

2. **Click OK.**

3. **Choose a color from the Color Picker shown in Figure 6-13.**

4. **Click OK.**

 Choose a basic color from the vertical rainbow and then select a specific hue (light or dark, intense or muted) from the large color box in the middle. Or, enter color values in the HSB, RGB, or Web Color boxes. I opted for a brown color.

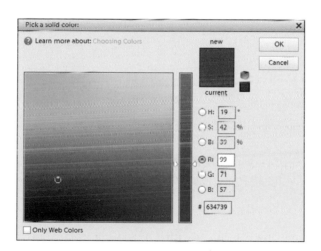

Figure 6-13: Choose a colorizing color.

5. **From the Layers palette, choose Color.**

6. **Lower the color layer opacity to blend by using the Opacity slider on the Layers palette.**

 The Opacity slider controls the color intensity, as shown in Figure 6-14. The black-and-white image should show through even at 100 percent because you changed the blend mode to Color.

If you have more than one color layer, all except the bottom one must have their opacity set to less than 100 percent. This allows the bottom color layers to show through. You'd think that changing the blend mode to Color mode would be enough, but it isn't.

Figure 6-14: Blending with opacity.

7. **Add more color layers, if you want.**

8. **Blend by erasing areas you don't want colorized.**

 This step lets you isolate colors from different layers and have them apply to specific areas of the image.

You can use adjustment layers for certain black-and-white and colorizing methods in Photoshop, Photoshop Elements, and Corel PaintShop Pro. *Adjustment layers* are non-destructive adjustment layers that alter the color, tone, brightness, contrast, and other qualities of the layers beneath them without actually changing any of the pixels. Think of it as a live preview. After you create these layers, you can also edit them or use the built-in mask to limit the changes to specific areas of the photo.

Working with Color Variations

Photoshop and Photoshop Elements have another colorizing tool that you can bend to your purpose: Color Variations. This tool removes color casts from JPEGs, though you should remove color casts from raw photos by now. Color Variations also lets you colorize photos.

Several controls are available in the Color Variations dialog box that increase or decrease colors in specific tonal regions: Midtones, Shadows, and Highlights. The downside is that you have only three color options to choose from: Red, Green, and Blue.

TIP

If you decrease any of the three primary colors, another color increases. Red and cyan are thus linked, as are green and magenta, and blue and yellow. Therefore, to increase cyan, decrease red.

To colorize a black-and-white image in Elements using Color Variations, follow these steps:

1. **Choose Enhance➪Adjust Color➪Color Variations.**

 The Color Variations dialog box appears, as shown in Figure 6-15.

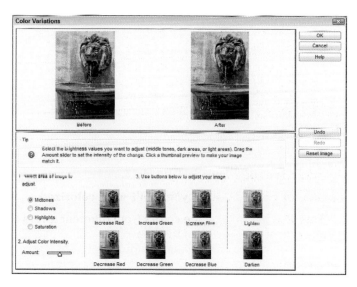

Figure 6-15: Making color variations.

2. **Increase and decrease colors by selecting a radio button and then adjusting the Amount slider.**

 The radio button options are Midtones, Shadows, Highlights, or Saturation.

3. **Choose a color to increase or decrease by clicking the appropriate button. To lighten or darken the image as a whole, click the Lighten or Darken button.**

 Although this method is a simple one, it's sometimes difficult to exercise fine control over the process, and the preview window is tiny. (Photoshop

also has Color Variations. They're almost identical. One glaring difference is that Photoshop gives you a lot more room to see what you're doing.)

4. **When you're satisfied with the results, click OK.**

Creating Duotones

While the technical aspects of this section apply to Photoshop, the entire discussion should be useful to you even if you don't use it. If you're not working in Photoshop, but in another photo editor, you can create your own Duotones with color layers.

Duotones are powerful yet simple. The greatest challenge you face is deciding what looks best to you, not implementing it.

I suggest first browsing through the extensive list of presets. When you become familiar with Duotones, start setting some of the options yourself. You can apply a number of inks, create specific Duotone curves for each color, and choose the colors themselves (by using the Color Picker or browsing the extensive color libraries).

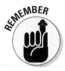

The drawback to creating Duotones in Photoshop is that you have to convert the image to grayscale and then convert it to Duotone. You can't stay in RGB, CMYK, or other color modes. Nor will your image be greater than 8 bits per channel.

Applying Duotone

To apply a Duotone, follow these steps:

1. **Convert your image to black and white using your favorite method.**

 This applies if you want to keep maximum control over the process.

 If you want to quickly apply a Duotone to an image without spending a whole lot of time converting it to black and white, jump right into Step 2.

2. **If necessary, convert the photo's bit depth from 16 bits per channel to 8 bits per channel.**

 Do so by choosing Image⇨Mode⇨8 Bits/Channel.

3. **Convert the image to grayscale by choosing Image⇨Mode⇨Grayscale.**

4. **Convert the image to Duotone by choosing Image⇨Mode⇨Duotone.**

 The Duotone Options dialog box shows a monotone initially, or the settings from your last application.

5. **In the Duotone Options dialog box, choose from the Preset drop-down menu.**

You might prefer to find some presets you like and possibly modify and save them as your own. (Choose settings you like, and then select the small drop-down menu tucked between the Preset menu and the OK button — within this list are Save and Load Preset menus.) Figure 6-16 shows a preset loaded in the dialog box and the image visible onscreen. I selected the mauve 4655 bl 2 option from the Preset menu.

Duotone Options

Preset:	mauve 4655 bl 2	▼	≡,	OK
				Cancel
Type:	Duotone ▼			☑ Preview

Ink 1:		▨	Black
Ink 2:		▨	PANTONE 4655 CVC
Ink 3:			
Ink 4:			

Overprint Colors...

Figure 6-16: Applying a Duotone preset.

6. **Click OK.**

That's it. See Figure 6-17 for my final photo. I recommend saving the colorized image as a separate file (TIFF for printing or as a Photoshop file) because it's now an 8-bits-per-channel duotone image. You can convert it back to RGB if you have other edits you want to make in that color space.

Figure 6-17: The scene is warmer and more inviting.

Making your own Duotone

To create your own, colorized image, use these options in Step 5 in the preceding section:

- *Type:* Select Monotone, Duotone, Tritone, or Quadtone.

- *Duotone Curve:* Click the little graph beside each color to control how the tones are applied. Make them darker or lighter, or increase the contrast, for example. The process is similar to adding points on a histogram to brighten or darken, but you're limited to specific ink percentages.

- *Ink:* Click the color swatch to open the Color Picker and choose a new color.

- *Color Name:* If you're using a preset, the preset color name appears. If you selected a color from the Color Picker, you can name the color whatever you want.

- *Overprint Colors:* Click the Overprint Colors button to open a dialog box where you can specify the order in which the colors are printed. For example, the result of printing red over blue can look different from printing blue over red.

Split toning

Split toning enables you to apply colors to a photo's shadows and highlights. This means you can selectively colorize black-and-white photos or create interesting special effects with color photos.

Split toning in Lightroom is a snap:

1. **Select a photo in your Library.**

2. **Activate the Develop module.**

3. **Convert to black and white if you want.**

 This also works with color photos, but the effect will be a bit more surreal.

4. **Select the Split Toning panel.**

5. **Adjust the Hue and Saturation of Highlights.**

 Hue is simply the color you want to apply. If you'd rather choose the color graphically, click the Highlights color swatch and then select a color. Saturation is how strongly you want it applied.

6. **Adjust the Hue and Saturation of Shadows.**

 Figure 6-18 shows the effects of making the highlights in this sunset scene mustard yellow and the shadows a deep blue. It's quite fun to play with Split Toning.

Figure 6-18: You can split tone color or black-and-white photos.

7. **Mix by adjusting the Balance slider.**

Adobe Camera Raw also has a Split Toning panel. It works the same as Lightroom's panel, but does not have the swatches that you can click to change. The closest thing to split toning in Photoshop or Photoshop Elements is Color Variations.

Cross-processing coolness

You have no direct way to cross-process in applications such as Photoshop Elements, but cross-processing in Photoshop and Lightroom is easy. Apple Aperture has a few good cross-processing presets. Cross-process is a term that comes from the art of processing film with the wrong chemicals. The appropriate adjustments appear so that you can edit as you want. Other programs sometimes seem to ignore cross-processing.

You can work around a lack of cross-processing options if you use split tone.

To cross-process a photo (color or black and white) in Photoshop, follow these steps:

1. **Choose Image⇨Adjustments⇨Curves.**

 The Curves dialog box appears. Photoshop uses curves to alter the curve of each color channel to create contrasted greens and yellows.

2. **Select the Cross Process (RGB) preset from the Preset drop-down list.**

 Figure 6-19 shows the open Curves dialog box with the Cross Process (RGB) preset loaded.

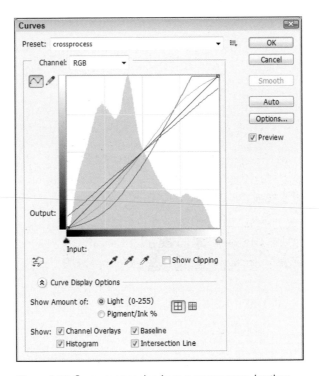

Figure 6-19: Cross-processing is one crazy curve, brother.

3. **Alter the curve, if you want, by editing the RGB curve or selecting specific channels (R, G, or B) and altering those curves individually.**

4. **Click OK.**

 You're free to continue editing or publishing your image. If you want to tone down the effect, try choosing Edit⇨Fade. Figure 6-20 reveals the cross-processed photo. Notice the otherworldly green tones applied to the image. That's the beauty of cross-processing.

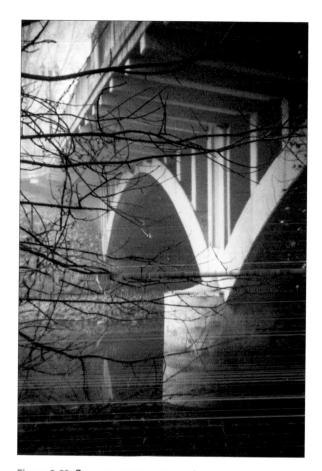

Figure 6-20: Gorgeous cross-processing.

To cross-process in Lightroom, follow these steps:

1. **Select the photo you want to edit in the Library.**

2. **Switch to the Develop module.**

3. **Right-click over the photo and select Settings⇨Lightroom Color Presets.**

 You'll see three cross-processing options.

4. **Click a cross-processing option to apply it.**

 I find it helpful to apply cross-processing presets, then choose Undo and apply another one for comparison. You may also want to create a copy and apply different presets or modified presets to them and compare.

Using In-Camera Creative Styles

Creative styles (Nikon cameras call this feature *picture control*) are a type of in-camera processing option. I love them because they let me creatively push photos in different directions without having to be a photo-retouching expert.

The processing is applied to the raw data and saved as a JPEG. If you have the camera set to JPEGs only and then take photos with a particular style, such as black-and-white, what's done is done. You can't undo it or retrieve a color photo to start over from. If you've set the camera to store the raw data in the form of a raw image (or RAW+JPEG), the raw photo preserves the original color information.

I strongly recommend saving RAW+JPEG if you want to experiment with different creative styles.

Some cameras also have photo editing or retouching features (in addition to shooting with a style) that allow you to process your saved photos with different options. For example, the Nikon D3200 has a Retouch menu that copies photos and converts them to black and white, sepia, or cyanotype styles (among many others). You don't have to worry about overwriting your original files. They're preserved.

Selecting styles

Selecting a creative style is easy. Here's how you do it:

1. **Enter an appropriate shooting mode.**

 Some cameras don't allow you to change styles when in an Auto mode or when you've selected a scene like Portrait. Others will.

 On cameras with multiple layers of styles and effects, you may not be able to use both at the same time. For example, you wouldn't be able to use the Toy effect and Monochrome style on the Sony Alpha A77. When you choose the picture effect, the creative style is automatically set to Standard.

2. **Go to the styles.**

 How you do this depends on the camera. Sony users press the Function button. Canon users press the Quick Control button (or use the Menu or Style buttons). Nikon users press the Menu button.

Here are some of the standard creative styles you see on most cameras:

- *Standard:* Your basic photo. Optimized for good all-round appearance.
- *Neutral:* Toned down compared to Standard. Use if you plan on processing it with software.
- *Vivid:* Increases the saturation and contrast to add pop.
- *Portrait:* Optimized for people and skin tones. May be softer than normal.
- *Landscape:* Optimized for natural tones. May be more colorful and sharper.
- *Black & White/Monochrome:* Removes the color for a classic black-and-white photo.

Some other options you may run across are:

- *Sunset:* Use when you're shooting into or in the sunset. This style emphasizes the reddish-orange colors.
- *Clear:* Captures transparent colors in bright areas. Good for lights.
- *Deep:* Colorful and solid.
- *Light:* Bright and airy.
- *Night Scene:* Tones down contrast to make night scenes more realistic.
- *Autumn Leaves.* Saturates reds and yellows.
- *Sepia:* Applies an old-school tint to a black and-white photo.

3. **Highlight a style.**

4. **Press the enter button.**

5. **Return to shooting.**

Modifying styles

You may be able to customize the built-in styles on your camera by editing them. They most often have three or four tweakable parameters, as shown in Figure 6-21. You might even be able to download styles from the Internet and load them into your camera.

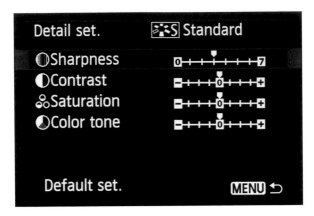

Figure 6-21: Customizing individual style parameters is for serious control freaks.

Contrast

Increasing contrast strengthens the difference between shadows and highlights in a photo — think bright, sunny day with deep shadows. *Decreasing contrast* reduces this distinction, resulting in a mid-tone–heavy photo — think foggy day with no shadows.

✔ To increase a photo's overall impact, increase contrast. Be careful not to increase it so much that you turn highlights white and shadows black. In that case, you lose precious detail.

✔ To mellow or age a photo, decrease contrast. Try decreasing contrast when shooting a naturally high-contrast scene. This rescues details that might be lost.

Saturation

Increasing saturation strengthens the colors. Decreasing saturation removes the color from a photo, subduing it.

✔ To mimic an aged color photo, decrease saturation.

✔ To add pizzazz, increase saturation.

Sharpness

As a whole, sharpness adjustments aren't as visible as the other two unless you zoom in or enlarge the photo.

✔ Increase sharpness to add definition to a photo. Oversharpening may cause the photo to look unnatural and accentuate noise.

✔ Decrease sharpness to reduce definition and give the photo a softer look.

Why You Should Bother

This chapter tells you about technical aspects of converting color photos to black and white, as well as how to add color effects back in. Why might you want to? Here are a few reasons:

✔ **For concealing:** Sometimes a color photo has something wrong that you can hide by converting it to black and white or colorizing. The accompanying photo has a so-so sky. In color, it takes away from the effect of the statue of General Anthony Wayne. When I converted it to black and white, the sky became less distracting. The result is an impressive study in tone and contrast.

Figure 6-22: General Wayne in black and white.

✔ **For emphasis:** Often, you can use black and white or colorization to emphasize certain elements. Details and geometry stand out and make a photo interesting from a completely different point of view.

✔ **For mood:** It's possible to create a mood by removing traces of traditional color. Black-and-white photos can be somber, but don't have to be. You can make them look old. Colorized photos can appear playful or downright zany. Create whatever mood you're after.

✔ **For art:** No one says you have to have a solid reason to convert a color photo to black and white or anything else. It's your art. You decide. Some photographers have developed their own sense of style over the years regardless of what anyone else thought. Figure 6-23 is a shot I took of my son while I was experimenting with some flash accessories from Gary Fong. (I was totally impressed with the accessories, by the way.) It's striking in color, but equally mesmerizing in black and white.

With practice, you can train yourself to see or think in black and white. You'll be able to more easily pick out potentially amazing tones, textures, and contrasts, and then bring them out as you take and process your shots.

Figure 6-23: Black-and-white photos have an artistry all their own.

Book VI
Shooting Movies

Elapsed recording time Recording symbol

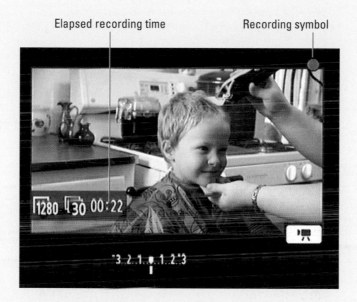

Contents at a Glance

Chapter 1: Setting Up for Movies

In This Chapter

✔ **Thinking in moving pictures**

✔ **Movie modes**

✔ **Getting the camera set up**

✔ **Improving your movies**

Y ou might not know it, but your dSLR makes a pretty good high-definition (HD) movie camera. It's got a larger sensor than compact cameras, you can set it up and customize it to match different conditions, it has decent ISO performance (see Book III, Chapter 3), and uses interchangeable lenses. In other words, most of the reasons it takes great photographs are the same reasons it can make quality movies.

If you know what you're doing.

Making movies is different enough from taking photos to warrant a separate minibook. There's format and size to consider, as well as audio, external microphone (or not), and transitioning to capturing continuous action.

This chapter is about helping you quickly make the transition from still photography to making movies — and with success.

Turning on the Movie Mindset

I don't want to insult your intelligence with an introduction that explains the basic differences between movies and still photos. You get it. What you may not realize is how those differences translate into how you'll shoot movies versus still photos.

Movies require a specific mindset:

✔ **Movies last longer than 1/60 second:** If you shoot still photos, you may be used to thinking of time in terms of fractions of a second. Each photograph lasts a discrete amount of time. Movies last much longer. If you shoot a 10-minute movie that has a maximum playback rate of 60 frames per second, you've shot the equivalent of 36,000 1/60 second photos.

Because it's hard to be still, quiet, and in focus throughout an entire movie, it's good to have a plan — a plan to use movie-editing software to create a finished product using what you capture as source material. Editing introduces a certain "forgiveness" into the process and lets you use shorter clips to create a longer movie. See Book VI, Chapter 2.

✔ **Steady as she goes:** You can't run around with the camera and act like a high-def Steadicam operator. The camera would give your audience motion sickness. A tripod is your friend.

When you shoot handheld videos, you have to continually fight camera movement. Your videos will be jumpier and look more "homemade" compared to a still photo shot with the same camera.

✔ **You can record sound:** Most digital SLRs have built-in mono or stereo microphones. Being able record sound is good, but also a challenge. Be careful not to make noise when you're shooting, and consider the overall environment where you are. Are large trucks driving by? Is there a locust plague? Your microphone may pick that up.

✔ **Autofocus is a major hassle:** Although modern dSLRs have great autofocus for still photos, you'll face challenges for movies:

- *AF messes with the exposure:* If your camera tries to refocus when shooting, the exposure can change. This exposure change ruins what you're shooting.

- *AF is fallible:* The camera might chase focus, going in, out, and back in before it settles.

- *AF makes noise:* If you're recording audio, the motor in the lens will make noise, which you will likely record.

As a result, you may get better results using manual focus. Don't be afraid to try it if autofocus isn't working well for you.

✔ **Hot blooded:** Unless you use Live view a lot, you probably don't think much about your camera overheating. Shooting movies puts a lot more thermal stress on the digital SLR. Your camera may warn you of this, but it may also shut down without warning.

Pay attention to how warm the camera feels and whether you're getting *hot spots* (areas that look discolored) on the LCD screen. If so, shut 'er down. If your camera comes with a temperature warning indicator (you know, a flashing red indicator), pay attention to it!

✔ **Memory cards:** Just when you thought that having a few 8GB memory cards were enough to last through a photo shoot, along came video. Shooting a lot of movies, especially at full HD (defined in "Setting Up Your Camera for Movies" later in this chapter), will make investing in larger, faster memory cards a necessity.

✔ **Storage:** When you transfer movies from the memory card to your computer, they take up space — *lots* of space.

✔ **Editing:** Serious movie editing requires serious software, which can cost serious money. Relatively inexpensive alternatives exist; I name a couple in Book VI, Chapter 2.

I don't want you to think of this list as one warning after another. Some really good things come with the territory as well:

✔ **Moving pictures:** These pictures move! If a picture is worth a thousand words, movies are quite often worth more. You can communicate more information, use movies for more purposes, and reach a very wide audience with movies. Become a YouTube star!

✔ **Sound:** Audio adds a completely new dimension, and it can make a movie more memorable.

✔ **You've already spent the money:** When you think about it, you got a full HD movie camera for free when you bought your still-photo dSLR. Experimenting with movies to see if you like shooting them won't cost you anything more to begin with.

Book VI
Chapter 1

Setting Up for
Movies

Controlling Movie Modes

 Some cameras have a Movie mode on the mode dial, as shown in Figure 1-1. Pretty nice. On those cameras, you may not be able to get to the MOVIE options until you've chosen Movie mode on the mode dial. However, you may not need to set the mode dial to Movie unless you're using advanced movie modes like Aperture priority Movie mode.

Cameras without a Movie mode on the dial may have a special switch that goes between Live view (using the LCD monitor on the back of the camera instead of the viewfinder) and Movie modes. Figure 1-2 shows this switch on a Canon 5D Mark III. In both cases, you traditionally start and stop recording by pressing the start/stop (or movie) button. But that's covered in the next chapter.

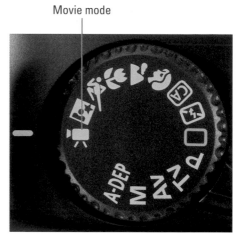

Movie mode

Figure 1-1: Set the mode dial to Movie to shoot movies.

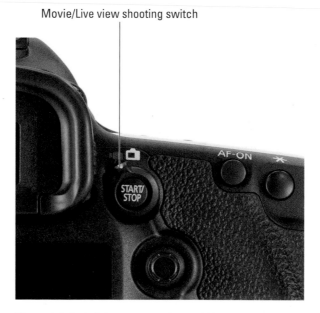

Movie/Live view shooting switch

Figure 1-2: Switch between movies and Live view with this button.

Setting Up Your Camera for Movies

Your movie options aren't wildly complicated. Get ready to know a few new concepts and terms.

It's quality

A movie's quality is determined by several things. Frame size is the most obvious, but not the only, factor. Frame rate and playback are also important. I discuss these topics in the following sections.

Frame size

Frame size, which is measured in pixels, determines a movie's size (width and height) and *aspect ratio* (ratio of width to height; HD movies are widescreen). Look in your camera manual to see the sizes available to you and how long you can record at each size and frame rate. Ignoring anything smaller than standard definition, Table 1-1 shows the top three sizes.

Table 1-1	Frame Size and Aspect Ratios	
Frame Size	*Definition*	*Aspect Ratio*
1920 x 1080	Full high definition (full HD)	16:9*
1280 x 720	High definition (HD)	16:9*
640 x 480	Standard definition (SD)	4:3

Used on HDTV sets and widescreen computer monitors.

Frame rate

Frame rate is how many frames of the movie are recorded and played back per second. Frame rate is measured in *frames per second (fps).* Frame rates can be confusing because there are two video playback standards used in different parts of the world.

Depending on where you bought your camera, you should have set the Video mode to one or the other values. Table 1-2 explains.

Table 1-2	Frame Rate Types	
Value	*Frames per Second*	*Where It's Used*
NTSC (National Television System Committee)	60 fps and 30 fps; frame rates are multiples of 30	North America, Japan, Korea, Mexico, and others, including many countries in Central and South America and the Caribbean
PAL (Phase Alternating Line)	50 fps and 25 fps; frame rates are multiples of 25	Europe, Russia, China, Australia, and many other areas of the world

Common frame rates for dSLR movies are explained in Table 1-3.

Table 1-3	Common Frame Rates for dSLR Movies	
Frame Rate	*When It's Used*	*Use It When*
60/50 (NTSC/PAL)	This tends to be the high frame rate. It is normally available in HD, not full HD.	You want smooth action.
30/25 (NTSC/PAL)	Standard setting for full HD movies.	You want to shoot HD but don't need the extra frame rate or would like smaller file size than the 60/50 fps setting produces.
24	When Steven Spielberg makes a movie.	You want the feel of a movie on the large screen (which includes some motion blur due to the slower frame rate). Most people can't tell the difference between 30 fps and 24 fps unless there's lots of motion or you *pan* (move the camera across the scene).

Frame rate options can depend on the movie size you're capturing. Each size may have a low and high-speed frame rate, and possibly a third option. Higher frame rates capture action and provide smooth playback. This results in less motion blur and a feeling of "HD" that enhances realism (some would say to a fault, so be sure to test the settings out to see what you like best).

Scan type

You might have the option of choosing between Progressive (P) or Interlaced (I) scan types.

TIP

Progressive scanning produces crisper movies with less motion blur. The downside to progressive scanning is the amount of data that needs to be drawn to the screen for each frame is more than for interlaced scanning. Scan method is sometimes listed as part of the frame rate. For example, you may see 30p/25p.

Compression method

Compression squeezes movie data in the file so the whole thing takes up less space. Methods vary by camera maker. You may be able to choose a compression method.

High-end Canon cameras have two compression methods; see Figure 1-3.

- ✔ **ALL-I (Intra-coded Frame):** Pay attention to how many minutes you can fit on a 16GB card, as listed in your camera's manual. Because each frame is compressed alone, movies shot in this format are easier to edit.

- ✔ **IPB (Interframe Bidirectional Compression):** These movies are much smaller than those that use the ALL-I method. Editing takes more computer power.

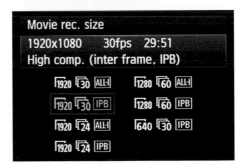

Notice also from Figure 1-3 the different movie size/frame rate/ compression options. You have quite a few to choose from.

Bit rate

Figure 1-3: Advanced Canon movie compression options.

Bit rate describes how much data is being transferred, and it greatly affects overall video quality. More data equals better quality. Sometimes bit rates are given to you as numbers. For example, you may be able to choose between 24 megapixels per second and 17 megapixels per second. At other times, you may see them described in terms of quality. For example, the Nikon D3200 has high bit rate options for high quality and NORM setting for normal quality.

If you're given a choice, choose a higher bit-rate setting.

Bit rates are sometimes tied to available file types. For example, Sony offers higher average bit rates when you choose their AVCHD movie format. When you choose MP4 on a Sony, you get lower bit rates.

Recording sound

Every movie-capable dSLR has a built-in microphone to record audio. Not all, however, have the same capability. You'll see one of the following options:

✔ *Single (mono)* records a single audio channel. Many mono dSLRs let you record in stereo if you attach a stereo microphone.

✔ *Dual-channel (stereo)* records two independent (they must be different to be called true stereo) audio signals.

Keep these bits of aural advice in mind:

✔ Keep your finger off the microphone. Make sure you know where the microphone is. Most are behind a handful of small holes; some appear under a screen. See Figure 1-4.

✔ Anything *you* say, along with any other sound, is picked up by the mic.

Internal microphone

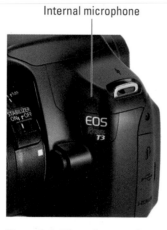

Internal stereo microphone

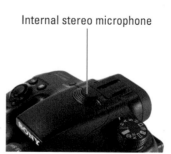

Figure 1-4: Microphones galore.

An external microphone provides better sound quality. Your camera should have an external microphone input terminal like the one in Figure 1-5.

External stereo microphone input

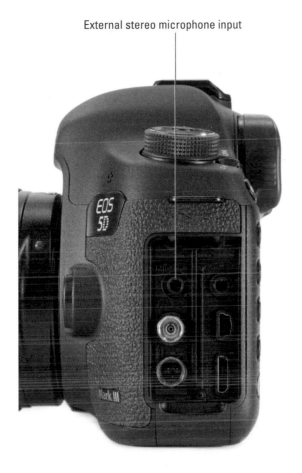

Figure 1-5: Plug your external microphone in the right terminal.

You may run into these types of options if you're recording sound:

- ✔ **Disable/Microphone Off:** Turn off sound recording.

- ✔ **Auto/Manual Sensitivity:** Choose Auto if you want the camera to record sound, and you don't want to mess with any settings. The camera turns the sound up or down for you. If you choose Manual, you have to do a bit more work. For more about the audio meter that shows up in this case, and how to set the audio level, see Book VI, Chapter 2.

Your camera might have a wind filter that minimizes the effects of wind noise. This option may subtly change the tone of the sound you record, however, so don't turn it on unless you really need it.

You're just my type and size

When you're making movies, you have to choose among different types and sizes, and you'll have to wrap your mind around a different kind of editing and storage. Movie files.

File type

At the moment, most dSLRs save movies as MP4 files with a .mov extension. Sony offers AVCHD as well; it keeps the highest quality settings for AVCHD.

If you're considering movie-editing software, make sure the kind you get supports the files you'll use.

Maximum file size and length

Your camera may limit the file size (in gigabytes) and length (in minutes) of movies that you record. Please read your camera's manual to find out the specifics as they apply to you. The best thing is to shoot shorter clips.

For example, the Nikon D3200 limits movie sizes to 4GB and 20 minutes. Your card may be able to hold much more data. You may have set the movie quality so that you can record more at one time. It doesn't matter. This is a hard limitation. Canon cameras tend to shoot longer (29 minutes and 59 seconds), but they have the same 4GB size limit. However, newer models automatically start a new movie file before the first one ends so you can put them together in software. If you go past 29 minutes and 59 seconds, though, you don't get the benefit of a second file with overlapping content. You're going to lose anything in between stopping and starting again.

Memory cards

When you're shooting movies, the quality and speed of your memory card are important to consider. For the best movie recording and playback performance, use the fastest and largest memory cards you can afford to buy.

If your camera uses either SD or CD cards:

- **Consider class:** Some memory cards are rated by class. The class number for Secure Digital (SD) cards indicates the minimum read/write speed in *megabytes per second (MBps)*. Therefore, a Class 10 SD card should perform better than 10 MBps. Some cameras suggest Class 4 or Class 6 cards at a minimum. Others set the base at Class 10. Your camera's manual will tell you what class is recommended.

✔ **Consider UDMA level:** Compact Flash (CF) cards are rated by UDMA (Ultra Direct Mode Access) level and then an explicit declaration of read/write speed. The latest UDMA level is 7, which supports speeds of up to 167 MBps.

Using time code

Time code lets you know where you are in a movie by referring to specific frames in the movie rather than a time reference.

Time code does you a world of good if you're doing any of the following:

✔ Syncing specific frames of video

✔ Using clips from more than one camera

✔ Adding close captioning

✔ Editing audio

Your camera might have time code options like the ones shown in Figure 1-6:

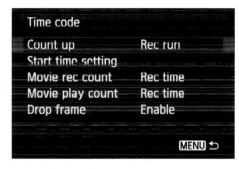

Figure 1-6: Set time code options.

✔ **Count Up:** Choose Recording Run to have the Time Code count up when recording a movie only. Choose Free Run to have the Time Code keep count regardless of whether you're recording.

✔ **Start Time Setting:** Choose Manual Input Setting to set the hour, minute, second, and frame yourself. Select Reset to reset the Time Code to 00:00:00:00. Choose Set to Camera Time for the time portion to match the camera's internal clock. The first frame will be 00.

✔ **Movie Recording Count:** Determine what's displayed on the movie-shooting screen (when you're not recording). Choose Recording Time to display the elapsed time. Choose Time Code to show the time code.

✔ **Movie Playback Count:** In contrast to the previous one, this setting controls what appears during movie playback. Set to Recording Time to see the elapsed time during playback, and Time Code to see the time code when you're paused or going forward through frames. Book VI, Chapter 2 talks more about playback.

✓ **Drop Frame:** When you turn on this option, the difference between the time code and actual frame count is corrected by dropping (also called *skipping*) time code frame numbers. The movie frames don't change either way. If you disable this setting, the time code may not reflect the actual frame you're looking at.

Using Live view for movies

All current dSLRs require you to frame, focus, and manage your shoot using Live view. You can't look back through the viewfinder. Take heart, viewfinderphiles.

When you're using the LCD monitor on the back of the camera, it'll look pretty much the same as when you're shooting still photos. You can set up the display the same way: Add more or less information, use a grid, level, and so forth. See Book I, Chapters 3 and 5.

Figure 1-7 shows the back of the Canon 5D Mark III while I'm shooting a movie. I turned off all indicators (except the AF frame, which I wasn't using). The red light shows that recording is in progress.

Figure 1-7: You'll have to use Live view when recording a movie.

Making exposure decisions

You can sometimes choose how the camera handles exposure when shooting movies. In general, exposure modes are divided among these options:

- ✔ **Full Auto:** The camera handles the aperture, ISO, and shutter speed. (You can read more about these settings in Book II, Chapters 1 through 3.) This is, in essence, point-and-shoot movie making. You can adjust exposure by pressing the exposure compensation button on your camera (this button is generally on the right side of the camera, either on the back or top, and accessible using your right thumb).

- ✔ **Semi-auto:** You may be able to set certain creative parameters (aperture, shutter speed, ISO) while the camera handles the overall exposure. These modes, shown in Figure 1-8 on the Sony Alpha A77, may require you to use manual focus.

- ✔ **Manual:** You control both the aperture and the shutter speed at the same time. The aperture affects the *depth of field* (area in focus), just like when taking still photos. Shutter speed affects the smoothness of the movie. Higher speeds record smoother action. Slower speeds can have motion blur.

Figure 1-8: This camera has four advanced movie modes.

Choosing a focus mode

Keeping your subject in focus is one of the more challenging tasks involved in shooting video. I recommend shooting movies in Manual focus mode. Practice until you get good at it, then keep practicing. That's what I do.

Your camera probably offers *autofocus (AF)*, but it may not work the way you expect it to. Some cameras don't continually refocus once the shooting starts. Those that do may be loud. If you're recording sound, you'll likely pick up the sounds of the autofocus motor. Sound issues aside, if the camera hunts to achieve focus, your movie will suffer greatly.

Figure 1-9 shows the AF modes on the Nikon D3200. Try them out and see if they meet your needs.

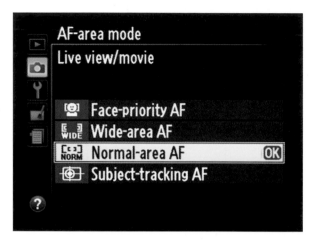

Figure 1-9: Setting up autofocus for movie shooting.

Making more decisions

Believe it or not, lots of other camera settings will affect the movies you shoot. Although they differ from camera to camera, look for how these options will affect your movies:

✔ **Exposure compensation:** Make sure to remove any exposure compensation you may have dialed in when shooting stills. Figure 1-10 shows a movie menu with exposure correction highlighted. Notice the other options on this screen as well; they are other settings you can use to change how your movies look. Don't forget that you have quite a bit of control over these aspects as well, not just setting the frame rate and movie size!

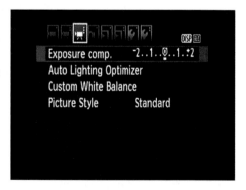

Figure 1-10: Exposure compensation is often the easiest way to adjust movie exposure.

↳ **Dynamic range settings:** These settings control how the camera attempts to capture the most detail possible in high-contrast scenes. See Book III, Chapter 5 for more information on exposure. You can use Canon's Auto Lighting Optimizer or Sony's D-Range Optimizer.

↳ **White balance:** White balance helps correct the camera's response to different lighting. Take a few test runs to make sure you're happy with the current setting. Auto is always worth trying, but don't be afraid to change if you're not happy with the color.

↳ **Metering mode:** Check your *metering* mode (how the camera senses the light in the scene). Center-Weighted and Spot modes are harder to control, and they may cause the exposure to fluctuate during the movie. This is a good time to use a Pattern or Matrix mode and not mess with it. See Book III, Chapter 5.

↳ **Metering timer:** You may have the option of setting a metering timer, which determines how long the exposure setting is displayed after you meter the scene. During this time, you can press and hold AE lock to hold the autoexposure settings. On most cameras, the AE lock is a button on the back of the camera.

↳ **ISO:** Beware of noise and heat. Shooting with higher ISOs will introduce more noise into your movies and potentially cause your camera to overheat faster than it would at a lower setting. If you see the overheat warning, turn off the camera immediately.

↳ **Styles and effects:** Try setting your camera's style or effects options to something creative. In particular, settings like Vivid (enhanced colors and contrast) and Black and White (no color) are powerful creative options and can save editing time later. Miniature and Toy settings are also fun to play with. See Book I, Chapter 3.

↳ **Silent Control:** Canon has a special mode that lets you change camera settings (while you're shooting) with a minimum of button presses and potential noise or shake.

↳ **Face Detection and Object Tracking:** These help to keep your subject in focus, but beware of the noise they may cause.

↳ **Choosing a lens:** Use the fastest lens you can. You'll be able to blur out the background if you have a lens with a large maximum aperture. Book II talks more about lenses.

Longer focal lengths make steadying the image much more difficult.

↳ **Lens Compensation:** Automatically correct lens characteristics like distortion and *vignetting* (darkened edges) on the fly.

These options don't live inside the camera, but are separate from it:

- **Tripods:** If your subject doesn't move, you may be able to use a tripod. Traditional still photography tripods and heads simply can't follow live action smoothly; they're meant to lock down the camera and keep it from moving! Unless you have a tripod and head built to shoot movies, it's probably best to hold the camera by hand. Using a shoulder rig (explained later in this chapter) to support the camera is the best of both worlds: movement and stability.

- **Background:** Always be on the lookout for distracting background elements, as shown in Figure 1-11. Try to avoid them — visual and aural — if possible.

- **Lighting:** Try shooting in conditions where you don't have to raise the ISO. Natural light is a joy to work in, but is harder to come by inside. Flashes won't do you much good when shooting movies, but continuous lighting and some additional gear (reflectors and so forth) may. See Book IV, Chapter 2 for more information on lighting.

Figure 1-11: That's me in the background taking photos.

Stepping Up Your Game

Technically speaking, dSLRs have everything you need to shoot movies. Another aspect of their usefulness is their compatibility with many professional-level video accessories. Each one can solve a problem or stretch your capability.

For example, manually focusing can be hard. Considering how pervasive and powerful autofocus is in still photography, focus rings on lenses aren't getting any larger. Until you can buy a video version of your favorite lens that sports a massive focus ring, using a focus follower will help you tremendously.

Consider this short list of gear to make your setup more professional and your videos more polished:

- **Your dSLR:** 'Nuff said.

- **A professional lens:** Don't skimp. Don't even think about skimping. A professional lens is a critical component to improving movie quality.

- **Shoulder rig:** Also known as a *handset, offset rig, handheld support,* or *dSLR cinema rig,* this thingamajig turns your dSLR from a handheld still camera to a shoulder-mounted video camera. They come in lots of styles, and all of them help you more comfortably hold your camera for extended periods of time (in a position that lets you see the LCD monitor; remember you won't be using the viewfinder when making movies). They are simply necessary if you want to shoot steady handheld video without your arms falling off. See Figure 1-12.

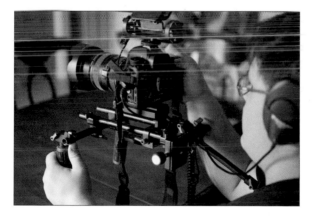

Figure 1-12: Rigs like these are arm savers.

✔ **LCD loupe:** These gizmos fit on the back of the camera to magnify and shield the LCD from bright light. You might also find this a useful tool when shooting still photos in Live view.

✔ **Focus follower:** Attach this ditty to the lens if you want to manually focus while shooting. The action is really smooth, it doesn't make noise, and it keeps you from bumping or jiggling the camera or lens.

✔ **Matte box:** You can get away with using the lens hood to keep light from hitting the front of the lens, but the best solution for video is a full-fledged matte box. It makes your dSLR look like an old-school movie camera. Matte boxes offer better protection from stray light than lens hoods and let you drop in filters. You can read more about filters in Book III, Chapter 4.

✔ **External stereo microphone:** If you want to shoot serious video, record some serious audio. That means stepping up from mono to stereo and, most often, mounting an external microphone on top of the camera, like the one you see in Figure 1-13.

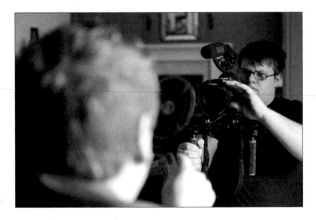

Figure 1-13: You can mount this microphone on your camera.

✔ **Headphones:** If possible, use them to monitor the sound and keep your head in the game. Not all cameras have a headphone jack. If yours does, it'll be with the camera's other terminals.

✔ **External audio recorder:** You may benefit from an external boom mic and audio recorder. This creates a new audio source completely off the camera and eliminates camera noise (unless you drop the camera and make a loud crash or something).

✔ **Other lighting gear:** Use whatever other lighting gear you need to, including but not limited to LCD lighting, reflectors, backgrounds, or soft boxes. See Book IV, Chapter 2.

✔ **A crew:** Shooting by yourself can be hard. Don't be afraid to ask for help. Figure 1-14 shows Team Pine Hills: Nate's on boom mic, recording audio separately from the camera. Dustin's operating the 5D Mark III. Pastor Mike is the talent. Although you could pull this off yourself, it's always fun to work with good people.

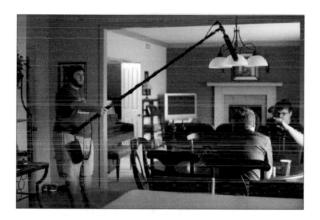

Figure 1-14: Shooting as a team helps ease your workload.

Chapter 2: Making Movie Magic

In This Chapter

- ✔ **Getting a grip on the process**
- ✔ **Shooting and reviewing movies**
- ✔ **Connecting your camera to a television**
- ✔ **Editing movies in your camera**
- ✔ **Finding editing software**

A few years ago, a debate raged between people who wanted to be able to shoot movies on their dSLRs and people who wanted the camera to remain true to its still photo heritage. Movies won. Digital SLRs, as it turns out, are great movie-making platforms.

You don't have to have a professional-level camera like the Mark II (or its successor, the 5D Mark III) to shoot full high-definition movies. Even entry-level dSLRs like the Canon EOS Rebels and Nikon D3200 have a robust set of movie-making features.

This chapter won't lead directly to an Oscar, but it does present the basics of shooting movies on a dSLR, playing back movies on your camera, and heads you toward editing your movies.

Controlling Your dSLR

I want to give you a sense of the general types of control you must manage when shooting movies. It's pretty straightforward when you press the record button, but getting there is about the details.

When you're shooting movies, keep in mind four types of control:

- ✔ **Movie control:** Setting up the technical details that define the type and quality of the movie you plan on shooting.
- ✔ **Creative control:** The creative decisions you'll make that will determine how your movie will look.

✔ **Exposure control:** Most often, setting the exposure controls to manage your movie's depth of field, the noise level, and smoothness. You may be able to take complete exposure control and also set the movie's brightness level.

✔ **Focus control:** Auto or manual.

You'll have to decide in certain areas whether to make a *point-and-shoot movie* (where all you do is point the camera at something and record) or something a little more complicated.

By approaching video with an eye towards projects as opposed to individual clips, you free yourself from thinking you have to shoot a video that's perfect from start to finish.

If you run into trouble, shoot the video in three or four takes and then edit the clips together. Watch television and movies to see how professional directors cut between scenes (DVD/Blu-ray commentaries are a gold mine of movie-making tips and tricks if you find a talented and talkative director). Look for instant projects or project templates in movie-editing software to help you get started.

Movie control

You must decide on your movie's technical details, including but definitely not limited to the following:

✔ Size

✔ Frame rate

✔ Quality

✔ Audio

Book VI, Chapter 1 covers the specific options you get to control in greater detail.

Creative control

You'll have a certain degree of control over how your movies look. How much control you get depends on your camera

Your camera's still photo styles (often called *Creative Style* or *Picture Style*) are the styles you get to choose for movies; settings like Black and White or Vivid are examples. These settings carry over to the movies you shoot. Book I, Chapter 5 talks more about creative styles. Figure 2-1 shows a mode dial.

The exposure settings change based on the scene you choose. For example, if you choose Portrait, the aperture is larger to decrease the depth of field. Likewise, if you choose the Sports scene, the shutter speed will be faster.

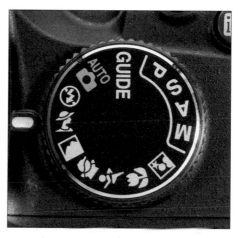

Figure 2-1: The mode dial offers options.

White balance settings are an important creative control to think about when shooting movies. Set it just as you would when shooting stills.

Some cameras have a Movie mode on their mode dial (see Figure 2-2), and require you to set it to Movie to shoot one. If this is the case, you can't shoot movies when the mode dial is set to something else. However, you should still be able to set the creative style and white balance. "Going Hollywood" in this chapter gives specific steps.

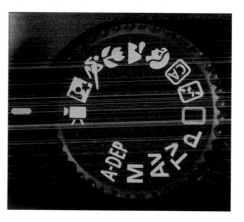

Figure 2-2: Sometimes you have to enter Movie mode from the mode dial.

Book VI Chapter 2

Making Movie Magic

Exposure control

You may be able to take over the exposure settings when shooting movies. Some cameras allow you to enter Program Auto, Aperture priority, Shutter priority, and Manual shooting modes. Others simply offer Manual control of movie exposure and don't give it a fancy name.

Use the same criteria for movies that you would for shooting still photos:

- ✓ Larger apertures reduce the *depth of field* (area in focus). Smaller apertures increase the depth of field.

- ✓ Higher ISOs let you shoot in lower light or when you want to limit the other exposure controls (for example, shoot with a smaller aperture), but at the cost of *noise* (grain).

- ✓ Shutter speed is a different beast. I follow the 180 Degree Shutter rule, which suggests that you set the shutter speed based on the frame rate of the movie you're shooting. Book VI, Chapter 1 talks more about frame rate.

To get a film look (a good compromise between motion blur and detail), double the frame rate to get the correct shutter speed. If the frame rate is 30 frames per second, set the shutter speed to 1/60 second. If you want a different effect, speed up or slow down the shutter speed. You make the call.

Focus control

Focus control is what you'd expect it to be: whether you manually focus or give the job to your camera. Whether you've chosen an automatic or more manual movie shooting mode, you have the choice of manual versus autofocus.

Going Hollywood

I'd love to be able to divide the process of making movies into an Easy section for those of you who just want to get started and an Advanced section for those of you who want more details, but I can't. You have to make a lot of decisions, even when you're taking it easy. Likewise, more complicated movie modes may not let you do some things the easier way.

A camera manual may suggest there are auto movie modes; don't misunderstand and think you have no say over things. If you don't know what your options are, you may not be getting the most out of your movies.

Prepping

Before you start shooting, set up everything you need for the scene. If you're shooting something beyond your control, figure out ahead of time where to stand and what restrictions there are, if any.

✔ Clean the camera and lens.

✔ Attach any accessories, and mount it on a tripod, if desired.

✔ Get the lighting, background, and other location-specific aspects ready.

✔ Prepare your subjects, if necessary. In parent-speak, that means telling the kids to stand still, stop messing with their clothing, and saying, "No, you cannot go to the bathroom. No, you can't have juice!"

✔ Make sure you have a full battery. Have more than one if possible. If you plan on shooting a lot of movies and you're near a power outlet, consider using an AC adapter instead of batteries.

✔ Make sure your memory cards are clean and ready to record to. If you need to format a card, see the steps in Book I, Chapter 4.

✔ Plan your movies and clips around the limitations your camera has on movie size and length. Currently, dSLRs don't record movies longer than between 20 and 30 minutes and larger than 4 gigabytes. Please read your manual to know your boundaries.

Shooting

Use the following steps as a guide to help you start shooting your own movies:

1. **Make sure everything's ready.**

 If you aren't sure where to start, see the section just before this one.

2. **Set your creative choices.**

 Don't forget to set things like this:

 - *Auto:* To let the camera take over, select Auto mode from the mode dial (if possible). See Figure 2-3.

 - *Scene:* Choose from the mode dial or menu to shoot with certain scene-appropriate creative and exposure settings.

 - *Creative style:* You may want to boost the color and contrast or shoot something in black and white.

 - *Picture effect:* You may be able to shoot using certain picture effects, like a toy camera.

 - *White balance:* Don't forget to set the white balance.

 - *Dynamic range enhancements:* Enable or disable your camera's dynamic range enhancing features if you like.

- *Metering mode:* Although it's probably not a creative choice, now is a good time to change the metering mode. See Book III, Chapter 5.

3. **Enter Movie mode, if necessary.**

 If it's on your mode dial, set it to Movie. If you have a Movie/Live view switch instead, set it to Movie.

4. **Set the movie options.**

 Make sure you set the right options for these options:

 - Size

 - Type

 - Quality

 - Frame rate

 Book VI, Chapter 1 covers this part of the process.

5. **Set up audio.**

 - Turn it on or off.

 - If you turn it on, choose Auto or Manual.

 - If you chose Manual, make those choices now.

6. **If necessary, press the Live view button or switch.**

7. **Set up the Live view display.**

 You may want to see a lot of information, or you may not. Figure 2-4 shows a typical movie display prior to filming (some fill the screen more than this). If you can have a grid, turn it on and choose a type.

8. **Choose auto (AF) or manual (M) focus.**

 If you're using AF, set the Live view/Movie sub-mode.

9. **Set exposure controls.**

 - If desired, set your camera's shooting mode to Program Auto, Aperture priority, Shutter priority, or Manual. You may also have specific Movie modes that mirror these still photo shooting modes.

 If you don't want to set any exposure controls yourself, enter an automatic shooting mode.

 - You may have to meter to set the final ISO.

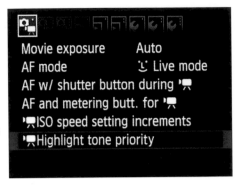

Movie exposure Auto
AF mode Live mode
AF w/ shutter button during
AF and metering butt. for
ISO speed setting increments
Highlight tone priority

Figure 2-3: Settings like this one may not immediately come to mind when you're ready to shoot.

- Generally speaking, your shutter speed should be fixed if you're following the 180-degree shutter rule.

- Choose a lens aperture that meets your creative desires.

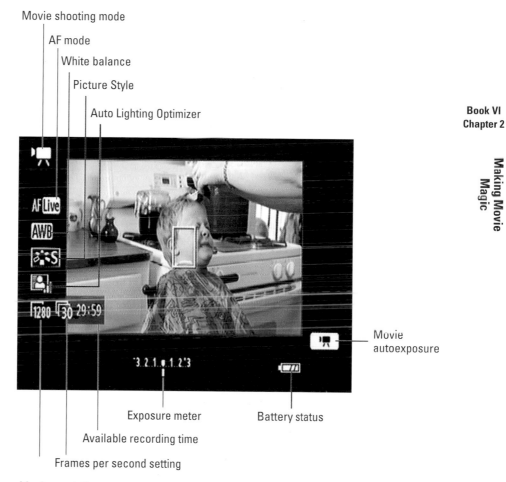

Movie shooting mode
AF mode
White balance
Picture Style
Auto Lighting Optimizer

Movie autoexposure

Exposure meter

Battery status

Available recording time

Frames per second setting

Movie resolution

Figure 2-4: He's not enjoying his haircut.

10. If you set Audio to Manual, set levels now.

An audio meter should appear on your screen, showing you the strength of the audio signal. Audio levels are measured in decibels (dB), and the scale runs from –40 (very, very soft) to 0 (as much as can be measured digitally without running out of room).

To get a good audio setting, listen to the source of the sound and watch the meter as you adjust the level. You want the sound to peak consistently in the –12 range (as shown in Figure 2-5). The indicators on the meter turn yellow at this point, which is good. You want to have a strong signal. However, you don't want it to be too strong. The extra space to the right of the current sound level, called *headroom,* should be large enough to give you a comfortable margin of error.

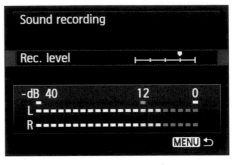

Figure 2-5: Setting the recording level.

When the meter reads 0 and appears red, as shown in Figure 2-6, that means the audio levels are too high. Turn it down or you risk recording distorted audio, which will more than likely ruin the clip.

11. **Frame the scene.**

Frame it just like you would when shooting a still using Live view.

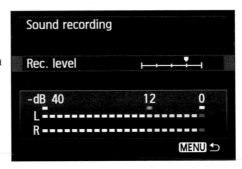

Figure 2-6: Lower the level to avoid the red clip indicator.

12. **Focus.**

If you're shooting a relatively static scene and manually focusing, take advantage of your camera's capability to zoom in when in Live view mode, if possible, and get a perfect manual focus. See Book I, Chapter 3.

13. **Begin shooting the movie.**

Press your camera's start/stop or record button.

14. **Monitor the situation.**

When recording, the display looks a lot like the Live view shooting display, as shown in Figure 2-7. Press your camera's Display button (or its equivalent) to cycle through the options.

Elapsed recording time Recording symbol

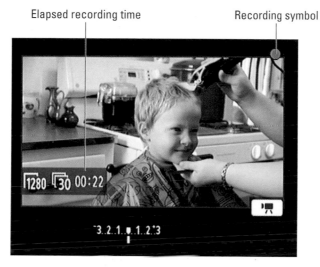

Figure 2-7: This display is currently set to show minimal information.

Watch the following indicators closely:

- *Recording:* A red indicator shows that you're recording. Make sure the light's on when it should be.

- *Overheating warning indicator:* Stop shooting if it comes on.

- *Battery level:* Think ahead if you're running out. Choose a time to replace it.

- *Time elapsed:* Watch the time elapsed in case your camera has an upper limit on clip sizes. You may have to stop and restart. See the callout in Figure 2-7.

- *Time remaining:* This often tells you how long you can record the current clip. It may not show how much space you have on your memory card.

- *Focus:* Make sure things are still in focus.

If you're manually focusing and moving, you'll have to focus on the fly. If you're using autofocus (AF), make sure you're pointing the focusing frame or AF point at the right spot in the scene.

15. **Adjust exposure, if necessary.**

You can adjust exposure compensation while recording a movie. To do so, press your camera's exposure correction button (it'll be near your right thumb, on top or on the back of the camera) and rotate the main dial. Rotate the dial to the right to increase the exposure compensation, as shown in Figure 2-8. This makes the scene brighter. Rotate to the left to decrease the exposure compensation and darken the scene.

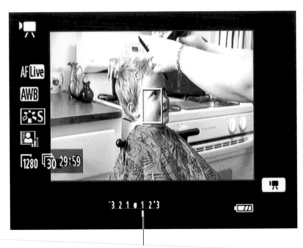

Exposure compensation amount (+1.0)

Figure 2-8: Adjusting the exposure using exposure compensation.

16. **Press your camera's start/stop or record button again to stop recording the movie.**

17. **Relax and take a deep breath.**

Shooting a movie takes longer than shooting a photo. As a result, the concentration required can be very demanding.

Enjoying the Show: Movie Playback

After you've shot your movie, you might want to play it back. You can use your camera to review it immediately. Normally, movies are displayed on your LCD monitor. If you want a larger image, connect your camera to a television. "Connecting to the Boob Tube" in this chapter explains how to hook up the camera to the TV.

To play back movies — either on the camera or a TV set — follow these steps:

1. **If necessary, choose Movie Playback mode on your camera.**

2. **Press the playback button.**

 You'll find the button on the back of the camera. It'll look like the play button on your Blu-ray or DVD remote.

 The movie you just shot should be first in the queue. If it's not, use your normal playback controls until you see the thumbnail that belongs to the movie you want to see.

 Quite often, you'll be able to spot movie files by their use of a special icon, as shown in Figure 2-9.

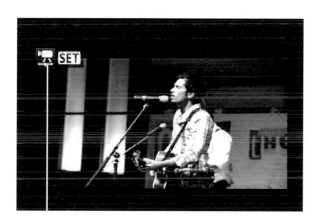

Movie icon

Figure 2-9: The movie camera symbol indicates that you're looking at a movie file.

3. **Press the OK (or its equivalent) button.**

 The movie may start playing, or you may see a strip of playback controls at the bottom of the screen, as shown in Figure 2-10. Use the controls as you would a DVD player.

4. **Adjust the volume, if you need to.**

 To adjust volume during playback, use the main dial on some cameras and a button on others. For example, the Nikon D3200 offers the zoom in and zoom out buttons to adjust volume.

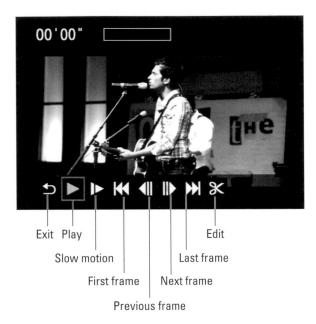

Exit Play

Slow motion

First frame

Previous frame

Next frame

Last frame

Edit

Figure 2-10: Handy playback controls.

5. **Control playback as you're watching.**

You might be able to control different aspects of movie playback. Look for ways to play, pause, advance, rewind, play in slow motion, and edit your movies. Each camera is different. Read its manual to find your camera's specific capabilities.

6. **When you're done watching, press the playback button.**

Connecting to the Boob Tube

Digital SLRs are made to connect to TVs either with an HDMI cable or the older A/V cables.

✔ **HDMI** lets you see your photos and movies in high definition. HDMI cables also handle the audio (which means, unlike the older A/V cables, there is only one connection). HDMI cables connect to your camera. The hole, or *port*, is smaller than the standard version that plugs into your HDTV.

✓ Standard **A/V** cables may use different connectors. Older ones use a small 1/8-inch connector (it looks like a headphone or microphone plug. New ones use USB (it looks like a wonky rectangle). Both end in color-coded plugs that connect to the TV: yellow for video and white for audio.

Connecting your camera to your TV is basically the same, regardless of the type of cable you use. Here's how:

1. **Turn off everything.**

 This protects the sensitive electronics in the TV and your camera. It also makes sure the video system activates after the connection is made.

2. **Open the rubber terminal cover on the side of your camera.**

 Look for the one that says HDMI if that's the type of connection you'll be making. Standard A/V connections will either be USB or an 1/8 inch input. See Figure 2-11.

<div style="text-align:right">**Book VI**
Chapter 2</div>

<div style="text-align:right">**Making Movie Magic**</div>

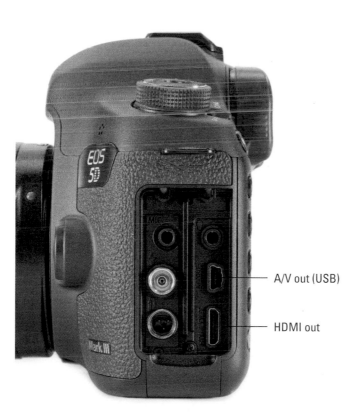

A/V out (USB)

HDMI out

Figure 2-11: Connect using the correct cables and terminals.

Bigger is better

I unplugged our 40-inch HDTV and carried it from our living room to my studio. (My wife was really happy about that.) I then hooked the TV to a Canon EOS 5D Mark III using an HDMI cable. After making the connections and settings, my wife wrangled a rabbit while I composed a close-up using Live view and manual focus. I stepped back and, with another camera, took the photo shown here while the 5D Mark III sent Live view video to the TV. Beats using a three-inch monitor!

3. **Connect the cable to your camera.**

 For USB and HDMI connections, be careful to insert the end of the cable straight into the receptacle. Don't twist, turn, or force it into the camera. It'll only go in one way.

4. **Connect the other end of the cable to your television.**

5. **Turn on the TV.**

6. **Switch TV input.**

 You'll have to look at your TV manual to figure this one out.

- If you're using an HDMI cable, switch the TV to the HDMI input port.
- If you're using a standard A/V cable, switch the TV to the appropriate input.

7. **Turn on your camera.**

The LCD on the back of the camera may not turn on. Don't worry. If it stays dark, it's because the camera is sending the signal to the TV. Some cameras send the signal *and* display it on your LCD monitor.

8. **Watch your movies.**

You can zoom in and out, protect, delete, or switch to looking at photos. In other words, go to town!

Taking a Little Off Around the Ears: In-Camera Movie Editing

Although it isn't a substitute for computer-based video-editing software, your camera may let you do some basic editing. Don't get too excited. This feature is most often limited to trimming from the beginning or end of the movie.

To do more complicated edits, including cutting out something from the middle of your movie, you'll have to use a computer and dedicated video-editing software. On-camera editing is handy but still quite basic. Figure 2-12 shows the editing interface on a Canon camera. You can cut from the beginning or the end, then save the file as a new movie or overwrite the original.

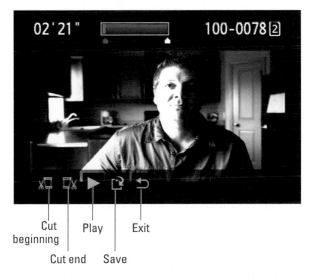

Figure 2-12: In-camera editing involves trimming from either end.

Going whole movie hog

If you want to do more than the basic in-camera editing functions allow, you should buy dedicated video-editing software. With it you can edit audio; add text overlays; create special effects; use filters; rerecord audio; create and manage movie projects with multiple source files; create DVDs or Blu-rays; and convert your movies to other sizes and formats.

This very small list offers some popular video-editing software. Shop around. Compare applications with the features you need. The best way to save money is to avoid paying for things you don't need. Within a general category, price isn't always the best gauge of quality.

- **Adobe Premier Elements** (Macintosh and Windows) is entry-level video-editing software. Visit www.adobe.com.

- **Adobe Premier Pro** (Macintosh and Windows) is for serious pros. Who have money. Visit www.adobe.com.

- **Apple iMovie** (Macintosh only) comes on most Macintosh computers. iMovie (with iDVD) is an entry-level video-editing application. Visit www.apple.com.

- **Apple Final Cut Pro X** (Macintosh only) is Apple's premier movie editor. It succeeds Apple Final Cut Pro and Final Cut Express. Visit www.apple.com.

- **Corel VideoStudio Pro** (Windows only) is an inexpensive yet feature-rich video-editing application. Visit www.corel.com.

- **Google Picasa** (Macintosh and Windows) has limited movie-editing features. It is, however, free. Visit www.google.com.

- **Pinnacle** (Windows only), a division of Avid, offers reasonably priced HD video-editing solutions. Pinnacle Studio is the entry-level product. Visit www.pinnaclesys.com.

- **Avid** (Windows and Mac) has a range of pro-level audio and video-editing suites that range from software-only solutions to full-fledged Avid-certified workstations. Visit www.avid.com.

Book VII

Getting Specific About Your Subject

Contents at a Glance

Chapter 1: People and Animals

In This Chapter

↙ **Beautiful performer**

↙ **Dreamy portrait**

↙ **At the zoo**

↙ **An artistic moment**

↙ **Catching the moment**

1 love photographing people. I'm not the traditional portrait taker, though. I like spontaneous shots of people going about their business. When you take photos of people, you normally want a very shallow *depth of field* (area of focus). This separates subjects from the blurred background and looks really nice. To achieve this effect, open your lens to its maximum aperture and either zoom in or step closer.

When people are moving, make sure to dial in a fast enough shutter speed so they don't blur. Because of this, I often take portraits in Shutter priority mode. Take it from me, you're wasting a creamy *bokeh* (unfocused area) if the subject isn't sharp! ISO often has to rise to pick up the exposure slack. Don't be afraid of a higher ISO. It's better to have a noisy photo that you can work with than nothing at all. If necessary, get additional lighting or use a flash. Book III, Chapters 1 through 3 talk more about aperture, shutter speed, and ISO.

This chapter is also about animals. Keep the same photographic principles in mind when you photograph house cats, zoo alligators, or backyard squirrels. Keep your shutter speed reasonably high and zoom in as much as you can.

Be relaxed around the people and animals you're photographing. Stressing out when you're taking their photo is going to stress them out. They won't relax and give you their best smile. If you can, blend into the background and capture spontaneous, unposed, portraits.

Capturing a Performer in Action

When you're photographing people in action, especially indoors, you often have to make dramatic exposure decisions.

I took the photo shown in Figure 1-1 during a practice session of our church band. The lighting was gorgeous, but not overly strong. I had to raise the ISO on the 5D Mark III to a staggering 12800 to capture this at 1/250 second. It works. The camera performed flawlessly and a bit of noise reduction in software cleaned things up.

The bokeh is exactly what you want in a portrait: soft enough that the subject is distinctly separate from it. The quality of the lens you use will directly affect the appearance of the bokeh (in this case, an EF 70–200mm f/4L IS USM). In addition, the wide aperture creates a shallow depth of field.

Settings: f/4, 1/250 second, ISO 12800, 135mm focal length, full-frame.

Figure 1-1: The lighting and creamy bokeh contribute to the beauty.

Using Creative Lens Effects

I tested a tilt-shift lens by taking a photo of my son. See Figure 1-2. It was a completely spontaneous moment. As I turned, he put his head on his arms with a loving expression on his face. I took the shot. Normally, this might have looked nice, but I was using a very unique type of lens. I had it tilted at an odd angle, which throws most of the photo out of focus. The central region is good, however, which makes it work in this case. Book II, Chapter 1 explains a bit more about the tilt-shift lens.

Normally, people use tilt-shift lenses for landscapes, not people. The moral of the story? Use what you have in any and every situation. You never know what you'll come up with.

Settings: f/2.8, 1/50 second, ISO 400, 80mm focal length, APS-C.

Figure 1-2: A spontaneous moment that turned out magical.

Getting On the Same Level

When photographing things close to the ground, it often pays to get down on the same level as your subjects. This creates interesting perspectives and photos that stand out from the rest. Book IV, Chapter 4 talks more about getting a new perspective.

Figure 1-3 is a shot I took of an alligator at our zoo. Rather than stand there and take a normal shot, I got down to look at the animal from the side. I got a completely different view of its face and expression this way. You see the teeth, the menacing eye, and the armored ridges on its back in a different light. It totally paid off.

If you have a camera with an articulated LCD monitor, you can use it to get on the ground. Hold the camera down and tilt the monitor upwards so that you can see it.

Of course, I had help. I was using a 300mm telephoto lens, which meant that I didn't have to stand next to the beast to get this shot. I increased the ISO and maxed the aperture so I could use a fast shutter speed with which to capture even a slow-moving animal sharply. Book II, Chapter 3 talks more about telephoto lenses.

Settings: f/4, 1/1000 second, ISO 1250, 300mm focal length, APS-C.

Figure 1-3: When in doubt, get down and zoom in.

Capturing Nonchalance

Not every portrait has to be traditional. Not every photo has to show a person's face. On a shoot with two of my sons, I'd just finished a shot in the other direction and looked back to see them waiting. The moment struck me, and I quickly framed and took the shot. I was using a Holga dSLR lens at the time, which explains the vignetting and softness. I love the effect! Book II, Chapter 1 explains a bit more about the Holga. See Figure 1-4.

Settings: f/8 (listed; actual is less), 1/25 second, ISO 400, 60mm focal length, APS-C.

Figure 1-4: People don't always need to be looking at you.

Choosing the Right Moment

You never really know what you're going to capture. I was at the harness races with the family one day, intent on photographing the action. I got quite a few good shots of the races. I was surprised, though, that I also got several keepers when the drivers were either warming up or cooling down.

The team in Figure 1-5 had finished a race and was returning to the paddock when I turned and saw them. The driver is covered with sand and leaning to one side. This shot is totally about him. The other elements provide context (his horse, of course, and the horse in the background) and balance the fact that he is very far to the right of the frame. Normally, that might bother me, but in this case, it works.

Settings: f/4, 1/1000 second, ISO 360, 300mm focal length, APS-C.

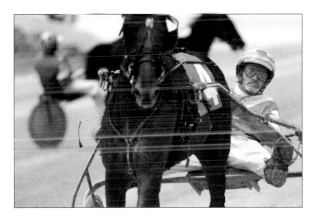

Figure 1-5: Be ready for the right moment and capture it!

Chapter 2: Landscapes and Nature

In This Chapter

↙ **Capturing sunset over the Maumee River**

↙ **Getting in the landscape**

↙ **Being adventurous**

↙ **Capturing a lonely tree**

*P*hotographing landscapes is different: You have to go where they are. You can't set one on a table in your studio or meet one at a local park. You have to find a means of transportation and travel.

The other fact is that you'll be dealing with the weather and sunlight at hand. You have no control over either, but you can choose one day or time over another. Aside from suggesting you routinely make trips to shoot during the golden hour, my advice is to mix it up. Clouds make skies look great, but aren't absolutely necessary. At times, you can frame landscapes without even seeing the sky. At other times, the sky is a central player.

When I photograph landscapes, usually I use a tripod and set my aperture to f/8. This ensures the depth of field will be large, which is what you want for most (but not all) land-scapes. If you want to experiment with filters, land-scapes are a natural subject.

Capturing a Sunset in HDR

Using a tripod helps me align exposure-bracketed photos for HDR, which I do frequently.

Figure 2-1 is a classic "sunset over the river during the evening golden hour using HDR" photo. I timed a trip for this spot at sunset, and the result was marvelous. In this shot, I set up the tripod and positioned the camera to look toward the farthest part of the river, not the setting sun.

Although it isn't impossible to include the sun in your shots, do so with care. Pointing your camera at the sun and focusing on it can damage the sensor.

This gives the photo an incredible depth. The setting sun (and the fact that HDR often enables you to push saturation, which is another way of saying color intensity, a bit) created the colors.

The camera settings are standard-issue landscape. Most times when you shoot a landscape, you want a large depth of field (area of focus) and no noise. Since I used a tripod, shutter speed wasn't an issue. Book III, Chapter 1, has more about depth of focus.

Settings: f/8, 1/40 second, ISO 100, 10mm focal length. APS-C.

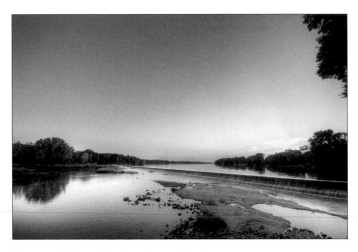

Figure 2-1: The golden hour is your friend.

Focusing on a Tree

The shot in Figure 2-2 is the result of driving to another location to take photos and noticing something interesting along the way. The small lake in the background was interesting, but when I evaluated the scene seriously, I realized I liked the trees better. I therefore set the camera up to focus on a single tree and offset it so that I could also see the lake and the background.

I took this landscape shot like I would shoot a portrait, which is how I got the blurred background. See? Rules are meant to be broken. You can read more about portrait shots in Book VII, Chapter 1.

Settings: f/2.8, 1/1250 second, ISO 100, 40mm focal length. APS-C.

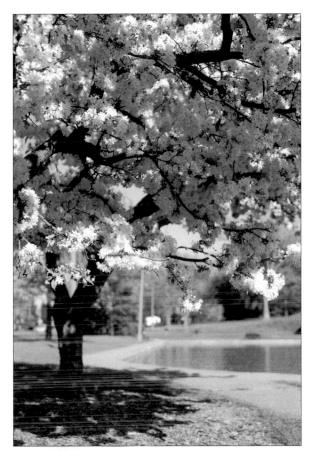

Figure 2-2: It's okay to feature a foreground object.

Getting in the Riverbed

Sometimes you get crazy ideas. Quite often, you should act on them. Take a look at the photo in Figure 2-3. First, I had just been to a local outdoor gear store. They specialize in camping, hunting, fishing, trekking, and other cool stuff. I went there to get some rubber boots so that I could get close to the river and keep my feet dry. I took this shot *on the way home* from buying them and a few pairs of socks. Second, I was using a tilt-shift lens. Go figure! You can read more about tilt-shift lenses in Book II, Chapter 1.

Settings: f/2.8, 1/1600 second, ISO 100, 80mm focal length. APS-C.

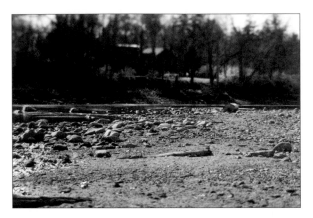

Figure 2-3: My being in the riverbed makes this a more interesting shot.

Going Out in the Fog

The bridge shown in Figure 2-4 is about a half-mile from where I live. I drive past it constantly and for years have wondered how best to photograph it. I had planned to get out on a sunny morning and capture the sun reflecting off the water and turning the bridge a nice gold color. I still plan to! This morning, however, was foggy. We don't get foggy mornings with any regularity, so I grabbed the camera and went to the bridge to see what I could photograph when I woke up and saw the weather. I took this shot with a Holga lens of all things (decidedly low tech). You can read more about Holga lenses in Book II, Chapter 1.

Settings: f/8 (listed; actual is less), 1/60 second, ISO 6400, 60mm focal length. APS-C.

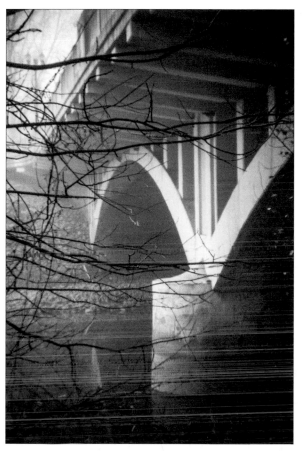

Figure 2-4: Looking for the perfect shot.

Combining Different Elements

I took the photo in Figure 2-5 looking out over Lake St. Claire, which is just to the northeast of Detroit. It's a great shot of the lake, but what makes the lake work are the tree, the greenery to the left, and the few puffy white clouds. Isn't that odd? When you can combine different elements, they can strengthen each other. The tree looks lonely as it tilts toward the lake. If you look close enough, you can see the boats on the water.

My lens choice was critical for this scene. At 10mm, that's ultra wide-angle territory. Book II, Chapter 2, has more about wide-angle lenses.

Settings: f/8, 1/320 second, ISO 100, 10mm focal length. APS-C.

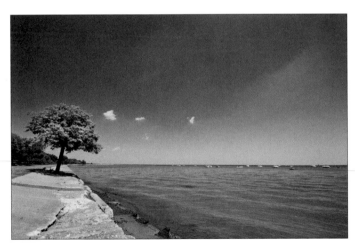

Figure 2-5: The lake by itself was boring.

Chapter 3: Sports and Action

Shutter speed. Shutter speed. I don't meant to repeat myself, but shutter speed. If you want to take action shots, you must make shutter speed your top priority. All else is secondary. Use the largest aperture you can and raise the ISO as much as you need to. A blurry action shot isn't worth printing out and framing. I know. Believe me!

The other part to keep in mind is how transitory things are: People, planes, horses, buggies — whatever you're after is in motion. You can't use a relaxed focusing mode. Put your camera in a continuous focus mode so that it keeps focusing as long as you have the shutter pressed halfway. Use a single AF point, unless it's something whose motion is so random you can't track it; in that case you can try a zone or other more advanced AF mode (if you have it). You can read more about autofocus in Book I, Chapter 5.

Be prepared. Pick a spot and camp out for a while. If that works, take tons of shots! When you're satisfied, move to another location. Before you get there, you can read Book III, Chapters 1 through 3 for more about aperture, shutter speed, and ISO.

Tracking the Action

I love planes. I love jets. Fast jets, loud jets, J-E-T-S, Jets Jets Jets. Figure 3-1 is a shot of a Lockheed Martin F-22 Raptor screaming by overhead, executing a fly-by during a local air show. To capture this sort of action, you need shutter speed and reflexes. I set the camera for 1/1000 second, which seemed to work well.

If you're photographing something super-fast, don't focus on one spot. Instead, pan and track the plane, using continuous focus to lock on. When everything works (except the weather in this case, which stunk), you get sharp photos of action, well, in action.

Settings: f/4.5, 1/1000 second, ISO 125, 300mm focal length. APS-C.

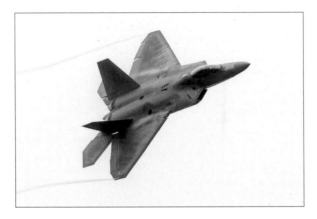

Figure 3-1: This was an awesome fly-by.

Picking Your Spot

Not every action shot needs to be an air show or a professional sporting event. The photo in Figure 3-2 is my son getting ready to run home during his summer baseball league. After walking around and checking out all the angles, I settled on looking down the base path from third to home. The change in perspective worked because I was able to include an interesting baseball-related background in the shot that includes several intriguing details: the batter, the stands, the fence, and the people in the stands. The background made all the difference.

I use my 300mm lens a lot. For illustrating action in a book, I must be able to take photos where you can see what's happening. If you want to try something like this, look into an affordable zoom lens that covers between 200mm and 300mm focal lengths. You can also rent or buy your own super telephoto lens.

Settings: f/4.5, 1/400 second, ISO 100, 300mm focal length. APS-C.

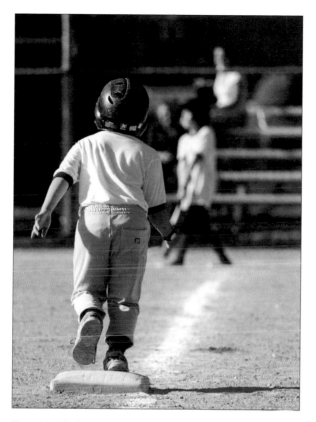

Figure 3-2: Being on the baseline was a good call.

Choosing the Right Moment

Pressing the shutter button at just the right moment is an important skill to develop if you want to shoot good action shots. Although it might seem like hit or miss, your sense of timing is very important.

Figure 3-3 shows a harness race in action. The horses and their drivers are rounding the final turn to head down the main strait. This isn't the type of shot you can plan. You have to feel the moment and press the button. The more practice you get, the better you'll become. As with other action shots with lots of motion, this required a fast shutter speed. The sun was shining, though, which meant the ISO could be low.

Settings: f/4, 1/1000 second, ISO 125, 300mm focal length. APS-C.

Figure 3-3: Sometimes you have to feel the right moment.

Capturing a Drive

The photo in Figure 3-4 is a good example of how difficult it can be to take good action shots. I was in a dimly lit gym that didn't seem all that dark until I used the camera and metered the scene. I quickly realized I was going to have problems. To read about metering, check out Book III, Chapter 5.

I switched to a 50mm prime lens whose maximum aperture is f/1.4 and opened it up wide. (Not everything has to be telephoto.) I also positioned the players so they'd run through direct sunlight. Only then could I set the shutter speed fast enough to capture them without blurring, and that was with a relatively high ISO (at least for the camera I was using). Here again, timing was important. I waited until the ball reached the top of a bounce to take this shot. There wasn't a huge amount of motion.

Settings: f/1.4, 1/500 second, ISO 1000, 50mm focal length. APS-C.

Figure 3-4: Dim indoor lighting can push your camera hard.

Picture Everything

I took the photo in Figure 3-5 at the same air show as the Raptor shot. This photo is of a North American P-51 Mustang taxiing out to the runway. It was raining off and on. During a short break it looked like the P-51 would make it up in to the air. It didn't, which meant that I didn't get a single flying shot of the Mustang. Had I not taken a few shots of it taxiing, I would have nothing to show.

However, there are several things about this shot that really stand out. First, the plane was very close, which lets you see the interesting details, such as the prop cutting through the air. You can also see the name of the plane and other markings very clearly. I almost didn't take it so I could save battery power and memory card space for when it got up into the air. Thankfully, I couldn't resist even a taxiing airplane. I used the same settings as my other shots that day.

Settings: f/4, 1/1000 second, ISO 180, 300mm focal length. APS-C.

Figure 3-5: You never know what will look good.

Chapter 4: Buildings and Cities

In This Chapter

- ✔ Using HDR to capture color
- ✔ Photographing reflections
- ✔ Capturing a fountain
- ✔ Taking nighttime shots
- ✔ Being in the Gateway Arch

*B*uildings and cities are man-made landscapes. You'll use many of the same techniques to photograph them as you would a sunset over a river. Framing and direction are important when photographing buildings. Hopefully, you'll be able to find one or more spots where the view is nice and the lighting shows off the building (or fountain, statue, or skyline). If not, pick another building or city.

You need a wide angle lens to capture larger buildings, especially when you're close to them. If you're photographing a cityscape or skyline, wide-angle lenses give you a greater sense of breadth and depth. It's impressive to see an entire building or a large part of a city. You can't get that with a 50mm lens unless you're shooting from a mile away!

Similarly, Aperture is the exposure setting you'll most often want to look at, so you can control the depth of field. Make it large to have more in focus. Start at f/8 if you want an expansive depth of field, and consider stopping down to f/16 or f/22 if you need to increase its size after reviewing your photos and examining the depth of field. Shutter speed won't matter and you can use a low ISO.

Using HDR

I like *high dynamic range (HDR)* photography because it helps you capture more detail in high-contrast scenes than you could with one photo. Why settle?

Figure 4-1 is an example of an HDR image (see Book V, Chapter 4) of a building in downtown Detroit. The sky and clouds were bright and the light was pretty harsh. Not only that, it was oppressively hot. HDR let me capture the range of natural contrast in this scene, from the dark granite to the bright reflections. If you look carefully, you'll see that I was standing very close to the building. I was only a few feet away from the nearest flagpole.

Photographing buildings, especially from this distance, often requires the widest-angle lens you have.

Settings: f/7.1, 1/80 second, ISO 100, 10mm focal length. APS-C.

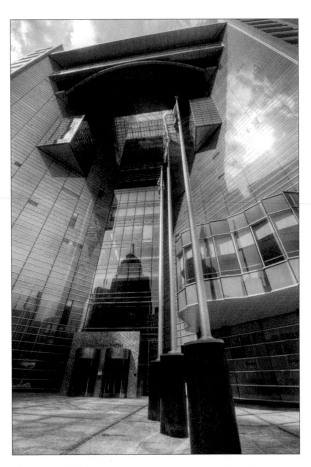

Figure 4-1: HDR let me capture detail and color in this scene.

Finding Unique Perspectives

My sons and I were out walking the grounds of a local university as I tested my new Holga lens (which you can read more about in Book II, Chapter 1). The shot in Figure 4-2 feels more like a landscape due to the reflections in the mirrored glass. The lens caused the *vignetting* (darkened edges), as well as the softness. The contrast and colors are very nice, however.

This scene, like a landscape, benefits from the light you see in the reflection. Notice the shadows cast by the trees? That's right, it's towards the evening golden hour. Had I tried to shoot this scene at a different time or with an overcast sky, it wouldn't have the same effect.

Settings: f/8 (listed; actual is less), 1/25 second, ISO 400, 60mm focal length. APS-C.

Figure 4-2: This reflection is mesmerizing.

Creatively Processing Your Shots

The fountain in Figure 4-3 is located on Belle Isle, just outside of Detroit. It was windy, sunny, and bright, and we intrepid travelers were tired and not looking forward to the drive home. Despite that, we got out and explored. I'm so glad we did, too: This fountain ranks among my favorite scenes.

In this shot, I positioned the sun to the left. It's hitting the water and fountain from behind and to the side. I held the camera vertically to block out some of the distractions. I also needed room for the pool in front and the spray.

I've processed this shot a number of ways. Instead of leaving it natural-looking (a typical blue sky with elements of green), I *desaturated* the image (lowered the color intensity) and added a dab of silver. The result is artistic and unique. You know, you can do whatever you want with your photos too!

Settings: f/11, 1/200 second, ISO 100, 18mm focal length. APS-C.

Looking Up

Figure 4-4 is a photo of the Cadillac Tower in (you guessed it) downtown Detroit. If you don't have tall buildings where you live, travel somewhere else to photograph them. This building is huge. I was able to stand across the street with my wide-angle lens and capture it fully. The dark sky (it was night) makes the building stand out nicely. Of course, shots like this need to be taken vertically.

The building is leaning away, which is a tell-tale sign that I pointed the camera up to take the shot. If this bothers you, you can remove *vertical distortion* in software afterwards. I don't really mind it in this case, and removing it can often do more harm than good.

When you're in any city taking photos, pay attention to your surroundings. Watch out for traffic and other pedestrians. You increase your safety by keeping to well-lit areas that are frequented by visitors or tourists. It also helps to be with people.

Settings: f/3.5, 1/4 second, ISO 1600, 18mm focal length. APS-C.

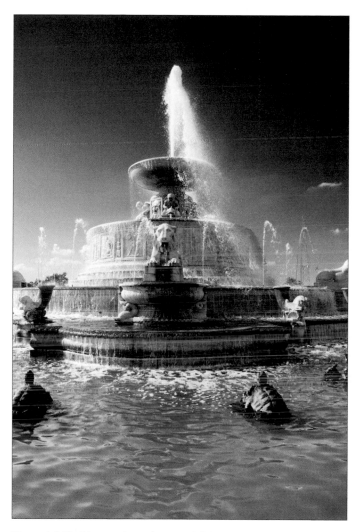

Figure 4-3: You'd never know it was a bright, sunny day.

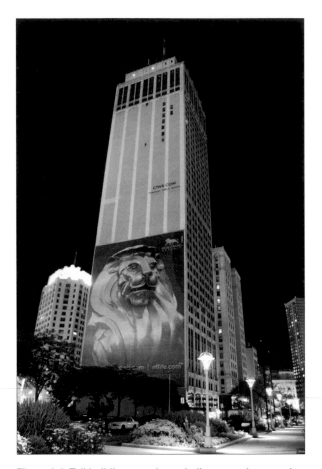

Figure 4-4: Tall buildings can be a challenge to photograph.

Looking Out from the Arch

When I was a kid, my family drove by the Gateway Arch in St. Louis a number of times on road trips. The closest we ever came to stopping and seeing it up close was when we got lost and accidentally left the highway. Years later, I was stationed at a nearby Air Force base and had the opportunity not only to visit but go up inside it several times. Now that I have my own family, I *wasn't* going to drive by without stopping. Figure 4-5 is one of the shots I took from the top.

We timed our visit perfectly to coincide with the evening golden hour. The perspective is looking out of the Arch to the northwest. The sun cast beautiful rays and the colors of the buildings really stand out. I chose a wide-angle lens to capture this, because I wanted to include part of the window in addition to the outside scenery.

I approached this scene much like a landscape. I set the aperture for a good depth of field and left the ISO at 100. The shutter speed was a reasonable 1/100 second. This shot shows the power of a unique scene taken from an interesting vantage point in good lighting.

Settings: f/8, 1/100 second, ISO 100, 14mm focal length. APS-C.

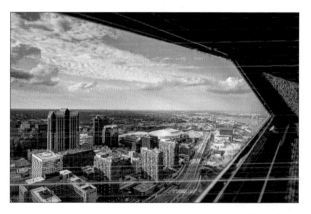

Figure 4-5: Great vantage points produce great photos.

Chapter 5: Close-Ups

In This Chapter

⮡ **Buzzing around a spectacular flower**

⮡ **Coming to get you**

⮡ **Lighting candles**

⮡ **Appealing to the Great Spirit**

Close-ups are a fantastic way to capture details. They help you see things in a different light, whether the photo is of a statue, a spider, or a flower. This change in perspective also helps you as a photographer.

After shooting close-ups for a while, you'll find that all your photographs improve. The reason is that you tend to pay close attention when shooting smaller details. The background, the lighting, the camera orientation, the depth of field, and other aspects of the scene become larger. You concentrate on them more fully.

Close-ups are fun. Just zoom in a bit and get close to your subject. If you have a stronger telephoto lens, you can stand farther back. This helps with animals.

Concentrate on making sure the *depth of field* (area of focus) is reasonably sized. The distance this equates to depends on your subject. It might be half a spider or a small slice of a candle. Stepping in close will shrink it. Also pay attention to shutter speed. Most close-ups are shot hand-held. If you're a bit shaky and the shutter speed is on the slow side (this depends on your abilities and whether you're using vibration reduction or not, but you should try for speeds faster than 1/60 second), the shot will be blurry. Look for bright light, preferably outdoors, or use a flash. Book IV, Chapter 1 talks about flash in depth.

Zooming In

My wife and I picked up a bunch of new plants one day. Figure 5-1 is one of the succulents, an Echeveria. The leaves are very delicately shaped. The overall effect is like a flower bud. Sometimes it's just that simple! Grab a plant. Photograph it. I think this photo is nice partly because of the natural light.

The *depth of field* (portion in focus) is fairly shallow, even at f/6.3. This photo hides that fact, though, because most of the flower is face on and not at an angle to the camera. If you look closely enough, though, you can tell that the bottom leaves, the pot, and the table are getting progressively more out of focus.

Settings: f/6.3, 1/500 second, ISO 125, 300mm focal length. APS-C.

Figure 5-1: This is a good example of a botanical close-up.

Noticing Your Surroundings

My wife and I were downtown one night, trying to capture shots of a new bridge. (It really is nice to have company when you're shooting; I highly recommend it.) We were coming back across the bridge when we approached and stood next to an ornate stone sign. At some point (thankfully it was sooner rather than later) we realized that it was covered in spiders. One had spun a web between the sign and a tree; see Figure 5-2. Not wanting to pass up an opportunity for a good shot, I set up the camera for a close-up and turned on the flash.

Part of the challenge was getting the spider in focus. It was dark, and not the best situation to try manual focus. At this distance, the depth of field is small enough that manually focusing is pretty much impossible. I had to rely on the camera's AF system to target the spider.

Although a bit creepy, the shot turned out. I didn't have a ton of lens to work with for this close-up. I was using an 18–55mm kit lens, which meant I had to zoom in *and* stand close.

Settings: f/8, 1/160 second, ISO 100, 55mm focal length. APS-C.

Figure 5-2: Oh. Hello, there.

Setting the Stage

You may have everything you need around your house (apartment, dorm, tent) to shoot your own creative close-ups. Figure 5-3 is several votive candles on top of an old TV tray, which is sitting on my bed. The lights are off.

I didn't shoot this with a macro or super telephoto lens. I used a 50mm prime lens, as close as I could get. Because the lighting was dim, this shot pushed the exposure envelope for hand-held photography. Even at f/1.4 and ISO 800, I was only able to coax the shutter speed to 1/80 second.

With scenes that you set up in studio (apartment, dorm, tent), you have time to set the stage and try things out. Experiment with alternatives.

Settings: f/1.4, 1/80 second, ISO 800, 50mm focal length. APS-C.

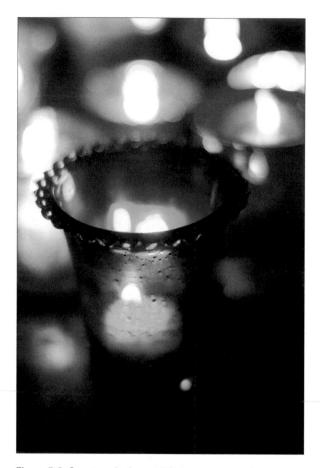

Figure 5-3: Spontaneity is good, but you can create your own scenes.

Crouching Chipmunk

I took a 300mm telephoto lens to the zoo and found out that I could use that lens not only for action shots, but animals. Most of the time, you need a long lens to take close-up pictures of wild animals. You simply can't get close enough to them with a normal lens. The funny thing about this shot is that I was walking between one exhibit and another when I looked down and saw a chipmunk by the path. I crouched down to get on his level. Otherwise, I would've taken a picture of the top of a chipmunk. I wanted to see his face and paws as he ate. The result is a nice, unexpected close-up of a chipmunk visiting the zoo just like us.

Notice that even at f/4, the depth of field is very shallow. Part of that is due to the longer focal length than normal. The rest is because I'm pretty close to the little guy.

Settings: f/4, 1/1000 second, ISO 1400, 300mm focal length. APS-C.

Figure 5-4: Not the largest animal at the zoo.

Stopping to Photograph

Figure 5-5 is a shot of a statue called *Appeal to the Great Spirit* by Cyrus Dallin, installed in Woodward Park in Tulsa, Oklahoma. This shot represents the kind of spontaneous effort you should be open to. During a trip, I saw the statue and wanted to photograph it. As soon as I got the chance, I spent an hour or so photographing this gorgeous work of art. The thing is, I could easily have decided to pass up the opportunity. Had I done so, I'd have robbed myself of the chance to take such a moving close-up.

If something catches your eye but you can't photograph it right then, take the time to revisit it.

I approached this as I would a portrait: with a 50mm lens and a wide aperture. The day was bright enough that the shutter speed was very fast. I focused on the horse, rather than the rider. It's just a bit different than you're expecting, and results in a nice effect. This type of subject also makes it possible to shoot several photos from all possible directions. You can choose later which ones best represent the subject.

Settings: f/1.4, 1/2500 second, ISO 100, 50mm focal length. APS-C.

Figure 5-5: The effort is worth it.

Index

D

1